The Eighteenth Century
Art, design and society, 1689–1789

From the Middle Ages to the Stuarts
Art, design and society before 1689

The Eighteenth Century
Art, design and society, 1689–1789

The Early Nineteenth Century
Art, design and society, 1789–1852

The Late Victorians
Art, design and society, 1852–1910

The Eighteenth Century
Art, design and society, 1689–1789

Bernard Denvir

Longman
London and New York

Longman Group UK Limited,
Longman House, Burnt Mill, Harlow, Essex CM20 2JE, England
and Associated Companies throughout the World.

Published in the United States of America
by Longman Inc., New York

First published 1983
Second impression 1988

British Library Cataloguing in Publication Data

A Documentary history of taste in Britain.
 The eighteenth century: art, design and
 society, 1689–1789
 I. Arts and society – Great Britain
 1. Denvir, Bernard
 700'.941 NX543

ISBN 0-582-49143-6

Library of Congress Cataloging in Publication Data

Denvir, Bernard, 1917–
 The eighteenth century.

 (A Documentary history of taste in Britain)
 Bibliography: p.
 Includes indexes.
 1. Art, British. 2. Art, Modern–17–18th
centuries–Great Britain. 3. Aesthetics, British.
I. Title. II. Series.
N6766.D4 1983 709'.41 82–16205
ISBN 0-582-49143-6 (pbk.)

Set in 10/12 Linotron 202 Bembo
Produced by Longman Singapore Publishers Pte Ltd
Printed in Singapore

Contents

Contents

reactions to eighteenth-century eclecticism by James Cawthorn, 1756; by J. Shebbeare in *Letters on the English Nation*, 1756; by Lord Kames in *Elements of Criticism*, 1762; and by Robert Morris in *The Architectural Remembrancer*, 1751 *57* **2.22 A Gothic bedchamber:** Thomas Gray describes Horace Walpole's bedchamber at Strawberry Hill in a letter to Dr Warton, 1759 *59* **2.23 Hogarth on architecture:** extract from 'Of Parts' in William Hogarth's *The Analysis of Beauty*, 1753 *60*

3. The rule of taste
The idea of taste as a dominant element in art; connoisseurs, collectors and the Grand Tour. *63*

4. Fine art and its institutions
Categories of art; the life of artists, patrons and
collectors; the rise of institutions, exhibitions
and art schools

Contents

5. The arts of manufacture
Design; pottery and porcelain; textiles and
wallpaper; prints 205

6. Man and nature
Gardens and landscape 244

Contents

List of plates

Preface

History is the pattern which the present imposes on the past, and in no field of that study is this more apparent than in the history of art, where the imposition of a concept of stylistic development, with all its essential simplifications, has become virtually accepted as obligatory. Yet we are conscious that art as it happened was created by people whose sole concern was not with a particular style, a specific aesthetic, but by people who were involved with many things, who reacted to the happenings of their temporal and physical contexts, who were preoccupied with practical as well as theoretical matters.

My main intention in compiling this series of volumes is to provide – however partially or incompletely – the student of art history and of related disciplines, as well as the general reader, with a body of material written by those living at the time, which may otherwise be difficult of access or widely diffused through an unfamiliar range of books. It is material concerned with the actualities of the world of art rather than with those theories which, though they may have provided it with an ideology, were as much a gloss on what was happening rather than the cause of its existence. In any case a great deal of material is already available to the student about theories of beauty, and so I have included references to them in an illustrative rather than a comprehensive way. On the other hand, I have allocated a fair amount of space to exemplifications of taste in action, always inclining rather to what is usually called the 'social history of art' rather than to its more rarefied stylistic or aesthetic dimensions.

I have taken the word 'art' in its wider sense to include architecture and design as well as the visual arts, and though it has not always proved possible to allocate equal amounts in each volume to these respective headings, I have endeavoured always to emphasize the interrelationship between them.

To faciliate easy reading I have restricted critical apparatus to a minimum – for I see these volumes as being able to be read as a

continuous narrative, capable of giving pleasure and even diversion, as well as for academic profit. A biographical index gives basic information about those people mentioned in the text, as well as about the authors of the various extracts. The spelling of the extracts is that of the original, except in a few cases taken from manuscript sources in which the orthography has been so eccentric as to be incomprehensible.

Inevitably, even in a work of this size, it has not been possible to include documentary accounts of every ripple in the stream of taste, every eddy in the current of creativity. I have been limited by the availability of material, by the restrictions of my own reading, and occasionally by my own prejudices and predilections. In some instances, however, apparent gaps may be due to planning rather than to inadequacy. In this particular volume for instance, little or no reference has been made to the controversies surrounding the picturesque, as I feel that this would more appropriately be dealt with in the volume covering the period between 1789 and 1851.

I am indebted to several people for their help and support, but I must especially mention my wife Joan, and Margaret Brenton, without whom it would have been impossible.

26 January 1982. Bernard Denvir

1. Introduction

The Glorious Revolution can be considered as convenient an event as any to mark the beginning of a period in British history which, despite the flurries of the Jacobite revolts, occasional outbursts of urban and rural unrest, and the loss of the American colonies, was marked by political stability, vast economic growth, an increase in population, and the emergence of a specifically British contribution in the fine arts, architecture and design to the cultural heritage of Europe, of a kind which had not appeared since the end of the Middle Ages. Symbolic of the birth of a new age of pride, self-confidence and magnificence was Wren's St Paul's, one of the largest churches in Christendom, dominating a London which, in fifty years, was to be transformed from a largely medieval city into a metropolis which was to excite the envy and arouse the admiration of every foreign traveller who, on returning home, rushed to commit to pen and paper his impressions of Britain.

It is difficult for us to realize the immense amount of building that went on in London during the first half of the eighteenth century. Never before had so many churches been built in so short a time. Not only were there the Wren churches, erected in the city mainly to replace those destroyed in the fire, but there were those others in Westminster and the suburbs, built on the proceeds of a special tax on coal levied for that purpose by an Act of the ninth year of the reign of Queen Anne. Even when new churches were not built – and this is especially true of suburbs such as Camberwell, Islington or Wapping, the Gothic structure of existing churches was restyled with vaguely Baroque façades, and the interiors remoulded to current taste.

Public buildings arose of a splendour not previously known in London. The hospitals at Greenwich and Chelsea, the Mansion House, the Foundling Hospital, the Adelphi, the Bank of England and the Pantheon, provoked visitors to make comparisons, which often had some stylistic if not factual veracity, with Venice, Florence and Rome. Then too there were the great private houses, built

to give evidence of their owner's wealth or taste, or both: Burlington House in Piccadilly, designed by its owner, with the help of Colen Campbell; Devonshire House, Chesterfield House, Cambridge House, and others slightly less grand, conceived mostly in that Palladian style which Burlington had done so much to impose.

Town houses – they could justifiably be called palaces – such as these were indeed indicative of great wealth, and in the eighteenth century millions of pounds were spent on building. The monies needed for the wars of William III had marked the beginning of a process which was to make the London banking system the most successful and sophisticated in Europe; wealth was pouring in from colonies and trading posts throughout the world, and British foreign policy was dominated largely by the need to make the world safe for British trade. New and improved agricultural methods were increasing what was still the basis of much wealth, the products of farming, and the growth of cities such as London was vastly increasing the rent-rolls of those who owned the land on which they were built. The Russells' receipts from their Bloomsbury properties rose from £3,700 in 1732 to £8,000 in 1771. Politics itself, with its network of bribery, corruption and more conventional forms of money raising, could transform Robert Walpole's status from that of a country squire to that of one of the richest men in England, if not in Europe, who could spend £1,500 (about £50,000 in modern money) a year on wine, and £1,219 3s. 11d. on the trimmings alone for the green velvet state bed designed for him by William Kent. England, Scotland, and Ireland became studded with great houses, temples dedicated to the display of the wealth and power of their owners: Blenheim Palace, which in modern money cost something close on twelve million pounds; the Walpoles' great house at Houghton, with its two or three hundred servants and gardeners; Castle Howard, Chatsworth, Woburn; the list is endless. Old houses were refurbished with Palladian fronts, and countless acres of land surrounding these houses and palaces were reshaped by men such as Capability Brown, or later, Humphry Repton, to conform to ideals which though varying throughout the century, were ultimately based on some pictorial prototype, whether it was Claude's Campagna, or prints of Chinese gardens derived from drawings of Jesuit missionaries and peripatetic orientalists. It was the ideal of every man of substance to possess 'a serpentine river and a wood', and Hogarth pointedly made Lord Squander in *Marriage à la Mode* marry his son to a merchant's daughter to raise more money for the building of his Palladian palace. In actual fact one

Lord Sandys mortgaged his estate to the tune of £23,000 to finance the construction of his house in the country.

This mania for building produced inevitably a noticeable change in the status and nature of the architectural profession. There were in the first place the gentlemen architects, to whom the profession was a creative hobby, men such as Thomas Archer, who designed the bowed north front at Chatsworth, and St John's, Smith Square, a man of good family, a graduate of Oxford, who had travelled extensively on the continent; Sir John Vanburgh, soldier, spy and playwright, before he turned to architecture, who was of aristocratic descent, and, of course, most famous of all, Richard Boyle, third Earl of Burlington, arbiter of taste, and designer of Burlington House, (largely rebuilt in the nineteenth century), his villa at Chiswick, the interior of the York Assembly Rooms, the dormitory at Westminster School and Tottenham Park in Wiltshire.

Social status apart, architects were now men of learning and sophistication, widely read, widely travelled. Sir William Chambers, who did so much to make architecture into a coherent professional occupation, had spent nine years travelling in the Far East, a year in Paris studying under Jacques-François Blondel, the most famous architectural teacher of his day, and five years in Italy, before he took up practice in London. His great rival Robert Adam had been a student at Edinburgh University before spending some four years in France, Italy and Dalmatia, where his study of Diocletian's Palace laid the foundations of his own architectural style. It was one which was to add yet another element to the historical eclecticism which gradually took over from the rather rigid dependence on Palladian principles, which had marked the earlier part of the century, and which was still to remain the norm to which English architecture would return again and again over the next two centuries.

Never before in history had architects had so many exemplars to stimulate their imagination and influence their style. Throughout the century the successors of Camden and Dugdale were exploring the past with assiduousness and an objectivity unknown to earlier generations, and their works were becoming available in editions which became progressively cheaper and better illustrated. Periodicals such as *The Gentleman's Magazine* revealed in each issue the expanding fields of historical and geographical knowledge which were becoming accessible to all. The great improvements which were being made in the art of engraving made possible the publication of superbly illustrated books which portrayed, with an

accuracy hitherto unknown, ancient, medieval and non-European art and architecture. The Palladian revival sponsored by Burlington depended largely on the fact that he encouraged the publication of books such as William Kent's *Designs of Inigo Jones* (1727), Robert Castell's *Villas of the Ancients* (1728), Isaac Ware's edition of Palladio's treatise (1738) and his own publication of Palladio's drawings for the restoration of Roman baths (1730). Chambers' *Designs of Chinese Buildings* (1757) and *A Dissertation on Oriental Gardening* (1772) opened up new vistas of stylistic expression. The Society of Dilettanti virtually laid the foundations of the scholarly study of the classical world by sponsoring the publication of a series of volumes, *The Antiquities of Athens measured and delineated* (4 vols 1762–1814) and *Ionian Antiquities* (5 vols 1769–1814), which became virtual storehouses of architectural precedent. Robert Adam's *Ruins of the Palace of the Emperor Diocletian at Spalato* (1764) not only provided the basis for a vindication of his own work, later extended in *The Works in Architecture of R. and J. Adam* (3 vols 1778–1822), but in its choice of domestic building, rather than public ones, did much to undermine the standing of Palladio, who had used temples and public baths as the precedents for the creation of a private vernacular. In addition to these more or less strictly architectural publications, there was throughout the century an ever increasing flow of books dealing with local antiquities, which illustrated, often in considerable analytical detail, the cathedrals, abbeys, churches, castles and domestic architecture of the Middle Ages. These pattern-books, for this was what they virtually were, could be used not only by architects, but by furniture, textile and wallpaper designers. They more than any other single factor were responsible for the eclecticism which so largely dominated British architecture and design from the middle of the century.

It would, however, be a gross distortion of actuality to think of the architectural world of the eighteenth century as consisting merely of scholarly professionals, poring over precedents from classical antiquity and the Middle Ages, to create great palaces and immense public buildings. Architects were recruited from tradesmen, bricklayers, carpenters, coach-painters and clergymen. There was a clutch of do-it-yourself books, written by professionals such as Batty Langley and Isaac Ware, to enable any country gentleman or city tradesman to run up a house or villa, with the help of a local builder. In London, and to a lesser extent in other provincial cities, there was a whole race of speculative master-builders who would undertake the building of houses, even complete streets, culling the

'architectural' elements – doorways, mouldings etc – from the per-
usal of books such as Batty Langley's *The City and Countryman's
Treasury of Design, or the Art of Drawing and Working the Ornamental
Parts of Architecture* (1741) (which cost 16s unbound) or, if they had
subscribed to it, the more magnificent *Vitruvius Britannicus* (1715
onwards) a record of the finest classical-style buildings erected in
England. Then too, in the country, there were traditional builders
who turned their hand to anything, and who were still employing
techniques, and even designs, which in essence went back to Tudor
times, if not beyond.

But whether your newly acquired or inherited wealth had led
you to build a palace in Yorkshire or a ten-roomed brick house in
Bloomsbury, you would need furniture, fittings and decorations.
Here again there was a continuous improvement in the techniques
and actual tools of the craftsmen – carpenters, joiners, plasterers,
weavers, metal-workers – involved. Isaac Ware in his *A Complete
Body of Architecture* advised the budding architect on the general
arrangement of the interior;

> The decoration of the inside of rooms may be reduced to three
> kinds; first those in which the wall itself is properly finished with
> elegance; that is where the materials of the last covering are of the
> finest kind, and it is wrought into ornaments, plain or uncovered;
> secondly where the walls are covered with wainscot, and thirdly
> where they are hung; this last article comprehending paper, silk,
> tapestry and decoration of this kind. For a noble hall, nothing is so
> well as stucco; for a parlour, wainscot seems properest, and for the
> apartment of a lady, hangings.

The most recent of these forms of wall-treatment, paper developed
considerably during the century. In the early part it was mostly of
the flock variety, intended to imitate the more expensive velvet or
leather which it was supplanting, and the design, usually based on
fruits or flowers, was of a bold conventional variety, of rich colours
against a lighter ground. Gradually, however, this type was sup-
planted by printed (instead of stencilled) papers, lighter in both
design and colour. The most famous, most expensive, and most
popular of these were made by J. B. Jackson of Battersea, who in
1754 published *An Essay on the Invention of Engraving and Printing in
Chiarco Oscuro . . . and the Application of it to the making of Paper-
hangings of Taste, Duration and Elegance*. In the course of the intro-
duction he exemplifies how sophisticated visual taste had taken a
hold of the 'middling' classes by pointing out that these papers
could be adorned with woodblocks of the Medici Venus, the Belve-

5

dere Apollo and other classical antiquities or, alternatively, with prints after Claude, Poussin or Salvator Rosa. Even the fastidious Horace Walpole did not disdain to use Jackson's paper at Strawberry Hill.

The sort of furniture to be found in the Georgian house depended very largely on the wealth and status of the owner. The rich either had it all designed by the architect of the house, who made it conform to the style of his own classical, Chinese or Gothic taste, or alternatively ordered it from one of the great London furniture makers such as Chippendale, from whose premises it would be laboriously carted down to the country. But the majority of people would get their furniture from a local craftsman or cabinet-maker, who in turn would rely for the design on one of the many pattern-books being published at the time. Of these the most famous, of course, was Chippendale's own *The Gentleman and Cabinet Makers's Director*, first published in 1754, again in 1755, and in an enlarged edition in 1762, which capitalized on the reaction against the classical style and translated French, *Chinoiserie* and Gothic designs into an admirable asymmetric idiom, adapted to English taste. In actual fact, many of the designs in the book are based on the work of other cabinet-makers such as Matthias Lock and Henry Copland. It was to this book that Chippendale largely owed his fame, for Tottenham Court Road, the cabinet-makers' district, was full of craftsmen of equal or even greater distinction, men such as William Vile, John Cobb and William France. The main source of reaction against the style which *The Director* imposed on the cabinet-makers of London came, not from one of themselves, but from Robert Adam who, though not personally responsible for much of the work attributed to him, usually provided drawings for some if not for all of the houses he designed (he used Chippendale extensively to execute work for him in a fashion which was in flat contradiction to that displayed in *The Director*). Classical in structure, light in colour, making extensive use of marquetry, ormolu and classical ornament, Adam's innovations really belong to a later period.

No area of design was left untouched by the increase and wider dissemination of wealth, and by the construction of new houses which accompanied it. Silversmiths such as Paul de Lamerie, textile manufacturers such as Thomas Lombe, porcelain factories such as those at Chelsea, Bow and Derby, all contributed to the creation of domestic splendour, and the statement on Wedgwood's memorial tablet that 'he converted a rude and inconsiderable manufacture into an elegant art, and a branch of national commerce' could equally

well have been applied to a host of other Georgian craftsmen and manufacturers.

In terms of social prestige, and the affirmation of personality, works of art assumed a role of primary importance. The pictures and statues which adorned a house were indicative of the status of its owner, and as a consequence the art market sprang into a frenzy of activity. Whereas in the seventeenth century there were about twenty active English art collectors of importance, by the middle of the eighteenth there must have been well over two hundred, and they were no longer confined to the aristocracy. Richard Mead (1673–1754) was typical of a new breed of collector. A successful medical practitioner who patronized contemporary artists, including Watteau, and made his collection accessible to all who wanted to see it, he built up a virtual museum which included prints, statues, fossils, Egyptian mummies, and animals preserved in spirits. It also included:

45 portraits by Hals, Holbein, Kneller, Ramsay, Richardson, Rembrandt, Rubens and others.
23 landscapes and sea-pieces, including works by Claude, Gaspard Poussin, Brueghel, Salvator Rosa, Rembrandt and Van de Velde.
13 architectural works by Canaletto, Panini and Poussin.
14 Dutch still lifes.
55 historical and religious pictures by Giulio Romano, Veronese, Annibale Carvacci, Guercino, Palma Vecchio, Carlo Maratti, Solimena, Barocci–Nicolas, Poussin, Rembrandt, Rubens, Vandyck, Watteau, Teniers, Gerard Dou and Borgognone.

With the possible exception of Holbein, and the proviso that Rembrandt was not as highly esteemed in the eighteenth century as he is in the twentieth, the painters represented in the Mead collection, and the distribution of the various categories of painting, were typical of eighteenth-century English taste as a whole. He himself had bought mainly on the English market which was dominated by the auctioneers, whose rooms had become places of polite resort – men such as Cocks, Longford and Christie. There was also an ever increasing number of galleries, such as the Adam Gallery in Lower Grosvenor Street, where Robert Adam displayed, for sale, the statues and casts which he had brought back from Italy, and a multiplicity of print shops for those with more humble ambitions.

The really great collectors, however, the Walpoles, the Cokes,

the Howards and the Charlemonts, were much more positive in their approach; indeed, collecting on the scale they did, they had to be. To amass his collection of pictures at Houghton, Robert Walpole employed the diplomatic service: spies, and agents of all kinds. It was sold by his spendthrift son to Catherine the Great, and still forms one of the most important elements of Russia's art treasures, and is complete with the exception of a few which were sold by the Soviet in the 1920s to Mellon, to help balance the Russian national budget. Charlemont used that astute connoisseur Sir Joshua Reynolds, amongst others, to make purchases for him, and many young artists who went abroad to study – as had become the habit – helped finance themselves either by acting as agents or by bringing home with them a collection of pictures or statues which they eventually sold in London.

The main source of supply was Italy, which swarmed with what Hogarth described in an article in the *London Magazine* as 'picture-jobbers . . . importing, by ship-loads, Dead Christs, Holy Families, Madonnas and other dark, dismal subjects, on which they scrawl the names of Italian masters'. There were consuls such as Joseph Smith of Canaletto fame, at Venice, and John Udney at Florence; bankers such as Jenkins in Rome, where most of the 'jobbers' were to be found; painters such as Gavin Hamilton; archaeologists such as James Byres, and a whole host of Jacobite refugees such as Andrew Lumisden and Robert Strange, who supplemented the meagre salaries or pensions they received from the Stuarts by dabbling in the sale of paintings and classical statues. Behind these dealers were the native Italian painters and sculptors, 'restoring' Greek and Roman statues, faking Leonardos and Guido Renis, or sometimes, as with the immensely successful Pompeo Batoni, painting portraits of visiting Milords.

For this was the age of the Grand Tour, a phenomenon of considerable importance in the history of English art, moulding attitudes, influencing style, creating patterns of taste. Usually accompanied by a tutor – men such as Adam Smith, and William Coxe the historian, undertook such tasks – the young Tourist could spend several years, sometimes as many as five, taking in many European countries, but concentrating mostly on Italy. 'Persons who propose to themselves a Scheme for Travelling generally do it with a view to obtain one or more of the following Ends; viz. First to make Curious Collections, as Natural Philosophers, Virtuosos or Antiquarians. Secondly to improve in Painting, Statuary, Architecture and Music. Thirdly to obtain the reputation of being

Men of Vertu and of an elegant Taste', wrote Dean Tucker in his highly successful *Instructions for Travellers* of 1757. The works of art which these young men collected made England one of the treasure-houses of Europe. Greek and Roman statues, Etruscan and Hellenistic vases by the shipload, crates of paintings by the great Venetian, Florentine and Roman masters made their way from Livorno to Bristol or London. Adam Smith, embittered by his own experiences, could complain that he who had been on the Grand Tour 'commonly returns home more conceited, more unprincipled, more dissipated and more incapable of any serious application either to study or business, then he could well have become in so short a time had he lived at home'. Sir Joshua, commenting on the behaviour of his fellow-travellers in Rome wrote

> Instead of examining the beauties of the works of fame, and why they are esteemed, they only enquire the subject of a picture, and where it is found, and write that down. Some Englishmen while I was in the Vatican came there and spent about six hours in writing down whatever the antiquary dictated to them. They scarcely looked at the paintings the whole time.
> (C. R. Leslie and T. Taylor, *Life and Times of Sir Joshua Reynolds* London, 1865, vol. i, p. 51)

There were those too, who, as Jonathan Richardson expressed it, 'look at pictures as though at a piece of rich hangings', and were quite happy to buy copies of works which they had been told were desirable.

Even allowing however for all the pretentions, the lack of real interest and the occasional hypocrisy, it is largely to the verve, the discrimination and the occasional adventurousness of eighteenth-century collectors that England owes the majority of her art treasures. In the course of the century, for instance, the Cavendishes, admittedly a magnificent version of the species, collected for their houses at Chatsworth, London and Chiswick works of art which could stock a national museum. They included (apart from English works) paintings by Claude, Poussin, Velasquez, Sebastiano Ricci and Rembrandt, medieval manuscripts, and one of the most remarkable collections of drawings ever amassed. This was largely the doing of William Cavendish (1673–1729), 2nd Duke of Devonshire, who in 1723 acquired a large group of splendid drawings from the collection of Nicolaes Anthoni Flinck of Rotterdam. In all, the Chatsworth collection of drawings includes: 30 attributed to Raphael; 40 by Giulio Romano; 70 by Parmigianino; 30 by Guercino; 36 by Rembrandt; 40 by Van Dyck; 30 by Rubens; and 20 by

Claude, excluding the famous *Liber Veritatis* acquired by the nation in lieu of death duties in 1957.

If the Cavendishes and their kind possessed one thing it was clearly Taste, and Taste was one of the major preoccupations of Georgian England, and with its kindred words 'vertu' and 'connoisseur', one of the dominant forces – in a negative or a positive way – in the fine arts. Derided by Pope, who in actual practice was an assiduous cultivator of its virtues, taste was given an ethical justification by Shaftesbury; 'I am persuaded that to be a virtuoso (so far as befits a gentleman) is a higher step towards the becoming a man of virtue and good sense than the being what, in this age, we call a scholar.' Apart from the social significance of the cautious proviso, with its implication that a gentleman should not get too deeply committed to anything which had a potential professionalism about it, Shaftesbury's remark underlined one particular aspect of the idea of taste, which dated back to the Renaissance ideal of the universal man. In Castiglione's *Il Cortegiano* (translated into English in 1561) vertū – a feeling for, and knowledge of, the fine arts – was considered one of the qualifications of the ideal courtier, a notion which had been put into practice in Stuart times by men such as Arundel and Buckingham. The idea was reinforced strongly by Henry Peacham whose *The Compleat Gentleman* of 1634 had great success as a book of manners and good behaviour. But it was Jonathan Richardson who, in his *Essay on the Whole Art of Criticism as it relates to Painting* and *A Discourse on the Dignity Certainty, Pleasure and Advantage of the Science of a Connoisseur*, published in 1715, expressed most clearly and most cogently the implications of this attitude to taste. He argued that a knowledge of the fine arts was a proper part of the equipment of a cultivated man, and that a grounding in this should be part of the education of an English gentleman. He emphasized the social advantages of being a 'Gentleman of Taste (Lord Chesterfield stressed the same point in his letters to his son), and the effects which an interest in the fine arts had on a nation by 'the reformation of our manners, refinement of our pleasure, and increase of our fortunes and reputation'.

Many of the things which Richardson had to say pointed to another and equally important element in the cultivation of taste – its social dimension. Eighteenth-century England witnessed a great deal of social change. As fortunes were made and what a later generation was to call the *nouveaux riches* struggled for recognition and acceptance into polite society, taste and its concomitants became both ways of achieving that recognition, and a weapon to keep the

less desirable in their station. There was – as indeed there still is – a widespread conviction that one's own taste is good, genuine and unaffected, whereas that of others – especially if they come from an inferior social class – is bad, spurious and hypocritical. The very titles of Richardson's books, with their emphasis on 'Dignity' and 'Advantage' as well as their content, with its references to social importance and the like, are indicative of this. The literature of the period abounds with such implications, underlining especially the notion that such interests should be 'without pecuniary advantage'. Invariably held up to ridicule was the taste of the 'cits' – tradesmen, businessmen and the like – who had dared to show an interest in pictures or architectural enterprises. At the same time too there was a general John Bullish reaction against anyone daring to profess an interest in art at all, part of that deep strain of patriotic philistinism which has become an integral part of the British national character. This attitude could take on many different colourings, ranging from the cultural patriotism of Hogarth, to a less specific prejudice, which lumped together under a cloud of disapproval dandies, macaronis, foreigners, critics, connoisseurs and picture dealers, the latter usually being portrayed as shifty, double-dealing, petty criminals.

Perhaps the most specific embodiment of the idea of taste was the existence of the Society of Dilettanti, described by its historians as a 'small body of gentlemen of education and distinction, many of whom have played a part in our history, and who for over 200 years have exercised an active interest in matters connected with public taste and the arts' (*History of the Society of Dilettanti*, L. H. Cust and S. Colvin, London, 1898). Qualification for membership depended on having made the Grand Tour; Horace Walpole rather sourly interpreted this as 'the nominal qualification for membership is having been in Italy, and the real one being drunk'. It is, in fact, doubtful to what extent the Society influenced public taste, apart from having indirectly stimulated the tendency towards classicism by its publication of masterly analyses of the architecture and archaeology of the classical world. Its mere existence was the most important thing about it. In terms of the support of contemporary art and design, the Society for the Encouragement of Arts, Manufacture and Commerce, founded in 1754, was more effective, offering awards for drawing to children and young people, giving gold and silver medals, and financial rewards, which could be as large as £140, to painters and sculptors of merit, and strongly supporting the decorative arts.

The need to acquire Taste stimulated the multiplication of means of achieving it. Aesthetics, 'the philosophy or theory of taste, or of the perception of the beautiful in nature and art' (*Oxford English Dictionary*) provided the theoretical basis, and flourished throughout the period, culminating in the controversy about the picturesque which marked the latter part of the century, and which will be discussed in the following volume as part of the ideology of romanticism. At the beginning of the century by far the most influential figure was Anthony Ashley Cooper (1671–1713) throughout whose *Characteristicks*, first published in their complete form in 1732, are scattered essays which combine theory and practice, precept and dogma, and justify his being thought of as the founding father of The Rule of Taste. Perhaps more effective, because more widely read, was Joseph Addison, whose essays in the *Spectator* hammered home to a large public the notion that 'the Taste is not to conform to the Art, but the Art to the Taste' (*Spectator* No. 29, 3 April 1711). The notion of the sense of beauty being perceived through some 'inner sense' was given a more pragmatic complexion by Francis Hutcheson whose *An Inquiry into the Original of our Ideas of Beauty and Virtue* (1725) attempted to work out a law – and that is what everybody was looking for – for assessing beauty in terms of the ratio between uniformity and variety, or as later generations would have it, between the classical and the romantic. George Berkeley was less helpful to the Gentleman of Taste, seeing beauty as 'a fugacious charm' perceived by an inner feeling without being very specific as to how that feeling was to be achieved. Henry Home, Lord Kames, whose *Elements of Criticism* (1762) ran through six editions between the date of its publication and 1785, dominated the field until the publication in 1790 of *Essays on the Nature and Principles of Taste* by his fellow Scot Archibald Alison (1757–1839), in which he suggested that 'the emotion of taste' depended on an imaginative sensation which stemmed from an associative train of thought and imagery, stimulated by contemplation of a specific object.

Stimulating to the mind though no doubt such publications were, they only gave the vaguest notion of what bas-reliefs to like, what paintings to buy or admire, what statues to consider authentic or fake. To supply this need there were many publications in the tradition of Richardson. Some took the form of guides to the Grand Tour. Typical of these was Smollett's *Travels through France and Italy* in which we find copious references to painters and paintings. He represented the plain John Bull no-nonsense school, thinking little

of the Medici Venus, finding Raphael's *Parnassus* ludicrous, and Michelangelo's *Pietà* 'indecent', but becoming almost incoherent in his praise of Guido Reni. Addision's *Remarks on Several Parts of Italy*, published in 1701, retained its popularity throughout the century. More concerned with classical antiquity than with any subsequent works, he praises St Peter's, but is scathing about the Middle Ages, writing about the Duomo at Siena: 'When a man sees the prodigious pains and expense that our forefathers have been at in these barbarous buildings, one cannot but fancy to himself what miracles of Architecture they would have left us, had they been instructed in the right way.' Edward Wright, who was in Italy from 1720 and left a small collection of Italian art, was more enterprising in his *Some Observations made in Travelling through France, Italy & c* published in 1732, praising the Campo Santo at Pisa, admiring Giotto, and describing a medieval statue at Ravenna as having 'a very genteel attitude and a fine Air of the head'.

Travel guides such as these expressed opinions, confirmed attitudes, and probably did more than anything else to formulate the general level of affluent taste in the eighteenth century. But more specific books were being published about the actual history of art, and the evaluation of contemporary painting. Du Fresnoy's *De Arte Graphica* was translated in 1695, with an introduction by Dryden. In 1707 Bainbridge Buckeridge published his *Essay towards an English School of Painting*, and twenty years later Henry Bell's *An Historical Essay on the Original of Painting* appeared, to be followed by a whole range of works in which art history, connoisseurship and criticism were interwoven in varying proportions. Of considerable importance too was the growing body of writings by contemporary artists – some like those of Hogarth and Barry, polemical; others like those of Reynolds informative and didactic. By 1762 when Horace Walpole's *Anecdotes of Painting*, based on manuscript notes collected by George Vertue, made its first appearance, there was no reason why anyone who so wished could not obtain a reasonable amount of reliable information about the history and appreciation of art. Nor was this confined to those prepared to read books and go to Italy. The pages of periodicals such as the *Gentleman's Magazine*, the *World*, the *Connoisseur*, the *Imperial Magazine* and the *European Magazine* constantly featured articles, some humorous, some serious, about almost every aspect of taste and its application. Often they were specifically concerned with individual artists, who were themselves becoming conscious of the publicity value of such writings.

There was no lack of opportunity for embryo connoisseurs to exercise their taste, even if they could not afford to go on the Grand Tour. Visiting stately homes, in London as well as in the country, was far more familiar to a generation which had not heard of the National Trust than one might have expected, and many such houses provided guide books. Even more positive was the attitude of the Duke of Richmond, who in 1758 opened his statue gallery in Whitehall to students. It was filled with casts of the 'most celebrated ancient and modern statues'. It was against this background that the idea of a national collection, which had been hovering around since 1602, when Sir Thomas Bodley provided for a gallery of antiquities in his Library at Oxford, and thus provided the basis of the Ashmolean Museum, which was opened in 1675, came to fruition. The private collection of 'books, manuscripts, prints, drawings, pictures, medals, cameos and natural curiosities' which had been amassed by Sir Hans Sloane, was acquired for the nation in 1753, and together with the Harleian and Cottonian collections of manuscripts formed the nucleus of the British Museum. Established by Act of Parliament for 'the learned and curious', it was housed in Montagu House, and opened to the public in 1759, acquiring, thirteen years later, Sir William Hamilton's collection of classical vases and antiquities.

Institutions such as the British Museum and the Duke of Richmond's gallery may have done much to influence taste, and arouse a greater awareness of the artistic past, but they did little for the contemporary artist. Unexpectedly more relevant in this respect was the Foundling Hospital, the brainchild of Captain Coram, which was opened to look after some 400 foundlings in May 1745, another wing being added in 1753. Hogarth had been associated with the charity since its inception in 1739. With that shrewdness which was so important an element in his character, he realized that a place visited by rich and influential philanthropists – it was an elegant building on the north side of Ormond Street – would be an ideal showcase for living artists to display their works. On 31 December 1746 a General Meeting of the Court of the Foundation minuted the fact that 'the following Gentlemen Artists had severally presented and agreed to present Performances in their different Professions for Ornamenting the Hospital, viz; Mr Francis Hayman, Mr James Wills, Mr Joseph Highmore, Mr Thomas Hudson, Mr Allan Ramsay, Mr George Lambert, Mr Samuel Scott, Mr Peter Monamy, Mr Richard Wilson, Mr Samuel Whale, Mr Edward Hately, Mr Thomas Carter, Mr George Moser, Mr Robert Taylor,

and Mr John Pine.' This was virtually the painting establishment of the day, all of them being members of the St Martin's Lane Academy. Thanks to the reputation that the Hospital acquired, and the celebrity of its musical recitals, largely the work of Handel, it became one of the most frequented places in London, and so enhanced the growing reputation of English painting and sculpture.

In 1771 Robert Strange, the engraver, in a diatribe against the policy of the Royal Academy, was to describe the age as 'the era of exhibitions' in *The Conduct of the Royal Academicians while Members of the Incorporated Society of Artists* (p. 5), and the fact the the title of the work includes two institutions whose major concern was the arrangement of exhibitions gives initial support to the validity of his phrase. Artists, since the beginning of the century, had been discontented with their inability to establish direct contact with a potential market. Many hung their works in taverns or the parlours of shopkeepers; some worked through the general picture-dealers who were really more interested in selling old masters, or persuading artists to make copies of them. Increasingly artists were coming to arrange spasmodic exhibitions of their own work, sometimes in their own studios, sometimes in rooms specially hired for the occasion. But their main source of contact with the public was through prints of their work, and Highmore in 1744 had set a precedent when he advertised in the *Morning Pöst* that he was proposing to publish by subscription twelve prints after his own paintings, representing episodes from Richardson's *Pamela*, and that the originals would be on view at his house, The Two Lyons, Lincoln's Inn Fields. Hogarth's popularity was based almost entirely on his prints. They were an important source of revenue too. William Woolett's engraving of Wilson's *Niobe* made £2,000, and that of Benjamin West's *Death of Work* in 1770 £15,000 in fourteen years.

Quite early in the eighteenth century there had been a strong feeling that the new type of artist who was arising – sophisticated, widely read and affluent, had need of some body which would give to the profession greater distinction than that of belonging to the Painter-Stainers' Company, and which would also provide a framework for regular exhibitions, as well as a stimulus to adequate publicity. In 1711 Kneller had opened an academy of drawing and painting, and he was succeeded as Governor by Sir James Thornhill, who later made an unsuccessful attempt at starting a rival institution. In 1735 Hogarth gave Kneller's academy a new lease of life at new premises in St Martin's Lane, where it assumed the name of the street. In 1755 the St Martin's Lane Academy approached the

Society of Dilettanti with a project of a more extensive type of academy, providing not only art education but exhibition facilities. Since the Society insisted that it should manage the proposed institution, nothing came of the project. The foundation of the Society of Arts (now 'Royal') in 1754 seemed to offer another chance for the creation of an academy of the kind which so many people seemed to want. Five years later at their annual dinner at the Foundling Hospital the artists involved agreed on a scheme for an exhibition, and incorporated themselves as the Society of Artists. Their first exhibition was held in the rooms of the Society of Arts, but again disagreements ensued about who should control it, and the artists hired a room in Spring Gardens, near Charing Cross – it was over a china warehouse – and continued to exhibit there for several years. Some indication of the success they had is revealed by the fact that, whereas in 1761 the profit from the sale of catalogues was £650, six years later it had risen to £1,145. The activities of the Society of Artists however covered only one aspect of the possible functions of a real academy, and its success bred dissensions, which led in 1768 to most of the directors, led by Sir William Chambers, resigning. Chambers had the ear of George III, and a committee drew up a constitution for a new body, largely based on the ideas of Chambers, Benjamin West, Francis Cotes, and George Michael Moser.

On 10 December 1768 the King gave his approval to an Instrument for the creation of 'The Royal Academy of Arts in London, for the Purpose of cultivating and improving the Arts of Painting, Sculpture and Architecture'. It provided for 40 Academicians, 36 of whom were named in the document; the setting up of a school of design; summer and winter academies of the living model; an annual exhibition of paintings, sculpture and designs, open to 'all Artists of distinguished Merit', at which each academician must exhibit one painting, under a penalty of five pounds; the establishment of Professorships of Anatomy, Architecture, Painting, Perspective and Geometry, and the creation of a library 'covering a wide range of subjects'. Provision was also made for 'a Porter of the Royal Academy, whose salary shall be twenty-five pounds a year', and 'a Sweeper of the Royal Academy, whose salary shall be ten pounds a year'. At the first meeting held on 14 December, Sir Joshua Reynolds was elected President, George Michael Moser Keeper, and Francis Milner Newton, who had extensive experience with other artistic bodies, Secretary. On 2 January 1769 Reynolds gave the first of his fifteen Discourses which were to become the

most widely read writings about art to have appeared in England. Housed originally in an auction room in Pall Mall, but later moving to the great exhibition hall in Somerset House, supported by royal patronage of both a moral and a financial kind, the Royal Academy was an instant success. It was both a symbol of what British art had achieved in the space of half a century, and the instigator of further improvements.

To begin with, there was its educational significance, represented by the Academy schools, with male models paid at 5s. a week, the females 10s. 6d. for a sitting of two or three hours (it was stipulated that no male person under twenty should draw from the female model, unless he were married, and that nobody, 'the Royal Family excepted' should enter the academy during the time the female model was sitting). A different Academician posed the figure each month, and Dr William Hunter, himself a noted figure in the art world, and the leading surgeon of the day, gave lectures on Anatomy. Edward Penny was appointed Professor of Painting, Thomas Sandby of Architecture, Samuel Wale of Perspective, and a number of honorary professors were appointed; Dr Johnson to Ancient Literature, Oliver Goldsmith to Ancient History and Richard Dalton was nominated Antiquarian. In the first year of its existence the Royal Academy admitted 77 students into its schools, of whom 36 studied painting, 10 sculpture, 3 architecture, and 4 engraving. The choice of the remaining 24 is not recorded.

The first exhibition opened on 26 April 1769, and on the evening of that day 'an elegant entertainment' was provided at the St Alban's Tavern (the precursor of the annual Royal Academy Banquet), presided over by Sir Joshua, attended by 'several of the nobility and many of the aristocracy who are patrons and lovers of the arts, who gave éclat to the occasion', and enlivened by the reading of a lengthy ode by the indefatigable Dr Benjamin Franklin, and the singing by Mr Vernon of a song composed by Mr Hull. The penultimate verse of this set the tone of self-satisfaction, cultural patriotism and sycophancy which represented one of the less pleasing aspects of the new body,

> No more to distant realms repair
> For foreign aid or borrowed rule,
> Beneath her monarch's generous care,
> Britannia founds a nobler school,
> Where Arts unrivalled shall remain,
> For George protects the polish'd train.

'George' himself, accompanied by the Queen, emphasized his generous care by visiting the exhibition on 25 May – two days before it closed. The number of works on show was 136, of which 79 were contributed by members of the Academy. The range of subject-matter is interesting; there were 48 landscapes, 40 portraits, 22 dealing with subjects from history, scripture and poetry, 5 animal or flower pieces, 9 sculptures, 2 specimens of die-engraving and 10 architectural subjects. In an Advertisement to the catalogue, which cost 6d. and gave the addresses of the exhibitors, the Academicians apologized for charging an admission fee of one shilling on the grounds 'that they have not been able to suggest any other means than that of receiving money for admittance to prevent the rooms being filled by improper persons'. The proceeds of the exhibition were £583 3s. 4d., out of which £145 19s. was given to indigent artists and their dependants. By 1780, when the Academy moved to Somerset House, the number of exhibits had risen to 489, and the receipts to £2,178 12s. On that occasion the *Morning Post* (2 May 1780) recorded that 'the concourse of the people of fashion who attended the opening of the Royal Academy exhibition yesterday was incredible; the carriages filled the whole wide space from the New Church to Exeter Change. It is computed that the door-keepers did not take less than £500 for the admission of the numerous visitants of all ranks.'

The attention of the press was significant, because it was indicative of a new, livelier interest in contemporary art that the Royal Academy both typified and stimulated. This was reflected too in the emergence of the art critic, writing for a daily paper rather than a journal, concerned more with contemporary art and the discussion of works by specific painters than with the enunciation of general principles or speculations about the nature of taste. Papers such as the *Public Advertiser* and the *Morning Post* not only reviewed the Academy exhibitions, but described visits to artists' studios to report on the progress of their works, and took a vigorous part in the controversies – personal or stylistic – which from time to time agitated the artistic world.

By virtue of their royal patronage, male academicians (the original forty included two women) were entitled to add the still restricted title of 'Esquire' to their names, typifying the degree of social recognition which artists had attained. Art had become a profession, not a trade, and the Academy emphasized the fact. In part this was a reflection of the change in their financial position. In 1753 Reynolds was charging 5 guineas for a head: in 1763 30 guineas,

and Samuel Johnson reported at this time that the painter's income was £6,000 a year. Gainsborough charged 160 guineas for a full-length portrait, and in 1770 Horace Walpole noted that Benjamin West 'gets three hundreds pounds for a piece not too large to hang over a chimney' (*Letters*, ed. Toynbee, Oxford, vol. vii, p. 379). A rigorous programme of intellectual self-improvement had been laid down for the artist by Jonathan Richardson (*Works*, London 1773, pp. 10, 11), who suggested that he should be equipped with a vast stock of poetical as well as historical learning, that he should understand anatomy, osteology, geometry, perspective, architecture and many other sciences, that he should read the best writers such as Homer, Milton, Virgil, Spenser, Thucydides, Livy, Plutarch 'but chiefly the Holy Scripture' and that 'he should frequent the brightest company and avoid the rest'.

At the same time, however, this enhancement of the social and intellectual status of the artist should not be allowed to disguise the fact that in eighteenth-century England only a very small proportion of the total number of people devoted to art and design achieved such heights. There was a vast submerged and largely forgotten body of painters and others who, either by the nature of their specialization, or the quality of their work, still occupied a position closer to trade than to profession. Outside London especially there was a whole horde of face-painters, either practising in provincial towns, or more frequently travelling around the country, visiting country houses, and even more modest establishments, doing portraits of their owners, and being given hospitality as part of their fee. Others of the same kind specialized in painting animals, or gardens. Then there were the inn-sign painters, for whom there was a constant demand in a world where a very high proportion of the population was illiterate, and signs were needed not only for shops and inns, but often for private dwellings. It was only towards the end of the century that street numbers were introduced. Such signs provided a kind of open-air art gallery, and crowds of visitors could be seen admiring, for instance, the full-length portrait of Shakespeare, suspended in an elaborate and ornate frame outside a hostelry in Drury Lane. Then there was stage painting, and its many branches (such for instance as preparing decorations for public celebrations in the parks and elsewhere, as well as for pleasure-gardens such as Vauxhall). Some of the artists who did work of this kind achieved considerable reputations. Jacques Philippe de Loutherbourg, who came to London in 1771 from Paris, where he had been a member of the Academy, was soon earning £500 a year from

Drury Lane, where he worked in close collaboration with Garrick, and his invention of the Eidophusikon, an ingenious system of moving pictures behind a gauze screen to the sound of music, was applauded by Gainsborough and Reynolds, who recommended ladies whose daughters cultivated drawing to take them there 'as the best school to witness the powerful effects of nature'. George Lambert too spent much of his artistic life as scene-painter to Covent Garden Opera House. Conversely the theatre exerted a very great influence on painting. A large number of artists who painted conversation pieces sited them in a stage-like setting and the décor of many of the scenes in works such as Hogarth's *Marriage à la Mode* is clearly theatrical.

Coach-painting too was a popular, and occasionally lucrative, branch of art. Giovanni Battista Cipriani, who came to London from Rome in 1755, is renowned mainly for his paintings on the Coronation Coach, but he typifies the catholicity of eighteenth-century art, in that he was employed in the decoration of many public and private buildings, such as Somerset House, the Old Library of the Royal Society and Houghton Hall, and became a foundation member of the Royal Academy. Contrasting with this adaptability was a degree of specialization in painting, which also produced a variety of minor artists. These were painters who specialized in the painting of draperies, hands, background or other subordinate parts of a picture. Some of these artists were quite famous. There was Joseph van Haeken, for instance, whose skill in painting draperies earned him a considerable income, and lasting fame from Hogarth's caricature of his funeral, showing all the leading portrait-painters of the time, attending in attitudes of despair; and Peter Toms, Reynolds' 'drapery man', who also worked for Gainsborough and Francis Cotes. He charged twenty guineas for painting the draperies, hands, etc. of a whole-length portrait, and for a three-quarter, three. Amongst his other activities Toms was a flower-painter (he sent paintings of this kind to the Royal Academy exhibitions) and Portcullis Pursuivant in the College of Heralds. Apparently he felt keenly that his artistic activities were not worthy of his talents, as he became an alcoholic and committed suicide in 1776.

To measure the achievement of English painting in the eighteenth century one has only to compare a portrait by Kneller with one by Reynolds or Gainsborough; a conversation piece by the early Devis with one by Zoffany; a landscape by John Wootton with one by Wilson or Gainsborough. The advances made in fluency

of handling, sophistication of composition, and clarity of vision are obvious, however appealing the earlier works may be. It was however an attainment which had only been achieved as the outcome of a series of stylistic tensions which had persisted throughout the century.

On the one hand there existed throughout a constant preoccupation with resisting foreign influences. This had several strands: cultural patriotism, the belief that foreigners were inferior, irritation at the vast amounts of money being lavished both on old masters and on living Italians such as Sebastiano Ricci, Canaletto, Pellegrini, Amigoni and Bellucci. On the other hand it was Venetian, Roman and French influences which did so much to raise the level of English art, and virtually every great advance made in painting – and to a lesser degree in architecture – had a foreign origin. Even the most indomitable propagandist of native talent, William Hogarth, was deeply indebted to Callot, Coypel, Quentin de la Tour, Rigaud and Hubert-François Gravelot, who worked here from 1732 to 1755 as an illustrator and engraver, and also taught Gainsborough, who himself was deeply influenced by Murillo. Of the thirty-six Academicians named in the foundation Instrument of the Royal Academy, 6 were Italian, 1 German, 1 French, 4 Swiss, 1 American, and 1 Irish. The rest were English, apart from Chambers, who had been born in Sweden of Scottish parents.

It was from Italian and French sources, dubiously inherited from antiquity and disseminated through the works of writers on taste and aesthetics, that there arose another cause of stimulating conflict in British painting during the period, the notion that there were categories in painting, each with its own relative value, and that the highest of these was 'history painting', others being valued according to their sacred or classical connotations and their 'elevation of style'. The trouble was that, although all English artists subscribed to this theory, and even Hogarth made a disastrous attempt to put it into practice, there were no opportunities here for the grand style. The initial problem was that the English Reformation had introduced a strongly iconoclastic note into religion, that great promoter of history painting in Catholic countries, just as much as it had devalued another rich source of 'elevated' iconography, the lives of the saints. Nor was the social and economic pattern of the country similar to that of most European countries; there was no lack of foreign commentators to point out the differences between St James's Palace and the Louvre. At the same time English patrons, acutely conscious of this pictorial class-distinction, seldom if ever

demanded history paintings from native artists. There was a story
(recorded in *Johnson's England*, ed. A. S. Turberville, Oxford, 1967,
vol. 2, p. 9) that a rich and enthusiastic admirer of one of Benjamin
West's paintings in this genre, when asked why he did not buy it,
replied: 'What could I do if I had it? You surely would not have me
hang up a modern English picture in my house, unless it was a
portrait?'

More than their European colleagues, British artists depended on
private patronage, and that predominantly of a domestic kind. It
has been said that English painting is almost exclusively concerned
with places and faces. The men and women of the eighteenth cen-
tury seemed to look upon art mainly as a means of recording their
own self-satisfaction. Just as today people being interviewed on
television in their own homes arrange around themselves their most
treasured and prestigious possessions, so did their predecessors,
when they had their portraits painted. They displayed their best sil-
ver teapot on the table, their finest carpet specially arranged under-
foot, their most expensive clothes – to the painting of which a great
deal of attention was given – adorning their persons. They liked to
have their most memorable or impressive experiences recorded too;
dressed in the uniform of a lieutenant or captain of the volunteers;
standing in front of a Roman ruin; seated in the Uffizi; astride their
prize mare, or driving their new barouche. The icons of eighteenth-
century English art were the icons of possession, of pride, of own-
ership, and of domesticity. Perhaps the most specific English con-
tribution to the language of painting, certainly one to which they
were especially addicted, was the conversation piece in which a
group of people would be shown in some recreational or commun-
al activity with close attention being paid to costume and accessor-
ies, in an atmosphere of constrained informality, and in which, as
Mario Praz put it (*Illustrated History of Interior Decoration from Pom-
peii to Art Nouveau*, London, 1964, p. 148): 'If the adults have the
stylised hauteur of fish in brilliant livery, the little ones of the fami-
ly, arrested by the painter in playful or light-hearted moments, sug-
gest the image of darting minnows among the motionless, intent
mature fish.'

In a way, the conversation piece could be looked upon as a kind
of upper-class genre painting, which was a category of art rated
very low in the hierarchy of appreciation, at least during the first
half of the century. But as the notion of the noble peasant and the
idealization of rustic life spread amongst a population which was
coming to relish the ideas of Rousseau and the novels of Richard-

son, genre painting, especially when combined with strong anec-
dotal elements, took on a new popularity in the work of Morland,
Opie, Romney and their contemporaries, the precursors of a type
of painting which would swamp the exhibition rooms of the
following century.

There was an endemic hunger for the anecdotal in an age inno-
cent of the pleasures of the television soap-opera; and when story-
telling was combined with the inculcation of those virtues so highly
approved of by a vigorous bourgeois society, and widely dissemi-
nated through the medium of prints, the results, as Hogarth had
discovered, were highly gratifying. It was prints as much as any-
thing else which were responsible for doing what a great deal of
aesthetic sermonizing had failed to do. From 1760 onwards patrio-
tic fervour, and the enlargement of 'history' to include recent or
contemporary events in which the participating characters wore
contemporary clothes and not togas or their equivalent, produced a
whole series of successful history paintings. Copley's *Death of
Chatham*, when put on public exhibition in 1781 attracted over
20,000 visitors at a shilling a head and the sixth exhibition of the
Royal Academy in 1774 contained, out of 354 works, 3 historical
pieces by Barry, 7 by Angelica Kauffmann and 3 by Benjamin
West. A great impetus was given to this category of painting too by
the initiative of John Boydell, who having made his fortune in the
1750s by marketing views of London, and then of England and
Wales, commissioned from the major artists of the day 162 oil-
paintings illustrating Shakespeare's plays. These were first of all ex-
hibited at the Shakespeare Gallery in June 1789, and the edition of
the poet's works which they were to illustrate began to appear in
unbound parts in January 1791. Although Boydell was the most
famous of these entrepreneural print-sellers, he was not the only
one. Thomas Macklin opened a similar Poets' Gallery in Pall Mall
in 1787, and Robert Bowyer a Historic Gallery in 1793.

Prints had achieved remarkable popularity, and they were skil-
fully marketed and publicized. More than anything else they were
responsible for the dissemination of visual literacy, for publicizing
the work of contemporary artists, and for spreading a knowledge
of the art of the past. Jonathan Richardson the elder, for instance,
had never been to Italy, and built up his remarkable knowledge of
the art of the past entirely from engravings.

Boydell's early success hints at the popularity of landscape as a
subject, and indicates the extent to which the print-sellers had con-
tributed to it. By the eighteenth century, nature had come to be

looked upon as a source of beautiful pictures, and though paintings of natural scenes were only regarded as 'high art' if they were peopled by a small collection of picturesquely robed ancients, their popularity was enhanced by the passion for gardens which informed the age, and an inherent English appreciation of nature. Portraits which combined the qualities of the conversation piece with those of landscape made a strong appeal to the squirearchy, and aesthetic conventions were satisfied when Wilson was able to prove that the artistically approved grandeur and beauty of Claude's vision of the Roman Campagna could be translated into visions of Berkshire or of the mountains of North Wales. It was significant of the times that when in 1773 Wedgwood commenced his 952-piece creamware service for the Empress Catherine II of Russia, he should have decorated it with 1,282 scenes, some taken from the products of the print-sellers, others specially commissioned from artists such as Anthony Devis, George Barret and John Pye. The cult of landscape was further stimulated by the growing popularity of water-colour and aquatint as media which not only encouraged the amateur, but favoured the development of on-the-spot sensibilities.

In the period between the Glorious Revolution and the French Revolution British art had developed from the rule of taste to the rule of liberty. But already the boundaries of the battlefield on which would be fought the war between romanticism and classicism, between sense and sensibility, had been defined.

2. A new sense of splendour

The buildings of Georgian Britain and their interiors.

2.1 A plan for London

The idea of a new London was in everybody's mind. John Evelyn the diarist was very conscious of what the twentieth century would call 'problems of urban renewal'. His comments on the riverside are especially pertinent, and forecast the South Bank.

That the Buildings should be compos'd of such a Congestion of mishapen and extravagant Houses; That the Streets should be so narrow and incommodious in the very Centre, and busiest places of Intercourse: That there should be so ill and uneasie a form of Paving under foot, so troublesome and malicious a disposure of the Spouts and Gutters overhead, are particulars worthy of Reproof and Reformation; because it is hereby rendered a Labirynth in its principal passages, and a continental Wet-day after the Storm is over. Add to this the Deformity of so frequent Wharfes and Magazines of Wood, Coale, Boards, and other course Materials, most of them imploying the Places of the Noblest aspect for the situation of Palaces towards the goodly River, when they might with far lesse Disgrace, be removed to the Bank-side, and afterwards disposed with as much facility where the Consumption of these Commodities lyes; a Key in the mean time so contrived on London-side, as might render it lesse sensible of the Reciprocation of the Waters, for Use and Health infinitely superior to what it now enjoys. These are the Desiderata which this great City labours under and which we so much deplore. But I see the Dawning of a brighter day approach; We have a Prince who is Resolv'd to be a Father to his Country.

John Eveyln,
Fumifugium, 1661

2.2 The cost of St Paul's

St Paul's was largely built on the proceeds of a coal tax, 2s. per chaldron (36 bushels) levied from 1680 till 1716. Anxious to raise a

25

loan on this to complete the work, the Commissioners in 1710 asked Wren to indicate what the future costs would be. Till that point £683,916 13s. 4¼d. had been spent on 'Building and Ornaments', £60,162 8s. on interest, and £16,054 9s. 6d. on the purchase of houses on the north side of the church.

Wren's estimate of 'work and ornaments proposed and unfinished' is as follows:

Masons' work in finishing the remaining of the Fence Wall, several cross walls to divide the Churchyard £680.10.0.

Queen's statue to be placed in the West area, with the figures, ornaments and pedestal belonging to it (all of marble and in great forwardness) as also an iron fence round the same, over and above what is already paid £1,260.0.0.

Carving four panels at the west end with historical Bass-Relievos, with a panel under one of the windows £315.0.0.

Digging the foundations of the walls above-mentioned with levelling the whole Churchyard and carrying away the earth and the rubbish £438.0.0.

Brickwork in the foundation of the said walls including materials and work £108.0.0.

Smiths' work for the iron fences upon the said crosswalls, a balcony in the upper west portico (which I propose to be of hammered iron), large casements to the lower windows of the body and choir of the church, with locks, hinges and bolts for several doors
£908.0.0.

Carpenters' work in taking down the timber fences round and in the Churchyard, with several sheds, the old Chapter House and the great scaffolds to the inside of the cupola, making and striking scaffolds for the carver and painter, making the floors of the north and south aisles, above, with several doors in the church and vaults.
£1,276.10.0.

Plumber for making good part of the roof and gutters damaged by the falling of stone and timber. £200.0.0.

Brass branches and pulleys for the body of the church, brass candlesticks for the choir, copper springs and brass collars and sockets for the casements, with copper cramps for the pedestal for the Queen's statue. £342.0.0.

Plasterer for finishing in the vaults and the lower part of the inside cap of the dome, with pointing several windows about the church

£105.0.0.

Glazier for glazing several windows in the church and dome

£124.0.0.

Painting the inside ironwork, the doors, the inside windows of the church and dome, the ironwork in the roofs, library staircase, laying in oil the two west porticos, painting the cross fences in the churchyard, the inside and outside iron balconies and laying in oil the remainder of the stonework in the dome. £992.0.0.

The cast iron fence round the Churchyard over and above £1,000 already paid Mr Jones the undertaker, according to his own computation at 6d. per pound, to which it is left, that way of doing it being carried contrary to my opinion. £10,000.0.0.

Running joints of the rail, the balisters, spikes and scrolls of the said fence with lead. £479.13.0.

Painting ditto £207.7.0.

Masons for cutting the holes for ditto £116.0.0.

Carpenters for making trussells and placing the gins for the said fence and gates £50.0.0.

Painting the cupola with panels of histories taken out of the Acts of the Apostles £3,500.0.0.

But if the same be painted with ornaments of architecture in Basso Relievo and the mouldings heightened with gold it may be done for two thousand pounds and several are more inclined to this latter way than the other.

Deal and timber for the floors and doors before mentioned with nails for the same and ropes and rails for scaffolding £300.0.0.

A large marble font with ornaments and appurtenances £300.0.0.

Salaries to Christmas 1711 £480.0.0.

Labourers and watchmen for the same time £540.0.0.

Incident charges in preparing and exacting securities for money to be borrowed; fees in auditing and passing accounts, as the Act of Parliament requires, with stationery, wares etc. £240.0.0.

Building a new Chapter House with the inside finishing thereof

£5,060

Paving the area at the west end and the street around the fence

£1,165.

Total £35,043

I have only further to take notice of two things more than have been proposed, vizt.

1. Chimes and a ring of bells which if included upon will come to £6,000.0.0.

2. Pinnacles and other ornaments round the top of the church, with statues to the three pedaments, which will require three years' time and cost £16,500.0.0.

Signed. Chr. Wren 28 Feb. 1710/II

There were human costs too; at this time building was a dangerous profession. Later in the same collection of MSS there is an account of how the money collected at the door of the new cathedral for charitable purposes was spent between 1707 and 1711.

To surgeons and apothecaries for the cure of men maimed and hurt in the works. £187.13.10.

To widows whose husbands were killed in the works £30.0.0.

Putting out and clothing apprentices £75.0.0.

To men disabled in the works and past their labour, with conveying some of them to the place of their nativity. £35.0.0.

Coroners and funeral charges of men killed in the works £12.4.6.

£339.18.4.

(*Historical MSS Commission Reports*: Duke of Portland, vol. X.1931)

2.3 Very handsome and convenient

The pen of Mrs Delany provides for us, in a letter she wrote on 16 September 1774 a picture of a great Georgian mansion, that of Lord Bute at Luton.

Lord Bute seemed happy in seeing us at Luton, and very pressing to have us stay, and made the best use of our time in showing us everything that was worth attending to, and they were very numerous. The situation you know. They have opened a view to the river, and the ground and plantations are fine. It would be better if there was a greater command of the river and MR BROWN had not turned all the deer *out of the park*; they are beautiful enliveners of every scene, where there is range sufficient for them. The house, tho' not entirely finished according to the plan, is very handsome and convenient, but as part of the old house remains, it does not appear to advantage, nor is the best front completed; and this makes it very difficult to describe as there is no regular entrance. You go in at the hall of ye old house, from thence into a parlour, and then into a large dining-room; all this the old house. You then go up some steps, cross a stone staircase, which leads you to a gallery, or rather passage from which you go into an ante-chamber. On the left hand a large drawing room, with a coved ceiling; on the right hand of the anteroom you go into a very fine saloon, with a large bow window opposite the chimney. The room is 64 feet by 24 in the bow; 33 wide, 20 high. Out of the saloon you go thro' two small rooms with cases of manuscripts, over which are models of the remarkable ruins about Rome, represented in cork. You then go into the library, the dimensions of which I have been so stupid as not to remember. It is, in effect three or five rooms, one very large one, well-proportioned in the middle, each end divided off by pillars, in which recesses are chimneys, and a large square room at each end, which, when the doors are thrown open make it appear like one large room or gallery. I never saw so *magnificent* and *so pleasant* a library, extremely well-lighted, and nobly furnished with everything that can inform and entertain men of learning and virtù. The only objection to ye house is 42 stone steps, which you must ascend whenever you go up to ye lodging appartments. When you are there, there is no fault to find, as they are fine rooms, and very commodious; five complete appartments – a bedchamber, 2 dressing rooms, and rooms overhead for a man and a maid-servant *to each*. One of these appartments is Lord and Lady Bute's, and four for strangers. Up another flight of stairs leads to the attic, where there are as many appartments as complete, but not as lofty. The furniture well-suited to all. The beds damask and rich satin, green, blue and crimson; mine was white satin. The rooms hung with plain paper, suited to the colour of ye beds, except mine, which was pea green, and so is the whole appartment below stairs. The

curtains, chairs and sofas are all plain satin. Every room filled with pictures, many capital ones, and a handsome screen hangs by each fireside, with ye plan of ye room, and with the names of the hands by whom the pictures were painted, in the order as they stand. The chimney pieces in *good taste*; no extravagance of fancy; indeed throughout the house that is avoided. Fine frames to the pictures, but very little gilding besides, and the ceilings elegant, and not loaded with ornament. A great variety of fine vases, foreign and English, and marble tables. I think I have led you a dance eno' to tire you, and wish I may have given a description plain enough to understand. I must not omit one part of our entertainment, which was a clock organ, which is an extraordinary piece of mechanism, and plays an hour and a half without once winding up. There are 30 barrels, of which the principal are Handel, Geminiani, and Corelli; the tone is mellow, and pleasant, and has an effect I could not have expected. It is a vast size, and has a great many stops, and I had rather hear it than any of their modern operas or consorts; many parts are judiciously brought in, and some parts of Handel's choruses tolerably executed.

(*The Autobiography and Correspondence of Mary Granville, Mrs. Delany*; Second Series, vol. ii, pp. 34–6. London 1862)

2.4 Reassurances about magnificence

Not everybody was pleased with the magnificence of the great new houses which were rising up all over England. The Duchess of Marlborough had many qualms about Blenheim, and in October 1713 Vanbrugh wrote to the Clerk at the Treasury who was responsible for paying hin for the Palace, in his own rather personal style.

I am much pleased here [Castle Howard in Yorkshire, which he had just designed for the Carlisles] to find Lord Carlisle so thoroughly convinced of the Conveniencys of his new house, because he has now had a years tryall of it; And I am the more pleased with it, because I have now a proof that the Duchess of Marlborough must find the same convenience in Blenheim, if ever She comes to try it (as I still believe she will in spite of all these black Clouds). For my Lord Carlisle was pretty much under the same Apprehensions with her, about long Passages, High Rooms & c. But he finds what I told him to be true. That those Passages would be so far from gathering & drawing wind as he feared that a Candle would not flare in them, of this he has lately had the proof, by bitter stormy

nights in which not one candle needed to be put into a Lanthorn, not even in the Hall, which is as high (tho not indeed so big) as that at Blenheim. He likewise finds that all his Rooms, with moderate fires are Ovens, and that this Great House, do's not require above One pound of wax and two of Tallow candles a night to light it, more than his House in London did nor in servants, is he at any expense more whatsoever than he was in the Remnant of an Old house, but three housemaids and one Man to keep the whole house and Offices in perfect cleanliness, which is done to such a degree *that the Kitchen* and all the Passages under the Principal floor are as dry as the Drawing Room; and yet there is a great deal of Company, and *very good housekeeping*. So that upon the whole (except for the keeping of the New Gardens) the expense of living in this Great fine house do's not amount to more than a hundred pounds a year more than was spent in the *Old One*. If you think the knowledge of this may be of any satisfaction to my Lady Marlborough, pray tell her what you hear.

(Quoted by H. Avray Tipping in *Country Life*, 1926, vol. lxi, p. 956)

2.5 Profiting from Palladio

In his admirably practical *A Complete Body of Architecture* (London 1756) Isaac Ware condemned the widely prevalent belief that the ideal was to 'transfer the buildings of Italy right or wrong, suited or unsuited to the purpose into England; and this, if done exactly, the builder has been taught to consider a merit in his profession'. He went on (p. 694) to give some sound advice on how to profit from the study of Palladio.

In studying a design of Palladio's, which we recommend to the young architect as his frequent practice, let him think, as well as measure. Let him consider the general design and purpose of the building, and then examine freely how far, according to his own judgement, the purpose will be answered by that structure. He will thus establish in himself a custom of judging by the whole, as well as by the parts; and he will find new beauties in the structure considered in that light.

He will improve his knowledge and correct his taste by such contemplation; for he will find how greatly the designer thought, and how judiciously he has done many things, which, but for such an examination, would have passed in his mind unnoticed, or at best not understood.

Possibly when he has thus made himself a master of the author's or designer's idea, he will see wherein it might have been improved. Now that he understands the work he will have a right to judge thus, and what would have been absurdity in one who knew not the science, or presumption in such as had not enough considered the building, will be in him the free and candid use of that knowledge he has attained in the art.

Let him commit to paper his thoughts on these subjects; not in words only, but in lines and figures. He will be able to reconsider them at leisure, and thence adopting or condemning his first thought, he will either way improve his judgement, and probably introduce new excellencies in his practice.

2.6 Classical precedents

Despite the respect which architects showed to Greek and Roman architecture, they had little detailed knowledge of it, or accurate ideas of its appearance, depending very largely on often inadequate illustrations to editions of Vitruvius and the like. By the second half of the century this largely altered thanks to the publication of *The Antiquities of Athens*, whose authors thus analyse their achievement(cf. pp. 176–8).

Many Authors have maintained these remains of [Greek] Antiquity, as Works of great magnificence, and most exquisite taste; but their Descriptions are so confused, and their Measures so inaccurate, that the most expert Architect could not from these Books form an idea distinct enough to make exact Drawings of any one building they describe. Their works seem rather calculated to raise our admiration than to satisfy our curiosity, or improve our taste.

Rome, who borrowed her Arts and frequently her Artificers from Greece, has by means of Serlio, Palladio, Santo Bartoli, and other ingenious men, preserved the memory of the most excellent Sculptures, and magnificent Edifices which once adorned her; and though some of the originals are since destroyed, yet the memory, the exact form of these things, nay the Arts themselves were secured from perishing, since the industry of these men have dispersed examples of them through all the Polite Nations of Europe.

But Athens, the mother of Elegance and Politeness, whose magnificence scarce yielded to that of Rome, and who for the beauties of a correct style must be allowed to surpass her, as much as an original excels a copy, has been almost entirely neglected, and unless exact drawings from them be speedily made, all her beau-

tious Fabricks, her Temples, her Theatres, her Palaces will drop into oblivion, and Posterity will have to reproach us, that we have not left them a tolerable idea of what is so excellent, and so much deserves our attention. The reason of this neglect is obvious.

Greece, since the Revival of the Arts (the Renaissance), has been in the possession of Barbarians. And Artificers capable of such a Work have been able to gratify their passion for fame or profit, without risking themselves among such professed enemies to the Arts, as the Turks still are, and whose ignorance and jealousy make an Undertaking of this sort still somewhat dangerous.

While those Gentlemen who have travelled there, though some of them have been abundantly furnished with Literature, yet have not any of them been sufficiently conversant with Painting, Sculpture and Architecture, to make their Books of such general use, or even entertainment to the Public, as a man more acquainted with those Arts might do; for the best verbal Descriptions cannot be supposed to convey so adequate an idea of the magnificence and elegance of Buildings, the fine form, expression or proportion of Sculptures, the beauty or variety of a country, or the exact scene of any celebrated Action, as may be formed from Drawings made on the spot, measured with the greatest accuracy, and delineated with the utmost attention.

We doubt not but a Work so much wanted will meet with the Approbation of all those Gentlemen who are lovers of Antiquity, or have a taste for what is excellent in these Arts, as we are assured that those Artists who aim at perfection must be infinitely more pleased, and better instructed, the nearer they can draw their examples from the fountain-head.

(James Stuart and Nicholas Revett, *The Antiquities of Athens.* 1762)

2.7 Every quality of a genius

Horace Walpole's account of the Earl of Burlington, though tinctured with that suspicion of sycophancy which was part of his complex character, is a just, near-contemporary estimation of his achievement (published in vol. IV of *Anecdotes of Painting in England*, 1771, 1780). It is also an interesting example of architectural criticism.

Never was protection and great wealth more generously and more judiciously diffused than by this great person, who had every quality of an artist and genius, except envy. Though his own designs

33

were more chaste and more classic than Kent's, he entertained him in his house till his death, and was more studious to extend his friend's fame than his own. In these sheets I have mentioned many other instances of the painters and artists he encouraged and rewarded. Nor was his munificence confined to himself and his own houses and gardens. He spent great sums in contributing to public works, and was known to chuse that the expense should fall on himself, rather than that his country should be deprived of some beautiful edifices. His enthusiasm for the works of Inigo Jones was so active, that he repaired the church of Covent Garden because it was the production of that great master, and purchased a gateway at Beaufort Garden in Chelsea, and transported the identical stones to Chiswick with religious attachment. With the same zeal for pure architecture, he assisted Kent in publishing the designs for Whitehall, and gave a beautiful edition of the antique baths from the drawings of Palladio, whose papers he procured at great cost. Besides his works on his own estate at Lonsborough in Yorkshire, he new fronted his house in Piccadilly, built by his father, and added the grand colonade within the court. As we have few samples of architecture more antique and imposing than that colonade, I cannot help mentioning the effect it had on myself. I had not only not ever seen it, but had never heard of it, at least with any attention, when, soon after my return from Italy, I was invited to a ball at Burlington House. As I passed under the gate by night, it could not strike me. At day-break looking out of the window to see the sun rise, I was surprised with the vision of the colonade that fronted me. It seemed one of those edifices in fairy-tales that are raised by genii in a night's time.

His Lordship's house at Chiswick, the idea of which is borrowed from a well known villa of Palladio's, is a model of taste, though not without faults, some of which are occasioned by too strict adherence to rules and symmetry. Such are too many correspondent doors in spaces so contracted; chimnies between windows, and which is worse, window between chimnies; and vestibules, however beautiful, yet too little secured from the damps of this climate. The trusses that support the ceilings of the corner drawing-room are beyond measure massive, and the ground floor is rather a diminutive catacomb than a library in a northern latitude. Yet these blemishes, and Lord Hervey's wit, who said 'the house was too small to inhabit, and too large to hang one's watch'[1] cannot deprecate the taste that reigns in the whole. The larger court, dignified by picturesque cedars, and the classic scenery of the small court that

unites the new and the old house are more worth seeing than many fragments of ancient grandeur, which our travellers visit under all the dangers attendant on long voyages. The garden is in the Italian taste, but divested of conceits, and far preferable to every style that reigned till our late improvements. The buildings are heavy, and not equal to the purity of the house. The lavish quantity of urns and sculpture behind the garden-front should be retrenched.

Other works designed by Lord Burlington, were, the dormitory at Westminster School, the Assembly Room at York, Lord Harrington's at Petersham, the Duke of Richmond's house at Whitehall, and General Wade's in Cork Street. Both the latter were ill-contrived and inconvenient, but the latter has so beautiful a front, that Lord Chesterfield said 'as the General could not live in it to his ease, he had better take a house over against it, and look at it'. These are mere details relating to this illustrious person's work. His genuine praise is better secured in Mr Pope's epistle to him.

I ought not to omit that his Countess, Lady Dorothy Saville had no less attachment to the arts than her Lord. She drew in crayons, and succeeded admirably in likenesses, but working with too much rapidity, did not do justice to her genius. She had an uncommon talent for caricatura.

2.8 For want of better helps

The designing of buildings – especially in the remoter provincial areas – could still be a haphazard and amateur business, with 'persons of distinction' guiding local builders. To assist such, the Scottish architect James Gibbs, who designed St Martin-in-the-Fields, King's College, Cambridge, and the Radcliffe Camera, Oxford, published his very successful *A Book of Architecture* in 1728, in the introduction to which he states the purposes for which he wrote it, and gives some advice about elegance and the value of professional help.

Persons of distinction were of the opinion that such a Work as this would be of use to such Gentlemen as might be concerned in build-

1. Lord Chesterfield's comment was certainly more poetic, and possibly more witty.

> Possessed of one great house for state,
> Without one room to sleep or eat,
> How well you build let flattery tell,
> And all mankind how ill you dwell.

ing, especially in the remote parts of the Country, where little or no assistance for Design can be procured. Such may here be furnished with Draughts of useful and convenient Buildings and proper ornaments, which may be executed by any Workman who understands Lines, either as here designed, or with some Alteration, which may be easily made by a Person of Judgement, without which a variation in Draughts, once well-digested, frequently proves a Detriment to the Buildings, as well as a Disparagement to the person that gives them. I mention this to caution Gentlemen from suffering any material change to be made in their Designs by the Forwardness of unskilful Workmen, or the caprice of ignorant, assuming Pretenders.

Some, for want of better helps, have unfortunately put into the hands of common workmen, the management of Buildings of considerable expense, which, when finished they have had the mortification to find condemned by persons of Taste, to that degree that sometimes they have been pulled down, at least alter'd at a greater charge than would have procur'd advice from an able Artist, or if they have stood, they have remained lasting Monuments of the Ignorance or Parsimoniousness of the Owners, or (it may be) of a wrong-judged Profuseness.

What heaps of Stone, or even Marble, are daily seen in Monuments, Chimneys and other Ornamental pieces of Architecture, without the least Symmetry or Order? When the same or fewer Materials under the conduct of a skilful Surveyor would, in less room, and with much less charge have been equally (if not more) useful, and by Justness of Proportion have had a more grand Appearance, and consequently better answered the Intention of the Expense. For it is not the Bulk of a Fabrick, the Richness and Quantity of the Materials, the multiplicity of Lines, nor the Gaudiness of the Finishing that gives the Grace or Beauty and Grandeur to a Building, but the Proportion of the Parts to one another and the Whole, whether entirely plain, or enriched with a few Ornaments properly disposed.

2.9 Simple rules for builders

The subtitle of Batty Langley's *The Builder's Chest Book* (1727), 'Being a necessary Companion for Gentlemen, as well as Masons, Carpenters, Joyners, Bricklayers, Plasterers, Painters, etc. and all others concerned in several Parts of Buildings in general', suggests the extent to which those ill-versed in the higher reaches of

architectural theory depended for the buildings they designed and built on a kind of basic grammar of construction. Proportions and other relevant details were clearly defined in his catechismatic style.

Of Galleries

M. *What Proportion should the length of a Gallery have to its breadth?*

P. Not less than five times its breadth, nor more than eight.

M. *What height ought Galleries to have?*

P. Their height ought to be equal to their breadth.

M. *What is the best Aspect for Galleries?*

P. The North, because its light is best for paintings & c. which they are generally adorn'd with.

M. *Is it not possible to make galleries too narrow or too wide?*

P. Yes, and therefore their breadth should never be less than sixteen feet, nor to exceed twenty-four feet.

Of Halls

M. *What is to be observed in the proportion of Halls?*

P. That their length be not less than twice their breadth, not to exceed three times.

M. *Of what height must Halls be?*

P. If their ceilings are flat, their height may be two thirds of their breadth, and if the ceiling be arched, the height may be five sixths of its breadth.

Of Chambers

M. *What situation is best for Chambers of Delight?*

P. The East, provided that any other hath not a better prospect.

M. *What proportion ought a good Lodging-Chamber to have?*

P. That its length be never more than its breadth and half breadth, nor less than the breadth itself, viz. exactly square.

M. *Of what height ought Chambers to be?*

P. The height of chambers of the first storey, not less than two thirds of their breadth; the second storey eleven twelfths of the first, and the third storey one quarter of the second.

Of Inner Doors

M. *Of what breadth may doors be made in large buildings?*

P. Doors in large buildings must be always in proportion to the place wherein they stand, their breadth must be not less than three feet, not more than six feet, and their height always equal (at least) to double their breadth, of two Diameters. Inner doors in small Buildings must never be less than two feet and half in breadth and in height six feet.

Of Windows

M. *What are the principal things to be observed in Windows?*
P. First their magnitude; secondly their number and thirdly, the bigness of the room that they are to enlighten; for it is possible to make rooms as well too light as too dark. The height of windows of the first storey may be two diameters, and where necessary two diameters and ¼, ⅓ or ½, the height of windows in the second and third storeys to be the same proportion as those of the chambers.

Of the placing of Doors and Windows

First let all the doors (if possible) be placed right opposite against one another, so that a clear view may be had throughout the whole house, which is both graceful and convenient.

Secondly, place your windows in such order that those on the right of the door be equal to those on the left, and those in the storeys above to be directly over those below.

Thirdly, 'tis of great service as well as ornament, to turn arches over doors and windows, to discharge the weight as lies over them.

Lastly, suffer not windows to be placed too near the Angles of a building, but leave the coyn as large as may be with conveniencey, for those coyns are the very nerves and support of the whole building.

Of Chimneys

The several sorts of chimneys are those of the hall, the parlour, the chamber, the study and the kitchen.

First, hall chimneys ought to be in the clear between Jaum[1] and Jaum 6 or 7 feet and in large buildings 8 feet. The height of the

1. Jaum = jamb – the side of an opening.

Mantle-tree to be about 5 feet, and the projecture of the Jaums about 2 feet 9 inches or 3 feet.

Secondly, parlour or chamber chimneys, not to exceed 6 feet between Jaum and Jaum, their height to be about 4 feet or four feet and a half, and projecture about 2 feet or two feet and a half.

Thirdly, chimneys in studies & c. their breadth to be 5 feet at most, height 4 feet and depth of the Jaums 2 feet.

Of Staircases

Great care ought to be taken in the placing of the staircase of any building but commonly the stairs are placed in the angle, wing or middle of the front. To every staircase are required three openings.

First, the door leading to them.

Secondly the window or windows as gives light to them and thirdly, their landing.

First the door leading to a staircase should be so placed that most of the building may be seen before you come at the stairs, and in such a manner that it may be easy for any person to find out.

Secondly, for the windows, if there be but one, it must be placed in the middle of the staircase that thereby the whole may be enlightened; but if more than one window place one in each storey.

Thirdly, the landing of stairs should be large and spacious for the convenient entrance into the rooms. In a word staircases should be spacious, light and easy in ascent. The height of large steps must never be less than six inches, nor more than 7 inches and a half. The breadth of steps should never be less than 10 inches, nor more than 15 inches.

In making of staircases this rule should be observed, that the number of steps at every landing should be odd, and not even, for thereby, when you begin to ascend with your right foot first (as all persons generally do) you will end with the same foot also.

2.10 **Building materials**

Ever practical, Batty Langley (in *The Builder's Chest Book*, 1727) has some interesting specifications about the nature and cost of building materials.

M. *What are the Materials belonging to a building?*
P. Brick, Tile, Mortar, Timber, Lead, Iron, Nails, Laths & c.
M. *How are good bricks to be chosen?*

P. In every kiln or clampe there are three degrees of brick. The first and worst are those that lie on the outside of the clampe, where the fire hath not power to burn them thoroughly, and these are called *Samell* bricks. The next are those within these Samell, and the very best are they that are burnt in the Heart or Body of the Clampe, which if they have much Saltpetre in them will run, and be, as it were glazed all over. But these for lasting exceed all the rest in the kiln, notwithstanding the earth and the making be the same.

M. *Of what magnitude ought every brick to be?*

P. Bricks have been made of various sizes, but the statute takes notice of one viz. *That they be nine inches in length, four inches and half in breadth and two inches and half in thickness*; but you shall rarely find them so, for the drying and burning will shrink them in the thickness considerably, although it does but little in the length and breadth.

M. *After what manner are bricks sold?*

P. By the thousand, but for their price it is uncertain in respect of Fuel to burn them, servants' wages, the conveniency of carriage & c. But the general price about Twickenham, Brentford & c. is from 12s. to 14s. a thousand.

M. *What number of bricks may a good bricklayer reasonably lay in a day, having a diligent labourer to serve him?*

P. In sound and new work a bricklayer will lay a thousand of bricks in a day.

M. *How many bricks will compleat a rod of work at one and a half brick thicknesses?*

P. Four thousand and five hundred.

M. *What quantity of lime and sand do you need to one rod of brickwork?*

P. One hundred and quarter of lime and two load and a half of sand.

M. *By the information I have received from you I shall be able to make choice of good bricks and the quantity of lime and sand necessary for them. I desire you to inform me something in relation to tiles.*

P. Tiles are made of a kind of earth which is much better than that of brick, and not much unlike that potters use for their ware. The sorts of tiles used in buildings are principally two sorts, viz. plain tiles and ridge tiles. Plain tiles should be in length ten inches and a half, in breadth six inches and in thickness near three quarters of an inch.

M. *After what manner are tiles sold?*

P. By the thousand as bricks are.

M. *How is tiling measured or rated?*

P. By the square, which is ten feet every way, making a hundred square feet.

M. *What quantity of mortar is necessary to lay square tiling?*

P. About one fourth of a part of what is allowed for a rod of brickwork.

M. *What are the kinds of wood that laths ought to be made of, and what scantlings[1] ought they to be, and in what parts of a building ought the different sorts be used?*

P. The sorts of laths allowed by the statute are principally of two sorts, the one five feet long, and the other four feet long. Those of five feet have five score or one hundred in the bundle, the other of four feet have six score or 120 in the bundle; their breadth ought to be one inch and a half, thickness half an inch, and of both these lengths there are three sorts.

First – Heart of Oak

Secondly – Sap-laths and

Lastly – Deal-laths

M. *What is the reason that laths are made of different lengths and goodness of stuff?*

P. Because all rafters on which they are nailed, are not placed at equal distances, and the reason of the variety of the goodness of the stuff, is always considered for the place wherein 'tis to be used; as for example those of Heart of Oak being the best, are most necessary for Tiling as being the most durable; the second sort of Sap-laths are best for plastered walls, and those of Deal for ceilings.

M. *What quantity of Nails is used in laying a bundle of laths?*

P. Five hundred to a bundle of 5 foot laths, and 600 to a bundle of four feet laths, every hundred of nails containing six score.

M. *How many tiles will cover a square yard?*

P. Three score tiles, laid at a seven inch gauge will cover a yard. But, as I said before, tiling is measured by the square and not by the yard.

M. *How many tiles and laths are required to complete a square of Tiling?*

P. Six hundred and fifty five tiles, or thereabouts will cover a square of tiling with one bundle of laths.

1. Scantlings in this context means the dimensions of stone or timber in building.

2.11 Brick or stone?

Issac Ware's *A Complete Body of Architecture* (London, 1756) was full of simple answers to simple problems. Here he is on brick versus stone.

We see many beautiful pieces of workmanship in red brick; and to name one, the front of the green-house in Kensington Gardens will be sure to attract every eye that has the least curiosity, but this should not tempt the judicious architect to admit them in the front walls of the building. In the first place, the colour itself is fiery and disagreeable to the eye; it is troublesome to look upon it; and in summer it has an appearance of heat that is very disagreeable; for this reason it is most improper in the country, though the oftenest used there from the difficulty of getting grey. But a further consideration is, that in the fronts of most buildings of any expense there is more or less stonework, now there is something harsh in the transition from the red brick to stone; in the other the grey stocks come so near the colour of the stone that the change is less violent, and they sort better together.

2.12 The common houses of London

Most of the smaller houses of Georgian London have disappeared, but to get a clear view of the architecture of the city at the time, one must realize that they were the dominant type of residence. Isaac Ware (*A Complete Body of Architecture*, 1756, pp. 354–7) gives this illuminating description of them.

The common houses in London are built all in one way, and that so familiar that it will need little instruction, nor deserve much illustration. The general custom is to make two rooms and a light closet on a floor, and if there be any little opening behind to pave it.

Some attempt to make flower gardens of these little spots, but this is very idle. Plants require a purer air than animals, and however we live in London, they cannot breathe where is so much smoke and confinement; nor will gravel continue clean many days from the turning.

In this respect therefore, instead of borders under the walls, the best method is to lay the whole with a good stone paving, and at the farther part to build the needful edifice, that cannot in London be removed further off; and something of a similar shape and little service opposite to it. An alcove with a seat is a common contrivance in the space between, but it is a strange place to sit in for

pleasure; all this therefore is better omitted; and the young architect is to have a general caution on this head, that will serve him on many more, that when there cannot be a proper ornament, nothing is so becoming as perfect plainness.

The lower storey in these London houses is sunk entirely under ground, for which reason it is damp, unwholesome and uncomfortable; but the excuse has weight; ground rent is so dear in London that every method is to be used to make the most of the ground plan; but even in the most ordinary houses in the country, where some of the offices may be made without doors, it will always be best, instead of these totally underground floors to have a basement storey.

In common houses the fore-parlour is the best room upon the ground floor; the passage cuts off a great deal from this, and from the back parlour; this usually running straight into the opening, or garden, as it is called behind; but it is a much better practice to make the back parlour the better room. This may be done as we have proposed by making the foreroom a hall, or retaining it in the form of a parlour; the passage into the garden may be from below, and consequently the breadth of the passage there taken in, which gives the back parlour a greater extent and another window.

The first floor in these common houses consists of the dining room, over the hall or parlour; a bed-chamber over the back parlour, and a closet over its closet.

The two rooms on the second floor are for bedrooms, and the closets being carried up thus far, there may be a third bed there too.

Over these are the garrets, which may be divided into a larger number than the floors below, for the reception of beds for servants.

With all the care that can be taken in this article, often the number of servants cannot be lodged there; and in this case a bed for one man or two maid-servants is contrived to let down in the kitchen, but in this case the necessary care of those people's health requires it should be boarded.

Such a house as we have been here speaking of is to be built for six or seven hundred pounds, or it will cost upwards, according to a little more extent of ground, and a little more than usual ornament. The common builders of them work jointly, one doing his share of the business in the other's house, according to their various subordinate professions so that it is not easy for them to say what they cost, but they are generally ready to sell them for fourteen years' purchase, exclusive of ground rent.

2.13 The design of shops

Increasing wealth, and more sophisticated merchandizing tech-
niques stimulated the growth of shops, and the attention paid to their
design, as Rouquet noted (*The Present State of the Arts in
England*, 1755).

This nation however is ready enough to fall even into the extremity
of method in everything related to commerce; for example when
they want to draw in customers to engage, to flatter, to seduce, or
even to impose upon them, the love of gain abundantly supplies
them on these occasions, with every expedient capable of produc-
ing such different effects; these they practise with a winning
address, and with a disinterested air, which are contradicted
however by too much eagerness and cringing. The seller always
stoops; the purchaser always assumes an imperious air; but they
have their turn; he who sells today becomes purchaser tomorrow.

The London shops of every kind, make a most brilliant and
agreeable show, which infinitely contributes to the decoration of
this great city. Everything is rubb'd clean and neat; everything is
enclosed in large glass show cases, whose frames, as well as all the
wainscot in the shop are generally fresh painted, which is produc-
tive of an air of wealth and elegance which we do not see in any
other city. The signs to their houses are very large, well-painted,
and richly gilt, but the costly iron work they hang by is so clumsy
and heavy that their weight seems to threaten the thin brick wall to
which they are fastened.

And yet they are not satisfied with all this decoration of mer-
chandises, with these show cases, with these paintings and gaudy
signs. Within these few years the custom has been introduced of
dressing the front of the shop, especially the mercers, with some
order of architecture. The columns, the pilaster, the freeze, the cor-
nice, every part in fine preserves its proportion, and bears as great a
resemblance to the gate of a little temple as a warehouse. These
shops they make as deep as possibly they can; the further end is
generally lighted from above, a kind of illumination which, joined
to the glasses, the sconces and the rest of the furniture, is in regard
to those passing by, frequently productive of a theatrical effect, of a
most agreeable vista. It is in this extremity of the shop that the En-
glish dealer burns that ill-placed and tiresome incense with which
he almost smothers his customers; here it is that, from too officious
a greediness, he oftener disgusts than persuades.

2.14 Rebuilding Woburn

When in 1732 John Russell, 4th Duke of Bedford, succeeded his brother, he found Woburn Abbey, the principal home of his family, sadly dilapidated, and set about restoring much of it. It was done in great style, with an eye to the latest in furnishings and fittings. Amongst the bills surviving are the following:

From John Devall, 1756

To a chimney-piece, the plinths, architraves and cornice veined marble, the rest statuary; the therm trusses carved with swags of drapery in front, raised eyes to sides, with swags of drapery in the pilaster part of ditto; tablet with cross, palms and frieze each side ditto; with eagle's heads and foliage, and flowers in knees of the architrave; a veined marble slab and dove, marble coverings. Marble, mason's work, carving and polishing, with all the mouldings fully enriched. £120.0.0.

From Michael Rysbrack, Statuary

May 29th 1756
Drawing, modelling and carving two statuary chimney-pieces, with four whole therms, and four profile therms, with festoons of fruits and flowers; and working the mouldings in front of the therms, and two friezes with rams' heads and cornucopias of fruit and flowers £195.0.0.

April 17th 1756
Drawing, modelling and carving and polishing a tablet for a chimney-piece representing a nymph laying on the ground and a boy running to her, being frightened by a sea monster £25.0.0.

*From Samuel Norman, Cabinet-Maker, Carver etc. at the Royal
Tapestry Manufactory, Soho Square*

For working anew two Japan cabinet stands and new japanning the frames, repairing and polishing the two fine India cabinets and silver burnishing the frames
For taking off the silver furniture of both cabinets, cleaning and burnishing the whole ornament in best manner £11.11.0.

From William Hollinworth & Co.

October 28th 1758

A large chandelier, richly carved and gilt in burnished gold with 18 branches to ditto	£86.0.0.
A balance weight and ceiling tassel covered with blue silk	£8.8.0.
5 pounds 2 ounces of large silk rein line	£6.0.0.
A strong double pulley	12.0.

(Gladys Scott Thomson, *Family Background*. Cape 1949)

2.15 Designing at a distance

James Caulfield, 1st Earl of Charlemont, built for himself on the outskirts of Dublin in the 1760s a country house known as Marino, which was designed by Sir William Chambers in a strictly classical style, and cost some £60,000. There was a very close co-operation between the two, and much of Chambers' designing was done from London by post. The following letters from Chambers to Charlemont show how the process worked, and how complete was the control of the architect over every detail.

August 25th 1767, London.

In obedience to your lordship's first letter, I herewith send you a design for the iron gates of the entrance to Marino, done in the manner your lordship desires. My clerk has misunderstood my sketch, and committed a mistake or two in the drawing, which I have endeavoured to correct in the margin, as there is not time this post for drawing it more correctly. I fancy the smith will understand it sufficiently. If not I have kept a sketch of it by me, and can send a more correct drawing in sufficient time, if your lordship thinks it necessary. With regard to the contents of your lordship's second letter from Dublin I shall certainly do what I can to serve Mr Sprowles, and procure him admittance, if possible into our new furnished houses, though the task is by no means easy as it begins to be the fashion for the ladies to lock up their rooms and carry the keys in their own pockets. I beg your lordship will present my most humble respects to Her Grace the Duchess of Leinster, and be so obliging to tell her that I shall with great pleasure obey Her Grace's commands on this and all other occasions on which she shall be pleased to honour me with them. I am sorry to find your lordship so much distressed with your workmen. Give me leave to offer a piece of Italian advice 'bisogna aver phlegma (flemma)',[1] I am not sure that the spelling is right, but I am sure the prescription is

the only efficacious one yet discovered. The pattern head, and also the pattern for the cove[2], cornice etc. of the casino were sent off a good time ago they must be found to hand before this, and I hope, safe. I sent to Barret to tell him he must contrive to send by first opportunity the sample of the sky-blew, as things I had to send were already gone, and therefore it could not go with them. I am sorry there is no person in Ireland to rely on for fixing the tints of the painting, as there is no possibility of sending patterns over unaltered, the want of air always making a very considerable alteration in the colours before they arrive in Dublin. I have enclosed the designs for the metal drawers. The poor man who had the bronzes in hand hath laid at the point of death for some time and there is no hope of his recovery; so that as soon as I get the models I must employ some other person to do the work, both for the medal cases and the Tritons. Alken has carved one of the little heads for the corner of the doors of the medal cases. It is very fine, but as he tells me he cannot do them under three guineas and a half a head, I have stopped his further progress till I hear from your lordship, and I think antique patteras[3] or nails which will cost but a trifle will answer the purpose almost as well. Be pleased to send me the inscriptions which are to be on the shields of the medal cases, for Mr Anderson has lost the former ones.

September 1767. Berners Street
. . . I feared myself you would not like the model of the head. I thought it dull when here, and I suppose it may have changed somewhat in the passage,[4] but it is all they can do in green, and when it is in quantity it looks much better than in single. I am glad the painter is to be here. I have not seen him yet, but when I do, I will get him all the information I possibly can concerning colours. Alken I have set about a head of Plato to match that of Homer, and also about a pattera for to supply the place of the heads. The Hercules Musarum is boasted[5], but the wood being damp, he has been

1. It is necessary to have patience.
2. Cove. A concave surface forming part of a ceiling to eliminate the angle with the wall.
3. Patteras. Originally a dish, but used in this context to describe a dish-shaped architectural ornament.
4. Chambers is apparently referring to the fact on which he has already commented that water colours did not keep their colour when boxed up.
5. Boast – to dress stone.

obliged to kiln-dry it; when that is done he will set about the finishing, and do it with all possible care. I have sent here enclosed a border for the flat of the casino ceiling, but can send no designs for the centre till I have the dimensions of the flat exactly, and if I could have a tracing on this paper of the whole ceiling it would be still better The design for the French table feet will be sent very soon.

September 15th, London 1767.
I wrote to your lordship two or three days ago, so that I have nothing new to say only to let you know that one of the Tritons for the candlesticks is cast; but as I find the pair will come to £36 by the time they are finished, exclusive of the models, I have stopped further proceedings till I hear from your lordship. For my part, as these things are for show rather than for use, I should recommend the wooden ones, well bronzed, which at the distance they are to stand will look full as well as the real ones.

Enclosed I send the designs for the foot of the side-boards for the French room. I have made them 7 foot long and 2 foot 9 inches wide and about 3 foot high, that they may range with the top of the surbase, which I suppose to be about the height. It is difficult, if not impossible to make out all the twists and turns of these sorts of work by a design, but if your lordship's carver is able and a little acquainted with French contours he will easily comprehend my drawing.

October 22nd 1767.
The bronze candlesticks will be finished with all expedition, and also all the other things ordered by your lordship of Anderson. He is dead, and his wife out of town, so that I know not exactly what was begun and what was not; but I find that the models for the medal cases were cast, and his man will finish them as well as he could have done himself. Herewith I send a design for the Apollo's head and also for a new galloss[6] as the one sent before cannot be reduced to 4¾ inches without being too trifling.

February 9th, 1768. London.
I think the looking glass in the girandoles of the library ante-room will answer very well. I believe we shall be able to finish the ornaments for the medal cases exactly, as we have found some figured

6. Galloss – an ornamentally headed nail.

sketches relating thereto. Cipriani and Wilson are both hard at it for your lordship. Enclosed I send Cipriani's drawings for the dragons of the gate at Marino. The vases were sent off some time ago for Chester, being twelve in number and the only tolerable forms I could meet with.

March 12, Berners Street.
The ornaments for the medal cases and the Triton candle-branches are nearly finished and shall be soon sent. With regard to Cipriani and Wilton, I fear it must be a letter from your lordship that can induce them to be expeditious. The Tritons are finished all but the bronzing, and they are so finely executed that it would be a pity not to have them quite complete. I have therefore ordered them to be entirely gilded, for I feared that bronzing would make them appear dull, and partly gilding upon the bronze would look tawdry. This will increase the expense of them, but I think it will answer when done.

(*Historical MSS Commission Reports*: Twelfth Report, Appendix X. Charlemont 1891)

2.16 A Georgian interior

In January 1774 Lloyd Kenyon, an up-and-coming lawyer (later first Baron Kenyon), got married and moved into a house at 18 Lincoln's Inn Fields. His bride wrote to her mother a detailed account of the interior, which must have been typical of many middle-class town houses.

The entrance is a broad lobby well lighted by a window over the door, and a staircase window. It is wainscot, painted white as far as the arch turned at the bottom of the staircase. On the left hand is a sweet, pretty parlour, stuccoed and painted white – marble chimney-piece and hearth; two windows, and at the lower end of the room, two pillars, on which stands a mahogany sideboard. On the side stands a *garde de vin*, on the other side, a chair, which I think must be displaced, and a small table put there. On the side, where the door opens, which is a long way from the window, stands our dining table, with one chair on one side, near the pillar. Between the windows is a very pretty round glass, ornamented with gilt papier-maché, in great taste, two chairs on each side the fire, a handsome cistern of mahogany, with brass hoops etc., under the

49

sideboard, and a Turkey carpet. The back room has only one window, which looks into a little flagged court, twelve of my steps long and six steps broad, but quite entire, and not overlooked by any window but our own, a marble chimney piece and hearth, a stove grate, the same to the other parlour [it] is wainscot, painted white, has a larger dining table for great days, a wardrobe from Chambers for Mr Kenyon's clothes, a wash-hand stand, a little closet, dark shelved conveniently, and four chairs, the same as the dining parlour. The room behind that is white wainscot, has two windows, is as large as the little drawing room, but has nothing at all in yet. There is a fireplace with a marble chimney piece; but that and all the back rooms are common fireplaces. Behind that is the backstaircase, and beyond that a butler's pantry, with a dresser that has two drawers and a cupboard under it, shelves over it for glasses etc. a lead cistern, and a pipe with water.

So much for that floor. The front staircase is a very good one, with a neat mahogany rail to the top of the house. I must tell you, before I proceed further there is a very handsome glass-lamp in the passage, another upon the landing, and a third by the dining room door. The dining room is twenty one feet and a half long, and seventeen feet wide, has a marble chimney piece and hearth, a handsome steel grate etc., it is to be new papered this week, and have the furniture all in order; it is quite ready when the paper is put up. The paper is to be a blue, small patterned flock; I will send you a bit of it. The back room has at present a bed in it, which is to be removed on Wednesday morning, and that room is to have the old blue flock wallpaper we found in it, blue moreen curtains, chairs, a toilet, a book-case – will not that be a nice breakfast room? In the little room behind that, which is wainscoted and painted white, there is a blue moreen bed, a little chest of dressing drawers, and two chairs; then comes my little store-room, which is about as large as half the drawing room, has two rows of shelves, a table across the end with drawers and cupboards under. In this place I keep china, glasses and all my stock of groceries; the plate chest is to be kept there too, when it arrives. Through this closet is the water-closet, very convenient and sweet; it is over the stable.

Up the next storey is our lodging room, over the dining room. It is hung with a green flock paper, has green moreen bed and window curtains, a large chest upon chest, so high that I must have a stepladder to look into the five top drawers, a dressing table and a glass in one pier, a small chest of dressing drawers on the other pier, a night table, a wash-hand stand, and eight chairs. The back

room is wainscoted, and is to have my bed from Chambers in. A maid's room behind that, and over my own store room, another pretty closet, with a linen press, and a light, large cupboard or small closet through it. The two back garrets have servants' beds in. The front is a landing. All the garrets have flat roofs, and are in every respect as good rooms as those below.

(*Historical MSS 'Commission Reports*: Fourteenth Report, 1924, Appendix IX, part iv)

2.17 Improvements in the home

There was a steady improvement in the quality and design of interiors during the century. Writing in 1749 John Wood the architect in his *An Essay towards a Description of Bath* commented on the changes which had taken place during the past twenty years.

About the Year 1727, the Boards of the Dining Room and other Floors were made of a Brown colour, with Scot and Small Beer, to hide the Dirt, as well as their own Imperfections; and if the walls of any of the Rooms were covered with Wainscott, it was with such as was mean, and never Painted; the Chimney Pieces, Hearths and Slabbs were all of Free Stone, and they were daily cleaned with a particular White-Wash, which, by paying Tribute to everything that touched it, soon made the brown Floors like the Starry Firmament; the doors were slight and thin, and the best locks had only Iron Coverings Varnished. Each chair seldom exceeded three half crowns in value; nor were the Tables, or Chests of Drawers better in their Kind, the chief having been made of Oak; the Looking Glasses were small, mean and few in Number; and the Chimney Furniture consisted of a slight Iron Fender, with Tongs, Poker and Shovel, all no more than three or four Shillings value. As the new Building advanced, Carpets were introduced to cover the Floors though laid with the finest clean Deals, or Dutch Oak Boards; the Rooms were all Wainscoted and painted in a costly handsome Manner; Marble Slabs and even Chimney Pieces became common; the Doors in general were not only made thick and substantial, but had the best kind of Brass Locks put on them: Walnut Tree Chairs, some with Leather and some with Damask or worked Bottoms supplied the place of such as were seated with Cane or Rushes; the Oak Tables and Chests of Drawers were exchanged; the former for such as were made of Mahogany, the latter for such as were made either of the same Wood or with Walnut Tree; handsome Glasses

were added to the Dressing Tables, nor did the proper Chimneys or Peers or any of the Rooms long remain without well Framed Mirrors of no inconsiderable Size; and the Furniture for every Chimney was composed of a Brass Fender with Tongs, Poker and Shovel aggreeable to it.

2.18 Keeping up with the times

On 20 September 1753 the *World* published a letter supposedly written by a tradesman, who has inherited an old-fashioned country house, which his wife has just renovated. The actual author was William Parrat, about whom little is known save that he published some poetry.

In about four months my house was entirely new furnished, but so disguised and altered that I hardly knew it again. There is not a bed, table, a chair, or even a grate, that is not twisted into so many ridiculous and grotesque figures, and so decorated with the heads, beaks, wings and claws of birds and beasts, that Milton's 'Gorgons and hydras and chimeras dire', are not to be compared with them. Every room is completely covered with Wilton carpet, I suppose to save the floors, which are all new laid, and in the most expensive manner. In each of the rooms is a pair or two of stands, supported by different figures of men or beasts, on which are placed branches of Chelsea china, representing lions, bears and other animals, holding in their mouths or paws sprigs of bay, orange or myrtle, among the leaves of which are fixed sockets for the reception of wax candles, which, by dispersing the light among the foliage, I own, make a very agreeable appearance. The upper apartments of my house, which were before handsomely wainscotted are now hung with the richest Chinese and Indian paper, where all the powers of fancy are exhausted in a thousand fantastic figures of birds, beasts and fishes, which never had existence. And what adds to the curiosity is that the fishes are seen flying in the air, or perhaps perching upon trees.

The best, or, as my wife calls it, the state bed chamber, is furnished in a manner that has half undone me. The hangings are white satin, with French flowers and artificial moss stuck upon it with gum, and interspersed with ten thousand spangles, beads and shells. The bed stands in an alcove, at the top of which are painted Cupids strewing flowers and sprinkling perfumes. This is divided from the room by two twisted pillars, adorned with wreaths of

flowers and intermixed with shell-work. In this apartment there is a cabinet of most curious workmanship, highly finished with stones, gems and shells, dispersed in such a manner as to represent several sorts of flowers. The top of this cabinet is adorned with a prodigious pyramid of china of all colours, shapes and sizes. At every corner of the room are great jars filled with dried leaves of roses and jessamine. The chimney-piece (and indeed everyone in the house) is covered with immense quantities of china of various figures, among which are Talapoins and Bonzes, and all the religious orders of the East.

The next room that presents itself is my wife's dressing room; but I will not attempt to describe it to you minutely, it is so full of trinkets. The walls are covered round with looking glass interspersed with pictures made of moss, butterflies and sea-weed. Under a very magnificent Chinese canopy stands the toilette, furnished with a set of boxes of gilt plate for combs, brushes, paints, pastes, patches, pomatums, powders, white, gray and blue; bottles of hungary, lavender and orange-flower water, and, in short, all the apparatus for disguising beauty. Here she constantly pays her devotions two hours every morning.

I have a thousand other curiosities in my house of which I know neither the uses nor the names. But I cannot help mentioning the gravel-walks, rivers, groves and temples, which on a grand day make their appearance at the desert. For you are not to suppose that all this profusion of ornament is only to gratify my wife's curiosity; it is meant as a preparative to the greatest happiness of life, that of seeing company. In short, Sir, it is become so great a sight that I am no longer master of it, being constantly driven from room to room, to give opportunity for strangers to admire it.

> Castles were undergoing renovations too. A year later Thomas Gray wrote to Dr Warton (*The Poems of Thomas Gray, with a selection of Letters and Essays*, ed. John Drinkwater, London, 1912) about a visit to Warwick Castle.

Out of the town on one side of it rises a rock that might remind one of your rocks at Durham, but that it is not so lofty, nor so savage, and that the water which washes its foot is perfectly clear, and so gentle that its current is hardly visible. Upon it stands the castle, the noble old residence of the Beauchamps and Nevilles, and now of Earl Brooke. He has sashed the great appartment, that's to be sure (I can't help these things) and being since told that square sash windows were not Gothic, he has put certain whim-whams within

side the glass, which, appearing through are to look like fretwork. Then he has scooped out a little burrough in the massy walls of the place, for his self and his children, which is hung with paper and printed linen, and carved chimney pieces, in the exact manner of Berkeley Square or Argyle Buildings. What in short can a lord do nowadays, that is lost in a great old solitary castle, but skulk about, and get into the first hole he finds, as a rat would do in like case?

2.19 Elegant and convenient

In his *Tour in Ireland* (vol.i, p. 3. Dublin, 1780) that observant traveller Arthur Young recorded his impressions of Charlemont's homes.

23 June 1776. Lord Charlemont's house in Dublin is equally elegant and convenient, the apartments large, handsome and well-disposed, containing some good pictures, particularly one by Rembrandt, of Judas throwing the money on the floor, with a strong expression of guilt and remorse; the whole group fine. In the same room is a portrait of Caesar Borgia by Titian. The library is a most elegant apartment of about 30 × 40 feet, and of such a height as to form a pleasing proportion; the light is well-managed, coming in from the cove of the ceiling, and has an exceeding good effect; at one end is a pretty ante-room, with a fine copy of the Venus de Medicis, and at the other two small rooms, one a cabinet of pictures and antiquities, the other medals. I drove to Lord Charlemont's villa at Marino near the city, where his lordship has formed a pleasing lawn margined in the higher part by a well-planted, thriving shrubbery, and on a rising ground a banqueting room which ranks high among the most beautiful edifices I have seen anywhere; it has much elegance, lightness and effect, and commands a fine prospect; the rising ground on which it stands slopes off to an agreeable accompaniment of wood, beyond which, on one side is Dublin harbour, which has the appearance of a noble river, crowded with ships moving to and from the capital. On the other side is a shore spotted with white buildings, and beyond it the hills of Wicklow, presenting an outline extremely various. The other part of the view – it would be more perfect if the city was planted out – is varied, in some parts nothing but wood, in others breaks of prospects. The lawn, which is extensive, is new grass, and appears to be excellently laid down, the herbage a fine crop of white clover (trifolium repens), trefoil, rib-grass (platage lanceolata) and other good plants.

2.20 An apologia for a small capricious house

Horace Walpole's villa at Strawberry Hill near Twickenham was an
epitome of eighteenth-century sensibility, and a remarkable exer-
cise in the Gothic style. In 1784 he published a description of it;
with an inventory of the furniture, pictures, curiosities etc. – the
latter in great detail, and including items such as 'an old brown tea-
pot'. He prefaced the work with the following charming apologia.

It will look, I fear, a little like arrogance in a private Man to give a
printed Description of his Villa and Collection, in which almost
everything is diminutive. It is not, however, intended for public sale,
and originally was meant only to assist those who would visit the
place. A farther view succeeded; that of exhibiting specimens of
Gothic architecture, as collected from standards in cathedrals and
chapel-tombs, and shewing how they may be applied to chimney-
pieces, ceilings, windows, ballustrades, loggias etc. The general
disuse of Gothic architecture, and the decay and alterations so fre-
quently made in churches, give prints a chance of being the sole
preservatives of that style.

Catalogues raisonnés of collections are very frequent in France and
Holland, and it is no high degree of vanity to assume for an existing
collection an illustration that is allowed to many a temporary auc-
tion – an existing collection – even that phrase is void of vanity.
Having lived, unhappily to see the noblest school of painting that
this kingdom beheld transported almost out of the sight of
Europe,[1] it would be a strange fascination, nay, a total insensibility
to the pride of family, and to the moral reflections that wounded
pride frequently feels, to expect that a paper Fabric and an assem-
blage of curious Trifles, made by an insignificant Man, should last,
or be treated with more veneration and respect than the trophies of
a palace deposited in it by one of the best and wisest Ministers that
this country has enjoyed.

Far from such visions of self-love, the following account of pic-
tures and rarities is given with a view to their future dispersion.
The several purchasers will find a history of their purchases; nor do
virtuosos dislike to refer to such a catalogue for an authentic certi-
ficate of their curiosities. The following collection was made out of
the spoils of many renowned cabinets, as Dr Mead's, lady Elizabeth
Germaine's, lord Oxford's, the Duchess of Portland's, and of about

1. Sir Robert Walpole's great collection of pictures was sold in 1777 to Catherine of
Russia.

forty more of celebrity. Such well attested descent is the geneaolo-gy of the objects of virtù – not so noble as those of the peerage, but on a par with those of race-horses. In all three, especially the pedi-gree of peers and rarities, the line is often continued by insignificant names.

The most considerable part of the following catalogue consists of miniature enamels and portraits of remarkable persons. The collec-tion of miniatures and enamels is, I believe, the largest and finest in any country. His Majesty has some very fine; the Duke of Portland more; in no other is to be seen, in any good preservation, any num-ber of the works of Isaac and Peter Oliver. The large pieces by the latter in the Royal Collection, faded long ago by being exposed to the sun and air. M. Henery at Paris and others have many fine pieces by Petitot. In the following list are some most capital works of that master, and of his only rival Zincke. Raphael's missal is an unique work in miniature of that monarch of painting, and the book of Psalms by Julio Clovio the finest examples extent of illu-mination. The drawings and bas-reliefs in wax by Lady Diana Beauclerk are as invaluable as rare.

To an English antiquary must be dear so many historic pictures of our ancient monarchs and royal family; no fewer than four fami-ly pieces of Henry 5th, 6th, 7th and 8th, of Queen Mary Tudor and Charles Brandon; of the duchess of Suffolk and her second hus-band, and that curious and well-painted picture of Charles 2nd and his gardener [*sic*]. Nor will so many works of Holbein be less pre-cious to him, especially Zucchero's drawings from his *Triumph of Riches and Poverty*.

To virtuosos of more classic taste, the small busts of Jupiter Serapis in basaltes, and of Caligula in bronze, and the silver bell of Benvenuto Cellini, will display the art of ancient and modern sculpture – how high it was carried by Greek statuaries appears in the eagle.

To those who have still more taste than appears in meer sight, the catalogue itself will convey satisfaction by containing a copy of madame du Deffand's letter in the name of madame de Sevigné; not written in imitation of that model of letter-writers, but composed of more delicacy of thought and more elegance of expression than perhaps madame de Sevigné herself could have attained. The two ladies ought not to be compared – one was all natural ease and tenderness – the other charms by the graces of the most polished style, which however are less beautiful than the graces of the wit they cloathe.

Upon the whole, some transient pleasure may even hereafter arise to the peruser of this catalogue. To others it may afford another kind of satisfaction, that of criticism. In a house affecting not only obsolete architecture, but pretending to an observance of the *costume* even in the furniture, the mixture of modern portraits and French porcelaine, and Greek and Roman sculpture may seem heterogeneous. In truth I did not mean to make my house so Gothic as to exclude convenience, and modern refinements in luxury. The design of the inside and the outside are strictly ancient, but the decorations are modern, and the mixture may be denominated in some words of Pope 'A Gothic Vatican of Greece and Rome'. Would our ancestors before the reformation of architecture, not have deposited in their gloomy castles antique statues and fine pictures, beautiful vases and ornamental china, if they had possessed them? But I do not mean to defend by argument a small capricious house. It was built to please my own taste, and in some degree to realise my own visions. I have specified what it contains; could I describe the gay but tranquil scene where it stands, and add the beauty of the landscape to the romantic cast of the mansion, it would raise more pleasing sensations than a dry list of curiosities can excite; at least the prospect would recall the good humour of those who might be disposed to condemn the fantastic fabric, and to think it a very proper habitation of, as it were the scene that inspired the author of *The Castle of Otranto*.[2]

2.21 A diversity of styles

The eclectic nature of eighteenth-century architecture in England provoked hostile reactions amongst some.

Is there a portal, colonnade, or dome,
The pride of Naples, or the boast of Rome?
We raise it here in storms of wind and hail,
On the bleak bosom of a sunless vale;
Careless alike of climate, soil and place,
The cast of Nature and the smiles of Grace.
Hence all our stucco'd walls, Mosaic floors,
Palladian windows and Venetian doors.

One might expect a sanctity of style
August and manly in a holy pile,

2. Walpole himself.

And think an architect extremely odd,
To build a playhouse for the Church of God;
Yet half our churches, such the mode that reigns,
Are Roman theatres or Grecian fanes;
Where broad arched windows to the eye convey
The keen diffusion of too strong a day;
Where in the luxury of wanton pride,
Corinthian columns languish side by side,
Clos'd by an altar exquisitely fine,
Loose and lascivious as a Cyprian shrine.

Our farms and seats begin
To match the boasted villas of Pekin
On every hill a spire-crowned temple swells,
Hung round with serpents and a fringe of bells;
Junks and balons on our waters sail,
With each a gilded cock-boat at his tail.
(James Cawthorn. 1756)

The simple and the sublime have lost all influence, almost every-where all is Chinese or Gothic. Every chair in an appartment, the frames of glasses and tables must be Chinese; the walls covered with Chinese paper filled with figures which resemble nothing in God's creation, and which a prudent nation would prohibit for the sake of pregnant women. Nay, so excessive is the love of Chinese architecture become, that at present foxhunters would be sorry to break a leg in pursuing their sport in leaping any gate that was not made in the Eastern taste of little bits of wood standing in all directions.

The Gothic too has its advocates; you see a hundred houses built with porches in that taste, such as are belonging to many chapels; not to mention that rooms are stuccoed in that taste, with all the minute, unmeaning carvings which are found in the Gothic chapels of a thousand years' standing.

(J. Shebbeare, *Letters on the English Nation* 1756)

Judged by numbers, the Gothic taste of architecture must be prefer-red before that of Greece, and the Chinese taste probably before either.

(Lord Kames, *Elements of Criticism*, 1762)

I beg make to an observation of the peculiar fondness for novelty which reigns at present. I mean the affectation of the (improperly

called) Chinese taste. As it consists in mere whim and chimera, without rules or order, it requires no fertility of genius to put in execution; the principals are a good choice of chains and bells, and different colors of paint. As to the serpents, dragons and monkeys, etc. they, like the rest of the beauties, may be cut in paper, and pasted on anywhere, or in any manner. A few laths, nailed across each other, and made black, red, blue, yellow, or any other color, or mixed with any sort of chequer work, or impropriety of ornament, completes the whole. But as this far-fetched fashion has lately been introduced, I am prevailed upon by a friend to give him a place for the following:
'Advertisement. There are now in the press and speedily will be published, "A Treatise on Country Five Barred Gates, Stiles, and Wickets, elegant Pig-styes beautiful Henhouses, and delightful Cowcribs, superb Cart Houses, magnificent Barn Doors, variegated Barn Racks, and admirable Sheep-folds, according to the Turkish and Persian Manner; a work never (till now) attempted. To which are added some designs of Fly-traps, Bees' Palaces, and Emmet Houses in the Muscovite and Arabian Architecture; all adapted to the latitude and genius of England. The whole entirely new and inimitably designed in two parts on forty pewter plates under the immediate inspection of Don Gulielmus De Demi Je ne scai Quoi, Chief Architect to the Grand Signior. Originally printed in the seraglio at Constantinople, and now translated into English by Jemmy Gymp. To be sold (only by Ebenezer Sly) at the Brazen Head near Temple Bar." '
(Robert Morris, *The Architectural Remembrancer*. 1751)

2.22 A Gothic bedchamber 1759

Horace Walpole's Strawberry Hill became the nodal point of the Gothic revival in its early, less scholarly form, dependent, in parts at least, on the extensive use of papier-mâché.

Mr W. has lately made a new Bedchamber (known as the Holbein Chamber), which as it is in the best taste of anything he has yet done, and in your own Gothic way, I must describe it a little. You enter at a peaked door at one end of the room (out of a narrow winding passage, you may be sure) into an Alcove, in which the bed is to stand, formed by a screen of pierced work opening by one large arch in the middle into the rest of the chamber, which is lighted at the other end by by a bow window of three bays, whose tops

are of rich painted glass in mosaic. The ceiling is coved and fretted in star and quatrefoil compartments, with roses at the intersections, all in papier-mâché. The chimney on your left is the High Altar in the cathedral at Rouen (from whence the screen is also taken) consisting of a low sur-based Arch between two Octogon towers, whose pinnacles almost reach the ceiling, all of rich work. The Chairs and dressing table are real carved ebony, picked up at auctions, the hangings uniform purple paper, hung all over the court of Henry ye 8th copied after the Holbein's in the Queen's Closet at Kensington, in black and gold frames. The bed is either to be from Burleigh (for Lord Exeter is new furnishing it, and means to sell some of his old household stuff) of the rich old tarnished embroidery; or if that is not to be had, and it must be new, it is to be a cut velvet with a dark purple pattern in a stone-colour satin ground, and deep mixt fringes and tassels.

(Thomas Gray to Dr Warton: *Letters* op. cit.)

2.23 Hogarth on architecture

The vigour and independence of Hogarth's thoughts about art and design as expressed in his *The Analysis of Beauty; written with a view of fixing the fluctuating ideas of Taste* (1753) are particularly apparent in the less familiar comments on architecture which appear in the section 'Of Parts', and which both forecast many later ideas, and define English stylistic characteristics very aptly.

Hitherto with regard to composition, little else but forms made up of straight and curved lines have been spoken of, and though these lines have but little variety in themselves, yet by reason of the great diversification that they are capable of in being joined with one another, great variety of beauty of the more useful sort is produced by them, as in necessary utensils and building. But in my opinion, buildings, as I before hinted, might be much more varied than they are, for after *fitness* hath been strictly and mechanically complied with, any additional ornamental members or parts may, by the foregoing rules, be varied with equal elegance; nor can I help thinking but that churches, palaces, hospitals, prisons, common houses and summer houses might be built more in distinct characters than they are by contriving orders suitable to each, whereas were a modern architect to build a palace in Lapland or the West Indies, Palladio must be his guide, nor would be dare to stir a step without his book.

Have not many Gothic buildings a great deal of consistent beauty in them? Perhaps acquired by a series of improvements made from time to time by the natural persuasion of the eye, which often very near answers the end of working by principles, and sometimes begets them. There is at present such a thirst after variety, that even paltry imitations of Chinese buildings have a kind of vogue, chiefly on account of their novelty; but not only these, but any other new-invented characters of buildings might be regulated by proper principles. The mere ornaments of buildings, to be sure, at least might be allowed a greater latitude than they are at present, as capitals, friezes & c. in order to increase the beauty of variety.

Nature in shells, flowers & c. affords an infinite choice of elegant hints for this purpose; as the original of the Corinthian capital was taken from nothing more, as is said, than some dock leaves growing up against a basket. Even a capital composed of the awkward and confined forms of hats and periwigs in a skilful hand might be made to have some beauty.

However, though the moderns have not made many additions to the art of building, with respect to mere beauty or ornament, yet, it must be confessed, they have carried simplicity, convenience, and neatness of workmanship to a very great degree of perfection, particularly in England, where plain good sense hath preferred those more necessary parts of beauty, which everybody can understand, to that richness of taste which is so much to be seen in other countries, and so often substituted in their room.

St Paul's cathedral is one of the noblest instances than can be produced of the most judicious application of every principle that hath been spoken of. There you may see the utmost variety without confusion, simplicity without nakedness, richness without tawdriness, distinctness without hardness, and quantity without excess. Whence the eye is entertained throughout with the charming variety of all its parts together; the noble projecting quantity of a number of them, which presents bold and distinct parts at a distance, when the lesser parts within them disappear; and the grand few, but remarkable well-varied parts that continue to please the eye as long as the object is discernible, are evident proofs of the superior skill of Sir Christopher Wren, so justly esteemed the prince of architects.

It will scarcely admit of a dispute, that the outside of this building is much more perfect than that of St Peter's at Rome; but the inside, though as fine and noble as the space it stands on, and our religion will allow of, must give way to the splendour, shew and magnificence of that of St Peter's, on account of the sculpture and

paintings, as well as the greater magnitude of the whole, which makes it excel as to quantity.

There are many other churches of great beauty, the work of the same architect, which are hid in the heart of the city, whose steeples and spires are raised higher than ordinary, that they may be seen at a distance above the other building; and the great number of them dispersed about the whole city, adorn the prospect of it, and give it an air of opulence and magnificence; on which account their shapes will be found to be particularly beautiful. Of these, and perhaps of any in Europe, St Mary-le-Bow is the most elegantly varied. St Bride's in Fleet Street diminishes sweetly by elegant degrees, but its variations, though very curious when you are near them, not being quite so bold and distinct as those of Bow, it soon loses variety at a distance. Some Gothic spires are finely and artfully varied, particularly the famous steeple of Strasburg.

Westminster Abbey is a good contrast to St Paul's, with regard to its simplicity and distinctness; the great number of its filigreen ornaments, and small divided and sub-divided parts appear confused when nigh, and are totally lost at a moderate distance; yet there is nevertheless such a consistency of parts altogether in good Gothic taste, and such propriety relative to the gloomy ideas they were then calculated to convey, that they have at length acquired an established and distinct character in building. It would be looked upon as an impropriety and as a kind of profanation to build places for mirth and entertainment in the same taste.

3. The rule of taste

The idea of taste as a dominant element in art; connoisseurs, collectors, and the Grand Tour.

3.1 Taste a peculiar relish

Shaftesbury's concept of taste as a kind of civic virtue became widely accepted, and its universal application to life was spelt out to readers of the *Weekly Register* for 6 February 1731.

Taste is a peculiar relish for an agreeable object, by judiciously distinguishing its beauties; is founded on truth, or veri-similitudae at least, and is acquired by toil and study, which is the reason so few are possessed of it. Nothing is so common as the affectation of, not anything so seldom found as Taste. Bad principles of education, an ill choice of acquaintance, the ignorance of instructors, and our own prejudices, all contribute to the confirmation of this evil. So much depends on a true Taste, with regard to eloquence, and even morality, that no one can be properly stil'd a gentleman, who does not take every opportunity to enrich his own capacity, and settle the elements of taste, which he may improve at leisure. It heightens every science, and is the polish of every virtue; the friend of society and the guide to knowledge; 'tis the improvement of pleasure, and the test of merit; it enlarges the circle of enjoyment, and refines upon happiness; it distinguishes beauty, and detects error; it obliges us to behave with decency and elegance, and quickens our attention to the good qualities of others; in a word 'tis the assemblage of all propriety, and the centre of all that's amiable.

Truth and beauty include all excellence, and with their opposites are the objects of censure and admiration. The rightly distinguishing them is the proof of a good Taste; to acquire which we must be impartial in our enquiry, cool in our judgement, quick to apprehend, and ready to determine what is an error, and what a beauty.

A good Taste is not confined only to writings, but extends to paintings and sculpture, comprehends the whole circle of civility and good manners, and regulates life and conduct as well as theory and speculation.

3.2 Pope on taste

On 4 April 1731 Alexander Pope, himself an accomplished amateur painter, and the friend of several artists, wrote to Lord Burlington (cf. 2.7), 3rd Earl of Burlington the following letter.

Twickenham Ap. 4th

My Lord,

I send you the enclosed with great pleasure to myself. It has been on my conscience to leave some Testimony of my Esteem for yr. Lordship among my Writings. I wish it were worthier of you. As to ye Thought which was just suggested when last I saw you, of its attending ye Book, I would have yr. Ldship think further of it; and upon a considerate perusal, if you still think so, the few Words I've added in this paper may perhaps serve two ends at once, and ease you too in another respect. In short 'tis all submitted to yr. own best Judgement. Do with it, and me, as you will. Only I beg yr. Lordship will not show the thing in Manuscript, till ye proper time; It may yet receive Improvement, and will to the last day it's in my power. Some lines are added towd. ye end on ye Common Enemy, the Bad Imitators and Pretenders, wch. perhaps are properer there, than in your own mouth.

My Ld.

Your most obedt. and affectionate servant, A. Pope.

(*Treasures from Chatsworth*. Arts Council 1980)

> The enclosure is Pope's famous poem on taste in which he expressed the views which Burlington was doing so much to inculcate, that building, gardening and connoisseurship itself should be guided by a sense of order and decorum, in contradiction to what both poet and peer saw as the wilder extravagances of the earlier period and the stylistic inaccuracies of the present. Burlington had already published one book on Palladio's designs of ancient Rome, and the work to which the poet refers was a succeeding – but never published – work. The theme Pope emphasized was that of restraint and functionalism.

You show us Rome was glorious, not profuse,
And pompous once were things of use;
Yet shall, my lord, your just, your noble rules
Fill half the land with imitating fools,
Who random drawings from your sheets shall take,
And of one beauty many blunders make;
Load some vain church with old theatric state,
Turn arcs of triumph to a garden gate;

Reverse your ornaments, and hang them all
On some patched doghole eked with ends of wall;
Then clap four slices of pilaster on't,
That laced with bits of rustic makes a font;
Shall call the winds through long arcades to roar,
Proud to catch cold at a Venetian door,
Conscious they act a true Palladian part,
And if they starve, they starve by rules of art.

 Oft have you hinted to your brother peer
A certain truth which many buy too dear;
Something there is more needful than expense,
And something previous e'en to taste – 'tis sense;
Good sense which is the only gift of Heaven,
And, though no science, fairly worth the seven;
A light which in yourself you must perceive;
Jones and Le Nôtre have it not to give.

 To build, to plant, whatever you intend,
To rear the column, or the arch to bend,
To swell the terrace, or to sink the grot,
In all let nature never be forgot;
But treat the goddess like a modest fair,
Nor overdress, nor leave her wholly bare;
Let not each beauty everywhere be spied,
Where half the skill is decently to hide.
He gains all points who pleasingly confounds,
Surprises, varies and conceals the bounds.

 Consult the genius of the place in all,
That tells the waters or to rise or fall;
Or helps the ambitious hill the heavens to scale,
Or scoops in circling theatres the vale;
Calls in the country, catches opening glades,
Joins willing woods, and varies shades from shades;
Now breaks or now directs, the intending lines,
Paints as you plant, and as you work designs.
(*Moral Essays*, Epistle iv)

3.3 The nature of taste

The notion that taste was an absolute by which men could measure themselves against their fellows and assess their own achievements, had been emerging as a social and creative theory. It was to be

variously interpreted by writers and philosophers. The three following interpretations written between 1757 and 1776 are fairly representative.

Every work of art has also a certain end or purpose, for which it is calculated; and it is to be deemed more or less perfect, as it is more or less fitted to attain this end. The object of eloquence is to persuade, of history to instruct, of poetry to please, by means of the passions and the imagination. These ends we must carry constantly in view when we peruse any performance; and we must be able to judge how far the means employed are adapted to their respective purposes. Besides, every kind of composition, even the most poetical, is nothing but a chain of propositions and reasonings; not always, indeed, the justest and most exact, but still plausible and specious, however disguised by the colouring of the imagination. . . .

Thus, though the principles of taste be universal, and nearly, if not entirely, the same in all men; yet few are qualified to give judgement on any work of art, or establish their own sentiment as the standard of beauty. The organs of internal sensation are seldom so perfect as to allow the general principles their full play, and produce a feeling correspondent to those principles. They either labour under some defect, or are vitiated by some disorder; and by that means excite a sentiment, which may be pronounced erroneous. When the critic has no delicacy, he judges without any distinction, and is only affected by the grosser and more palpable qualities of the object; the finer touches pass unnoticed and disregarded. Where he is not aided by practice, his verdict is attended with confusion and hesitation. Where no comparison has been employed, the most frivolous beauties, such as rather merit the name of defects, are the object of his admiration. Where he lies under the influence of prejudice, all his natural sentiments are perverted. Where good sense is wanting, he is not qualified to discern the beauties of design and reasoning, which are the highest and most excellent. Under some or other of these imperfections the generality of men labour; and hence a true judge in the finer arts, even during the most polished ages, is observed to be so rare a character; strong sense, united to delicate sentiment, improved by practice, perfected by comparison, and cleared of all prejudice, can alone entitle critics of this valuable character, and the joint verdict of such, wherever they are to be found, is the true standard of taste and beauty. But where are such critics to be found? By what marks are they to be known? How distinguish them from pretenders? The questions are embarrassing and seem to throw us back into the same uncertainty from which, in the

course of this essay we have been trying to extricate ourselves.

But, in reality, the difficulty of finding, even in particulars, the standard of taste, is not as great as it is represented, though in speculation we may readily avow a certain criterion in science, and deny it in sentiment, the matter is found in practice to be much harder to ascertain in the former case than in the latter. Theories of abstract philosophy, systems of profound theology, have prevailed during one age; in a successive period these have been universally exploded; the absurdity has been detected; other theories and systems have supplied their place which again gave way to their successors, and nothing has been experienced more liable to the revolutions of chance and fashion than those pretended decisions of science. The case is not the same with the beauties of eloquence and poetry. Just expressions of passion and nature are sure, after a little time, to gain public applause, which they maintain for ever.... But notwithstanding all our endeavours to fix a standard of taste, and reconcile the discordant apprehensions of man, there still remain two sources of variation, which are not sufficient indeed to confound all the boundaries of beauty and deformity, but will often serve to produce a difference in the degrees of our approbation or blame. The one is the different humours of particular men; the other, the particular manners and opinions of our age and country. The general principles of taste are uniform in human nature; where men vary in their judgements some defect or perversion in the faculties may commonly be remarked, from want of practice, or want of delicacy; and there is just reason for approving one taste and condemning another. But where there is such a diversity in the internal frame or external situation as is entirely blameless on both sides, and leaves no room to give one the preference above the other; in that case a certain diversity of judgement is unavoidable, and we seek in vain for a standard by which we can reconcile the contrary sentiments.

(David Hume, *Four Dissertations*. 1757)

I mean by the word Taste no more than that faculty, or those faculties, of the mind which are affected with, or which form a judgement of the works of imagination and the elegant arts. This is, I think, the most general idea of that word, and what is the least connected with any particular theory. And, my point in this inquiry is to find whether there are any principles, on which the imagination is affected, so common to all, so grounded and certain, as to supply the means of reasoning satisfactorily about them. And such princi-

ples of Taste, I fancy there are; however paradoxical it may seem to those who on a superficial view imagine that there is so great a diversity of Tastes, both in kind and in degree, that nothing can be more indeterminate.

All the natural powers in man, which I know, that are conversant about external objects are the Senses, the Imagination, and the Judgement. And first with regard to the senses. We do, and we must, suppose that as the confirmation of their organs are nearly, or altogether the same in all men, so the manner of perceiving external objects is in all men the same, or with little difference. We are satisfied that what appears light to one eye, appears light to another; that what is dark and bitter to this man, is dark and bitter to that; that what seems sweet to one palate, is sweet to another; and we conclude in the same manner of great and little, hard and soft, hot and cold, rough and smooth; and indeed of all the natural qualities and affections of bodies. If we suffer ourselves to imagine that their senses present to different men different images of things, this sceptical proceeding will make every sort of reasoning on every subject vain and frivolous, even that of sceptical reasoning itself, which has persuaded us to entertain a doubt concerning the agreement of our perceptions. But as there will be very little doubt that bodies present similar images to the whole species, it must necessarily be allowed that the pleasures and the pains which every object excites in one man, it must raise in all mankind, whilst it operates naturally, simply, and by its proper powers only; for if we deny this, we must imagine that the same cause operating in the same manner, and on subjects of the same kind, will produce different effects, which would be highly absurd. . . . The cause of a wrong Taste is a defect of judgement. And this may arise from a natural weakness of understanding (in whatever the strength of that faculty may consist) or, which is more commonly the case, it may arise from a want of proper and well-directed exercise, which alone can make it strong and ready. Besides that, ignorance, inattention, prejudice, rashness, levity, obstinancy, in short all those vices which pervert the judgement in other matters, prejudice it no less in this, its more refined and elegant province. These causes produce different opinions upon everything which is an object of the understanding, without inducing us to suppose that there are no settled principles of reason. And indeed, on the whole, one may observe that there is rather less difference upon matters of Taste among mankind, than upon those which depend on the naked reason.

(Edmund Burke, *On Taste: A Philosophical Enquiry into the Origin of Our Ideas of the Sublime and the Beautiful.* 1756)

I shall now say something on that part of *taste*, which, as I have hinted to you before, does not so much belong to the external frame of things, but is addressed to the mind, and depends on its original frame, or to use the expression, the organization of the soul; I mean the imagination and the passions. The principles of these are as invariable as the former, and are to be known and reasoned upon in the same manner by an appeal to common sense, deciding upon the common feelings of mankind. This sense and these feelings appear to me of equal authority, and equally conclusive. Now this appeal implies a general uniformity and agreement in the minds of men. It would be else an idle and vain endeavour to establish rules of art; it would be pursuing a phantom to attempt to move affections with which we were entirely unacquainted. We have no reason to suspect there is a greater difference between our minds than between our forms, of which, though there are no two alike, yet there is a general similitude, that goes through the whole race of mankind. This sense, and these feelings appear to me of equal authority and equally conclusive. Now this appeal implies a general uniformity and agreement in the minds of men. It would be else an idle and vain endeavour to establish rules of art; it would be pursuing a phantom to attempt to move affections with which we were entirely unacquainted. We have no reason to suspect there is a greater difference between our minds than between our forms, and those who have cultivated their taste can distinguish what is beautiful or deformed, or in other words what agrees with or deviates from the general idea of nature of nature in one case as well as in the other . . .

Whoever would reform a nation, supposing a bad taste to prevail in it, will not accomplish his purpose by going directly against the stream of their prejudices. Men's minds must be prepared to receive what is new to them. Reformation is a work of time. A national taste, however wrong it may be, cannot totally be changed at once; we must yield a little to the prepossession which has taken hold on the mind, and we may then bring people to adopt what would offend them, if endeavoured to be introduced by violence. When Battista Franco was employed, in conjunction with Titian, Veronese and Tintoretto, to adorn the library of St Mark, his work, Vasari says, gave less satisfaction than any of the others; the dry manner of the Roman School was very ill calculated to please eyes that had been accustomed to the luxuriancy, splendour and richness of Venetian colouring. Had the Romans been the judges of this work, probably the determination would have been just contrary, for in the more noble parts of his art, Battista Franco was perhaps not inferior to any of his rivals.

Gentlemen,

It has been the main scope and principal end of this discourse to demonstrate the reality of a standard in Taste, as well as in corporeal beauty; that a false or depraved taste is a thing as well known, as easily discovered, as anything that is deformed, mis-shapen, or wrong in our form or outward make, and that this knowledge is derived from the uniformity of sentiments among mankind, from whence proceeds the knowledge of what are the general habits of nature; the result of which is an idea of perfect beauty.

If what has been advanced be true, that besides this beauty of truth, which is formed on the uniform, eternal and immutable laws of nature, and which of necessity can be but *one*; that besides this one immutable verity there are likewise what we have called apparent or secondary truths, proceeding from local and temporary prejudices, fancies, fashions, or accidental connexion of ideas; if it appears that these last have still their foundation in the original fabrick of our minds, it follows that all these truths or beauties deserve and require the attention of the artist in proportion to their stability or duration, or as their influence is more or less extensive.

> (Sir Joshua Reynolds, from *Discourse Seven* delivered to the students of the Royal Academy, 10 December 1776).

3.4 Taste as a source of virtue and profit

In 1715 Jonathan Richardson published his *A Discourse on the Dignity Certainty, Pleasure and Advantage of the Science of a Connoisseur* in which he expressed views about the necessity for improving a knowledge of the arts, which were to gain momentum as the century progressed, and which were to be basic to much thinking on the subject.

If gentlemen were lovers of painting, and connoisseurs, this would help to reform themselves, as their example and influence would have the like effect on the common people. All animated beings naturally covet pleasure, and eagerly pursue it as their chief good; the great affair is to chose those that are worthy of rational beings, such as are not only innocent, but noble and excellent. Men of easy and plentiful fortunes have commonly a great part of their time at their own disposal, and the want of knowing how to pass those hours away, in virtuous amusements, contributes perhaps as much to the mischievous effects of vice, as covetousness, pride, lust, love of wine, or any other passion whatsoever. If gentlemen therefore found pleasure in pictures, drawings, prints, statues, in-

taglias, and the like curious works of art; in discovering their beauties and defects; in making proper observations thereupon, and in all the other parts of a connoisseur, how many hours of leisure would here be profitably employed, instead of what is criminal, mischievios and scandalous! I confess I cannot speak experimentally, because I have not tried those; nor can any man pronounce upon the pleasures of another; but I know what I am recommending is so great a one that I cannot conceive the other can be equal to it, especially if the drawbacks of fear, remorse, shame, expence & c to be taken into the account.

Second, our common people have been exceedingly improved, within an age or two by being taught to read and write; they have also made great advances in mechanicks, and in several other arts and sciences; and our gentry and clergy are more learned, and better reasoners than in times past; a further improvement might yet be made, and particularly in the arts of design: If, as children are taught other things, they together with these, learned to draw, they would not only be qualified to become better painters, carvers and engravers, and to attain the like arts immediately and evidently depending on design, but they would thus become better mechanicks of all kinds.

And if to learn to draw, and to understand paintings and drawings were made a part of the education of a gentleman, as their example would excite others to do the like, it cannot be denied but that this would be a further improvement, even of this part of our people; the whole nation would, by these means be removed some degrees higher into the rational state, and make a more considerable figure amongst the polite nations of the world.

Third, if gentlemen were lovers of painting, and connoisseurs, as of course, they would soon be, many sums of money which are now consumed in luxury, would be laid up in pictures, drawings and antiques, which would be, not as plate or jewels, but a really improving estate; since, as time and accidents must continually waste and diminish the number of these curiosities, and no new supply (equal in goodness to those we have) is to be hoped for, as the appearance of things at present are, the value of such as are preserved with care must necessarily increase more and more, especially if there is a greater demand for them, as there certainly will be if the taste of gentlemen takes this turn; Nay, it is not improbable that money laid out this way, with judgement and prudence (and if gentlemen are connoisseurs, they will not be imposed on, as they too often are) may turn to better account than almost any other.

We know the advantages Italy receives from her possession of so many curious works of art, fine pictures and statues; If our country become famous in that way, as her riches will enable her to be, if our nobility and gentry are lovers and connoisseurs, we shall share with Italy in the profits arising from the concourse of foreigners for the pleasure and improvement that is to be had from the seeing and considering such rarities.

If our people were improved in the arts of designing, not only our paintings, carvings and prints, but the work of all other artificers would also be proportionately improved, and consequently coveted by other nations, and their price advanced, which therefore would be no small improvement of our trade, and with that of our wealth.

I have observed heretofore, that there is no artist whatsoever that produces a piece of work of a value so vastly above that of the materials of nature's furnishing as the painter does; nor any consequently that can enrich a country in any degree like him; Now if painting were only considered as upon the level of other manufactures, the employment of more hands, and the work being better done, would certainly tend to the increase of our wealth, but this consideration over and above adds a great weight to the argument in favour of the art as a means to this end.

Instead of importing vast quantities of pictures and the like curiosities for ordinary use, we might fetch from abroad only the best, and supply other nations with better than we now commonly take off their hands; For as much a superfluity as these things are thought to be, they are such as nobody will be without; not the meanest cottager in the kingdom, that is not in the extremest poverty, but will have something of picture in his sight. The same is the custom in other nations, in some to a greater, and in others to a less degree. These ornaments people will have as well as what is absolutely necessary to life, and as sure a demand will be for them as for food and cloaths, as it is in some other instances, which had thought at first to be equally superfluous, but which are now become considerable branches of trade, and consequently of great advantage to the public.

Thus a thing, as yet unheard of, and whose very name, to our dishonour, has at present an uncouth sound, may come to be eminent in the world, I mean the English school of painting, and whenever this happens, who knows to what heights it may rise; for the English nation is not accustomed to doing things by halves.

3.5 Thoughts of a man of taste

Poet, gardener, writer, man of taste, William Shenstone was the very epitome of English eighteenth-century middle-class culture. The garden he designed at his home The Leasowes in Shropshire became virtually a place of pilgrimage. His *Works in Verse and Prose* published in 1764 contained numerous aphorisms and 'maxims' which reflect the kind of pragmatic aesthetics evolved by 'the rule of taste'.

I wonder that lead statues are not more in vogue in our modern gardens. Though they may not express the finer lines of the human body, yet they seem perfectly well calculated, on account of their duration, to embellish landskips, were they some degrees inferior to what we behold. A statue in a room challenges examination, and is to be examined critically as a statue. A statue in a garden is to be considered as one part of a scene or landskip; the minuter touches are no more essential to it, than a good landskip painter would esteem them were he to represent a statue in his picture.

It is always to be remembered in gardening that sublimity or magnificence, and beauty or variety, are very different things. Every scene we see in nature is either tame and insipid, or compounded of those. It often happens that the same ground may receive from art, either certain degrees of sublimity and magnificience, or certain degrees of variety and beauty, or a mixture of each kind. In this case, it remains to be considered in which light they can be rendered most remarkable, whether as objects of beauty, or magnificence. Even the temper of the proprietor should not perhaps be wholly disregarded; for certain complexions of soul will prefer an orange tree or a myrtle to an oak or a cedar. However, this should not induce a gardener to parcel out a lawn into knots of shrubbery, or invest a mountain with a garb of roses. This would be like dressing a giant in a sarsenet gown, or a Saracen's head in a Brussels night-cap. Indeed the small and circular clumps of firs, which I see planted upon some fine large swells put me often in mind of a coronet placed upon an elephant's or camel's back. I say a gardener should not do this, any more than a poet should attempt to write of the King of Prussia in the style of Philips. On the other side, what should become of Lesbia's sparrow – should it be treated in the same language with the anger of Achilles?

There is a kind of counter-taste, founded upon surprise or curiosity, which maintains a sort of rivalship with the true, and may be expressed by the name *Concetto*. Such is the fondness of

some persons for a knife-haft made from the royal-oak, or a tobac-co-stopper from a mulberry tree of Shakespeare's own planting. It gratifies an empty curiosity. Such is the natural appearance of Apollo and the nine Muses in a piece of Agate; a dog expressed in feathers, or a wood cock in mohair. They serve to give surprise. But a just fancy will no more esteem a picture because it proves to be produced by shells, than a writer would prefer a pen because a person made it with his toes. In all such cases difficulty should not be given a casting weight, nor a needle be considered a painter's instrument when he is so much better furnished with a pencil.

What an absurdity it is in the framing, even prints, to suffer a margin of white paper to appear beyond the ground; destroying half the relievo the lights are intended to produce? Frames ought to contrast with paintings, or to appear as distinct as possible; for which reasons frames of wood inlaid, or otherwise variegated with colours are less suitable than gilt ones, which, exhibiting an appearance of metal accord the best contrasts with colour.

The passion for antiquity, as such, seems in some measure opposite to the taste for beauty or perfection. It is rather the foible of a lazy and pusillanimous disposition, looking back and resting with pleasure on the steps by which we have arrived thus far, than the bold and enterprising spirit of a genius whose ambition fires him only to reach goal.

3.6 Foretastes of functionalism

Amongst aesthetic theories which tended to the consideration of abstract principles, a certain practical approach, almost forecasting the ideas of functionalism, was occasionally to be found.

Most kinds of beauty are derived from sympathy. A man who shows us any house or building, takes particular care, amongst other things, to point out the convenience of the apartments, the advantages of their situation, and indeed it is evident the chief part of the beauty consists in these particulars. This observation extends to tables, chairs etc. Mr Philips has chose *Cider* for the subject of an excellent poem. Beer would not have been so proper, as being neither so agreeable to the taste or eye. But he would certainly have preferred wine to either of them, could his native country have afforded him so agreeable a liquor. It is evident that nothing renders a field so agreeable as its fertility, and that scarce any advantages of ornament or situation will be able to equal this beauty. I know not

but a plain overgrown with furze and broom, may be, in itself, as beautiful as a hill covered with vines or olive trees, though it will never appear so to one who is acquainted with the value of each. In painting a figure which is not justly balanced is disgraceful; the principal part of personal beauty is an air of health and vigour, and such a construction of members as promises strength and activity. The mere view and contemplation of any greatness enlarges the soul, and gives it a sensible delight and pleasure. A wide plain, the ocean, eternity, a succession of several ages; all these are entertaining objects, and excel anything however beautiful, which accompanies not its beauty with a suitable greatness. It is a quality very observable in human nature, that any opposition which does not entirely discourage and intimidate us, has rather a contrary effect, and inspires us with a more than ordinary grandeur and magnanimity. In collecting our force to overcome the opposition, we invigorate the soul and give it an elevation with which otherwise it would not have been acquainted.

(Hume, *Treatise on Human Nature II.* 1739).

3.7 On intricacy in form

The fact that Hogarth was a shrewd self-publicist, and the perhaps excessive importance he attributed to 'the serpentine line' in his *The Analysis of Beauty* (1753) should not be allowed to diminish the importance and originality of his ideas about art and design – which he saw in a refreshingly united way – many of them anticipating later theories. In the chapter on intricacy, he reveals the vigour of his style and the inventiveness of his thought.

The active mind is ever bent to be employed. Pursuing is the business of our lives, and even abstracted from any other view gives pleasure. Every arising difficulty, that for a while attends and interrupts the pursuit, gives a sort of spring to the mind, enhances the pleasure, and makes what else would be a toil and labour become sport and recreation.

Wherein would consist the joys of hunting, shooting, fishing and many other favourite diversions, without the frequent turns and difficulties and disappointments that are daily met with in the pursuit? How joyless does the sportsman return when the hare has not had fair play! how lively and in spirits, even when an old cunning one has baffled and out-run the dogs!

This love of pursuit, merely as pursuit, is implanted in our na-

tures, and designed, no doubt, for necessary and useful purposes. Animals have it evidently by instinct. The hound dislikes the game he so ardently pursues, and even cats will risk the losing of their prey to chase it over again. It is a pleasing labour of the mind to solve the most difficult problems; allegories and riddles, trifling as they are, afford the mind amusement, and with what delight does it follow the well-connected thread of a play or novel, which ever increases as the plot thickens, and ends most pleased when that is distinctly unravelled.

The eye hath this sort of enjoyment in winding walks and serpentine rivers, and all sorts of objects, whose forms are composed principally of what I call the *waving* and *serpentine* lines.

Intricacy in form therefore I shall define to be that peculiarity in the lines which compose it, that *leads the eye a wanton kind of chase*, and from the pleasure that gives the mind entitles it to the name of beautiful; and it may justly be said that the cause of the idea of grace more immediately resides in this principle than in the other five, except variety,[1] which indeed includes this and all the others.

That this observation may appear to have a real foundation in nature, every help will be required which the reader himself can call to his assistance, as well as what will here be suggested to him.

To set this matter in somewhat a clearer light, the familiar instance of a common jack with a circular fly may serve our purpose better than an elegant form, preparatory to which imagine the eye, at a common reading distance, viewing a row of letters, but fixed with most attention to the middle one which is A.

Now as we read a ray may be supposed to be drawn from the centre of the eye to that letter it looks at first, and to move successively with it from letter to letter, the whole length of the line. But if the eye stops at a particular letter, A, to observe it more than the rest, these other letters will grow more and more imprefect to the sight, the further they are situated on either side of A, and when we endeavour to see all the letters in the line equally perfectly at one view as it were, this imaginary ray must course it to and fro with great celerity. Thus, though the eye, strictly speaking can only pay due attention to these letters in succession, yet the amazing ease and swiftness, with which it performs this task enables us to see considerable spaces with sufficient satisfaction at one sudden view.

Hence, we shall always suppose some principal ray moving

1. The principles which Hogarth had described were, fitness, variety, regularity, simplicity, quantity and lines.

along with the eye, and tracing out the parts of every form, we mean to examine, in the most perfect manner, and when we would follow with exactness the course anybody takes that is in motion, this ray is always supposed to move with the body.

In this manner of attending to forms, they will be found whether *at rest* or in motion, to vie movement to this imaginary ray, or, more properly speaking, to the eye itself, affecting it *thereby* more or less pleasingly according to their different *shapes* and *motions*. Thus, for example, in the instance of the jack, whether the eye (with this imaginary ray) moves slowly down the line to which the weight is fixed, or attends to the slow motion of the weight itself, the mind is equally fatigued, and whether it swiftly courses round the circular rim of the flyer, when the jack stands, or nimbly follows one point in its circularity whilst it is swirling about, we are almost equally made giddy by it. But our sensation differs much from either of these unpleasant ones, when we observe the curling worm, into which the worm-wheel is fixed, for this is always pleasing either at rest or in motion, and whether that motion is slow or quick.

That it is accounted so when it is *at rest*, appears by the ribbon twisted round a stick, which has long been an established ornament in the carving of frames, chimney-pieces, and door cases, and called by carvers the stick and ribbon ornament, and when the stick through the middle is omitted, it is called *the ribbon edge*; both to be seen in almost every house of fashion.

But the pleasure it gives the eye is still more lively in *motion*. I never can forget my frequent strong attention to it, when I was very young, and that its beguiling movement gave me the same kind of sensation then, which I have since felt at seeing a country-dance, though perhaps the latter might be somewhat more engaging, particularly when my eye pursued a favourite dancer, through all the windings of the figure, who was then bewitching to the sight, as the imaginary ray we were speaking of, was dancing with her all the time.

This single example might be sufficient to explain what I mean by *the beauty of a composed intricacy of form*, and how it may be said with propriety to lead the eye a kind of *chase*.

But the hair of the head is another very obvious instance, which being designed chiefly as an ornament, proves more or less so, according to the form it naturally takes, or is put into by art. The most amiable in itself is the flowing curl, and the many waving and contrasting turns of naturally intermingling locks ravish the eye

with the pleasure of the pursuit, especially when they are put into motion by a gentle breeze. The poet knows it as well as the painter, and has described the wanton ringlets waving in the wind.

And yet to shew how excess ought to be avoided in intricacy, as well as in every other principle, the very same head of hair wisped and matted together would make the most disagreeable figure, because the eye would be perplexed, and at a fault, and unable to trace such a confused number of uncomposed and entangled lines, and yet notwithstanding this, the present fashion the ladies have gone into of wearing a part of the hair of their heads braided together from behind like inter-twisted serpents, arising thickets from the bottom, lessening as it is brought forward, and naturally conforming to the shape of the rest of the hair it is pinned over, is extremely picturesque. Their thus interlacing the hair in varied quantities is an artful way of preserving as much of intricacy as is beautiful.

3.8 Distaste for taste

If, on the one hand, the activities of men such as Burlington had created the concept of taste as a form of self-improvement both intellectual and social, there were countless others prepared, for chauvinistic, political or personal interests to deride it. Throughout the century a constant flow of satire was directed against the notion of taste or virtu.

> Blest age, when all men may procure
> The title of a connoisseur;
> When noble and ignoble herd
> Are governed by a single word;
> Though like the royal German dames,
> It bears a hundred Christian names;
> As Genius, Fancy, Judgement, Gout,
> Whim, Caprice, Je-ne-scais-quoi, Virtu,
> Which appellations all describe
> TASTE, and the modern tasteful tribe
> (Robert Lloyd, *The Cit's Country Box*. 1759: cf. Francis
> Grose, *The Olio*, pp. 54–7)

Hogarth's *Time smoking a picture* was a theme which kept recurring, and it was natural that connoisseurs should be pilloried in association with the ever-increasing tribe of dealers, whose numbers multiplied as the century wore on. The following is an extract from an essay, attributed to the artist, which appeared in the *London Magazine* in 1737.

The picture-jobbers from abroad are always ready to raise a cry in the public prints, whenever they think their craft is in danger; and indeed it is their interest to depreciate every English work as hurtful to their trade of importing, by ship-loads, Dead Christs, Holy Families, Madonnas and other dark, dismal subjects, on which they scrawl the names of Italian masters, and fix on us poor Englishmen the character of universal dupes. If a gentleman with some judgement casts his eye on one of those pictures, and expresses doubt as to its perfection or originality, the quack answers, 'Sir, you are no connoisseur; the picture is, I assure you, in Alesso Baldminetto's second and best manner, boldly painted, and truly sublime; the contour gracious; the air of the head in the high Greek taste, and a most divine idea it is.' Then spitting in an obscure place, and rubbing it with his handkerchief, takes a skip to t'other side of the room, and screams out in raptures, 'There's an amazing touch! A man should have this picture a twelve month before he can discover all its beauties!' The gentleman, though possessed of judgement, ashamed to be out of fashion by judging for himself, is struck dumb by this cant, gives a vast sum for the pictures, very modestly confesses that he is, indeed, quite ignorant of painting, and bestows upon a frightful picture with a hard name, without which it would not be worth a farthing, a frame worth fifty pounds.

The following sketch in the *Ladies Miscellany* of 1770 features Sir Samuel Sapskull, a rich city knight, and Mr Pallet a dealer-cum-connoisseur.

Sir Samuel Well, Mr Pallet, what curious little picture have you got in your hand?

Mr Pallet A curiosity, indeed, Sir Samuel. It is a landscape by Verdipratti; an original, and very scarce. There is not above three of them in England.

Sir Samuel And pray, sir, what is the purchase of it?

Mr Pallet A hundred guineas, Sir Samuel.

Sir Samuel Why 'tis as black as ink.

Mr Pallet That's a proof of its age, Sir Samuel. 'Tis a prodigious advantage of pictures, they are mellow'd by time, Sir Samuel.

Sir Samuel I don't know what you mean by mellowed, but I am sure I never saw trees of such a colour you won't tell me, I hope, they are green trees? There's Tom Brusher will touch up a picture for a quarter of the money, as bright as noonday, that will dazzle your eyes to look at it. I hate those black trees.

79

Mr Pallet I am sorry to hear you say so, because your taste will be universally condemn'd. Your neighbour, Sir Solomon, gave more money for another, by the same hand, not half so black. A Verdipratto, Sir Samuel, is not to be met with every day.

Sir Samuel Ha, ha – say you so, why then . . you may leave your Verdopratto. 'Tis a little upon the gloomy side to be sure; however, I'll hang Mr Verdopratto up in the sun and then we shall see what he would be at.

In the period between 1751 and 1753 Samuel Foote, a successful playwright, gave a series of sketches at a theatre in The Haymarket, one of which was entitled *Taste*, in which an artist Brush and two art market types, Carmine and Puff, exercise their skills first on Lord Dupe, and then on a Novice.

Act II; Scene i. *An Auction Room*

Enter Puff as M. le Baron de Groningen, Carmine as Canto and Brush.

Lord Dupe Sir, you have obliged me. All these you have marked in the catalogue are originals?

Brush Undoubted. But, my lord, you need not depend solely on my judgement; here's Mynheer Baron de Groningen, who is come hither to survey and purchase for the Elector of Bavaria, – an indisputable connoisseur; his bidding will be a direction for your lordship. 'Tis a thousand pities that any of these masters should quit England. They were conducted hither at an immense expense, and if they now leave us, what will it be but a public declaration that all taste and liberal knowledge is vanished from amongst us?

Lord Dupe Sir, leave the support of the national credit to my care. Could you introduce me to Mynheer? Does he speak English?

Brush Not fluently, but so as to be understood. Mynheer, Lord Dupe, the patron of arts, the Petronius for taste, and well-timed generosity, the Leo and the Maecenas of the present age desires to know you.

Puff, alias Baron de Groningen Sir, you honour me very mightily. I was hear of Lord Dupe in Holland. I was told he was one deletant, one curieuse, one precieuse of his country.

Lord Dupe The Dutch are an obliging, civilised, well-bred, pretty

kind of people. But, pray, sir, what occasions us the honour of a visit from you?

Puff I was come to bid for paints for the Elector of Bavaria.

Lord Dupe Are there any here that deserve your attention?

Puff Oh, dare are good pieces; but dare is one I likes mightily; the off sky and home track is fine, and the maister is in it.

Lord Dupe What is the subject?

Puff Dat I know not; vat I minds, vat you call the draws and the colours.

Lord Dupe It is, my lord. St Anthony of Padua exorcising the devil out of a ram-cat; it has a companion somewhere – oh here – which is the same saint in the wilderness reading his breviary by the light of a glow-worm.

Brush Invaluable pictures both, and will match your lordship's Corregio in the saloon.

Lord Dupe I'll have 'em. What pictures are those Mr Canto?

Canto They are not in the sale, but I fancy I could procure them for your lordship.

Lord Dupe This, I presume, might have been a landscape; but the water, the men and the trees, and the dogs and the ducks, and the pigs; they are obliterated – all gone.

Brush An indisputable mark of its antiquity – its very merit; besides, a little varnish will fetch the figures again.

Lord Dupe Set it down for me. The next?

Canto That is a 'Moses in the Bulrushes'. The blended joy and grief in the figure of the sister in the corner, the distress and anxiety of the mother here, and the beauty and benevolence of Pharaoh's daughter, are circumstances happily imagined, and boldly expressed.

 Brush Lack-a-day, 'tis but a modern performance; the master is alive, and an Englishman.

Lord Dupe Oh, then I would not give it house-room.

Enter Novice

Brush Mr Canto, the gentleman would be glad to see the busts, medals and precious reliques of Greece and ancient Rome.

Canto Perhaps, sir, we may shew him something of greater antiquity. Bring them forward. The first lot consists of a hand without an arm, the forefinger gone, supposed to be a limb of the Apollo Delphos; the second half a foot, with the toes entire, of the Juno Lucina; the third the Caduceus of the Mercurius Infernalis; the fourth half of the leg of the infant

81

Hercules – all indisputable antiques, and of the Memphian marble.

Puff Let me see Juno's half foot. All the toes entire?

Canto All.

Puff Here is a little swelt [swelling] by this toe, that looks bad proportion.

All Hey, hey.

Puff What's dat?

Canto That? Pshaw! that? Why that's only a corn.

All Oh!

Puff Corn! Dat was extreme natural; dat is fine, the maister is in it.

All Very fine! Invaluable.

Canto Bring forward the head from Herculaneum; Now, gentlemen, here is a jewel.

All Ay, ay, let's see.

Canto 'Tis not entire, though.

Novice So much the better.

Canto Right, sir, the very mutilations of this piece are worth all the performances of modern artists. Now, here's touchstone for your tastes!

All Great, very great indeed.

Novice Great! Amazing! Divine! O let me embrace the dear, dismembered bust – a little further off! I'm ravished! I'm transported! What an attitude. But then the locks! How I adore the simplicity of the ancients! How unlike the present, prick-eared puppets! How gracefully they fall all adown this cheek! so decent and so grave and – who the devil do you think it is Brush? Is it a man or a woman?

Canto The connoisseurs differ. Some will have it to be the Jupiter Tonans of Phidias, and others the Venus of Paphos from Praxiteles; but I don't think it fierce enough for the first, nor handsome enough for the last.

Novice Very handsome enough.

All Very handsome; handsome enough.

Canto Not quite; therefore I am inclined to going with Signor Julio de Pampedillo who, in a treatise dedicated to the King of the Two Sicilies, calls it the Serapis of the Egyptians, and suppose it to have been fabricated about eleven hundred and three years before the Mosaic account of the creation.

Novice Prodigious! And I dare swear true.

All Oh true; very true!

82

3.9 Middle-class tastes

To an extent unknown before, successful tradesmen and merchants migrating to the inner suburbs of London, such as Kennington or Camberwell, had begun to adorn their houses with prints and paintings. John Boyle, Earl of Cork and Orrery (described by Dr Johnson as 'My friend the Earl of Cork, who had a great desire to maintain the literary character of his family, was a genteel man, but did not keep up the dignity of his rank. He was so generally civil that nobody thanked him for it') contributed the following account to the *Connoisseur*, No. 33, 12 September 1754. The inherent snobbery is an interesting and fairly new phenomenon.

I went last Sunday, in compliance with a most pressing invitation from a friend, to spend the whole day with him at one of those little seats which he had fitted up for his retirement once a week from business. It is pleasantly situated about three miles from London, on the side of a public road, from which it is separated by a dry ditch, over which is a little bridge, consisting of two planks, leading to the house. The hedge on the other side of the road cuts off all prospect whatsoever, except from the garrets, from whence indeed you have a beautiful vista of two men hanging in chains on Kennington Common, with a distant view of St Paul's cupola enveloped in a cloud of smoke. I set out on my visit betimes in the morning, accompanied by my friend's book-keeper, who was my guide, and carried over with him *The London Evening Post*, his mistress' hoop, and a dozen of pipes, which they are afraid to trust in the chair. When I came to the end of my walk, I found my friend sitting at the door in a black velvet cap, smoking his morning pipe. He welcomed me into the country, and having made me observe the turnpike on my left and *The Golden Wheatsheaf* on my right, he conducted me into his house, where I was received by his lady, who made a thousand apologies for being catched in such a dishabille.

The hall, for so I was taught to call it, had its white wall almost hid by a curious collection of prints and paintings. On one side was a large map of London, a plan and elevation of the Mansion House, with several lesser views of the public buildings and halls; on the other side was *The Death of the Stag*, by the happy pencil of Mr Henry Overton, finely coloured; close by the parlour door, there hung a pair of stag's horns, over which there was laid across a red roccelo and an amber-headed cane. When I had declared all this to be mighty pretty, I was shown into the parlour, and was presently asked who was that over the chimney-piece. I pronounced it to be a very striking likeness of my friend, who was drawn bolt-upright in

a full-bottomed periwig, a laced cravat, with the fringed ends appearing through a button-hole, a black livery gown, a snuff-coloured velvet coat, with gold buttons, a red velvet waistcoat, trimmed with gold, one hand stuck in the bosom of his shirt, and the other holding out a letter with the superscription 'To Mr —, Common-Council-Man of Farringdon Ward Without'. My eyes were then directed to another figure in a scarlet gown, who I was informed was my friend's wife's great-great-uncle, and had been sheriff, and knighted in the reign of King James I. Madam herself filled up a pannel on the opposite side, in the habit of a shepherdess, smelling to a nosegay, and stroking a ram with gilt horns.

I was then invited by my friend to see what he was pleased to call his garden, which was nothing more than a yard, about thirty feet in length, and contained about a dozen little pots ranged on each side with lilies and coxcombs, supported by some old laths, painted green, with bowls of tobacco-pipes on their tops. At the end of this garden he made me take notice of a little square building, surrounded with filleroy, which he told me an alderman of great taste had turned into a temple, by erecting some battlements and spires of painted wood on the front of it; but concluded with a hint that I might retire to it on occasion

As the riches of a country are visible in the number of its inhabitants, and the elegance of their dwellings, we may venture to say that the present state of England is very flourishing and prosperous, and if the taste for building increases with our opulence, for the next century we shall be able to boast of finer country seats belonging to our shopkeepers, artificers and other plebians, than the most pompous descriptions of Italy or Greece have ever recorded. We read, it is true, of country seats belonging to Pliny, Hortensius, Lucullus and other Romans. They were patricians of great rank and fortune; there can therefore be no doubt of the excellence of their villas. But who has ever heard of a Chinese bridge belonging to an Attic tallow-chandler or a Roman pastry-cook? or could any of their shoemakers or tailors boast a villa with its tin cascades, paper statues, and Gothic root-house?

> The same idea, with its undercurrent of social criticism, was taken up by Robert Lloyd in his *The Cit's Country Box* of 1759 (a *Cit* was a citizen – usually in 'trade', and therefore not a gentleman) which describes the birth of what was to be London suburbia.
>
> The wealthy Cit, grown old in trade,
> Now wishes for the rural shade,

And buckles to his one-horse chair,
Old *Dobbin*, or the founder'd mare;
While wedged in closely by his side,
Sits Madam, his unwieldy bride,
With *Jacky* on a stool before 'em,
And out they jog in due decorum,
Scarce past the turnpike half a mile,
How all the country seems to smile!
And as they slowly jog together,
The Cit commends the road and weather;
While Madam doats upon the trees,
And longs for every house she sees,
Admires its views, its situation,
And thus she opens her oration.

'What signify the loads of wealth,
Without that richest jewel, health?
Excuse the fondness of a wife
Who doats upon your precious life!
Such easeless toil, such constant care,
Is more than human strength can bear.
One may observe it in your face –
Indeed, my dear, you break apace;
And nothing can your health repair,
But exercise and country air,
Sir Traffic has a house you know,
About a mile from *Cheyney-Row*;
He's a *good* man, indeed 'tis true,
But no so *warm*, my dear, as you;
And folks are always apt to sneer –
One would not be outdone, my dear!'

Sir Traffic's name so well apply'd
Awaked his brother merchant's pride;
And Thrifty, who had all his life
Paid utmost deference to his wife,
Confess's her arguments had reason,
And by th'approaching summer season,
Draws a few hundred from the stocks,
And purchases his Country Box,
Some three or four miles out of town
(An hour's ride will bring you down),
He fixes on his choice abode,

Not half a furlong from the road;
And so convenient does it lay,
The stages pass it every day . . .

Well then suppose them fixed at last;
White-washing, painting, scrubbing past,
Hugging themselves in ease and clover,
With all the fuss of moving over;
Lo, a new heap of whims are bred,
And wanton in my lady's head!

'Well to be sure it must be owned,
It is a charming spot of ground;
So sweet a distance for a ride,
And all about so *countrified*!
'Twould come to but a trifling price
To make it quite a paradise;
I cannot bear those nasty rails,
Those ugly, broken, mouldy pales;
Suppose, my dear, instead of these,
We build a railing all Chinese.
Although one hates to be exposed,
'Tis dismal thus to be enclosed;
One hardly any object sees,
I wish you'd fell those odious trees.
Objects continual passing by
Were something to amuse the eye,
But to be pent within the walls –
One might as well be at St Paul's
Our house beholders would adore,
Was there a level lawn before,
Nothing its views to incommode,
But quite laid open to the road;
While every traveller in amaze,
Should on our little mansion gaze,
And pointing to the choice retreat,
Cry "That's Sir Thrifty's country seat".

No doubt her arguments prevail,
For Madam's TASTE can never fail.

Now bricklayers, carpenters and joiners,
With Chinese artists and designers,
Produce their schemes of alterations,

To work this wond'rous reformation
The useful dome which secret stood,
Embosom'd in the yew-tree's wood,
The traveller with amazement sees,
A temple – Gothic or Chinese,
With many a bell and tawdry rag on,
And crested with a sprawling dragon;
A wooden arch is bent astride
A ditch of water four foot wide,
With angles, curves and zig-zag lines,
From Halfpenny's exact designs,
In front a level lawn is seen,
Without a shrub upon the green,
Where Taste would want its first great law,
But for the skulking, fly ha-ha,
By whose miraculous assistance,
You gain a prospect two fields distance
And now from Hyde-Park Corner come[1]
The gods of Athens and of Rome,
Here squabby Cupids take their places,
With Venus and the clumsy Graces;
Apollo there with aim so clever,
Stretches his leaden bow for ever,
And there without the pow'r to fly,
Stands fix'd a tip-toe Mercury.
The villa thus completely grac'd,
All own that Thrifty has a Taste,
And Madame's female friends and cousins,
With common-council-men by dozens,
Flock every Sunday to the Seat,
To stare about them and to eat.

3.10 A view of art history in 1728

A knowledge of the art of the past was being gradually diffused in the course of the century. Nor was it as limited in scope and naive in its assumptions as is often thought. *An Historical Essay on the Original of Painting*, by Henry Bell, a Cambridge graduate and architect of Lyme Regis, published in 1728, set out to examine 'I. Some Pos-

1. Hyde Park Corner was the site of several cheap statuary shops.

sibilities and Pretentions to its (painting's) Invention before the
Flood. 2. Its Commencement again after the Flood, and its Progress
through Several Nations to the Time of Cimabue 1276.' Here are
some of its comments on these phases.

Antediluvian Art

We need not travel far among the Antediluvian Patriarchs before
we meet with Enos the son of Seth and Grand-Child to the sole
Monarch of the World, the Patriarch Adam, who, as learned Rab-
bins report, seeing that those descended of Cain addicted them-
selves to Wickedness, which was Idolatry, erring from the Worship
of the true God, he, desirous to restrain them and guide them again
into the true Worship, made use of Symbols and Hieroglyphs, and
by the Figures of Animals, Simples,[1] Brute Beasts and other visible
Things which fall under the Sence, he endeavoured to draw them
by Degrees to those Things which were invisible. All which, we
presume, may serve to evince that ART was not wholly unknown to
the Patriarchs of Old; and altho' we can't absolutely depose that it
was revealed to Adam, and from him propagated to his Posterity;
yet we may without any Scruple determine that the Antients had
some Knowledge of it, and that it emerged to some competent
Attainment before the Flood.

The Peculiar Genius of China

If we think fit to travel as far as the Indies, we shall find the King-
dom of China to be not only (reported) of that great Antiquity,
over which their Kings have successively swayed their Sceptre in
Peace, without Conquest or Invasion, for some Thousands of
Years, but also by Advantage of that Peace (the Nurse of the Arts)
and their peculiar Genius and Constitutions, they have always been
great Searchers into, and lucky Inventors of many wonderful Arts
and Sciences; and to mention those two (so well known) of Paint-
ing and Guns, both of which they tell us have been used among
them Time out of Mind, which we shall not endeavour to vindi-
cate, but take what is presumed and acknowledged by all, that these
ARTS were undoubted known to them long before they were even
practised in our European nations, which if so, there is Place for
some Probability from a parallel Collection of the Rise and Prog-

1. Simples = plants.

ress of the ARTS, that many other curious Inventions, and particularly those of Drawing and Painting appearing more obvious and easily attainable. I say we can't but conjecture they had an early Knowledge of them, consequently that they were practised among them long before they appeared on the Stage of this Quarter of the World. Neither is it altogether immaterial to think those Arts to be as old as their Religion itself, and consequently their Nation (as reported) has ever entertained Paganism and Idolatry, and worshipped the Devil in various Shapes, and have had Images and Pictures of several both he and she Saints, and their Characters recorded in long Legends of their several Lives, besides an incomparable Sort of other Idols and Images with which both their Temples and Sepulchres at the solemn Interment of their Corps were furnished and adorned. The Reason of which might probably be taken from the same Opinion they entertained, as Mr Purchas relates, with the Egyptians of the Transmigration of Souls, therefore they were at so great Expenses in their Funeral Solemnities, and particularly their Coffins were adorned with all the Curiosity that Art could invent, which that it might not be wanting in Anything, it was their Care and Study in their Life to provide against that Time when (as Masseus acquaints us) they had this peculiar Custom, after all other Ceremonies performed, to burn upon the Graves of the Deceased many Papers painted with Men, Cattle and Provision for their Use in the next World.

And, as they fell in with some of the Opinions of the Egyptians, so also were they skilled in the Practice of some of their Hieroglyphicks, some of which are still extant among their Writings and printed Records, particularly one of great Antiquity at this Day to be seen in the Vatican Library in Rome, made up in various Folds, besides many others in the Hands of the Virtuosi, in all representing Pictures, as some Landskips, Stories, and the like; besides the Form of their Writing was in a manner of the same Nature, where every Character contained not only Words, but some of them entire Sentences.

Giotto

But he, of all the Painters, worthy of the highest Reputation, after the Death of Cimabue, was his Disciple Giotto, born at Vespignano, a village Fourteen Italian Miles from Florence, the son of a Husbandman, and by his Father set to keep Sheep, in which Employment Cimabue first met him, and found him at the same time ex-

erting the Ideas of his native Fancy, and drawing the Picture of one of his Sheep on the Sand, or a Tile-shed with a Coal, or some such course Material, upon which he conceived such an Opinion of the natural Inclination of the young Lad, that he immediately applyd to his Father for his Consent to take him along with him to his House, and instruct him in the rudiments of the Art; wherein after a short Time he became so mighty a Proficient that he not only equalled, but excelled his Master, quitting that rude Manner of Practice of the Greeks, and Cimabue, and other Painters before that Time, and was the first that introduced a modern ART, and true Way of Painting Portraits by the Life, which except that Cimabue attempted in that Kind, was a thing they were unacquainted with for many Ages before, and not only in this particular, but in the whole ART he gave Presages of his future Attainments, which afterwards receiving a due Accomplishment, he became famous for his excellent Skill in expressing the Affections, and all Manner of Gestures, so happily representing everything with such an Identity and Conformity to the original Idea, that he was said to be the true Scholar of Nature.

3.11 Design, ancient and modern

'Design' was seen by the artists of the eighteenth century roughly as the equivalent of what today we would call 'composition', but it still retained something of the older implication of the drawn expression of the creative idea in the mind of the artist. In his *An Inquiry into the Beauties of Painting* (1761) Daniel Webb expressed this in comparing ancient ideals with currently fashionable ideas about the work of Raphael, Michelangelo and Correggio.

B. The testimonies which you produce from their writings, but above all the Greek statues, which we may look upon as living witnesses, sufficiently prove the merits of the ancients. Let us now, if you please, consider that of the moderns, thus establishing a general idea of comparison between the two, we shall have a more perfect one of both. I do not mean to lead you into a detail of the perfections or imperfections of our different artists; it will be sufficient to throw the merit of the cause upon someone who is generally allowed to be the most excellent.

A. There is no difficulty in our choice. I shall lay before you the reflections I have made on the designs of Raphael, with this

latitude, that you may admit or reject them as they happen to square with your own, for this should always be the case where we profess to have no other guide but feeling, and to form our judgement merely from effects.

The design of Raphael was, in its beginnings, dry, but correct; he enlarged it much on seeing the drawings of Michael Angelo. Of too just an eye to give in entirely into the excesses of his model, he struck out a middle style, which however was not so happily blended, nor so perfectly original as to throw off influence of the extremes. Hence in the great he is too apt to swell into the charged; in the delicate to drop into the little. His design, notwithstanding, is beautiful, but never arrived at that perfection which was discovered in Greek statues. He is excellent in the characters of Philosophers, Apostles and the like, but the figures of his women have not that elegance which is distinguished in the Venus of Medicis or the daughter of Niobe. In these his convex contours have a certain heaviness, which, when he seeks to avoid, he falls into a dryness still less pardonable.

B. Yet his proportions are esteemed excellent, and their symmetry such as to give his figure an effect beyond the promise of their stature.

A. It is true, but yet, not having formed his manner on the most beautiful antique, we do not see in him that elegance in the proportions, that freedom in the joints which lend all their motion to the Laocoon and Gladiator. Instead of these the figures of Michael Angelo were his models in the great style, whence in convex contour, having quitted the lines of nature, and not having substituted those of ideal beauty, he became too like his original, as may be seen in his *Incendio di Borgo*. Would you therefore place Raphael in his true point of view, you must observe him in middle age, in old men, or in the nervous nature. In his Madonnas he knew well how to choose, as likewise how to vary the most beautiful parts in nature. But he knew not, like the Greek statuaries, how to express a beauty superior to the natural. Thus in his *Galatea* at the palace Chigi, where he has professedly attempted a character of perfect beauty, he has fallen short of the beauty of his Madonnas. The cause of which seems to me to be this, that, in the former he drew after his own ideas, which were imperfect; in the latter he copied beautiful nature, which was almost perfect. I am confirmed in this opinion by a second

91

observation; of all the objects of paint, Angels call most for ideal beauty; those of Raphael are by no means distinguished in .this particular, for he had no examples of them in nature, but was obliged to draw them from his own imagination.

B. Accordingly he has given them a motion, spirit and expression for which he could have no example.

A. True; but these do not constitute beauty, which is our present object. On the contrary in Raphael they often contradict it. Thus in the heads of his Madonnas, the nose is generally too large; he thought no doubt this gave more sensibility and meaning to the face. In the same manner his men of the middle and advanced age have their features too strongly marked; the muscles, especially those of the lips and eyebrows are changed. It is plain that he preferred this form because by it he could more easily express the several motions of the mind. But the perfection of an art is to unite the justest expressions to the finest forms. The Belvedere Apollo and the Daughter of Niobe are the standards of beauty; what energy, what a divine expression is there in the one! what an affecting sensibility in the other! There are few expressions, if we except those which excite in the beholder either hatred or contempt, which may not be more happily marked in a fine countenance than in such as are ill-favoured; where the features are charged, the slightest movements throw them into forcible expressions; the consequences of which are, that the finer symptoms of passion are in a great measure lost, and the stronger ones lose much of their force by the facility with which they are expressed. But in a face naturally beautiful and composed, not only the degrees of passion are traced with delicacy, but the violent agitations of the soul affect us more sensibly by the total disturbance and alteration which they always produce in the countenance. . . .

B. This is to turn a pleasing art into a useful science, and to make every picture a school of virtue. But yet I cannot forgive you having reduced the design of Raphael so much below the standard at which it is usually placed.

A. The judicious Poussin has gone much further than I have done, or even than he had a right to go when he affirmed that Raphael among the moderns was an angel, but that compared with the ancients he was an ass. This is too much; however it serves to show the difference that was between

them. But, setting aside these comparisons, our purpose is to come at a settled idea of the most perfect design. What is it to us if the examples were produced two thousand or two hundred years ago? A man of taste, like the philosopher, should be a citizen of the world, acknowledge merit wherever he meets it, indifferent whether it shines forth in a Raphael or Apelles, in a Michelangelo or a Glycon.

B. You have advanced that the greatest excellence of design was grace; whence is it then that Correggio, who in this is inimitable, is by many placed so low in the class of Designers?

A. This arises from a want of attention to the character and pursuits of this amiable painter. His constant aim was grace, and a happy effect of clear-obscure. A waving and varied Contour was necessary to this end. Hence he gave wholly into the serpentine, studiously avoiding right lines, and acute angles as too simple in their effects. Thus the habit, and even the necessity of varying his out line, threw him into little errors of drawing, which spring, not as some think, from an ignorance of this branch of art, but from a predilection for another sort, and there are few, I believe, who would wish those inadvertencies away accompanied with the charms which gave occasion to them.

B. It is a dispute among the critics, whether he ever saw or imitated the antique.

A. This dispute is his greatest praise, for they who suppose he did, cannot otherwise account for the general beauty and elegance of his design, while those who are of a contrary opinion, grounded on imperfect relations of his life, or the lapses and unsteadinesses of his pencil, are forced to impute that beauty and elegance to a pure strength of genius.

Certainly his manner seems to have in it all the warmth of invention, as it has a certain boldness, superior to imitation, and productive of uncommon graces. Upon the whole, I think, we may affirm of his design, where it is not sacrificed to his more favourite aims, that it is often masterly and always pleasing, a quality rarely met with in those servile and unideal painters who think they have achieved every perfection if they keep within the rules of drawing, with these leaness passes for health and weakness for judgement, and while they think it sufficient to be free from faults, they fall into that capital fault, the want of beauties.

3.12 How to be a judge of painting

The travellers on the circuit of the Grand Tour, no less than those who visited the stately homes of England to admire the works of art which they contained, clearly needed specific guidance and Webb provided it. His advice was sensibe and pragmatic. In his Preface to '*An Inquiry* . . . ' he declared his intentions.

I am sensible that, among my readers, there will be some, whose excellent taste and clear judgment must place them much above my instructions; from these I hope for indulgence. The persons for whom I write are our young travellers, who set out with much eagerness and little preparation, and who, for want of some governing objects to determine their course, must continually wander, misled by ignorant guides, or bewildered by a multiplicity of directions. The first error I have taken note of is the extreme eagerness with which they run through galleries and churches; *nimium vident, nec tamen totum* (in trying to see everything, *they see nothing*). A few good pictures well considered, at such intervals as to give full time to range and determine the ideas which they excite, would in the end turn to a much better account.

The second error is the habit of estimating pictures by the general reputation of the painters; a rule, of all others, the most productive of ignorance and confusion. For example Domenichino may at times be ranked with Raphael; at times he is little superior to Giotto. And we often find that the best works of the middling artists excel the middling works of the best. If then, we are guided wholly by the prejudice of names, we no longer trust to our own senses; we must acknowledge merit which we do not see, and undervalue that which we do; distressed between authority and conviction, we are disgusted with the difficulties of an art, which is, perhaps of all others the most easily understood, for that composition must be defective, which cannot to a careful observer point out its own tendency, and those expressions must be either weak or false which do not in some degree mark the interest of each actor in the drama. In nature we readily conceive the variety and force of characters; why should we not do so in Painting? What difficulty can there be in distinguishing whether the airs of the heads be mean or noble; the style of design, confined, charged, or elegant; whether the proportions be just or unequal; the carnations[1] cold or animated? If the colours in a picture be happily disposed, the general effect will

1. Carnations = flesh colours.

be pleasing; and in proportion to the force of the clear obscure[2], the figures will be flat or projecting, or in other words more like nature. If we consider these points without prejudice, it will, I think, appear that of all the arts, Painting is the most natural both in its means and effects. It is the most direct and immediate address to the senses; and this must be the reason that the best writers of antiquity, in treating of other arts, so frequently borrow their examples and illustrations from this. When I thus make light of the difficulties of painting, I must be understood to speak of its effects, not of the practice; and yet, even as to this, there are ten painters who have excelled in the mechanic parts, for one who has excelled in the ideal. So that the scarcity of good paintings arises not from a difficulty of execution, but from a poverty of invention. Hence it is, that painters of an inferior class, have, in their happier hours, struck out some excellent pictures; and some again are seldom successful, except when they work on the ideas of others. Andrea Sacchi is an example of the first, and Domenichino of the second. But I am straying from the design of this Preface, which was to point out to the younger part of my readers those errors which tend most to defeat their knowledge of painting. I have already named two, the third is the hasty ambition of distinguishing the several masters. With many this precedes and often holds the place of all other knowledge, and yet, I will venture to affirm, that where this does not spring from a nice discernment of the beauties or imperfections of the picture before us, and those turning chiefly on the composition and expressions, it is an idle art, more useful to a picture merchant than becoming a man of taste. It cannot be denied that a sameness of manner in treating various subjects is a weakness; it is a want of variety both in the mechanick and the ideal. Yet it is by this very weakness, or some insignificant particularities in the colouring, standing, attitudes or draperies, that we so readily distinguish the various hands. It may be a check on this affectation, to observe that among the infinity of painters, there are not perhaps a dozen, who are worth studying; it is not by little circumstances that we know a Raphael or a Correggio; their superior talents are their distinctions. Women of ordinary forms are marked by the jewels of their necks, or the colours of their clothes, but a D---s of G----n [Duchess of Grafton] is singled out by a pre-eminence in beauty.

2. Clear obscure: an Anglicization of chiaroscuro – the distribution of light and shade in a picture.

There is a fourth error which I would fain discredit, and then I shall have done with this unpleasing task. I have observed many to look at pictures with no other view than to show their acuteness in detecting little errors in drawing, or lapses of the pencil; these do not study painting to become knowing, but to appear so. But let them reflect there is more true taste in drawing forth one latent beauty than in observing a hundred obvious imperfections. The first proves that our spirit co'operates with that of the artist; the second shews nothing more than that we have eyes, and that we use them to very little purpose. If these errors appear in the same light to my reader that they do to me, he will see the necessity there was for some better plan that that which we have hitherto followed in the study of Painting.

3.13 Criteria of collecting

Thomas Herbert, 8th Earl of Pembroke, was an avid collector of classical antiquities; in 1720 he bought more than 1,300 busts from the collections of Cardinal Mazarin and the Roman family of Giustiniani. James Kennedy's *Description of the Antiquities and Curiosities in Wilton House*, published in 1769, was one of the several highly successful guides to the Pembroke Collection, which were published in the eighteenth century, and it is of especial interest in that it indicates the principles which guided the Earl – who was often optimistic in his attributions – in the choice of his purchases. The emphasis on education is significant, so too is the attitude to Egyptian and Etruscan art.

The Earls of Pembroke had, from the reign of Henry viii been encouragers of the fine arts, and very early shewed their taste in employing Holbein and Jones in improving their noble seat at Wilton; however, it was reserved for Earl Thomas to raise it to a degree of magnificence and splendour beyond any this nation afforded, and which made it justly vie with the most celebrated abroad.

This Nobleman possessed every qualification necessary to constitute a real connoisseur and virtuoso, in a very eminent degree. He had an exquisite natural taste, improved by extensive learning, and a fondness for the study of antiques. His conversation with the best Italian Antiquaries of his age cherished his own propensities, and he resolved to form his collection on a plan which would render it valuable, and be always a monument of his superiority in this way.

Before he began to purchase, he confined himself by the following limitations:

I. He resolved not to run into all sorts of curiosities, but to buy such as were illustrative of ancient history and ancient literature. It would have been an endless matter to have endeavoured to acquire Gems, Statues, Medals, Relievos, Bustos, domestic utensils and a thousand other antiques, which however Cardinal Albani, many of the Popes, and the present King of Naples have done. Being on the spot when many of these were found, they had opportunities of completing sets, which no foreigner could possibly have. It was therefore certainly more prudent to decline what he had no hopes of perfecting, than to fill his house with fragments, which would neither satisfy the ignorant, nor please the connoisseur.

For this reason he rejected Cameos, Intaglias, and the smaller Lares and Penates (I)[1]. Bustos he was particularly fond of, as they expressed with more strength and exactness, the lineaments of the face. Besides, the viewing of these brought to the spectator's mind the history and glorious exploits of ancient kings and heroes.

Though his Lordship had a superior esteem for the Antique, yet he greatly praised the Grand Duke of Tuscany's collection, consisting of above eight hundred modern Statues. Lewis xiv, in his estimation, deserved not less applause, for his encouragement of French artists, who made many Statues in marble and lead after originals, and ornamented his gardens with them. These made excellent models for young statuaries and engravers to copy.

Lord Pembroke was sensible that in a few years sculpture would receive but little encouragement, that Antiques would be monopolised in a few hands, and therefore was willing before this event took place, as many copies might be taken as would disseminate a correct taste, and give a relish for ancient beauties. This accordingly is come to pass, at present a sculptor of the best genius can hardly find employment, while every paultry painter who can sketch a likeness is caressed.

II. No duplicates were admitted. The case however is widely different in respect of Divinities. As the symbols of many of these could not be exhibited together, so more figures than one of them

1. Penates. In Roman religion one of the sets of gods who look after the household: 'Lares et penates'.

became necessary. To exemplify this: *Venus rising from the sea* cannot be exhibited but in that one action. Suppose her chariot, drawn by Doves, with Cupid, Mars, Adonis and a variety of other actions and Deities belonging to her were introduced into one piece, what would be the consequence, but that it would disgust every observer, as all things so crowded universally do? *Venus picking a thorn out of her foot*, and *Venus holding a shell*, are as different in attitude as if they in no way related to the same person.

The same reasoning will hold good of Apollo, Hercules, Bacchus and others, so that his Lordship most judiciously multiplied such statues as were explanatory of different attributes, for thereby, as it were, a history was made of these Divinities.

Altars, Urns and such like came under the denomination of Duplicates for the most part; however some of them preserved in Relievo many curious things relative to the sepulture, marriages and other Rites of the Greeks and Romans; when this was the case, they were valued and retained. Accordingly there are eleven sorts of interments and five different Altars.

III. Lord Pembroke rejected whole Nations, as the products of Egypt, Hetruria [sic] and Magna Graecia, though he admitted a few to diversify his collection. The numerous and whimsical Egyptian deities, which captivate the eyes of some Connoisseurs, were looked on by his Lordship with indifference. The Hieroglyphics wherewith they are loaded, at present are unintelligible, or if they were known, could communicate nothing worth attention. He therefore was satisfied with an Isis, Osiris and Orus, nor was he solicitous about more, though he greatly admired the Jaspers and marbles of that country.

Etruscan figures are no less *outré* and inexplicable than the foregoing, yet great regard has been paid to the works of that country, and much pains taken to elucidate them. Some of their Vases are beautifully relieved and painted, but not easily to be met with, unless in the Cabinets of the Curious. Even were they to have been procured, they would have answered none of his Lordship's views.

IV Even works of the best ages were bought with limitations. As images were objects of adoration with the Heathens from the earliest times, they consequently were multiplied each family having many, and the temples great numbers. To this religious opinion concerning statues, that they represented the Deity under a human appearance, is using the improvement and perfection of sculpture. Statues at the beginning were as gross as Mens' conceptions, being

little better than rude stones and blocks without shape. As politeness and improvement advanced, they entertained more becoming ideas of the divine nature, and the only means they had of expressing them suitably, were to exhibit them under those appearances most esteemed among men.

Thus beauty, or a just conformation of features, which a complexion suited to the climate, has always and ever will, claim the love and admiration of the beholder. Hence the most beauteous persons were the models for their Gods and Goddesses, and the closer they followed the original, the nearer they approached to perfection. His Lordship observed that this perfection was not to be expected in the ancient productions of the Grecian artists, it was a work of time, advanced but slowly, and was confined in some measure to a particular Epoch.

Nothing does more honour to Lord Pembroke's taste than confining his choice to the best ages.

3.14 Problems of a collector

In the 1750s James Caulfield, Viscount Charlemont (later the first Earl) went on the Grand Tour with his tutor the Reverend Edward Murphy. In Italy he made extensive purchases of statues and paintings, mainly through the agency of an English artist, John Parker, who was left with the responsibility of forwarding them to Ireland. The problems which the harassed Parker had to face are suggested by this letter which he wrote to Charlemont from Rome on 26 July 1755.

By a letter from Mr Murphy, dated July 11th 1755, I have an account of your lordship having been frightened about the case of medals, but that they were found, I hope in good condition, as I had taken particular care in packing them up. With them is the French box which your lordship left and writ for from Florence. He sent me also a list of things wanting, viz. all bronzetti, Gladiator, two Centaurs, Silenus, Antinous, basso-relief Venus by Gugliemo della Porta. These I did not send, some not being in order, as the Venus that Vierpoyl was to bed in a frame (if your lordship remembers), and is not yet done, no more than the basso-relief Antinous (to bed also) nor the busts of Caesar, Brutus and Pompey in bronze, that he was to do, the busts too in red marble; I have often recommended them to him, nor can I give them to others, he having your lordship's order to do them; if yet not done, it is no fault

of mine. I suppose he will do them when the Gladiator is finished, which, he says, is very forward. I have not seen it, as I am kept in bed with my wounds. The pictures I have bought for your lordship I have intended to have sent with Patche's[1] and Pompeo's[2] (to have had only one license for them and the bronzes) when done. The first never let me know he had finished, nor should I have known they were sent, but by the account of Belloni's the banker of the money paid etc., nor do I know his reason for sending them away unknown to me. Pompeo has not finished nor can I get the portraits out of his hands; he is paid the half of the great one. Mr Murphy desires a particular account of all those things sent as yet or to send. The first is impossible for me to do, as I had no inventory than of the books, the which I was obliged to leave for the license to send them anyway. I don't doubt but that your lordship will find them all. They were packed up by me and Vierpoyl in the two large cases, one full of books only, the other contained besides the books, in a case at the bottom your marble mosaic table, the case of medals and the walnut-tree case with drawers for the medals. In the other case the Farnese globe, and under it the basso-relief of Minerva teaching the use of olives, bedded in a frame, and other gessi of fasces etc., belonging to Mr Murphy; other cases, all the books of loose prints, views etc; and both your lordship's and Mr Murphy's cases in one large one, the Etruscan vases, boxes of lava etc., etc.; other cases containing Mr Murphy's clay heads and two bronze heads, Caesar and Brutus. All your lordship's marble busts viz. Swift, Homer, Brutus the elder and younger, antique faun, modern faun; girl's head from Alessandria, and Agrippina, each separate cases. These were all I sent, and I have Peter Cassidy's letter of their safe arrival not only at Livorno, but at Dublin for my satisfaction. Who or what ships carried them, or to whom directed there, he never informed me, having, as he writ me, Mr Murphy's orders, how to dispose of them, when he was there. I have since my return from Naples sent him the two granite tables, and have his letter of their arrival, and being sent, I hope they are safe in your lordship's hands by this. I have nevertheless writ to Cassidy to send me a particular account of the number of cases he forwarded to Dublin, to whom directed, and by what ships, the which I shall send Mr Murphy on receipt for your lordship's and his satisfaction; and also another copy of the account he desires again, having already sent

1. Patche – Thomas Patch
2. Pompeo – Pompeo Batoni

him once, since he informed that I had forgotten to enclose it, directed for him at Gurnell and company. Since then he has writ that I directed to him at Knox and Cragheads. Perhaps Gurbell, not serving your lordship has never sent him the letter, or by this he may have received it. In it I gave him a particular account of the draught of Belloni's for £162.9s. 5d. your lordship's account, and his own £98.4s. 3d. This is the whole, in all £260.13s. 8d. and in his to me by your lordship's order, dated July 11th, he demands of me account of a draught of £300 sterling; (a mistake), of all this sum I have never touched but 300 crowns of the credit of 400 your lordship signed and left with me the day your lordship left Rome. . . . Mr Murphy's letter threatened me with the loss of your lordship's protection (to me the greatest misfortune that could happen) on this account if not cleared up. This, I must confess, has disturbed me not a little, on the account that Mr Murphy had communicated your lordship's letter to poor old father, who will be inconsolable as he writes me, till he hears. Your lordship's goodness and generosity will not condemn me, I know, till heard, so that on this head I shall make myself easy, and waiting your lordship's commands.

(Historical MSS Commission Reports: Charlemont papers 1891)

3.15 The English in Rome

Rome not only attracted those who made the Grand Tour, for most of whom it was the goal of the journey (only a smaller number went on to Greece), but it was also the place to which most aspiring English artists went. There too – as at Venice and Florence – there was a considerable resident English colony, some Catholics, some Jacobite refugees, who devoted most of their time to selling antiquities – often of dubious origin – and conducting English visitors around the city. Thomas Jones, the landscape painter, describes two of them in his *Memoirs* (Walpole Society, vol. 32, 1951).

April 1st 1780.
There were two personages then who for Years had the guidance of the Taste and Expenditures of our English Cavaliers, and from whose hands all bounties were to flow – Mr Jenkins originally came here in the humble Station of one of ourselves, but soon after his Genius breaking forth in its proper direction, he luckily contracted for part of the Cargo of an English Ship at Civita Vecchia, which, being disposed of to great Advantage in Rome, he thereby laid the

foundation of his future fortune – from his knowledge & experience in Trade & Commerce, manufactories etc., he became so great a favourite of the late Gangarelli [Pope Clement XI] that if that Pontiff had lived a little longer it is said he might have made him a Cardinal if he chose it – however, by purchasing and selling at his Own Prices, Old Pictures, Antique Gems and Statues, with the profits of a lucrative Banking House, he was enabled to vie with the Roman Nobility in Splendor and Magnificence.

Mr Byers professed himself an Architect, but dealt likewise in Pictures and Antiques. He was besides the principal *Antiquarian* to the English, or Person who attended Strangers to shew and explain the Various Buildings both Modern and ancient, statues and pictures & other Curiosities in this City and its Environs. Each of these Gentlemen had his Party among the artists, and it was customary for every one to present a Specimen of his Abilities to his Protector, for which he received in return an Antique Ring or a few Sechins – These Specimens were hung up in their respective Rooms of Audience for the inspection of the Cavaliers who came – Each Party likewise by established Custom dined with its Patron on Christmas Day. By accident I was first introduced to Mr Byers as I happened to travel from England with Norton [Christopher Norton, working 1759–95; an engraver and dealer] his partner or Coadjutor. But being first invited to the Christmas Dinner by Mr Jenkins I was looked upon as enrolled under his Banner. This Custom however began to wear away as the last holydays a Party dined by Subscription at my Apartments & Mr Jenkins sat down to a Sumptuous Entertainment attended by only one Person – when he declar'd it should be the last he should ever provide on like Occasion.

As I have never received any favour from either of these Gentlemen, so I never expected any,[1] not that I thought that I had ever offended Mr Byers, and his reception of me whenever I waited upon him, particularly of late, was polite in the *extreme*. That circumstance indeed made some, who pretended to know him better than me, suspect that he had met with some Offence – but to put it

1. On 8 April, Jones made a list of the pictures he had been commissioned to paint in Rome from which it is apparent that most of them had been obtained through Jenkins, Byers or Gavin Hamilton. They included:
A View on the Coast of Baja on a Cloth 9 Palms 2 inches by 6 P. 2 I. for Mr Yorke £70.
A View of the Lake of Avernus on a Cloth 7 Palms 5 Inches by 5 P. 41 for Ditto. £50. both these last to be delivered with frames to Mr Byers who is to pay for them.

beyond a doubt, Norton at length told me in plain Terms, that I had used him very ill – and pray how (said I) Mr Norton? Sir, said he 'you did not receive the money for Mr Yorke's Commission' through Mr Byers' hands, which is always customary for Pictures that are consigned to his Care'. 'Sir,' I replied, 'if Mr Byers had procured me the Commission, I might have been bound in gratitude to let him have had the profit of the remittance, but as he had not procured this or any other – I think I had the right to be paid in the manner most convenient and profitable to myself.'

Some ideas of the multiplicity of commissions which British artists in Italy undertook, and the variety of their activities, can be deduced from the letter which the sculptor Thomas Banks wrote to his friend Ozias Humphrey, who had been there three years earlier.

Rome, Decr. 13th 1777

My very good Friend

I have both your favors now before me, the last of which came to hand today, and is also without a date, as well as the former. The Musick you wrote about is already prepared & I believe waits for an opportunity of being sent. Our composers and performers for the ensuing Carnival are already arrived, we are to have serious Operas at the Aliberti. Anfossi Composes for the Valle & Argentina, & if anything curious and extraordinary turns up I will get it & send it to you, not going upon my own Judgement, but that of the generality of the people – I am extremely sorry to hear of the accident which happend to yr cases but I hope all is not spoil'd. Marchant [Nathaniel, a sculptor and gem engraver who was in Rome between 1773 and 1779] was very uneasy about his Lyon & Horse, as it was the only Model of that kind in London, but now his fears will be over – I waited on Mr Caesaroli [Domenico Caesaroli, a mosaicist] according to yr desire & told him you had sent the books as you had promis'd; he seemed mighty well pleased, but we see nothing of Signor Angelini the Sculptor yet in whose trunks the books are. This is all which I think I need notice in yr former letter which I should have answered sooner if it was not that I was waiting till I could send off your cases containing the Layman & Laocoon's head, which I received from Mr Smith [father of John Thomas Smith] are both safely packed up & put on a vessel bound to Leghorn, and consigned to Mr Thos Violette, Mercht by whom they will be taken & put on board a ship for London directed for you. With regard to your pencils [brushes] I do not wonder at yr enquiring about them. I ordered them as soon as you sent word by

Mrs Stevens' letter[1] to Mrs Banks. The man was so long about them that I hadn't then time enough to send by Home [Robert] & there had been no opportunity since, but I believe it will not be very long now before one offers. With regard to the affair with Wedgwood[2] I am greatly obliged to you for thinking of me, but Jeffery's [James Jefferys] is of opinion, as well as myself that it wouldn't do – in short the further consideration of it must be left till by my own personal appearance I can see and determine something. I am very glad to hear of the success of Mr Romney, Sir Joshua, Gainsborough and yrself. With regard to yr own I never had the least doubt of it & can readily believe you paint better now than when you was in Rome....

We expect a great many English gentlemen here this season; some are already come; Ld Hervey, Bishop of Derry, visits the artists much and has bought all Treshman's antique paintings; Ld and Lady Maynard arrived a week ago, and are gone to Naples – here is a Mr Molesworth and Mr Penn and Mr Curzon, Mr Tands and Mr Bosset. This latter has bought Delane's [Solomon Delane] picture which he painted for Sr Charles Bamfylde, Stuart Mackenzie [James] is also gone to Naples. There are several others, whose names I do not recollect. Together with yr. Cases I have shipped my basso-relievo of Caractacus for Mr Grenville (George)[3] & intend drawing on him for the Money, as he has not done me the Honr to take any notice of my letters hitherto. I have also taken up twenty crowns of yr money of Mr Jenkins, with which I have defrayed the Carpenter's bill, a Peruquieres bill & the pencil man's bill. Of the carpenters and pencil maker's bill I have receipts but that of the Peruquiere Mr Day never gave me. It was not my intention to trouble Mr Jenkins abt this little affair, but could not very well help it. I suppose before this time he has sent you the bill & you have paid the money. The Carpenter's bill for the present Cases I have not yet got...

> Yr very obliged friend & obednt servt
> T. Banks
> (C. F. Bell, *Annals of Thomas Banks*. Cambridge 1938)

1. Mrs Stevens was the widow of the architect Edward Stevens, who exhibited at the Royal Academy between 1771 and 1773. He died in Rome at an early age in 1775.
2. A project for modelling bas-reliefs for Wedgwood.
3. George Grenville commissioned – and was tardy about paying for – this bas-relief in 1774.

The impact of Italy on English landscape painters was significant, and is illustrated in the letters which Jonathan Skelton, who died in Rome in March 1759 at the age of about twenty-nine, wrote to his friend and patron William Herring of Croydon, who financed his stay there.

Here's no encouragement among the Italians for Painters of any kind, nor indeed very little from any other Nation. If I sell none of my Pictures here, I purpose to send them to England every 6 or 8 months. If you'll be so kind as to apply to one of ye Commissioners of the Custom House, they'll come free from paying Duty.[4] As I propose to generally introduce some particular Place about Rome into my pictures, I flatter myself that they'll sell pretty well. I have already laid in two pictures, and am going a second time over them, both partly Studies from Nature. The weather now at times is so fine that I can draw in ye Fields without the Cold interrupting me. Here many Young People study Landscape – I think I may say without Vanity I am the best Landscape painter in Rome. I have taken a very handsome lodging on the Trinita del Monte on one of ye finest situations about Rome; it commands almost the whole City of Rome besides a good deal of ye Country. The Famous Villa Madama (where Mr Wilson took his View of Rome from which I always thought his best Picture) comes into my View. I shall have the finest opportunity of painting Evening Skies from my Painting-Room that I could almost wish – surely I shall be inspired, as I am going to live in the Palace[5] of a late Queen and in the same apartments that Vernet had, when he was here, and within 80 or 100 yards of ye House where those celebrated Painters Nicolo and Gaspar Poussin lived!

Tivoli April 23rd 1758
I now sit in the murky Caves and gloomy Woods admiring the Thundering Cascades of Tivoli bounding o'er lofty Rugged Rocks,

4. There was a duty of a guinea a foot on paintings imported into England, but those who had the right contacts could get it waived. It persisted till 1794, when the *Morning Chronicle* (24 May) reported that twenty-three artists signed a letter from Rome thanking the Duke of Sussex for obtaining for artists returning from abroad the right to bring in their paintings and casts free of duty.
5. The Palazzo Zuccari, which had been the residence of Maria Casimira (1635–1716) the widow of John III Sobieski and is on the right side of the Piazza Trinità de' Monti. It was acquired by Alessandro Nazari, and converted into apartments where many English artists, including Reynolds, Thomas Patch, David Allan, Joseph Wilton and others lived in Rome.

whose spirey points seem ready to pierce the clouds. This ancient City of Tivoli I plainly see has been ye only school where our two most celebrated Landscape Painters, Claude and Gaspar studied. They both have taken their Manners of Painting from hence. I see at the same time that one was as strict an imitator of Nature as the other. On one side of this place, from ye very spacious even top of a high Mountain one may behold many of the most pleasing compositions of Claude Lorraine in the Campagnia of Rome, with that City 18 miles distant towards which place the Anio winds its way through the Campagnia from hence. [On] the other side you would be surprised with all the most noble Romantic wildness of Gaspar Poussin. I have been here a fortnight and I intend to stay a week longer. The first week I spoiled almost all my drawings, this wild nature being a new kind of Study to me; this week I have succeeded tolerably well. About ten weeks hence I purpose to come and stay here 3 or 4 months and paint from Nature, as you advise. Almost all this Summer and the next I intend to study in the most advantageous places within 20 miles of Rome, which will cost me about 10 or 15 pounds a year more, for all those places which are the best for my purpose are the Villas of the Nobility of Rome, which makes it more expensive than the great City. I hope by what I have proposed to make a greater Progress in the two years that I stay in Italy, than I should in upwards of three years supposing that I stayed most of my time in Rome. After my return to Rome I intend for one fortnight to paint two of my Tivoli studies in Oil. After that I purpose to go to Albano for 12 or 14 days. My good friend Mr Lumisden will be there at the time.

(Walpole Society 1956, vol. 31, pp. 137–9)

3.16 Canaletto in England

British diplomats, businessmen and artists, such as Joseph Smith and Owen MacSwinny in Venice, John Udney in Florence, Gavin Hamilton in Rome, were not only active in promoting the sale of Italian works of art to visiting grandees such as Coke of Norfolk, but actively promoted their artists in Britain. The most typical case was that of Canaletto. On 28 November 1727 MacSwinny wrote from Venice to the Duke of Richmond at Goodwood.

The fellow [Canaletto] is whimsical, and vary's his prices every day; and he that has a mind to have any of his work must not seem

to be too fond of it, for he'l be worse treated for it, both in the price and the painting too.

He has more work than he can do in any reasonable time, and well, but by the assistance of a particular friend of his I got, once in two months a piece sketched out, and a little time afterwards finished by force of bribery.

I sent your Grace by Captain Robinson (Commander of the *Tokely Gully*) who sails from hence tomorrow *two of the Finest pieces* I think he has ever painted and of the same size with Mr South- well's little ones (which is a size he excells in) and are done upon copper plates. They cost me two and twenty sequeens each. They'll be delivered to yr Grace by Mr John Smith as soon as they arrive in London.

You shall be served by the Rosalba [Rosalba Giovanna Carriera, 1675–1758; the successful pastellist] better than you had hoped for, the original of the German Girle (that is of her face) being still in her hands. But you must say nothing of this because the piece you saw is now in London. She promises to finish ye dress (the designs of which she has by her in several sketches) in a month's time. But I must take a fine gold frame and the chrystal that is bespoke for it, which together with ye picture will come to about four or five and twenty sequeens.

I shall have a view of the Rialto Bridge done by Canal, in twenty days, and I have bespoke another view of Venice for, by the bye, his excellence lyes in painting things which fall immediately under his eye.

The four pieces of Canal come to *88 sequeens*, and the Rosalba etc. to 24, which comes to about Fifty Six Guineas sterling and if your Grace will permit me to charge Four Guineas more, for the Freight and expenses in packing 'em up, and sending 'em on board with ye Customs etc., and some former expenses of the same na- ture, the same will amount to sixty guineas, which I'll draw for at twice, as your Grace desires.

> Three months later MacSwinny wrote again, illustrating the hazards involved in such transactions.

The three pictures are cased up; and lye ready to be embarqued on the first ship that sails hence for London; That is if the news from London gives us any hopes of an accommodation with Spain, for I should be sorry that these pictures met with the same fate that yr picture by Rosalba did; therefore I shall take my measures about

'em from the advices in the following Gazettes, and Canaletto has just finished the piece of the Rialto Bridge, and as soon as its companion is done I'll forward 'em to you with the Country Girle by Rosalba.

(From the archives of Goodwood, quoted W. T. Whitley, *Artists and their Friends in England 1700–1799*. London 1928)

In 1746 Thomas Hill, who had been tutor to the second Duke of Richmond, wrote to his former pupil after a dinner at the Duke of Montagu's, where he had met McSwiney, who was apparently very drunk:

Canales, alias Canaletti is come over with a letter of recommendation from our old acquaintance the Consul of Venice to Mac, in order to make his introduction to your Grace as a patron of the politer arts, or what the Italians understand by *virtu*. I told him the best service I thought you could do him would be to let him draw a view of the river from your dining-room, which, in my opinion, would give him as much reputation as any of his Venetian prospects.

(From *A Duke and his Friends*, by The Duke of Richmond. London 1910)

Canaletto did in fact paint two such pictures, and was also commissioned by Sir Hugh Smithson (later the first Duke of Northumberland) to paint a *View of the City of London through one of the Centres of the Arches of the New Bridge at Westminster*. But there were complications. George Vertue noted (*Notebooks*, vol. 2, p. 67) the rumour – possibly put about by dealers – that the painter who had been working in London was not Canaletto, but an imposter.

Signor Canaletti from Venice having been in London some time has painted several views about London, of the new bridge at Westminster and London Bridge and about Whitehall, in the country for the Duke of Beaufort, views of Badminton etc. On the whole something of him is obscure or strange. He does not produce work so well done as those of Venice or other parts of Italy which are in collections here and done by him there. Especially his figures in his works done here are apparently much inferior to those done abroad which are surprisingly well done and with great freedom and variety, his water and his skies at no time excellent, or with natural freedom, and what he has done here, his prospects of trees, woods, or handling or pencilling of that part not so various or so skilful as might be expected. Above all he is remarkable for reservedness and

shyness in being seen at work at any time or anywhere, which has much strengthened a conjecture that he is not the veritable Canaletti of Venice whose works there have been bought at great prices, or that privately he has some unknown assistant in making, or filling up his pieces of work with figures.

A month or so later however Vertue had discovered his error.

At last after some time I heard how that difficulty was speaked about this man was not the person so famed in Italy at Venice. It seems that his name and family was Canali – so he was always called. He had a sister who had a son who, having some genius was instructed by his uncle Canali and the young stripling came on forward in his profession, on being taken notice of for his improvement he was called Canaletti the young. But in time getting some degree of merit, he being puffed up amongst those of a natural genius to be distinguished, disobliged his uncle remarkably, who turned him adrift. But he, well imitating his uncle's manner of painting, became reputed and the name of Canaletti was used indifferently by both uncle and nephew. From thence the uncle came to England, and left the nephew at Venice.

As if conscious of these doubts, Canaletto put an advertisement in a newspaper on 4 July 1749.

Signor Canaletto hereby invites any gentleman that will be pleased to come to his house to see a picture done by him, being *A View of St. James's Park*, which he hopes may in some measure deserve their approbation. The said view may be seen from Nine in the Morning till Three in the Afternoon, and from Four to Seven in the Evening for the space of fifteen days from the date of this advertisement. He lodges at Mr. Wiggan's, cabinet-maker, Silver St. Golden Square.

Not all immigrant artists however were so successful as Canaletto. In 1744 Vertue recorded the story of Soldi, a Florentine.

Soldi, the painter by his merit and the interest of friends has had considerable business, lived well, kept house, a Madam etc, entertainments, which expenses put him into difficulties, running into debt and behind hand; at present his creditors prosecuted him to the Fleet (the debtors' prison) where he is now under composition. But his high mind and conception, grandiosity – willing to be thought a Count or a Marquis rather than an excellent painter – such wild vauntings have done him no good, and in this case will make it more difficult to submit to his creditors' terms.

Upon this occasion, some friends of his, finding he has business in hand begun for nobility and others, if a brace of hundreds and prospects of going on were enough, if he can make any abatement of his pride or expenses some hopes he may be re-established. The only singular affectation of thinking himself above the dignity of a painter, in his birth or parentage will be a check on his diligence and promoting his interest to get above necessity and beforehand – he can't relish his friends at certain times commending his skill in the art he professes, he would rather have the world believe he does them honour when he paints for them.

> Soldi died penniless in 1771 and Reynolds paid his funeral expenses out of his own pocket.

3.17 Prints and foreign parts

> Prints were opening up not only the world of past art, but present-ing the public with a far more convincing and accurate account of the actual physical world than had ever been possible before. This letter from the famous traveller James Bruce of Kinnard throws light not only on the processes involved in thus recording travels, but on the way in which English prints and engravings had found their way into the most unusual places. Dated 16 May 1768, it is addressed to the engraver Robert Strange, whom Bruce had met in Italy in 1762.

I suppose you will expect some account of what I have been doing in Asia, but as I hope several of my letters may at last have reached you, I shall not repeat the list which I have given you several times, and to which my bad health has prevented any later addition. You will see my works begin to be nearly as numerous as yours. I wish they resembled them in anything else. I have made myself as great a slave to them as ever man working for his bread did, and am aston-ished when I think of my own perseverance and self-denial. All that my utmost care and application can do is there; what degree of merit that will give them I will not judge, but will very cheerfully submit them to you. I have not, as far as I know, left one stone from which anything can be learnt, either in Africa, or the heart of Syria, through which I have travelled: and though the plague is very violent at Alexandria, such is my desire to embrace every-thing, and to return soon, that I part in a few days for Aegypt, and shall advance as far as the Cataracts, and return by the coast of the Red Sea. And after visiting Arabia Petraea and Deserts, I shall re-

turn through Syria, Mesopotamia, and take my station somewhere in Armenia, as far to the North-East, as the troubles of Persia and Georgia permit, to observe the transit of Venus in June 1769, and then continue my journey homeward through Asia Minor, by Constantinople, through the Morea and Bosnia to Ragusa, where I shall perform quarantine, and return speedily home through Sicily and the kingdom of Naples.

I heard while at Aleppo that a society of lovers of the arts had agreed to send a person well qualified into the Levant to make drawings and collect antiquities, and that his appointment was £1,000 per ann. and Mr Dingley in the City was the principal director. I dare say you will have told them how fruitless and unnecessary this [will] turn out. I have, I am sure, passed through every place where Europeans can go, and to many where no person merely an artist will expose himself, and to several where, with all the desire any one can have to run the risque, the ignorance of the language and customs of the country will be an invincible obstacle. And as for antiquities, they will nowhere meet with any but my leavings, either of medals intaglios and basso relievos, which will not be worth the carriage. In several places indeed I have received but little profit from my researches by Mr Montagu's having been there before me. Syria has indeed made me pay dearly for what I found there; I have had a severe fever, and five relapses this last year. It is an unwholesome climate, full of bad air, but the air of Mount Libanus, and still later of Nazareth has greatly strengthened me. We are entirely unprovided either with surgeons or physicians, and had it not been for the great humanity and attention of Dr Russell at Aleppo, I believe all my works would have been posthumous. I do recollect I think to have heard you say in Italy that Mr Mylne had some intention to publish a work on Sicily. I pray you to write me if it is so; I would not willingly interfere with anybody, and least of all with him. I am sure what he offers to the public will be very much as it ought to be, and if his intention continues, I will willingly relinquish the journey, or, if the drawings I may make do any ways serve him, he shall be entirely master of them. It gives me very great pleasure to hear his bridge [Blackfriars] goes on to his wishes. In all the clamours against him I never had a doubt, as I thought him sure of his principles; other architects there are paving streets, while he is employed in bridges and palaces. There is a particular providence presides over the arts, which, with a little patience, puts everybody in their proper places; it is very necessary that this should be an article of your credo.

I thank you for your kind offer of assisting me in my works. I have nearly finished twelve drawings of Palmyra, and four of Baalbeck, their size is 24½ inches by 16¼. It is but to you I say it, they will be the most magnificent prints of the kind ever published. I have not meddled with the regular architecture or description (except notes for my own instruction out of regard to Mr Wood). I have collected all the dresses of the different nations of Asia for figures for them. What do you say? Will you go halves in the publication? I desire but your superintending and correcting the engraving. We had great difficulty to get there, and still greater in returning; I am sure every design has cost me an eminent risque of my life.

I must now give you some account of your own performances even in the heart of Syria, for so far they are arrived. At Aleppo I saw in the house of a French merchant[1] where I lodged, an entire room alloted for your works without any other master being admitted. The room was elegantly fitted up in every respect, and all your performances there in elegant frames, from your first Cupid and Madonna down to your *Sleeping Child* by Guido, but *Justice* and *Meekness* were not yet arrived. You make a very great figure, but there is still room for many more of your prints, which are to be sent as soon as possible. In all the English houses there was not one to be met with, – fye upon us! What you say of our proficiency in England gives me great pleasure, and would give me much more if the encouragement came from the King, for, till that is the case we shall never do great things. The taste of the people, and especially that of England, is always changeable, but what kings promote is speedily accomplished. You see an example in France what royal patronage in a long reign has done. They were, I may say, till your time, the only engravers, the only painters and the only draughtsmen in Europe; they still excel all others in the two last. What is this, but the remaining genius which Louis the 14th rais'd and cultivated, which still subsists tho' his present Majesty has not at all contributed to maintain it.

I hear with the utmost concern that the engraving of my prints of Paesto at Paris has produced an edition there by M. Soufflet, which neither has nor deserves to have had any success. I am still more vexed to hear that, notwithstanding this, he is printing by subscription a work perfectly on my plan. I suppose during your

1. Strange had worked for some considerable time as an engraver in Paris.

absence he has seen my prints and probably copied them. Pray let me know how this is, and whether I have no friend that, in some review or periodical paper will advertise the public of the matter, and engage them to wait for mine. After receiving no answer or account, I did not dare risque my manuscript, as no direct opportunity ever offer'd for England, and last winter the fair copy was lost in a bark in the Gulf of Sidra, together with many of my books and designs and all my mathematical instruments, among which was a large astronomical quadrant, and two telescopes, which cost me a considerable sum, and which I am now obliged to replace. I was making the journey by land, and so escaped being involved in the misfortune. I have made a fair copy anew, and it is now ready but I have some thoughts to join it to *The Antiquities of Sicily* and make two volumes of *The Antiquities of Magna Graecia*. If your public encourages the plagiaries of M. Soufflet, at a time when I am taking such pains for their pleasure and instruction, they are not the patrons of art you would make them appear. I am well persuaded your collection of pictures is a good one; pray did you buy the two little landscapes of Albani at Bologna, or did you not find something worthy of your pains at Parma?

(James Bruce, *Travels* London 1791.)

3.18 Greek taste and Roman spirit

The Society of Dilettanti, formed in 1732, originally as a convivial gathering of young men of wealth and birth, who had been on the Grand Tour and were interested in art and antiquities, came to play a significant role in that ordered exploration of the treasures of the ancient world which was one of the most significant achievements of the eighteenth century. Between 1748 and 1753 Nicholas Revett, an architect, and James Stuart, a painter, had visited Greece, making detailed analyses of its architecture, which they published in 1762 *The Antiquities of Athens, measured and delineated by James Stuart FRS and FSA, and Nicholas Revett, painters and architects*. It was the foundation of the modern study of Greek archaeology, and fostered in Britain a 'Grecian Gusto' which made them famous and fashionable. Having accumulated a certain amount of capital, the Society decided to finance another expedition to explore the classical antiquities of the Middle East. It was to consist of Revett, Richard Chandler, an Oxford scholar, and William Pars, a young artist, and the following instructions, a model of lucidity and good sense, were drawn up for them.

113

Whereas the Society of Dilettanti have resolved that a person or persons properly qualified be sent, with sufficient appointment to some parts of the East, in order to collect information, and to make observations relative to the ancient state of these countries, and to such monuments of antiquity as are still remaining; and the Society having further resolved that a sum not exceeding £2,000 be appropriated to that purpose, and having also appointed you to execute their orders on this head; we the Committee, entrusted by the Society with the care and management of this scheme, have agreed on the following instructions for your direction in the discharge of that duty to which you are appointed.

1. You are forthwith to embark on Board the Anglicana, Captain Stewart, and to proceed to Smyrna, where you will present to Consul Hayes the letters which have been delivered to you from one of His Majesty's Principal Secretaries of State, and from the Turkey Company, and you will consult with Mr Hayes about the most effectual method of carrying these instructions into execution.

2. The principal object at present is that, fixing on Smyrna as your headquarters you do from thence make excursions to the several remains of antiquity in that neighbourhood, at such different times, and in such a manner as you shall, from the information collected on the spot, judge most safe and convenient; and that you do procure the exactest plans and measures possible of the buildings you shall find, making accurate drawings of the bas-reliefs and ornaments, and taking such views as you shall judge proper; copying all the inscriptions you shall meet with, and remarking every circumstance, which can contribute towards giving the best idea of the ancient and present state of these places.

3. As various circumstances, best learnt on the spot, must decide how you shall proceed in the execution of the foregoing article, we shall not confine you in that respect, and shall only observe in general, that by a judicious distribution of your time and business you may, with proper diligence, in about twelve months visit every place worth your notice within eight and ten days of Smyrna. It may be most adviseable to begin with such objects as are less distant from that city, and which may give you an opportunity of soon transmitting to the Society a specimen of your labours. You will be exact in marking distances and the direction in which you travel, by frequently observing your watches and pocket compasses, and you will take the variation as often as you can.

4. Though the principal view of the Society in this scheme is pointed at such discoveries and observations, as you shall be able to make with regard to the ancient state of these countries, yet it is by no means intended to confine you to that province; on the contrary, it is expected that you do report to us, for the information of the Society whatever can fall within the notice of curious and observing travellers, and, in order to ascertain more fully our meaning on this head, we do hereby direct, that from this day of your departure from hence to that of your return, you do each of you keep a very minute journal of every day's occurrences and observations, representing things exactly in the light they strike you in the plainest manner, and without regard to style or language, except that of being intelligible; and that you do deliver the same, with whatever drawings you have made (which are to be considered the property of the Society) to Mr Hayes, to be by him transmitted, as often as conveyances shall offer to us, under cover to William Russell Esq., Secretary to the Levant Company and you shall receive from us, through the same channel, such further orders as we may judge necessary.

5. Having ordered the sum of £200 to be invested in Mr Chandler's hands to defray all expenses which may be incurred till your arrival at Smyrna, we have also ordered a credit in your favour to the amount of £800 *per annum* to commence from the date of your arrival in that place; you giving drafts signed by Mr Chandler and Mr Revett of Mr Pars, the whole to be disposed of as follows, viz. £100 a year to Mr Revett, £80 a year to Mr Pars, who are each of them to be paid one quarter in advance; the remaining £620 to be applied to the common purpose by Mr Chandler, who is to be Treasurer, paymaster and accountant, and may appropriate to his private use such part of that sum as he shall find necessary, informing us of the management of the common stock, and transmitting to us his account from time to time.

6. And though our entire confidence in your prudence and discretion leaves us no room to doubt but that perfect harmony and good understanding, which are so necessary to your own happiness, as to the success of the undertaking, will subsist among you, yet in order to prevent any possible dispute which might arise about different measures in the course of this expedition, we expressly declare that the direction of the whole is hereby lodged in Mr Chandler, assisted by Mr Revett. And, though Mr Revett and Mr

Pars should protest against any measure proposed by Mr Chandler, it is our meaning that any such difference of opinion should not in the least interrupt or suspend your operations, but that at the same time that such persons as dissent from or disapprove of what is proposed, shall transmit to us their reasons for such dissent, they do notwithstanding continue to pursue Mr Chandler's plan until they receive our further orders for their conduct.

Given under our hands at The Star and Garter, this 17th day of May 1764.
Signed: Charlemont, Rob. Wood, Tho. Brand, Wm. Fauquier, James Stuart, Middlesex, Le Dispenser, J. Gray, Bessborough.

(Cust, L. *History of the Society of Dilettanti*, London 1911.)

3.19 A taste for archaeology

A taste for collecting was not confined to the upper classes. In 1760 Mrs Philip Lybbe Powys recorded, in one of her frequent peregrinations, that in Yeovil:

We failed not going to Mr Forbes's, an inn [*The Angel*] so very famous for an extraordinary kitchen that we were told it was worth going miles to see; and indeed it answered description, and may be called a general repository for curiosities of every sort its owner can collect – as china, pictures, shells, antiques etc., all ranged in order. There is two dishes of Roman earth, very handsome, and of great value, having been in this town three hundred years; and in another corner lay a lamp which Mr Forbes said was really dug out of the ruins of Herculaneum, and therefore esteems it very highly. But 'tis not only the kitchen at the inn deserves notice; the whole house is a curiosity.

(*Passages from the Diaries of Mrs Philip Lybbe Powys*, ed. E. J. Cleminson, Longman 1899)

4. Fine art and its institutions

Categories of art; the life of artists, patrons and collectors; the rise of institutions, exhibitions and art schools.

4.1 In praise of English art

English painting was growing in self-confidence by the beginning of the century, and Bainbridge Buckeridge's *Essay towards an English School of Painting*, addressed to Robert Child, and published in 1707, struck a note of cultural chauvinism which was to echo throughout the century.

But why should we be so unjust to ourselves, as to think we stand in need of an excuse, for pretending to the honour of a school of Painters as well as the French, who have been in possession of it almost as long as the Italians. You know, Sir, by the many beautiful pieces you have seen of the principal masters of both nations, that if they have had their Vouets, their Poussins, and le Bruns, we have had our Fullers, our Dobsons and our Coopers; and have not only infinitely out-done them in Portraits, but have produced more masters in that kind than all the rest of Europe.

We may also affirm, that the art is indebted to us for the invention of Metzotinto, and the perfection of crayon-Painting. By our author's account of Pastils, a name formerly given to Crayons, one may see that the Italians had a very slight notion of a manner that is practised here with so much success. They made their drawings on a grey paper, with black and white chalk and left the paper to serve for the middle tint. Their colours were like ours, dry, without any mixture of oil or water. Our countryman, Mr Ashfield, multiplied the number and variety of tints, and painted various complexions in imitation of oil; and this manner has been so much improved among us, that there is no subject which can be expressed by oil, but the crayons can affect it with equal force and beauty.

You, Sir who are so good a critic, and so generous a patron of the art, cannot but wish we had the same advantage as other schools have in an academy. It is true, we have several admirable collections, and your own in particular, whose pieces are enough to inform the most industrious disciple, and inspire his genius to

arrive at a mastery in the art. I have heard a famous Painter assert, that our English nobility and gentry may boast of as many good pictures, of the best Italian masters, as Rome itself, churches only excepted; and yet it is so difficult to have access to any of these collections, unless it be yours, Sir, who seem to have made your excellent collection as much for the public instruction, as for your own private satisfaction, that they are, in a great measure, rendered useless, like gold in misers' coffers. Had we an academy, we might see how high the English genius would soar, and as it excels all other nations in Poetry, so, no doubt, it would equal, if not excel, the greatest of them all in Painting, were her wings as well imped [engrafted] as those of Italy, Flanders and France. As for Italy, her academies have kept her genius alive, or it would have expired with her masters, who first shewed she had one, as her genius in poetry died with Tasso and his contempories. The French indeed are a forward people, who pretend to rival all nations of the world in their several excellences; yet considering they value themselves so much on their own academy, it is a matter of wonder to see so little improvement in them by it: And if we are equal only to them now, how much should we outshine them, had the English disciples in this art as many helps and encouragements as theirs?

4.2 National characteristics in art

On 6 December 1712 the *Spectator* discussed categories of painting, and the extent to which each nation had its own artistic varieties in a manner which may be thought of as typifying the general body of opinion on that subject at the time.

Painting is an Art of vast Extent, too great by much for any mortal Man to be in full Possession of, in all its Parts; 'tis enough if any one succeed in painting Faces, History, Battels, Landscapes, Seapieces, Fruit, Flowers or Drolls, & c. Nay no Man ever was excellent in all the Branches (tho' many in Number) of these several Arts, for a distinct Art I take upon me to call every one of these several Kinds of Painting.

And as one Man may be a good Landscape-Painter, but unable to paint a Face or a History tolerably well, and so of the rest; one Nation may excel in some kinds of Painting, and other kinds may thrive better in other Climates.

Italy may have the Preference of all other Nations for History-Painting; Holland for Drolls, and a neat finished manner of Work-

ing; France for Gay, Jaunty, Fluttering Pictures; and England for
Portraits; but to give the Honour of every one of these kinds of
Painting to any one of those Nations on account of their Excellence
in any of these parts of it, is like adjudging the Prize of Heroic,
Dramatic, Lyric or Burlesque Poetry, to him who has done well in
any one of them.

Where there are the greatest Genius's, and most Helps and En-
couragements, 'tis reasonable to suppose an Art will arrive to the
greatest Perfection: By this Rule let us consider our own Country
with respect to Face-Painting. No Nation in the World delights so
much in having their own, or Friends' or Relations' Pictures;
whether from their National Good-Nature, or having a Love to
Painting, and not being encouraged in that great Article of Reli-
gious Pictures, which the Purity of our Worship refuses the free use
of, or from whatever other Cause. Our Helps are not inferior to
those of any other people, but rather they are greater; for what the
Antique Statues and Bas-reliefs which Italy enjoys are to the His-
tory-Painters, the beautiful and noble Faces with which England is
confessed to abound, are to Face-Painters; and besides, we have the
greatest Number of the Works of the best Masters in that kind of
any People, not without a competent Number of those of the most
Excellent in every Part of Painting. And for Encouragement, the
Wealth and Generosity of the English Nation affords that in such a
degree, as Artists have no reason to complain.

And accordingly in fact, Face-Painting is no where so well per-
formed as in England: I know not whether it has lain in your way
to observe it, but I have, and pretend to be a tolerable Judge. I have
seen what is done Abroad, and can assure you that the Honour of
that Branch of Painting is justly due to us. I appeal to the judicious
Observers for the Truth of what I assert. If Foreigners have often-
times, or even for the most part, excelled our Natives, it ought to
be imputed to the Advantages they have met with here, join'd to
their own Ingenuity and Industry, nor has any one Nation disting-
uished themselves so as to raise an Argument in favour of their
Country; but 'tis to be observed, that neither French nor Italians,
nor any one of either Nation, notwithstanding all our Prejudices in
their Favour, have, or ever had, for any considerable time, any
Character among us as Face-Painters.

This Honour is due to our own Country; and has been so for
near an Age: So that instead of going to Italy, or elsewhere, one
that designs for Portrait Painting ought to Study in England.
Hither such should come from Holland, France, Italy, Germany,

& c. as he that intends to Practices any other kinds of Painting, should go to those Parts where 'tis in greatest Perfection. 'Tis said the Blessed Virgin descended from Heaven to sit to St Luke; I dare venture to affirm, that if she should desire another Madonna to be Painted by the Life, she would come to England; and am of Opinion that your present President, Sir Godfrey Kneller, from his Improvement since he Arrived in this Kingdom, would perform that Office better than any Foreigner living.

4.3 A French view

The prevalence of portrait painters, and the fact that British painting seemed exclusively composed of them had already become a commonplace of foreign criticism, and a French visitor made the point as early as 1690, when the Abbé Le Blanc write his *Lettres d'um Français* to his friend De Bos, first published in 1745.

At present in London the portrait painters are more numerous and more unskilful than ever they were. Since Mr Vanloo came hither, they strive in vain to run him down; for nobody is painted but by him. I have been to see the most noted of them; at some distance one might easily mistake a dozen of their portraits for twelve copies of the same original. Some have their heads turned to the left, others to the right; and this is the most sensible difference to be observed between them. Excepting the single countenance or likeness they have all the same neck, the same arms, the same colouring and the same attitude. In short these pretended portraits are as void of life and action as of design in the painter.

4.4 The popularity of portraiture

That shrewd French observer of the English cultural scene, André Rouquet, made some sharp observations on the status of the portrait painter, his selling techniques and the attitudes of his clientěle in his *The Present State of the Arts in England* (1755).

Portraiture is the kind of painting the most encouraged, and consequently the most followed in England; it is the polite custom, even for men, to present one another with their pictures

A portrait painter in England makes his fortune in a very extraordinary manner. As soon as he has obtained a certain degree of reputation, he hires a house fit for a person of distinction; then he

assumes an air of importance and superiority over the rest of his profession, depending less on his personal abilities to support this superiority than on the credit of some powerful friend, or some woman of quality, whose protection he has purchased, and which he sometimes courts, not much to his honour. His aim then is not so much to paint well, as to paint a great deal; his design is to be in vogue, one of those exclusive vogues which for a while shall throw into his hands all the principal portraits that are to be drawn in England. If he obtains this vogue, to make a proper use of it, he is obliged to work extremely quick, consequently he draws a great deal worse, by having a great deal more business. Fashion, whose Empire has long subverted that of reason, requires that he should paint every face in the island, as it were against their will, and that he should be obliged to paint much worse than he should really chuse, even by those who employ him. He thinks of nothing but monopolising the whole business, and imagines himself a very clever fellow in stupidly expressing an insolent compassion for some defect in politics or abilities which he humbly pretends must be the cause of the bad success of his bretheren; from whence he takes occasion to publish that they are quite neglected, and affects in appearance to wish them a better fate. Thus I have seen it practised in late instances. And yet I do not pretend but that there are vogues in consequence of merit only, but these are very rare. A stock of assurance and affectation will enable a man to make the best of a small share of abilities, and even to supply their place where they happen to be wanting.

We cannot say the public are really the dupe of all these puerilities, which we have been here exposing, they are only dupes to the fashion which they follow, even with reluctance; it is the fashion which carries them to a painter, of whom they have no great opinion, to engage him out of vanity to draw their picture, which they have no occasion for, and which they will not like when finished. But the women especially must have their pictures exposed for some time in the house of that painted who is most in fashion

Every portrait painter in England has a room to shew his pictures, separate from that in which he works. People who have nothing to do make it one of their morning amusements to go and see these collections. They are introduced by the footman, without disturbing the master, who does not stir out of his closet unless he is particularly wanted. If he appears, he usually pretends to be about some person's picture, either to have an excuse for returning sooner to his work, or to seem to have a great deal of business, which is

often-times a good way of getting it. The footman knows by heart all the names, real or imaginary, of the persons whose portraits, finished or unfinished, decorate the picture room; after they have started a great deal, they applaud loudly or condemn softly, and giving some money to the footman, they go about their business. Then they declare openly for or against the artist; the dispute grows warm; they pretend to be judges, and those who have declared in his favour, make him draw their pictures to prove his abilities.

When a portrait painter happens to have a little business, it is usual for him to employ other hands in the painting of the drapery. Two rival artists took it into their heads to hire entirely to themselves another painter, whose name was VanHaken, to be employed in the drawing of the drapery; this man had real abilities, and might have done much better things, but chose to confine himself to his branch, because he was always sure of business. The two painters agreed to pay him eight hundred guineas a year, whether they could find him work to his amount or not; and he, on his side, engaged to paint no drapery, but for them. When either of those painters was engaged to draw a picture, it was frequently on the condition that the drapery should be done by VanHaken. And indeed his drapery was charming, and in excellent taste, and extremely natural. The two rival painters who had thus engrossed VanHaken, occasioned a good deal of confusion amongst the rest of his brother artists, who could not do without his assistance. The best of them knew not how to draw a hand, a coat, or ground; they were obliged to learn it, and of course to work harder. Sad misfortune! From that time ceased that extraordinary sight at VanHaken's, when he used to have canvases sent him from different parts of London, and by the stage coaches from the most remote towns of England, on which one or more masks were painted, and at the bottom of which the painter who sent them took care to add the description of the figures, whether large or small, which he was to give them. Nothing can be more ridiculous than this custom which would have continued, had VanHaken still continued.

This kind of practise supposes a prodigious number of portraits, and indeed it is amazing how fond the English are of having their pictures drawn; but as peoples' fortunes are more upon a level in England than in any other country, and as the very best painters take only ten or twelve guineas for a bust, this moderate price is no hindrance to the custom of frequently making a present of one's picture.

4.5 Honesty in art

The idea that art depended on its honesty and truthfulness was to be one of the main doctrines of the romantic attitude, and to reach its plentitude of expression in the nineteenth century. But it was already making its appearance early in the eighteenth, and the problems it created were analysed by that popular philosopher Anthony Ashley Cooper, 3rd Earl of Shaftesbury in his Essay on the *Freedom of Wit and Humour*, first printed in 1710, which appears in the first volume of his *Characteristicks*, 1758 ed, pp. 96 *et seq*.

And thus, after all, the most natural beauty in the world is honesty and moral truth. For all beauty is Truth. True features make the beauty of a face, and true proportions of the beauty of architecture, as true measures that of harmony and musick. In poetry, which is all fable, truth is the perfection. And whoever is scholar enough to read the ancient philosopher, or his modern copyists, upon the nature of a dramatick and epic poem, will easily understand this account of the truth.

A painter, if he has any genius, understands the truth and unity of design; and he knows he is even then unnatural, when he follows nature too close, and strictly copies life. For his art allows him not to bring all nature into his piece, but a part only. However, his piece, if it be beautiful, and carries truth, must be a whole, by itself complete, independent, and withal as great and comprehensive as he can make it. So that particulars, on this occasion, must yield to the general design; and all things be subservient to that which is principal; in order to form a certain easiness of sight, a simple, clear and united view, which would be broken by the expression of anything peculiar or distinct.

Now the variety of nature is such as to distinguish everything she forms by a peculiar, original character, which, if strictly observed, will make the subject appear unlike to anything extant in the world besides. But this effect the good poet and painter seek industriously to prevent. They hate minuteness, and are afraid of singularity, which would make their images, or characters appear capricious and fanatical. The mere face-painter, indeed, has little in common with the poet, but like the mere historians, copies what he sees, and minutely traces every feature and odd mark. 'Tis otherwise with the men of invention and design. 'Tis from the many objects of Nature, and not from a particular one that these genius's form the idea of their work. Thus, the best artists are said to have been indefatigable in studying the best statues, as esteeming them a better rule than the most perfect human body could afford....

But here, I find, I am tempted to do what I have myself condemned. Hardly can I forbear making some apology for my frequent recourse to the rules of common artists, to the masters of exercise, to the academies of painters, statuaries, and to the rest of the virtuoso tribe. But in this I am so fully satisfied I have reason on my side, that, let custom be ever so strong against me, I had rather refer to these inferior schools to search for Truth, and Nature, than to some other places, where higher arts and sciences are professed.

I am persuaded that to be a virtuoso (so far as befits a gentleman) is a higher step to becoming a man of virtue and good sense than the being what in this age we can call a scholar.

4.6 The difficulties of elevated art

Reynolds' comments on the lack of 'history' painting in England reflects the universal attitude that categories of paintings had relative values; history (including religious painting) at the top; portrait and genre at the bottom. Throughout the century there had been a conscious drive to 'improve' English painting by encouraging work of this kind. One of the most enthusiastic purveyors of this idea was James Barry, who in 1774 published *An Inquiry into the Real and Imaginary Obstructions to the Acquisition of the Arts in England*, a powerful and in many ways effective polemic in favour of the kind of patronage which would allow the development of what he saw as a higher type of art. In 1775 he undertook to provide a cycle of paintings for the great room of the Royal Society of Arts in The Adelphi, without any fee other than the admission payments to two exhibitions of the work in 1783 and 1784, together with the profits from prints made of them. In 1783 to publicize these exhibitions he published *An Account of a Series of Pictures in the Great Room of the Society of Arts*, in the introduction to which he presented his views with typical fervour and lack of charity.

When I was at Rome, Abbé Winckelmann, the Pope's antiquary, published a history of the art, which gave great offence to many of our people, as it contained very severe reflections upon the character of the English, charging them with the want of capacity and genius to succeed in the superior exertions of the art of painting etc., and that their practice demonstrated that they were fitted for nothing greater than portraits and other low matters, from whence no honour could be derived, either to the artist or the country. Abbé Winckelmann having in this matter only gleaned after Abbé Dubos and the President Montesquieu these injurious opinions

which become the common creed of the greatest part of the dilet-tanti. It appeared to me that the setting of these matters in their true point of light would be an undertaking not unbecoming an artist; and from whence some little credit might be derived; I was ready enough to flatter myself that the doing of this had fortunately been reserved for me; and accordingly, soon after my return from Italy, I took the liberty of humbly presenting his majesty (as the first fruits of his Academy) with my *Inquiry into the Real and Imaginary Obstructions of the Arts in England*, published in 1774, and it has been not a little flattering to me since, to find that the object of it true and indubitable, by those who stand in the highest estimation with the public, for judgement, knowledge and candour.

But the most satisfactory proof of all was yet wanting; I mean the actual production of some great work of historical painting.

This was little likely to happen; not so much from any insurmountable difficulty in the undertaking itself, as from the servile, trifling views of the public, the particular patrons, or more properly, the employers of the artists, who from causes explained in the inquiry above mentioned were intent upon nothing but the trifling particulars of familiar life, wasting the whole time, vigour and practice of our artists, in such a way as made genius and high information quite useless, and rendered the few who, from nature and study, were at all qualified, but the more unfit to reach that standard by which alone we could be entitled to view with the great performances of Italy, France etc.

The difficulty of subsisting by any other species of art than that of portrait painting, the mean counsel of parents and friends, under the mistaken notion of prudence, and the love of ease and affluence, had so operated upon our youth, that the country had become filled with this species of artists.

When men suffer themselves to be forced away from their own views of obtaining an honest fame by advancing their art, by adding new energies to it, by attempts to unite it more closely with the utility an improvement of mankind, in manners, in understanding, in private and in public virtue; when men are prevailed on to relinquish these, it may well be imagined that some few may be found capable of running into their very opposites, into what is not only mercenary and sordid, but also vicious. From our too eager attention to the trade of portraits, the public taste for the arts has been much depraved, and the mind of the artist often shamefully debased; and yet the sole painting of these portraits, comparatively contemptible as it appears to people of elevated minds, to for-

eigners, and, indeed, to all who are not acquainted with and interested in the originals, is notwithstanding, the means amongst us by which is obtained a fashion, a fortune, and upon true commercial ideas, rank and fortune, as the business and resort of the shop, and the annual profits of it, are the only estimates which generally come under consideration. This then is the mess of pottage for which these Esaus sell their birthright; and the loss is surely more than the gain in such a barter, where well-deserved glory is meanly sacrificed to a factitious thirst for lucre and vanity, with which it is impossible for the mind to be satisfied.

When, therefore, we reflect that, in the number of those who apply to the arts, many must unavoidably fail of success, from the want of natural parts and genius; many more from the want of education and proper culture; many others lost in sordid pursuits, in pleasure, indolence etc., there can be very few indeed likely to think of struggling with the difficulties of elevated art; of this, some few wait in vain for patrons, who though not always necessary to those who will employ themselves in mean and ordinary things, are yet greatly wanting for the furtherance of superior views. A very little would do a great deal in this way; and it is to be hoped that patronage and honourable countenance will not be flung away without benefit to art, or credit to either the country or the donor. But this, added to other reasons, will sufficiently account why so little has been hitherto done in superior art.

If picture knowledge is new in England, it will not always be so; we ought not to build too confidently on the ignorance of the public. The majesty of historical art requires not only novelty, but a novelty full of comprehension and importance. It is an absurdity to suppose, as some mechanical artists do, that art ought to be so trite, so brought down to the understanding of the vulgar, that those who run may read. When the art is solely levelled to the immediate comprehension of the ignorant, the intelligent can find nothing in it, and there will be nothing to improve, or reward the attention even of the ignorant themselves, upon a second or third view. So much for what was wanting in historical art.

As I had been bred up in this way, had every advantage of study, and time before me, I thought myself bound in duty to the country, to the arts and to my own character, to endeavour at supplying this deficiency of a public work of historical art, and to try whether my abilities would enable me to exhibit the proof as well as the argument.

4.7 A wild opinion

In his *Inquiry into the Real and Imaginary Obstructions to the Acquisition of the Arts in England* (1774) James Barry not only assailed the fashionable theory of Winckelmann that the nature of a national art is determined by physical factors such as race and climate, but made a determined stand on what he saw as stylistic priorities, a stand which was to be reflected in much of the future history of art education.

As to the notion that a portrait-painter can, when called upon, paint history, and that he can, merely from his acquaintance with the map of the face, travel with security over other regions of the body, every part of which has a peculiar and different geography of its own; this would be too palpably absurd to need any refutation. He may indeed, by reading and conversation, beg, borrow, collect or steal opinions, and he may make out general theories; but even in the way of theory, what he mixes of his own head will be at best loose and vague, as it cannot be confirmed by the result of his own observation, from repeated and familiar practice. It is easy to collect eulogiums upon Michael Angelo and the other great fathers of historical excellence; but we ought to be careful how we add to them. I repeat this because of a wild opinion which has got into circulation, and must be attended with very mischievous consequences should any young artist regulate his practice by it. The opinion is, that the grand style, and an attention to exactness in the minuter parts of the body are incompatible; and Michael Angelo is mistakenly held out as the example of a style of art consisting of all genius and soul, and which was above attending to an exactness in the minutiae and detail of his figures. This is false, both in the precept and the example. Michael Angelo is, of all men, one of the most remarkable for this precision, and this attention to the detail, or smaller parts of his figures; there is actually more work, and 'making out' (as the artists call it) in one arm or leg executed by this great man, than is to be found in two entire figures of these vague, slovenly theorists.

It may answer the convenient purposes of inability to insinuate that this attention to particular parts is an affected display of knowledge and a boastful ostentation, but this is naturally to be expected; we can all of us be eloquent enough in declaiming upon the depravity or misuse of such matters as happen to be out of our reach

As to the many who can have no part in the question of superior art, they ought, in conscience, to content themselves with those

greater profits which in this commercial country must ever follow from the practice of the lower branches, especially as they cannot hope to keep up for ever that false weight and importance which they have assumed in consequence of those greater gettings. It is therefore to be hoped that they will no longer find it practicable to play the part of 'dog in the manger' as they have hitherto done, for a great many of the blocks and impediments which have been thrown in the way of superior art, have been greatly owing to the secret workings and machinations of these men.

4.8 The diversity of talent

Posterity has been selective about those artists whose names it has retained. As well as the famous, there was a whole range of 'inferior' artists, working at a multiplicity of tasks – coach-painters, inn-sign painters, itinerant portrait-painters, and just unsuccessful painters. Here are a few examples.

A Dutchman, named Vanderstraeten hired a long garret, where he painted cloths many feet in length, as long as they were woven, and painted the whole at once, continuing the sky from one end to the other, and then the several grounds etc. till the whole was one long landscape. This he cut, and sold by parcels as demanded to fit chimneys etc. and those who dealt in this way would go to his house, and buy three or four, or any number of feet of landscapes. One day when Vanderstraeten's wife called him to dinner, he cried out; 'I will come presently: I have done Our Saviour, I have only the twelve Apostles to do.' Nor is this improbable of such a man, who could paint a picture of the size he usually practised in a minute, a spot for the head, and two or three touches for the rest. And notwithstanding they were so slight, even these pictures were not entirely devoid of merit, for he had something like genius and taste, and painted much in the style of Francisque, and did all that could be done in the time he allowed himself, and I may perhaps be partial to him on that account, having had great pleasure when young in visiting him.

(Joseph Highmore, *Gentleman's Magazine* March 1751)

James Bunk

In a Work which is intended to record the progress of the arts by professional artists, it is necessary to notice those who have contributed their feeble efforts toward supporting a spirit of enrichment

and decoration among the inferior virtuosi. In that class of artists may be reckoned the person here mentioned, who was a painter of no great powers. He was chiefly employed by those who required subjects for mechanical movements. Such as clocks for the East Indies, in which figures are represented, that are put in motion by the machine which they decorate.

He painted in a variety of ways, landscapes and still life, but his favourite productions were candle-light pieces; such as, old men reading by the light of a taper held in the hand, with many similar subjects, wherein the light of a candle was sufficiently well represented to catch the eyes of inferior collectors; but his works were mostly copies after prints from Schalken, and Hontorst.

He was an exhibitor with the Free Society of Artists, from the year 1766 to 1769 inclusive; during which time he resided at Stangate, Lambeth. It is not known when he died, but it is supposed to have been about the year 1780, as he ceased to exhibit at that period.

(Edward Edwards, *Anecdotes of Painters*, 1808)

Hamlet Winstanley (a pupil of Kneller) travelled about and drew pictures from the life in oil colours – often on small pieces of cloth, only the face; pasted them, then sent to London on larger cloths; one, two or three more whole family pieces he did in this manner; only did the faces, sent them to Mr VanHaken, an excellent painter of drapery. He stuck them on large, stained cloths, as he pleased, and made postures and draperies, and so made them complete pictures. . . . Mr VanHaken having an excellent, free, genteel and florid manner of pencilling silks, satins, velvets, gold lace etc., has worked hard for several painters for dressing and decorating their pictures, which, without his help and skill would make but a poor figure. They send their pictures, when they have done the face, to be drest by him, in which he has a very ready talent, and more merit than anyone living since Baptist, who painted much in that way for Sir Peter Lely. It is a great addition to their work, and indeed puts them so much on a level that it is difficult to know one hand from another.

(George Vertue, *Notebooks*, Walpole Society 1932)

4.9 Sign painting

In an age when virtually every shop had its own sign – to assist the illiterate – sign painters were greatly in demand, and though one of

129

the more humble branches of art, it was one of the most prolific; Watteau in France, Hogarth in England both produced works in this genre, and it was the most popular and accessible form of art. In 1762 Bonnel Thornton, a writer and man about town, organized an exhibition of the 'Society of Sign Painters' at his house in Bow Street, but as the *London Evening Post* observed: 'As it is imagined by the public in general that the exhibition of a pretended Society of Sign Painters is intended as a burlesque upon the laundable Society for the encouragement of arts and sciences, no advertisements shall appear in this paper anyways tending to a reflection on so honourable and respected a body.' There was probably a similar satirical undercurrent in the paragraph which appeared in the *Adventurer* on 5 December 1752.

I am, at present, but a humble journeyman sign-painter in Harp Alley; for, although the ambition of my parents designed that I should emulate the immortal touches of a Raphael or a Titian, yet the want of taste among my countrymen, and their prejudice against every artist who is a native, have degraded me into the miserable necessity, as Shaftesbury says of 'illustrating prodigies in fairs, and adorning heroic sign-posts'. However, as I have studied to improve even this meanest exercise of the pencil, I intend to set up for myself, and to reduce the vague practice of sign-painting to some standards of elegance and propriety.

Some idea of the diversity of the more humble varieties of painting can be gleaned from the reminiscences which John Thomas Smith, who became Keeper of Prints and Drawings in the British Museum, included in his *Nollekens and His Times*, which, though published in 1829, refers back to the previous century, when he was a pupil of that sculptor.

We visited the studio of Joseph Wilton RA, and viewed his works as well as the model of King George III's state-coach, a most beautiful little toy, exquisitely adorned with ornaments modelled in wax by Capitsoldi and Voyez, the panels being painted in watercolour by Cipriani. The designs consisted of flowers and historical emblems, and Cipriani also painted the same subjects upon the coach itself; but he was not the first eminent artist who had thus adorned a coach, or even painted a sign.

The old royal state coach was purchased by the City of London; the panels of which were repainted by Dance, afterwards Sir Nathaniel Dance Holland, Bart,[1] who was the painter of that most

1. This story is highly unlikely.

admirable whole-length picture of Garrick in Richard III, now in the front drawing-room of Sir Watkins Williams Wynn Bart in his town mansion in St James's Square.

Mr Smirke, the celebrated artist, also served his time under a Herald-painter of the name of Bromley, who died lately in Queen Street, Lincoln's-Inn-Fields.

George Morland painted a sign of a White Lion, for a public-house at Paddington,[2] Monamy, the famous Marine-painter decorated a carriage for the gallant and unfortunate Admiral Byng, with ships and naval trophies; and he also painted a portrait of Admiral Vernon's ship, for a famous public-house of the day, well known by the sign of the *Porto Bello*, remaining until recently within a few doors north of the church in St Martin's Lane.

After the battle of Culloden, most of the old signs of military and naval victors gave way to the head of Duke William; and Horace Walpole has noticed his change in his thirteenth letter to Mr Cosway, dated April the 16th 1747.

'I was' says that elegant author, 'yesterday out of town, and the very signs, as I passed through the villages, made me make some very quaint reflections on the mortality of fame and popularity. I observed how the Duke's head had succeeded almost universally to Admiral Vernon's, as his had left but a few traces of the Duke of Ormond's. I pondered all these things in my heart, and said unto myself, surely all glory is but as a sign.'

Clarkson, the portrait painter, was originally a coach-panel and sign-painter; and he executed that most elaborate one of Shakespeare, which formerly hung across the street at the north-east corner of Little Russel Street in Covent Garden; the late Mr Thomas Grignon informed me that he had often heard his father say that this sign cost five hundred pounds! In my boyish days it was for many years exposed for sale for a very trifling sum, at a broker's shop in Lower Brook Street, Grosvenor Square. The late Mr Grace of Great Queen Street, assured me that it was in his early days a thing that country people would stand and gaze at, and that that corner of the street was hardly passable.

Charles Catton Esq., R. A. was also in his early life, a coach and sign painter; he painted a lion as a sign for his friend, Wright, a famous coach-maker, at that time living in Long Acre. This picture, though it has weathered many a storm, is still visible at the

2. The White Lion, much frequented by drovers, which was opposite the house where Morland lived.

coach-maker's, on the west side of Wells Street, Oxford Street.

Baker, a famous Flower-painter, decorated coach-panels with borders and wreaths of flowers; and he made a most splendid display of his taste on the panels of the coach of the famous Dr Ward, who enjoyed almost the whole practice of his profession, after he had so succesfully set the sprained thumb of George II.

Richard Wilson, the landscape painter, once condescended to paint a sign of *The Three Loggerheads*, for the house so-called, near the spot where he died.[3]

4.10 Coach and herald painters

Charles Catton R.A. was born at Norwich, and apprenticed to a coach-painter in London of the name of Maxfield. With a laudable ambition to improve his talents he became a member of the Academy in St Martin's Lane, where he acquired a good knowledge of the human figure, which together with his natural taste, ranked him above all others of his profession in London.

He was the first herald-painter who ventured to correct the bad manner of painting the supporters of coats of arms, which had long been the practice of his predecessors, whose representations of animals were considered as heraldic fictions rather than the resemblance of animated nature. At the foundation of the Royal Academy he was appointed one of the members.

He also served the office of Master of the Company of Painter-Stainers in the year 1784.

He retired from business some years before his death, which happened rather suddenly in the last week of August.

He left a son who practises in art, especially as a scene-painter.

It should be observed that the profession of coach-painting might some years ago boast itself as holding rank among the arts, but, since the opulent coach-makers have taken this branch of decoration into their hands, the herald-painters are become no more than their journey-men, consequently the most ingenious amongst them have no stimulus to exert their talents, or seek improvement, when neither honour nor profit can be obtained from their exertions.

Hence it is, that while carriages have been in the highest degree improved both for elegance and comfort, the painted decorations

3. On the old Flintshire/Denbighshire border near Mold, in North Wales.

have degenerated into a state of frivolity an meanness, from which it is not probable that they should emerge, until the profession is restored to that independent state which it enjoyed at the time Mr Catton began his career.

(Edward Edwards, *Anecdotes of Painters*. 1808)

4.11 Enthusiastic amateurs

Since Elizabethan times an ability to draw and paint had been considered an essential part of upper-class education. In August 1713 Alexander Pope, who had studied painting with Charles Jervas, who succeeded Kneller as Principal Painter to George I, wrote to his friend, the poet John Gay.

Every day the performance of others appear more beautiful and excellent and my own more despicable. I have thrown away three Dr Swifts, each of which was once my vanity, two Lady Bridgwaters, a Duchess of Montague, besides half a dozen Earls and one Knight of the Garter. I have crucified Christ over and over again in effigy, and made a Madonna as old as her mother, St Anne. Nay, what is more miraculous, I have rivalled St Luke himself in painting; and as it is said an angel came and finished his piece, so you would swear a devil put the last hand to mine, it is so begrimed and smutted. However, I comfort myself with a Christian reflection, that I have not broken the commandment; for my pictures are not the likeness of anything in heaven above, or in earth below, or in the water under the earth.

(Alexander Pope: *Letters*, London 1751)

In 1771 Smollett had Mr Bramble writing to Dr Lewis on 19 May in *Humphry Clinker* about another amateur 'who paints landscapes for his amusement'.

I shall to-morrow set out for London. Although I am no admirer of Bath, I shall leave it with regret; because I must part with some old friends, whom, in all probability, I shall never see again. In the course of coffee-house conversation, I had often heard very extraordinary enconiums passed on the performances of Mr Taverner, a gentleman residing in this place, who paints landscapes for his amusement. As I have no great confidence in the taste and judgment of coffee-house connoisseurs, and never received much pleasure from this branch of the art, those general praises made no impression at all on my curiosity; but, at the request of a particular

friend, I went yesterday to see the pieces which had been so warmly commended. I must own I am no judge of painting, though very fond of pictures. I don't imagine that my senses would play me so false as to betray me into admiration of anything that was very bad; but true it is I have often overlooked capital beauties, in pieces of extraordinary merit. If I am not totally devoid of taste, however, this young gentleman of Bath is the best landscape-painter now living; I was struck with his performances in such a manner as I had never been by painting before. His trees not only have a richness of foliage, and warmth of colouring, which delights the view; but also a certain magnificence in the disposition and spirit in the expression, which I cannot describe. His management of the chiaro oscuro, or light and shadow, especially gleams of sunshine, is altogether wonderful, both in the contrivance and execution; and he is so happy in his perspective, and marking his distances at sea, by a progressive series of ships, vessels, capes and promontories, that I could not help thinking I had a distant view of thirty leagues upon the back-ground of the picture. If there is any taste for ingenuity left in a degenerate age, fast sinking into barbarism, this artist, I apprehend, will make a capital figure, as soon as his works are known.

4.12 A painting coalman

The eighteenth century was not without its own 'primitives'. Most of these practised in the area of popular prints, inn signs, and reach-me-down portraiture, but there were some who had more sophisticated skills, as this extract from the *Gentleman's Magazine* for January 1735 suggests.

One Joseph Browne, a poor coal-heaver here in Norwich, aged 34, merely by application and good natural parts, has not acquired the art of reading and writing and common arithmetic, but is become an excellent copying painter. He learned by the strength of memory that a drawing or character of the word *Grocer* or *Draper* signify those trades, without being able to divide the words into letters. He has looked into no books of drawings or colouring, but one entitled *The Polygraphic Dictionary*, which he now has thrown aside, and a mean book of perspective which he once borrowed. The first piece which brought him into public notice was a copy of a sea-piece of Monamy's about two years ago; he afterwards copied some of Tenier's, and other good masters; and many gentlemen have since

lent and procured him some of his best pieces, to be copied for themselves and their friends, which he does at a price much below the merit of his performance; for as yet he values his time employed in painting at little more than he could get a coal-heaving, which he still continues at occasionally, by way of relaxation from the employment of his mind. He has by the force of his genius attained a colouring which has so much the appearance of age as surprises the most eminent painters. He has got so much of perspective as to measure distances, and either makes the copy larger or smaller at pleasure.

4.13 The Kneller factory

Successful artists still used – as Rubens for instance had done before – an assembly-line-like procedure in their studios. An anonymous correspondent to a London paper (quoted W. T. Whitley, *Artists and their Friends in England*. London, 1928) described, some years after the death of Sir Godfrey Kneller, how he operated a picture factory 'established upon as regular principles as the fabricating of carpets at Kidderminster'.

In his hands, painting became a trade, and was conducted upon precisely the same principles. To execute as many pictures as he could get orders for in the shortest space of time was his only object, and to facilitate their progress he appointed each assistant to his peculiar province. When he had finished the face, and sketched in the outlines of the shoulders etc., the picture was given to the artist who excelled in painting a hat, and when the hat was fixed upon the head, or tucked under the arm, the canvas was consigned to the painter of the periwig, who having given eternal buckle [waves] to the flowing white curls which hung in ample ringlets on each shoulder, turned it over to another, who gave the glossy blue velvet coat, that a further industrious artisan had ornamented with curious worked buttons, each of them wrought up with all the laborious accuracy of the German school. One excelled in the delineation of the laced handkerchief and point ruffles, while the broad gold lace which decorated the scarlet waistcoat was the forte of another.

His women were treated in precisely the same manner: one German genius had the adjustment of the laced tucker, another gave the embroidered stomacher. To one he committed the care of the graceful robe which was so elegantly disposed that the wearer could not walk across the room without dropping it off, while another

135

was to paint the red and green parrot which perched upon Madame's left hand; and the lamb which she was stroking with the other was the province of the *pastoral* painter.

4.14 The importance of dress in painting

A problem which greatly exercised painters and sculptors, as it was to for the next hundred years – especially when the outburst of public statuary in Victorian England raised it in an acute form – was that of dress. Were portraitists and others to garb their sitters in togas or wigs, in the dresses of Van Dyck or those of Vauxhall? As usual Jonathan Richardson had some sensible words to say about it in his *Essay on the Theory of Painting* (1715).

The draperies must have broad masses of light and shadow, and noble large folds to give a greatness; and these artfully subdivided give grace. Not only the large folds and masses must be observed, but the shapes of them, or they may be great, but not beautiful. The linen must be clean and fine; the silk and stuffs new, and the best of the kind.

Lace, embroidery, gold and jewels must be sparingly employed. Nor are flowered silks used by the best masters as plain; nor these so much as stuffs, or fine cloth; and this is not to save themselves trouble, of which, at the same time, they have been profuse enough in a more proper place. In the cartons[1] Raphael hath sometimes made silks, and some of his draperies are scolloped, some a little striped, some edged with a kind of gold lace, but generally they are plain. Though he seems to have taken more pains than needed in the landscapes, as he hath also in those badges of spiritual dignity on the heads of Christ and the Apostles; but these, as all other ensigns of grandeur and distinction, as they have been wisely invented to procure respect, awe and veneration, give a greatness, as well as beauty to a picture.

It is of importance to a painter to consider well the manner of cloathing his people. Mankind have shewn an infinite variety of fancy in this, and for the most part have disguised rather than adorned human bodies. But the truest taste in this matter the ancient Greeks and the Romans seem to have had; at least the great idea we have of those brave people prejudices us in favour of whatever is theirs, so that it shall appear to us graceful and noble; upon

1. Now in the Victoria and Albert Museum.

which of either accounts, whether of a real or imagined excellence, that manner of cloathing is to be chosen by a painter when the nature of his subject will admit of it. Possibly improvements may be made, and should be endeavoured, provided one keeps this antique taste in view, so as to preserve the benefit of prejudice just now spoken of. And this very thing Raphael hath done with great success, particularly in the cartons. Those who, in representing ancient stories have followed the habits of their own times, or gone off from the antique, have suffered by it; as most of those of the Venetian school have done.

But, however a figure is clad, this general rule is to be observed, that neither must the naked be lost in the drapery, nor too conspicuous; as in many of the statues and bas-reliefs of the ancients, and which by the way, they were forced to, because to have done otherwise would not have had a good effect in stone. The naked in a cloathed figure, like the anatomy in a naked one, should be shewn, but not with affectation.

Portrait painters, seeing the disadvantage they were under in following the dress commonly worn, have invented one peculiar to pictures in their own way, which is a composition, partly this, and partly something purely arbitrary.

Such is the ordinary habit of the ladies, that how becoming soever they may be supposed, as worn by them, or such as we are accustomed to, or upon whatever other account, it is agreed on all hands that in a picture they have but an ill air, and accordingly are rejected for what the painters have introduced in lieu of it, which is indeed handsome, and perhaps may be improved.

In the gentlemen's pictures the case is very different, it is not so easy to determine as to their drapery.

What is to be said for the common dress is that

> It gives a greater resemblance; and
> Is historical as to that article.
> The argument for the other are that
> They suit better with the ladies pictures, which (as has been observed) are universally thus dressed.
> They are not so affected with the change of the fashion as the common dress; and
> Are handsomer; that is have more Grace and Greatness.

Let us see how the case will stand, this latter consideration of their handsomeness being for the present set aside.

The first argument in favour of the arbitrary, loose dress seems

to have no great weight; nor is there so much as is commonly thought in the second; because in those pictures which have that kind of drapery, so much of the dress of the time is always, and must be retained, and this in the most obvious and material parts, that they are influenced by the change of fashion is a manner as much as those in the habit commonly worn. For proof of this I refer you to what was done when the great wigs, and spreading huge neck cloths were in fashion. So that here does not seem to be weight enough to balance against what is on the other side, even when the greatest improvement as to colour, or materials of the common dress is made, for still there will be a sufficient advantage upon account of resemblance and history to keep down the scale.

Let us now take in the argument of Grace and Greatness, and see what effect that will have.

The way to determine now is to fix upon the manner of following the common dress, whether it shall be with, or without improvement, and in what proportion. This being done, let that you have fixed on be compared with the arbitrary loose dress in competition with it, and see if the latter has so much the advantage in Grace and Greatness as to over balance what the other had, when these were not taken in; if it hath, this is to be chosen, not the common dress.

Thus I have put the matter into the best method I was able in order to assist those concerned to determine for themselves, which they can best do, fancy having so great a part in the affair. And so much for this controversy.

4.15 Kneller's technique

This account of Kneller's technique *c.* 1690 was recorded by Ozias Humphrey from a painter named Fever, who also said that Kneller had told him he needed ten or twelve sittings for a portrait.

Mr Fever's description as he did see Mr Kneller paint Mr Montagu's picture. The second and third sitting his palette was in this fashion, like a battledore or hornbook assaying his lesson [held up in front of him]. He tempered his colours thus.

First lay white, then all the rest round his palette. He took white a pretty deal and tempered yellow ochre with it; he held the knife up to the light (and if) it seemed a great deal too yellow for the life, then he took read ochre and mixed with it, then he took lak [lake] and mixed with it also, then he laid that down for the first general.

He took from this general patch to make the other tempers, and not from the new white.

He took some from the general patch and tempered more yellow ochre with it, which was [produced] a more yellow flesh laid down in the second place. Then he took some more of the general patch, and added more red, and laid that down in the third place. Then he took some more of the first general patch, and tempered some fair white with it, and laid it next to the white for his highest light of all. Then he took some of the white and a little bice and yellow ochre, and made some blueish, greenish, yellowish temper. He tempered no shadows but run to the simple colours, and made them out with the pencil and all the rest.

He proceeded thus. He made his first patch for the light of the forehead, nose and maxillary. He was not intent, but talked very much so that he could not be but more than a little [more] than an hour and a half about the face, though if they did sit two hours and a half it looked cold and hard. He charged his pencil very much in linseed oil, without wiping it, and took some of the linseed oil onto his palette, and took a little of it now and then and laid it of itself on the hard edgings of the colours, and it melted finely and softened it, and where the colour was still and not easy to work, he would mix a little oil with it, and make it work free.

Then he put in some yellowish shadows, a very little of that shadow made a cold face look warm.

The third sitting was the same as the second sitting, only [he] made his picture warmer, and mended his draft still, so at last [he] wrought it very like.

He had two looking glasses behind him, so that they could see the life and the picture.

4.16 Drawing a horse

In eighteenth-century England the horse played a role of immense social and economic importance in society, as a method of transport, a sport, and a symbol of prestige. People were often more keen on having portraits of their horses than of their wives or children. Of all the artists specializing in such work the most outstanding was George Stubbs. His success and popularity were largely based on the publication of his *The Anatomy of the Horse*, preliminary details of which appeared in advertisements and leaflets in 1765.

PROPOSALS for Publishing by Subscription THE ANATOMY OF THE HORSE INCLUDING a particular description of the Bones, Cartilages, Muscles, Facias, Ligaments, Nerves, Arteries, Veins and Glands. Represented in Eighteen Tables, all done from Nature. By GEORGE STUBBS, Painter.

CONDITIONS. The Tables engraved on Plates 19 inches by 15. The Explanation of the Tables will be printed on a Royal Paper answerable to the Plates, each of which will be printed upon an half Sheet of Double Elephant. The Price of the Book to Subscribers will be 4L. 4s. one Half to be paid at the Time of Subscribing, the other Half when the Book is delivered. The Price to Nonsubscribers will be 5L. 5s. The Names of the Subscribers will be printed at the Beginning of the Work.

N.B. The Plates being all finished and the whole Work in the Press, it will be published as soon as 150 Subscribers have sent in their Names; which will, together with their subscriptions, be received by the following Booksellers, viz. Mr Dodsley, in Pall mall; Mr Nourse, in the Strand; Mr Owen, at Temple Bar; Mr Newberry, in St Paul's Churchyard; and by all other Booksellers in Great Britain and Ireland. Subscriptions are likewise received by Mr Stubbs at his House in Somerset Street, opposite North Audley Street, Oxford Road.

This Work being the Result of many Years actual Dissections, in which the utmost accuracy has been observed, the Author hopes, that the more expert Anatomists will find it a useful Book as a Guide in comparative Anatomy; and all Gentlemen who keep Horses, will by it, be enabled not only to judge of the Structure of the Horse more scientifically, but also to point out the Seat of Diseases, or Blemishes, in that noble Animal, so as frequently to facilitate their Removal, by giving proper Instructions to the more illiterate Practitioners of the Veterinarian art into whose Hands they may accidentally fall.

Received the Day of 1765 Of
2L. 2s. being Half the Subscription Money for one BOOK of the Anatomy of the Horse. Geo. Stubbs.

> Stubbs' claim that his work was 'the Result of many Years' actual Dissections' is substantiated by the account given by Ozias Humphrey (in a manuscript in the Picton Library, Liverpool) of the process he employed.

As these studies and operations were singular and very important, the manner in which they were conducted may not be uninteresting

to relate. The first subject which was prepared was a horse which was bled to death by the jugular vein, – after which the arteries and veins were injected. Then a bar of iron was suspended from the ceiling of the room, by a Teagle of Iron to which Iron Hooks were fixed. Under this bar a plank was swung about eighteen inches wide, for the Horse's feet to rest upon, and the Horse was suspended to the Bar of Iron by the above-mentioned Hooks which were fastened into the opposite side of the Horse to that which was intended to be designed; by passing the Hooks through the ribs and fastening them under the Backbone and by these means the Horse was fixed in the attitude which these prints represent and continued hanging in this posture six or seven weeks, or as long as they were fit for use.

His drawings of a skeleton were previously made – and then the operations upon this fix'd subject were thus begun. He first began by dissecting and designing the muscles of the abdomen – proceeding through five different layers of muscles till he came to the peritoneum and the pleura through which appeared the lungs and the Intestines – after which the Bowels were taken out and Cast away – Then he proceeded to dissect the Head, by first stripping off the Skin and after having cleaned and prepared the muscles & c for the drawing, he made careful designs of them and this with the explanation which usually employed him a whole day. Then he took off another layer of Muscles, which he prepared, designed and described, in the same manner as in the Book – and so he proceeded till he came to the Skeleton – It must be noted that by means of the Injections the muscles, the Blood-vessels and the Nerves retained their form to the Past without undergoing any change of position. In this manner he advanced his work by stripping off the skin and cleaning and preparing as much of the subject as he concluded would employ a whole day to prepare design and describe, as above related till the whole subject was completed.

4.17 Gainsborough at work

Ozias Humphry, whose diary is a valuable source of information about eighteenth-century English artists, lived at Bath from 1760 to 1764, and was intimate with Gainsborough there. To him we owe the only account of Gainsborough's painting technique at this time.

Exact resemblance in his Portraits was Mr Gainsborough's constant Aim, to which he invariably adhered. These Pictures (as well as his

Landskips) were often wrought by Candlelight, and generally with great force and likeness. But his Painting Room, even by day (a kind of darkened Twilight) had scarcely any light; and our young Friend has seen him, whilst his Subjets have been sitting to him, when neither they nor their pictures were clearly discernible. Having previously determined and marked with chalk upon what part of the Canvasses the faces were to be painted, they were so placed upon the Eisel (for this purpose the canvass was not yet attached to its stretcher, but remained loose, secured by small cords as to be close to the subject he was painting) which gave him an Opportunity (as he commonly painted standing) of comparing the Dimensions and Effect of the Copy with the original, both near and at a distance; and by this method (with incessant study and exertion) he acquired the power of giving the Masses and general Forms of his models with the utmost Exactness Having thus settled the Ground Work of his Portraits, he let in (of necessity) more light for the finishing of them; but his correct preparation was of the last importance, and enabled him to secure the proportions of his Features, as well as the general Contours of Objects, with uncommon Truth.

(Ozias Humphry, *Diary*. Royal Academy Library.)

4.18 Reynolds in action

William Mason, the poet and amateur painter who translated Dufresnoy's *De Arte Graphica* into English, with notes by Reynolds, was on close terms with that painter, and in his *Observations on Sir Joshua Reynolds' Method of Colouring* (published in 1859) describes his technique.

Lord Holderness employed me to go to the painter and fix with him his Lordship's time of sitting. Here our acquaintance commenced, and as he permitted me to attend every sitting, I shall here set down the observations I made upon his manner of painting at his early time, which, to the best of my remembrance was in the year 1754.

On his light-coloured canvas he had already laid a ground of white, where he meant to place the head, and which was still wet. He had nothing on his palette but flake-white, lake and black, and began without making any previous sketch or outline, he began with much celerity to scumble these pigments together, till he had produced in less than an hour, a likeness sufficiently intelligible, yet withal, as might be expected, cold and pallid to the last degree. At

the second sitting, he added I believe, to the three other colours a little Naples yellow, but I do not remember that he used any vermillion, neither then, nor at the third trial; but it is to be noted that his Lordship had a countenance much heightened by scorbutic eruption. Lake alone might produce the carnation required. However this be, the portrait turned out a striking likeness, and the attitude, so far as a three-quarters canvas would admit – perfectly natural and peculiar to his person, which at all times bespoke a fashioned gentlemen. His drapery was crimson velvet, copied from a coat he then wore, and apparently not only painted, but glazed with lake, which has stood to this hour perfectly well, though the face, which as well as the whole picture, was highly varnished before he sent it home, very soon faded and soon after the forehead particularly cracked, almost to peeling off, which it would have done long since had not his pupil Doughty repaired it.

> This coincided with the advice about not using preliminary drawings Reynolds gave students in his *Discourses* on 11 December 1769.

But while I mention the porte-crayon as the student's constant companion, he must still remember that the pencil [*Reynolds is using the word in its old-fashioned sense of painting brush*] is the instrument by which he must hope to obtain eminence. What therefore I wish to impress upon you is, that whenever an opportunity offers, you paint your studies instead of drawing them. This will give you such a facility in using colours that in time they will arrange themselves under the pencil, even without the attention of the hand that conducts it. If one act excluded the other, this advice could not without propriety be given. But if Painting comprises both drawing and colouring, and if, by a short struggle of resolute industry, the same expedition is obtainable in painting as in drawing on paper, I cannot see what objection could justly be made to the practice; or why that should be done by parts, which may be done all together.

If we turn our eyes to the various Schools of Painting, and consider their respective excellencies, we shall find that those that excel most in colouring, pursued this method. The Venetian and Flemish Schools, which owe much of their fame to colouring, have enriched the cabinets of the collectors of drawings with very few examples. Those of TITIAN, PAUL VERONESE, TINTORET and the BASSANS are in general slight and undetermined. Their sketches on paper are as rude as their pictures are excellent in regard to harmony of colouring. CORREGGIO and BAROCCI have left few, if any finished draw-

ings behind them. And in the Flemish school RUBENS and VANDYCK made their designs for the most part either in colour or in chiaro oscuro. It is as common to find studies of the Venetian and Flemish Painters on canvas, as of the schools of Rome and Florence on paper. Not but that many finished drawings are sold under the names of those masters. Those, however, are undoubtedly the pro-ductions either of engravers, or of their scholars who copied their works.

These instructions I have ventured to offer from my own experi-ence but as they deviate widely from received opinions, I offer them with diffidence; and when better are suggested, I shall retract them without regret.

> On another occasion (recorded in C. R. Leslie RA and Tom Taylor, *Life and Times of Sir Joshua Reynolds.* John Murray 1865, vol. i. pp. 114–18) Reynolds spoke more freely and frankly about his technique and its sources.

Not having had the advantages of an early academical education, I never had that facility of drawing the naked figure which an artist ought to have. It appeared to me too late, when I went to Italy and began to feel my own deficiencies, to endeavour to acquire that readiness of invention which I observed others to possess. I con-soled myself however by remarking that these ready inventors are extremely apt to acquiesce in imperfections, and that if I had not their facility, I should for this very reason, be more likely to avoid the defect which too often accompanies it, – a trite and common-place mode of invention.

I considered myself as playing a great game; and instead of beginning to save money, I laid it out faster than I got it, in pur-chasing the best examples of art that could be procured; for I even borrowed money for that purpose. The possession of pictures by Titian, Vandyck, Rembrandt etc. I considered as the best kind of wealth. By carefully studying the works of great masters this advantage is obtained; we find that certain niceties of expression are capable of being executed, which otherwise we might suppose beyond the reach of art. This gives us a confidence in ourselves, and we are thus invited to endeavour at not only the same happiness of execution, but also at other congenial excellencies. Study, indeed, consists in learning to see nature, and may be called the art of using other mens' minds. By this kind of contemplation and exercise we are taught to think in their way, and sometimes to attain their ex-

cellence. Thus, for instance, if I have never seen any of the works of Correggio, I should never, perhaps, have remarked in nature the expression which I find in one of his pieces; or, if I had remarked it, I might have thought it too difficult, or perhaps, impossible to be executed.

My success and continual improvement in any art, if I may be allowed that expression, may be ascribed to a principle which I will boldly recommend to imitation; I mean a principle of honesty, which in this, as in all other instances, is, according to the vulgar proverb, always the best policy, – I always endeavoured to do my best. Great or vulgar, good subjects or bad, all had nature; by the exact representation of which, or even by the endeavour to give such a representation, the painter cannot but improve his art.

My principal labour was employed on the whole together; and I was never weary of changing and trying different modes and effects. I had always some scheme in my mind and a perpetual desire to advance. By constantly endeavouring to do my best, I acquired a power of doing that with spontaneous facility, which was at first, the whole effort of my mind; and my reward was threefold; the satisfaction resulting from acting on this just principle, improvement in my art, and the pleasure derived from a constant pursuit after excellence.

I was always willing to believe that my uncertainty of proceeding in my work, that is my never being sure of my hand, and my frequent alterations, arose from a refined taste, which could not acquiesce in anything short of a high degree of excellence. I had not an opportunity of being early initiated in the principles of colouring; no man, indeed, could teach me. If I have been settled with respect to colouring, let it at the same time be remembered that my unsteadiness in this respect proceeded from an inordinate desire to possess every kind of excellence that I saw in the work of others; without considering that there is in colour, as in style, excellencies which are incompatible with each other; however, this pursuit, or indeed any similar pursuit, prevents the artist being tired of his art. We all know how often those masters who sought after colouring changed their manners, while others, merely from not seeing various modes, acquiesced all their lives in that with which they set out. On the contrary, I tried every effect of colour, and leaving out every colour in its turn showed every colour that I could do without it. As I alternately left out every colour, I tried every new colour, and often, it is well know, failed.

4.19 Some models

Although artists' models had not become so professional as they were to be in the following century, they were beginning to assume some considerable importance in the world of art. Mostly they were chosen by chance, although discharged soldiers were often preferred because of their experience in maintaining the same pose for long periods.

When Sir Joshua was painting his first Venus (Dec. 1759) I was frequently near his easel, and although before I came to town, his picture was in some forwardness, and the attitude entirely decided (which however I rather believe he designed from a plate of Leda, or like subject of some old master, than from real life) yet I happened to visit him when he was finishing the head from a beautiful girl of sixteen, who he told me, was his man Ralph's daughter, and whose hair in fine natural curls, flowed behind her neck very gracefully. But a second casual visit presented me with a very different object; he was then painting the body, and in his sitting chair a very squalid beggar-woman was placed with a child not a year old quite naked upon her lap. As may be imagined, I could not help testifying my surprise at seeing him paint the carnation (flesh colour) of the Goddess of Beauty from that of a little child, which seemed to have been nourished rather with gin than with milk, and saying that 'I wondered he had not taken some more healthy looking model', but he answered, with his usual naiveté, that 'whatever I might think, the child's flesh assisted him in giving a certain *morbidezza* to his own colouring, which he thought he should hardly arrive at, had he not such an object when it was extreme (which it certainly was) before his eyes.

At another time I happened to call upon him when he was painting the *Death of Cardinal Beaufort*, when a circumstance equally curious with the foregoing occurred. He had merely scumbled in the positions of the various figures, and was now upon the head of the dying cardinal. He had now got for the model a porter, or coal-heaver, between fifty and sixty years of age, whose black and bushy beard he had paid for letting him grow; he was stripped naked to the waist, and with his profile turned to him, sat with a fixed grin, showing his teeth. I could not help laughing at the strange figure and recollecting why he had ordered the poor fellow so to grin, on account of Shakespeare's line,

'Mark how the pangs of death do make him grin'.

1. *St Paul's Cathedral*. Wren's pre-fire design, showing the west elevation of the transepts with a section through the nave. (Courtesy the Warden and Fellows of All Souls' College, Oxford.)

2. *St Paul's Cathedral*. An engraving of the interior, published by Robert Sayer, showing the crossing looking north-east. (Courtesy The Guildhall Art Gallery.)

3. *Chiswick Villa: longitudinal section.* Preparatory drawing for Lord Burlington's design for the villa, completed in 1727. (Courtesy the Trustees of the Chatsworth Settlement.)

4. *Westminster Bridge under construction from the South East*, 1746, by Antonio Canaletto (1697–1768). The bridge was finished on 25 October 1746, though owing to faulty workmanship it had to be rebuilt, and opened again in 1750. (Courtesy the Duke of Northumberland.)

5. *Taste, or Burlington Gate*, published 1731/2. Attributed to Hogarth, this satire on Burlington and his friends shows (A) Alexander Pope, (B) the Duke of Chandos, (E) William Kent, and (F) Burlington.

6. *Time smoking a picture*, March 1761. Designed by Hogarth as a subscription ticket for an engraving of that artist's *Sigismunda*, it is an attack on the view put forward by Addison (*Spectator* No. 83) and others that time improves paintings.

8

7

9. *The Anatomy of the Horse.* One of the plates in Stubbs' *The Anatomy of the Horse*, 1766.

7. (*Opposite*) *Italian picture dealers humbugging my Lord Anglaise* (sic). Rowlandson's version of the Grand Tour.

8. (*Opposite*) *Preparations for the Academy. Old Joseph Nollekens and his Venus.* Rowlandson's mildly lascivious view of the famous sculptor at work. The work in hand seems to be based on *Venus chiding Cupid*, now in the Usher Art Gallery, Lincoln.

Christie

OR THE KING of EPITHETS

*Let me entreat—Ladies—Gentlemen—permit me
to put this inestimable piece of elegance under your protec-
-tion.——only observe,———The inexhaustable Munificence
of your superlitively candid Generosity must HARMONIZE
with the resulgent Brilliancy of this little Jewel!——*

Pub.ᵈ Janʳ 1.ˢᵗ 1782 by H Humphrey Nͦ 18 New Bond Street

10. *Eloquence, or The King of Epithets.* The formidable Mr Christie in action, as seen in a print published in 1782 by H. Humphrey of New Bond Street. (Courtesy Christies.)

CONDITIONS of SALE.

1*st* THE *highest Bidder* to be the Buyer and if *any Dispute* shall arise between any *two* or *more Bidders*, the LOT so *disputed* shall be *put up again*.

2*dly*, No *Person* to advance *less* than 6 *d*. *Above* a *Pound* 1 *s*. *Above* Five Pounds 2 *s*. 6 *d*. and so on in *Proportion*.

3*dly*, The *Purchasers* are to give in their *Names* and *Places of Abode*, and *positively* to pay down 5 *s. in the Pound*, in Part of Payment of the *Purchase Money* ; in Default of which, the LOT, or LOTS *so purchased*, to be *immediately put up again and Resold*.

4*thly*, The LOTS shall be taken away with all Faults at the *Buyer's Expence* within one Day after the Sale.

5*thly*, To *prevent* the INCONVENIENCIES that *too frequently attend* LONG and OPEN ACCOUNTS, the *Remainder* of the *Purchase Money* to be ABSO-LUTELY Paid ON or BEFORE the *Delivery*.

Lastly, Upon *Failure of complying* with the a-*bove* CONDITIONS, the Money so *deposited in Part* of *Payment*, shall be *forfeited* ; *the* LOTS *un-cleared* within the Time aforesaid, shall be *Re-sold* by *public* or *private Sale*, and the *Deficiency* (if any) *together with the Charges attending such Re sale, shall be made good* by the *Defaulters* at this S A L E.

11. *Conditions of Sale*, as laid down by Christies, and printed in their cata-logues in the eighteenth century.

Henry Newton

UPHOLSTER.

At the Three Tents
the Corner of Cullum Street in Lime Street

near Leaden-Hall Market

London

Maketh up & Selleth all Sorts of
—— Upholsterers Goods . ——

Chairs, Cabinet-Work & Glasses, with all Sorts
of Ticks, Feathers, Quilts, Blankets, Coverlids & Ruggs,

Household Goods Bought Sold & Appraised.

Likewise Funerals Perform'd .

12. *Trade Card* of Henry Newton, reproduced in Ambrose Heal's *London Furniture Makers* (Batsford 1953).

Brackets for Busts, Dressing Chest and Bookcase, Clock Cases, and Bureau Table

13. *Elegant and useful designs.* A plate from Chippendale's *The Gentleman and Cabinet Maker's Director*, 1754

14. *Strawberry Hill, The Chapel, Cabinet or Tribune*. A plate from Horace Walpole's *Description of Strawberry Hill*, from a drawing by Edward Edwards. The book was published in 1784.

15. *The state bed at Osterly House.* One of the finest surviving specimens of
eighteenth-century furniture, now in the Victoria and Albert Museum,
with some of its original hangings.

16. *Fan design.* A drawing by an anonymous artist showing the Lord Mayor's Pageant in 1686 on the site now occupied by the Mansion House. (Courtesy the Museum of London.)

17. *Tailpiece to a catalogue*. Engraved by Grignion from a drawing by Hogarth, this satire on the connoisseur appeared at the end of the catalogue for the exhibition of the Society of Artists at Spring Gardens in May 1761.

18 *Baby Carriage*, designed by William Kent in 1754 for Prince Henry
Frederick, who later became Duke of Cumberland. (Courtesy the Trustees
of the Chatsworth Settlement.)

I told him that, in my opinion, Shakespeare would never have used the word 'grin' in that place if he could have found a better; that it always conveyed to me a ludicrous idea, and that I never saw it used with propriety, but by Milton, when he tell us that death

'grinned horribly,
A ghastly smile'.

He did not agree with me on this point, so that the fellow sat grinning for upwards of an hour, during which time he sometimes gave a touch to the face, sometimes scumbled on the bedclothes with white, much diluted with spirit of turpentine. After all, he could not catch the expression he wanted, and, I believe rubbed the face entirely out in the present finished picture, which I did not see till a year after this first fruitless attempt, is certainly different, and on an idea much superior. I know not whether he may have changed the model. Yet the man who then sat had a fine, firm countenance of the swarthy kind, not unlike some portrait or other I have seen of Titian; I think it is one of the Cornaro family. I remember I told him so, and a few days after, when I called on him, he had finished a head of St Peter, which he told me he had taken from the same subject.

I do not remember to having seen the man who sat for Count Ugolino, and from whom he painted various other heads; but the beggar-boy from whom he painted *The Infant Samuel*, a boy reading in a crimson coat, and another standing with a portfolio under his arm, and I believe some other heads, I often found on his chair. This boy (at the time about fourteen) though not handsome, had an expression in his eye so forcible, and indicating so much sense, that he was certainly a most excellent subject for his pencil. There is something in his history which deserves to be recorded. He was an orphan of the poorest parents, and left with three or four brothers or sisters, whom he taught, if they were able, to make cabbage-nets, and he went about with them, offering them for sale, by which he provided both for their maintenance and his own. What became of him afterwards I know not. Sir Joshua has told me, when talking of his beggars, that when he wanted them again, they very frequently were never to be found by any enquiries he made concerning them.

(Rev. William Mason, from *Sir Joshua Reynolds' Notes and Observations of Pictures, also the Rev. W. Mason's Observations*; ed. William Cotton. London 1859.)

4.20 Flesh tints

George Romney was especially famous amongst his contemporaries for his 'flesh tints'. One of his pupils thus described his technique (W. Hayley, *Life of George Romney*. Chichester 1809).

His pencil was uncommonly rapid, and to see him introduce the background into one of his large pictures was something like enchantment. He was very anxious concerning the preparation of his colours; the arrangement of his flesh palette was very curious and simple, and in some of his figures, especially in the arms, it is easy to trace the different graduations of tints as they stood on the palette. This may be observed in his most delicate flesh, particularly in the arms of a *Bacchante with a dog* sent to Sir William Hamilton at Naples; in his *Serena in a boat*; in the left arm of Mr Henderson in the character of Macbeth. This last was the most finished of all his flesh colour, and he told me he could go no further. The head of Creon's daughter is less finished than any other from the same lady (Emma Hamilton); the child is very fine; the drapery was painted in an hour from a living model, which manner he preferred whenever he could accomplish it; the lions were by Gilpin. Perhaps *The Girl Spinning* is the best picture he painted at this period; he first caught the idea from observing a cobbler's wife sitting in a stall.

4.21 Bleached canvas and mineral colours

It was typical of the relationship between artist and patron that the latter could find it perfectly reasonable, not only to dictate the nature and subject of the work he commissioned, but even the media to be used. In January 1779 in Naples, Thomas Jones ran foul of the technical idiosyncrasies of a potential customer.

About this time arrived Sir Thomas Gascoyne. He had seen my performances at Rome, and admired them much. My friends there had written me word that he meant to do great things for me, particularly, that I was to make copies of the famous *Altieri Claudes* for him. On his arrival he immediately sent for me & I waited on him at Lord Tilney's[1] Hotel, where he had taken up residence. Sir Thomas examined me, and cross-examined me with respect to the Cloths and Colours I made use of; whether I prepared the canvasses myself? and whether my colours were all Minerals? I innocently

1. John, 2nd Earl Tylney.

told him that I bought my Cloths and Colours ready prepared at the Colour shops & [that they were] the same that all other Painters used. Oh no reply'd he, 'Mr Hackaert[2] at Rome, always prepares his own Cloths and bleaches them in his Garden half a year before he begins painting them – that all his Colours were prepared from Minerals, & procured at vast labour and Expense from the different Mines in Germany'. As I was endeavouring to persuade Sir Thomas that the Transparent Colours which we used could not possibly be prepared from such Substances, we were interrupted by Lord Tilney who entered the room and told Sir Thomas that they had a great many Morning Visits to pay, but politely added that if he would ask his friend Mr Jones to eat a bit of Dinner with him, he should have more time to talk on Business – I accordingly waited on his Lordship at the appointed hour, and found a company of English Gentlemen and an Italian Abbé, sitting down to a most elegantly furnished Table. After dinner I waited with some impatience to receive Sir Thomas' orders but as the Conversation turned on other matters, and as I fancied at least, that my Company seemed to cause a sort of embarrassment in their Discourse, I got up, and ask'd Sir Thomas for his further commands. He coolly answered I should hear from him another time. I then took leave, and as I *never did hear from him* afterward, I suppose I lost his Commissions for not making use of *bleached Canvasses and Colours entirely Mineral*.

(Walpole Society, vol. 32, 1951)

4.22 Light and dark in painting

The nature and functions of chiaroscuro were one of the dominant preoccupations of eighteenth-century painters, and in the fifth of his lectures to students of the Royal Academy, delivered in 1784, (published 1802), the pugnaciously argumentative James Barry who was expelled from that institution in 1799, dealt with the subject in illuminating detail.

The indispensable necessity of selection or judicious choice in all the component parts of a picture has been urged at some length in a former discourse, and in no part of the art is this truth more evident than in that which is now the subject of our attention; for it does greatly depend upon the happy or unskilful distribution of the

2. Jacob Philipp Hackaert.

lights and darks, whether objects shall present themselves with that disgusting confusion and embarrassment which distract our sight, or with that unity and harmony which we can never behold without pleasure. There are times when the scenes about Hyde Park, Richmond, Windsor and Blackheath, appear very little interesting. The difference between a meridian and evening light, the responses of extensive shadow, the half-lights and catching splendours that those scenes sometimes exhibit, compared with their ordinary appearances, do abundantly show how much is gained by seizing upon those transitory moments of fascination, when nature appears with such accumulated advantage. If this selection be so necessary respecting objects intrinsically beautiful, how much more studiously should it be endeavoured at, when we are obliged to take up with matters of less consequence. How many of those deservedly esteemed productions of the Flemish and Dutch schools would be thrown aside as intolerable and disgusting were it not for the beautiful effects of their judicious distribution of importance in the other parts. These echoes prevent the too great silences which would otherwise prevail in the middle tint and shade, and still further they remove that appearance of magic-lanthorn-like, and too artificial contrivance which sometimes offends in the works of Rembrandt, Caravaggio and others. If the frame, boundary, or termination of a picture be (as it ought to be) considered only as a window-frame, or the limits of any other aperture through which we behold a certain part of the creation, where any given action, business or event may be supposed to happen, it must then appear evident that nothing can be more ill-judged than the practice of sacrificing all the extremities of the picture to a concentrated light upon the middle group, except where the subject makes it proper, as in Corregio's *Nativity*, and other night scenes. By this absurd conduct the picture becomes, as it were, less than the canvas, its connexion with the rest of the creation is destroyed, and all opportunity taken away of that *artificial infinite* where ingenuity may have so many resources of suggested beauty or sublimity; where the imagination, when satisfied with the scene before it, might, by the concatenated secondary lights, be led on to the conception of something still further out of the picture. . . .

Although these recipes for the mechanical distribution of the lights and darks have been very sagaciously deduced from the practice of excellent chiaroscurists, and cannot fail of being attended with benefit, yet the student should always recollect that a beauty impertinently placed, and obtained at the expense of a perfection of

a greater order, will justly be considered as a great deformity, and that consequently, the measure of these subordinate considerations must be dictated by the lights and darks. Art is selection; it is perfect when this selection is pursued through the whole, and it is even so valuable when extended but to a part only, as to become a passport for the rest. . . .

With respect to the conduct necessary to be pursued in obtaining this advantageous distribution of the lights and darks in a picture, there is little now can be said upon it, as our neighbours on the continent have long since developed the principles of practise adopted by the great chiaroscurists. In has been, with good discernment, observed that the constant maxim of those great artists was to dispose all their dark and light objects after such a manner as would best contribute to their being seen with the greatest possible advantage and ease. That to this end they arranged them in groups, and masses of light, half-light, darks and half-darks, and reflexes. Of these lights and darks, one was principal, the rest subordinate, and all generally co-operated to produce a totality and entireness in the work. The principal light was generally so disposed, as to give the greatest lustre to that part where the action and personages were of the greatest importance, and where, accordingly, it was most proper to arrest the attention of the spectator. How far this light should extend, depended upon the previous arrangement of the objects, and the discreet and sentimental accommodation of it to the nature of the subject: but it is observable that, by extending it too far, its comparative value is proportionately lessened.

Although this principal light should, as it were, occupy only its own sphere, and not be repeated, yet it is not to be without its satellites or dependents. Revivifications and echoes of it, subordinate in magnitude or force, or both should, notwithstanding, by an artful concatination, be distributed to the circumstances of secondary matters of higher importance. The expression of the subject must not appear to be created for the chiaroscuro, but the direct contrary. The chiaroscuro and the other attentions of the composition should be calculated to give the expression and sentiment of the subject all possible force and value. Everything admissible in the chiaroscuro should fairly follow from that natural order in which the groups and other objects have been necessarily arranged for the better expression of the subject. This firmly fixed as the invariable law, it may then be observed that in the infinitely various configurations of the sky and clouds, which may, with equal possibility be connected with the subject, much assistance may be de-

rived by obtaining such accidental lights or shades as, not interfering with propriety, their admission, extent, or local situation may be considered as a matter purely optional; and still further, although in the very arrangement of the figures and groups, the expression of the subject, with its becoming dignity, fitness and propriety be the prime object, yet, without detracting from this, some attention must be paid in the collocation of these figures and groups, that they may either by their direct or perspective situation produce an agreeable variegated unity in their lights and forms.

Thus with attention and amorous assiduity, it is almost always in the power of an artist to superinduce an harmonious and sentimentally expressive chiaroscuro upon that ordinary distribution of light and shade which natural bodies necessarily exhibit.

4.23 A deterioration of monuments

The spread of stylistic eclecticism to funerary monuments – especially in Westminster Abbey – was a source of disquiet to many others besides the author of an article in the *Connoisseur* for July 1755.

In my late visit to Westminster Abbey, I could not but remark the difference of taste which has prevailed for setting up edifices for the dead. In former times we find that they were content to clap up the bust or statue of the deceas'd, set round perhaps with the emblems of his merits, his employments or station in life. If any person was remarkable for his virtue and piety, it was pointed out by two or three chubby-faced little cherubims, who were crying for his death, or holding a crown over his head. The warrior was spread at full-length in a compleate suite of armour, with the trophies of war hung round about him, and the bishop was laid flat upon his back, with his coifed head resting on a stone bible, and his hands, joined together in the posture of praying.

If Socrates, or any other of the ancient philosophers could revive again, and be admitted to Westminster Abbey, he would be induced to fancy himself in a Pantheon of the heathen gods. The modern taste (not content with introducing Roman temples into our churches, and representing the Virtues under allegorical images) has ransacked all the fabulous accounts of the heathen theology to strike out new embellishments for our Christian monuments. We are not in the least surprised to see Mercury attending the tomb of an orator, an Pallas or Hercules supporting that of a warrior.

Milton has been blamed for his frequent allusions to the heathen theology in his sacred poem; but surely we are more to be condemned for admitting the whole class of their fictitious deities into the house of God itself.

If there is not a stop put to this taste, we may soon expect to see our churches instead of being dedicated to the service of religion, set apart for the reception of the heathen gods. A deceased Admiral will be represented like Neptune, with a trident in his hand, drawn in a shell by dolphins, preceded by Tritons, and followed by Nereids, lashing the marble waves with their tails. A General will he habited like Mars, bearing a helmet and spear in polished stone; and a celebrated toast will be stuck up naked, like the Venus de Medicis, cut in alabaster.

Should anyone propose to take down from St Paul's Cathedral those paintings by Sir James Thornhill, representing the transactions of St Paul, and in their place to set up Titian's pictures of the amours of ancient gods, everyone would be shocked at the impiety of the proposal. Nor is the fashion of introducing heathen deities into our monuments much less absurd; for while any of these are suffered to remain in our churches, the reproof of Our Saviour concerning the temple at Jerusalem may perhaps become applicable to the present time, 'My house is a house of prayer, but ye have made it into a DEN OF THIEVES.'

Modern taste is continually striking out new improvements. We may therefore conclude, that when our statuaries have travelled thro' the ancient Pantheon, and exhausted all the subjects of the Grecian and Roman mythologies, we shall have recourse to the superstitions of other nations for the designs of our monuments.

They will then probably be adorned with Aegyptian hieroglyphics, and the tomb of some future hero may be built according to the model of the prophet's tomb at Mecca. It is not to be doubted but that the Chinese taste, which has been already introduced into our gardens, our buildings, and our furniture, will also find its way into our churches; and how elegant must a monument appear, which is erected in the Chinese taste, and embellished with dragons, bells, pagodas and mandarins!

4.24 The rise of a sculptor

The career of Thomas Carter had a curious beginning, as described in the columns of the *European Magazine* for 1803, but in substance

153

was no doubt similar to that of others. He was, above all else, a master of the chimney-piece, some of his most famous being at Welbeck; Holkham; Uppark, Sussex; Blair Castle, Perthshire. His prices were around £100 for a single chimney piece. He also did several funerary monuments.

Carter, the Statuary, or as he was then termed the Stone-Cutter, when a very young man had a shed near the Chapel in May Fair, indeed I think upon the very spot where the fair was formerly celebrated. His business was then confined to what may literally be termed the *lower branches* of his profession, such as tomb-stones, grave-slabs etc.

On this spot Carter used to labour from day to day, from the rising to the setting of the sun. As he was one morning at work, he observed a gentleman, rather in years, very plainly dressed, whom he has frequently seen pass by, and sometimes stop at his window, enter his shop. The Gentleman asked him some questions respecting his business; and the Sculptor, thinking he wished to employ him, displayed his small collection of models, and directed his attention to the works he had in hand. The Gentleman commended his industry, desired he might not hinder him, so after some apology, he began to chip his stone, his visitor going off without a word.

In a day or two the Stranger, at a very early hour, called again to enquire whether he was married or single, and whether he had any children. Carter replied that he was married, described his wife as 'the best woman in the world', his child as 'one of the beautifullest infants he had ever seen'. Again the Gentleman smiled, and continued 'You seem to be a very industrious young man.'

'Industrious' said Carter, 'one had need to be so in these times; you see I cannot even keep a labourer constantly; I do almost everything myself.'

'Do you want any money?' Carter stared, 'Want money? Lord love me! Yes, I believe I do!'

'Would a hundred pounds be of use to you?'

'A hundred pounds' said the astonished sculptor, 'Lord love me! It would be the making of me forever.'

'How so?'

'Ready money would enable me to purchase materials at a cheaper rate; to employ a young man[1], to attend my business; in fact it would make a man of me.'

1. Katherine Esdaille in *The Life and Works of François Roubiliac* (Oxford 1928) suggests that the 'young man' whom Carter employed was Roubiliac.

'Do you know Clarges Street?' said the Stranger.

'Lord love me! to be sure I do; it is just by!'

'You must breakfast there with me to-morrow morning at nine o'clock'.

'Who must I enquire for?'

'Mr Jervase' said the Gentleman.

'You want a job done?'

'Many' returned Jervase, 'therefore be punctual.'

'Ah' said the sculptor, 'there's no doubt of that.'

Punctual he was accordingly, and his reception was of the kindest. The £100 was pressed upon him; recommendation and patronage, and loans if necessary, were freely proffered, and the results were all that could be desired. Jervase had the satisfaction to discover in a short time, that his bread was not cast upon the water. Everything succeeded with Carter, his business extended, and, I think, he engaged in some of the new erections in May Fair and its vicinity. Thus by his ingenuity and industry he realised what in those days was termed a large fortune.

4.25 Problems of Church patronage

For a variety of reasons, one of which was the danger of being accused of 'popery', the clergy were not generally patrons of the arts during the period. Thomas Newton, later Bishop of Bristol, was involved in an ambitious attempt made by the Royal Academy in 1773, when he was Dean of St Paul's, to adorn that cathedral. He recounts the episode in his *Life of Dr. Newton, Bishop of Bristol, by Himself* prefixed to his *Works* (London 1782).

As Dr Newton was known to be such a lover of their art, the Royal Academy of Painters in 1773 made an application to him, by their worthy President, Sir Joshua Reynolds, representing that the art of painting, notwithstanding the present encouragement given to it in England, would never grow up to maturity and perfection, unless it could be introduced into churches, as in foreign countries; individuals for the most part being fonder of their own portraits, and those of their families, than of any historical pieces; that, to make a beginning, the Royal Academicians offered their services to the Dean and Chapter, to decorate St Paul's with Scripture histories, and six of their members, Sir Joshua Reynolds, Mr West, Angelica Kauffman, Cipriani, Mr Barry, and I think Mr Dance, had been chosen each to paint a picture for this purpose; that these pictures

should be seen and examined, and approved by the Academy before they were offered to the Dean and Chapter, and the Dean and Chapter might then give directions for alterations and amendments, and receive or refuse them as they thought them worthy or unworthy of the places for which they were designed; none should be put up, but such as were entirely approved, and they should be all put up at the charge of the Academy, without any expense to the members of the church.

St Paul's had all along wanted some such ornaments, for rich and beautiful as it was without, it was too plain and unadorned within.

Sir James Thornhill had painted the History of St Paul in the cupola, the worst part of the church that could have been painted. Besides the exposition of these pictures to the weather, they are at such a height that they cannot conveniently be seen from any part and add little to the beauty of the church. They had better have been placed below, where they could have been seen, for there are compartments which were originally designed for bas-reliefs or such decorations; but the parliament, as it is said, having taken part of the fabric money, and applied it to King William's wars, Sir Christopher Wren complained that his wings were clipt, and the church was deprived of its ornaments. Here then, a fair opportunity was offered for retrieving the loss, and supplying former defects. It was certainly a most generous and noble offer on the part of the Academicians, and the public ought to think themselves greatly obliged to them for it. The Dean and Chapter were all equally pleased with it, and the Dean in the fulness of his heart, went to communicate it to the great patron of the arts, and readily obtained his royal assent and approbation; but the trustees of the fabric, the Archbishop of Canterbury and the Bishop of London were also to be consulted, and they disapproved the measure. Bishop Terrick, both as trustee of the fabric, and as bishop of the diocese, strenuously opposed it; whether he took it amiss that the proposal was not first made to him, and by him the intelligence conveyed to his majesty, or whether he was really afraid, as he said, that it would occasion a great noise and clamour against it, as an artful intrusion of popery. Whatever were his reasons, it must be acknowledged that some other serious persons disapproved the setting up of pictures in churches. It was in truth, not an object of that concern as to run the risk of a general outcry and clamour against it, but the general opinion plainly appeared to be, on the contrary side, much in favour of the scheme; and whatever may have been the case in the days of our first reformers, there was surely no danger now of

pictures seducing our people into popery and idolatry; they would only make Scripture history better known and remembered.

The House of Commons have given a rich painted window to their church of St Margaret's Westminster, and why should such ornaments be denied to the capital church in the kingdom? Some time before this another opportunity was unfortunately lost of decorating St Paul's. When Bishop Newton was only one of the residentiaries, a statuary of some note came to him in the summer months of residence, desiring leave to set up a monument in St Paul's to one who had formerly been a Lord Mayor and representative of the City of London. The Dean and the other bretheren of the Chapter being in the country, he went to consult with Archbishop Secker on the subject, and Archbishop Secker was so far from making any objection, that he much approved the design of the monument, saying what advantages foreign churches have over ours, and that St Paul's was too naked and bare for want of monuments, which would be a proper ornament, and give a venerable air to the church etc. But when the thing was proposed to Bishop Osbaldeston, he was violent against it; Sir Christopher Wren had designed no such things; there had been no monuments all the time before he was bishop, and in his time there should be none.

Reynolds made a similar point at length in his *Journey to Flanders and Holland* (1781):

It is a circumstance to be regretted, by painters at least, that the Protestant countries have thought proper to exclude pictures from their churches. How far this circumstance may be the cause that no Protestant country has ever produced a history painter, may be worthy of consideration.

When we separated from the church of Rome, many customs indifferent in themselves were considered as wrong, for no other reason perhaps but because they were practised by the communion from which we had parted. Among the excesses which this sentiment produced, may be reckoned the impolitic exclusion of all images from our churches. The violence and acrimony with which this separation was made being now at an end, it is high time to assume that reason of which our zeal seems to have deprived us. Why religion should not appear pleasing and amiable in its appendages, why the House of God should not appear as well-ornamented and as costly as any private house made for man, no good reason, I believe, can be assigned.

The truth is acknowledged, in regard to the external building in Protestant as well as in Catholic countries. Churches are always the most magnificent edifices in any city; and why the inside should not correspond with the exterior, in this and every other Protestant city it would be difficult for Protestants to state any reasonable cause.

Many other causes have been assigned why history painting has never flourished in this country; but with such reason at hand, we need look no further. Let there be buyers who are the true Maecenases, and we shall soon see sellers vying with each other in the variety and excellence of their works. To those who think that wherever genius is, it must blaze out like fire, this argument is not addressed; but those who consider it not as a gift, but as a power acquired by long labour and study should reflect, that no man is likely to undergo the fatigue required to carry any art to any degree of excellence, to which, after he has done, the world should pay no attention.

Sculpture languishes for the same reason, being not with us made subservient to our religion as it is with the Roman Catholics. Almost the only demand for considerable works of sculpture arises from monuments erected to eminent men. It is to be regretted that this circumstance does not produce such an advantage to the art as it might do, if instead of Westminster Abbey, the custom were once begun of having monuments to departed worth erected in St Paul's Cathedral. Westminster Abbey is already full; and if the House of Commons should vote another monument at the public expense, there is no proper place, certainly in the Abbey, in which it can be placed.

Those which have been recently erected are so stuck up in odd holes and corners that it begins to appear truly ridiculous; the principal places have been long occupied, and the difficulty of finding a new nook or corner every year increases. While this Gothic structure is encumbered and overloaded with ornaments which have no correspondence with the taste and style of the building, St Paul's looks forlorn and desolate, or at least destitute of ornaments suited to the magnificence of the fabric. There are places designed by Sir Christopher Wren for ornaments which might become a noble ornament to the building, if properly adapted to their situation. Some parts might contain busts, some single figures, some groups of figures, some bas-reliefs, and some tablets with inscriptions only, according to the expense intended by him who should cause the monument to be erected.

4.26 Problems with the parish

Getting payment for work done was always a problem, and not only for painters and sculptors, and not only with private patrons. In 1770 Archdeacon Harley approached Sir William Chambers with a commission from the Vestry of the Parish of Marylebone to design a new church to compete with St. George's Hanover Square. But despite the vast amount of work which the architect did for the project, the Vestry could not make up its collective mind, and on 16 February 1774 Chambers exploded in a letter to Harley, after the Vestry had tried to fob him off with the payment of £120.

I am sorry to find from the discourse we had yesterday in the street, that the Gentlemen of the Vestry propose making me so trifling an offer for all the trouble which they have given me with regard to the intended Church & some other works which have been executed under my direction. I will not suppose there is any intention to affront me by offering what I cannot with Decency accept of, & must therefore conclude either that the Gentlemen have forgot what has been done or are no Judges of its value, in either of which cases it is necessary to set them right. I cannot do this myself for Reasons very obvious, but must necessarily be troublesome to some friend. Would you Dr Sr, who have so kindly assisted me on many other occasions be so obliging as to take this matter in hand, and when you have a proper opportunity represent to the Gentlemen the following circumstances – I was appointed by the Vestry, I believe upwards of two years ago, their Architect, & it was then agreed that I should be allow'd 5 p cent upon the work executed in Consequence of this appointment. I have by the Directions of the Vestry attended the execution of the Vaults and Burial Grounds, and also the Court-House, having made or examined the Estimates, settled the Bills, measured the works and inspected into the Construction & finishing of the whole by a regular & due attendance either by myself, my Assistants or Clerks, as the nature of the works required. I am consequently entitled to 5 p cent upon the amount of the bills for these two works, which to the best of my recollection amount to about £3,500 & 5 p cent thereon is £175. For the Church I have made no less than 6 different Designs, all of them large & complicated, consequently very difficult to contrive & tedious to execute. I will not trouble you with a Busshell of Sketches and Calculations which were made previous to the Designs, but I have sent you the finished Drawings to show by which those who understand such works will judge of the rest. I have besides made

three Different Estimates, one of which is sent for the Gentlemens' inspection; it fills three sheets of paper, & those who understand it know how laborious & tedious such Calculations are, in short Dr Sr Upon the nearest Calculation I can make I am upwards of two hundred pounds out of pocket by these works in wages to Clerks, measurers' bills, allowance to Assistants &c., &c., & there is no Architect of reputation, I am persuaded who would do the Designs &c., &c., which I have done for the church for less than 3 hundred Guineas beside the sum due to me on the other works. A vast deal of my own time has been employed in these works, particularly in the Contrivance of the Designs, besides the wages &c. I have paid to others. I do not, however, mean to insist upon a generous, or even a just Requital for my Trouble and Expences. I am too well acquainted with the temper of the public Bodys. If I am treated with tolerable Kindness, tis all I expect, & I shall be ready to submit to any terms my friends shall judge reasonable.

(British Museum Add. MAA 41136, 2–2 v., repr. in John Harris, *Sir William Chambers* London 1970 pp. 92–3)

4.27 A contract for a monument

The artisan-like rôle which even famous artists still assumed is suggested by the nature of contracts into which they entered with patrons. Typical is that drawn up between Ann Lynn and François Roubiliac the sculptor for a monument to her late husband George Lynn of Southwick in Northamptonshire, a famous mathematician, who produced a new table of logarithms. The script of the contract is in the Bibliothèque de la Ville de Lyon, and it was reproduced in Katherine Esdaille's *The Life and Works of Louis François Roubiliac* (Oxford 1928).

An agreement made the eighteenth day of April in the year of Our Lord One thousand seven hundred and fifty nine between Lewis Francis ROUBILIAC of Saint Martin's Lane in the Parish of Saint Martin in the fields in the County of Middlesex statuary of the one part, and Ann LYNN of Southwick in the County of Northampton widow of the other part, as follows (that is to say) that the said Lewis Francis ROUBILIAC in consideration of the sum of two hundred pounds of good and lawful money of Great Britain to him the said Lewis Francis ROUBILIAC in hand paid at or before the sealing and delivery hereof by the said Ann LYNN the receipt whereof is acknowledged and of the further sum of three hundred pounds of like lawful money to be paid to the said Lewis Francis ROUBILIAC his

executors or administrators when the monument hereafter men-
tioned shall be completed DOTH hereby for himself his executors
and administrators covenant and agree to and with the said Ann
LYNN her executor and administrators that he the said Francis Lewis
ROUBILIAC shall and will make and erect and set up in and upon the
ground purchased by the said Ann LYNN in the Parish Church of
Southwick aforesaid for that purpose a marble monument to the
memory of George LYNN the breadth whereof to be at least seven
feet and the heighth thereof to be at least fourteen feet and compleat
the same in a good and workmanlike manner according to a plan
drawn thereof, agreed to and signed by the said Lewis Francis
ROUBILIAC and the said Ann LYNN the choice of the [illegible] and
quality of the marble for erecting the said monument to be left to
the choice of the said Lewis Francis ROUBILIAC and the said Ann
LYNN for herself and her executors and administrators in considera-
tion of the above agreement to be performed by the said Lewis
Francis ROUBILIAC his executors or administrators the said further
sum of three hundred pounds when the said monument shall be so
erected and compleated, according to the said plan thereof and
further that it is mutually agreed upon by and between the said par-
ties that the said Ann LYNN her Administrators and Executors shall
not be lyable to pay, or be at any further expence above the said
sum of Five hundred pounds for or on account of ingraving or cut-
ting the inscription on the said Monument, Packing Cases, Car-
riages of the same, putting up and iron rails round the said Monu-
ment (Parish Fees and anything done to the Foundation where the
said Monument is to be erected, mending or Alterations in the
Church Wall on account of erecting the said Monument excepted).
IN WITNESS whereof the said parties have hereunto interchangeably
Sett their hands and Seals the day and year first above written.

April the 15 1759 *Ann Lynn*
Sealed and delivered (being first *L. F. Roubiliac*
duly stampt) in the presence of: Received the above mentio'd
Ricd. Barford Sum of two hundred pounds on
Margaret Twells account.
 L. F. Roubiliac

4.28 Patronage

For the most part patrons treated artists with delicacy and respect.
Typical of this attitude is the letter which James, first Earl of Char-
lemont addressed to William Hogarth about the portrait which he
had commissioned.

Mount Street, London. 19th August 1753

Dear Sir, I have been so busy with ten thousand troublesome affairs that I have not been able to wait upon you, according to my promise, nor even to find time to sit for my picture, and I am obliged to set out for Ireland tomorrow. We must defer that 'till my return, which will be in the latter end of January, or in the beginning of February at farthest. I am still your debtor, more so indeed than I shall be able to pay, and did intend to have sent you before my departure what trifling recompense my abilities enable me to make you. But the truth is, having wrongly calculated my expenses, I find myself for the present unable even to attempt paying you. However, if you be in present need of money, let me know it, and so soon as I get to Ireland, I will send you, not the price of the picture, for that is inestimable, but as much as I can afford to give you for it. Sir, I am, with the most sincere wishes for your health and happiness, your most obedient, humble servant, Charlemont.

> Later Charlemont bought *The Lady's Last Stake* and sent the following letter:

Dublin, 29th January 1760

Dear Sir, Enclosed I send you a note upon Nisbitt for one hundred pounds, and considering the name of the author, and the surprising merit of your performance, I am really much ashamed to offer such a trifle in recompense for the pains you have taken, and the pleasure your picture has afforded me. I beg you would think that I by no means attempt to pay you according to your merit, but according to my own abilities. Were I to pay your deserts, I fear I should leave myself poor indeed. Imagine that you have made me a present of the picture, for literally as such I take it, and that I have begged your acceptance of the enclosed trifle. As this really is the case, with how much reason do I subscribe myself your most obliged humble servant, Charlemont.

(B.M. Add. mss 22–394, ff 33 and 35).

4.29 Problems of payment

The relationships between artist and patron were often apt to be both delicate and complex. Robert Strange, the engraver, who was actively involved in picture-dealing, had bought a large number of works of art during his stay in Italy, and had embarked upon a scheme for engraving them. He was approached by Lord Forwich

with an offer to buy the drawings on which he would base the prints, and wrote to his friend, the Jacobite exile, Andrew Lumisden, who for many years had been secretary to the Young Pretender, asking for his advice about the best form payment could take. Lumisden replied on 11 December 1762.

I have had little time to consider what you say of Lord Forwich's desire to purchase your drawings. This is indeed an article of consequence to you, and ought to be duly examined. Your drawings are such as will always attract purchasers; and I am persuaded you may dispose of them at almost any price you please. However, if you can at present secure a reasonable price for them, perhaps 'tis more adviseable to accept of it than to trust entirely to hope. Lord Forwich's situation is rather a discouragement to treat with him unless his father [the Earl of Cowper] should concur in that purchase. The father may live many years, and the son, an expensive young man, will not be in a position, perhaps, to pay you either the interest of the price, or the annuity as you shall agree on. As to the price, I am entirely at a loss what to say. I cannot think it unreasonable of you to demand £50 a drawing, one with another; for as you are to frame and glass them very handsomely, this will reduce your price to about £45 a drawing. You might therefore, engage for 24 drawings, to be specified for £1,200. As the drawings can only be delivered in proportion as they are engraved, it will be years before his Lordship is possessed of the whole. If you dispose of the drawings for a certain sum, that sum, or the interest of it only will be payable, I reckon, from the delivery of the first drawing, for it would be hard to pay before he reaps any satisfaction; and if you agree for an annuity, it will only be payable for the same period, viz. the delivery of the first drawing. It requires time and reflection whether it would be better for you to have a sum of money in hand, or an annuity.

(R. D. *Robert Strange and Andrew Lumisden*. London 1856, vol. 2)

There could be problems of a more irritating nature. Frederick Hervey, Earl of Bristol and Bishop of Derry, was notorious for his unreliability in dealings with artists such as Thomas Banks, Flaxman, John Deare and Wright of Derby, whom the Bishop tried to avoid paying by criticizing the work which he had commissioned. This prompted the following verses from William Hayley, which are given additional significance from the fact that Wright was especially noted in his time for his ability to paint fire and flames.

A Bishop who wished to be rank'd with a few,
Who are cried up by fashion as men of virtu
Most wisely conjectur'd 'twould aid his desire
To purchase from Wright a picture of fire;
But his spirit more mean than his gusto was nice,
Tried a singular trick for reducing the price.
And his bargain to make either cheaper or void,
He thus preach'd to the artist his pride had employed –
'Indeed Mr Wright, you mistake or neglect
The true tint of fire, and its proper effect;
I wonder you think of employing your hand
On a branch of your art that you don't understand.'
Hold, meaness and pride, tho' your mantled in lawn,
Ye shall meet due contempt, and your masque be
withdrawn,
You shall never wound, unrepaid with disgrace,
A genius so modest with insult so base.
You black dilettante! hence, learn to your shame,
No mortal can give more expression to flame!
If flashes more brilliant your eyes wish to dwell,
Your Lordship must go for your picture to ****;
From the plan I propose, tho' not much to your heart,
I think there might rise some advantage to art;
Your Lordship by going those flames to inspect,
Might learn more of fire and its proper effect,
And the Devil, who often creates himself mirth,
By caricaturing odd beings from earth,
Would find proper hints for his pencil to sketch
In a mitre bestowed on so sordid a wretch.
(William Hayley, *Works*. London 1781)

4.30 Gainsborough and a client

William Legge, second Earl of Dartmouth, was a man of science, a
philanthropist and a noted connoisseur. The kind of relationship he
established with artists is implied in these three letters from Gains-
borough about a portrait of Lady Dartmouth, and the alterations
which it was suggested should be made to it. The reflections about
the choice between historic or contemporary dress for portraits are
of especial interest.

1771 April 8. Bath
I received the honour of your Lordship's letter acquainting me that

I am to expect Lady Dartmouth's picture at Bath, but it has not yet arrived. I shall be extremely willing to make any alterations your lordship shall require, when her ladyship comes to Bath for that purpose, as I cannot (without taking away the likeness) touch it except from life. I would not be thought, by what I am going to observe, that I am at all unwilling to do anything your lordship requires to it, or even to paint an entire new picture for the money I received for that, as I shall always take pleasure in doing anything for Lord Dartmouth, but I should fancy myself a great blockhead if I was capable of painting such a likeness as I did of your lordship and not have sense enough to see why I did not give the same satisfaction in Lady Dartmouth's picture, and I believe your lordship will agree with me in this point, that next to being able to paint a tolerable picture, is having judgement enough to see what is wrong with a bad one. I don't know if your lordship remembers a few impertinent remarks of mine upon the ridiculous use of fancy dresses in portraits about the time that Lord North made us laugh in describing a Family Piece his lordship had seen somewhere, but whether your lordship's memory will reach this trifling circumstance or not, I will venture to say that had I painted Lady Dartmouth's picture dressed as her ladyship goes, no fault (more than in my painting in general) would have been found with it. Believe me my lord, though I may appear conceited in saying it so confidently, I never was far from the mark, but I was able, before I pulled the trigger, to see the cause of my missing, and nothing is so common with me as to give up my own sight in my painting room, rather than give offence to my best customers. You see, my Lord, I can speak plainly when there is no danger of having my bones broke, and if your Lordship encourages my giving still a free opinion upon the matter, I will do it in another line.

1771 April 13. Bath.
I can see plainly your Lordship's good nature in not taking amiss what I wrote in my last, though it is not so clear to me but your Lordship has some suspicion that I meant it to spare myself the trouble of painting another picture of Lady Dartmouth, which time and opportunity may convince your Lordship was not my intention, and here I give it under my own hand, that I will most willingly begin upon a new canvas. But I only for the present beg your Lordship will give me leave to try an experiment upon that picture to prove the amazing effect of dress. I mean to treat it as a cast-off picture and dress it (contrary, I know, to Lady Dartmouth's taste)

in the modern way; the worst consequence that can attend it, will be her ladyship's being angry with me for a time. I am vastly out in my notion of the thing, if the face does not immediately look like, but I must know if Lady Dartmouth powders or not in common. I beg only to know that, and have the picture sent down to me. I promise this, my lord, that if I boggle a month by way of experiment to please myself, it shall not in the least abate my desire of attempting another to please your Lordship when I can be in London for that purpose, or Lady Dartmouth comes to Bath.

Postcript. I am very well aware of the objection to modern dress in pictures, that they are soon out of fashion and look awkward, but as that misfortune cannot be helped, we must set it against the unluckiness of fancy dresses taking away likenesses, the principal beauty and intention of a portrait.

1771 April 18, Bath

Nothing can be more absurd than the foolish custom of painters dressing people like scaramouches, and expecting the likeness to appear. Had a picture, voice, action etc. to make itself known as actors have upon the stage, no disguise would be sufficient to conceal a person; but only a face, confined to one view, and not a muscle to move to say, 'Here I am', falls very hard upon the poor painter, who perhaps is not within a mile of the truth in painting the face only. Your Lordship, I am sure, will be sensible of the effect of dress so far, but I defy any but a painter of some sagacity (and such you see am I, my Lord) to be well aware of the different effects which one part of a picture has upon another, and how the eye may be cheated, as to the appearance of size etc. by an artful management of the accompaniments. A tune may be so confused by a false bass, that, if it is ever so plain, simple and full of meaning, it shall become a jumble of nonsense, and just so shall a handsome face be overset by a fictitious bundle of trumpery of the foolish painters own inventing. For my part (however your Lordship may suspect my genius for lying) I have that regard for truth that I hold the finest invention as a mere slave in comparison, and believe I shall remain an ignorant fellow to the end of my days, because I never could have patience to read poetic impossibilities, the very food of a painter, especially if he intends to be knighted in this land of roast beef, so well do serious people love froth. But where am I, my Lord this my free opinion in another line with a witness? Forgive me, my Lord, I am but a wild goose at best, all I mean is this, Lady

Dartmouth's picture will look more like, and not so large when dressed properly, and if it does not, I will begin another.

4.31 Art auctions

Rouquet was one of the first to emphasize the spectacular growth in the business of selling works of art on a public rather than a private level (*The Present State of the Arts in England, 1775*).

In London there are extraordinary sales of pictures and curiosities, which are a kind of market for the productions of the arts. This occasion furnishes us with another instance of that regularity and method which the English introduce into all sorts of business, and especially of the excessive care they take to consult the purchaser's ease.

Within these twenty or thirty years they have built several halls' or auction rooms in London, which are set aside for the sale of pictures.

These halls are lofty, spacious, and separate from any other building, to the end that on every side they may receive full light through glass windows which range all round them, but which do not come down so low as to hinder the walls at a certain height from being occasionally covered with pictures. Any private person, broker or other, who has collected a quantity of pictures sufficient to make a public sale, agrees with the proprietor of one of these auction rooms, who is at the same time praiser and crier. He receives the pictures and ranges them in his hall, according to their excellence and value, each with its respective ticket; then he prints a catalogue of them wherein each picture is to be found in the order of the ticket or number, with the real or supposed name of some eminent master; the subject is also mentioned in these catalogues, and they are supplied gratis. Tho' the conditions of these sales are known to all the world, yet they are repeated every time at the beginning of these catalogues, to the end that, considered as a mutual compact or agreement, they may be a means of determining without litigation, the rights of the seller as well as the purchasers. One of these conditions fixes the sum that you shall advance; and less than that you are not allowed to bid. If the thing be put to sale at any price between three and six shillings, you are not allowed to advance less than three pence; under twelve shillings you are to advance six pence; and this rule is observed in the same proportion

of the penny to the shilling, till the article mounts to a hundred guineas where it ends, whatever may be the sum to which it is further carried.

These reasonable conditions are made to prevent the prolonging of the time of sale to no sort of purpose, and to avoid the ridiculous and unmanly practice of advancing a penny for an article which was put to sale at six hundred pounds.

As soon as the sale is advertised, the room in which it is to be held, and where the pictures are advantageously displayed, is open for two or three days successively, to everybody that has a mind to go in, except the meanest of the populace. A police officer, dressed with the ensigns of his employment stands to guard the door. The inhabitants of London amuse themselves with going to see the goods exposed to sale, just as the people amuse themselves in Paris in the great hall when the performances of the artists of the academy are exposed to public view. As soon as the day and the hour of the sale, which is twelve at noon, are come, the room is filled with persons of different sexes and conditions. They take their places on benches opposite to a little rostrum, which stands by itself, and is raised in the further end of the room about four feet from the ground. The auctioneer mounts with a great deal of gravity, salutes the assembly, and prepares himself a little, like an orator, to perform his office with all the gracefulness and eloquence of which he is master. He takes his catalogue, he orders his servants to present the first article, which he declares aloud; in his hand he holds a little ivory hammer, with which he strikes a blow on the rostrum, when he thinks proper to signify to the company that the article put up for sale is determined.

Nothing can be more entertaining than this sort of auction; the number of persons present, the different passions which they cannot help showing on these occasions, the pictures, the auctioneer himself and his rostrum, all contribute to diversify the entertainment. There you may see a tricking broker, who shall employ another secretly to buy what he himself runs down before the company, or who shall lay a dangerous snare by pretending to purchase with the greatest eagerness a picture belonging to himself. There some shall be tempted to buy, and others sorry for having made any purchase. There a man shall give fifty guineas through vanity and pique, when he would not have given five and twenty, had he not dreaded the shame of being outbid in the presence of a numerous assembly whose eyes were all fixed on him. There you shall see a woman of quality grow as pale as ashes, when she finds herself in

danger or losing a wretched pagoda which she does not want and which upon any other occasion she would not have purchased.

The number of articles marked on the catalogue for each day, is about seventy; from the order and regularity observed at these sales, a person absent is enabled to judge within half an hour, at what time such or such an article will be put to sale; a vast conveniency for those who have no time to spare. This sort of sale has spread a pretty general taste for pictures in London; a taste which they not only excite, but form; there you learn to know the different schools and different masters; in a word it is a kind of gaming, where the knowing ones employ all the wiles and artifices imaginable to make dupes of the unwary, and too often they succeed.

4.32 The artist as dealer

The last two decades of the century saw a great increase in the number of old masters imported into England, as a consequence of the political and social turmoil on the mainland of Europe. Very active in all this was Sir Joshua Reynolds, who recounts to one of his patrons, the Duke of Rutland, his efforts in Brussels.

July 19th 1785 London
I set out tomorrow morning for Brussels, and consequently take the liberty of writing to your Grace in the midst of hurry and confusion. I have but just received a catalogue of the pictures which are now on sale at Brussels. The Emperor has suppressed sixty-six religious houses, the pictures of which are to be sold by auction. Le Comte de Kageneck informs me that the Emperor has selected for himself some of the principal pictures; however there is one altarpiece which belonged to the convent of the *Dames Blanches* at Louvain which is to be sold. The subject is the Adoration of the Magi, ten foot by seven foot eight inches, which I take to be about the size of your picture of Rubens. I do not recollect this picture accurately, and what is valde diflendus [highly irritating] I have no notes to refer to, they are, alas, in your Grace's possession. The picture, I suspect, is the only one worth purchasing if your Grace has any such intention, or will honour me with discretionary orders in regard to other pictures. I shall leave orders for your letter to be forwarded to me at Brussels. The sale does not begin till the twelfth of September; during the whole month of August the pictures are shut up, but for what reason I can't imagine. The principal object of my journey is to re-examine and leave a commission for a picture of

Rubens of St Justus – a figure with his head in his hands after it had been cut off – as I wish to have it for the excellency of its painting; the oddness of the subject will, I hope, make it cheap. Whether it will be a bargain or not, I am resolved to have it at any rate.

August 22nd 1785.

I set out for Brussels the day after I wrote to your Grace, but left word that if any answer arrived to be sent after me, but my stay abroad was so short that I missed it; however, I have since received it in London. I was much disappointed in the pictures of the suppressed religious houses; they are the saddest trash that was ever collected together. The *Adoration of the Magi* and *St Justus* by Rubens, and a *Crucifixion* by Van Dyck were the only tolerable pictures, but these are not the best of those masters. I did not like the Justus as well as I did before, but I think of sending a small commission for it; the two others, I dare say will not go for above £200 each. The Van Dyck was in the Church of the Dominicanes at Antwerp. I was shewn some of the pictures which were reserved for the Emperor, which were not a jot better than the common run of the rest of the collection.

Though I was disappointed in the object of my journey, I have made some considerable purchases from private collections. I have bought a very capital picture of Rubens of Hercules and Omphale, a composition of seven or right figures, perfectly preserved, and as bright as colouring can be carried. The figures are rather less than life; the height of the picture, I believe, not above seven feet. I have likewise a Holy Family, a Silenus and Bacchinalians, and two portraits, all by Rubens. I have a Virgin and Infant Christ, and two portraits by Van Dyck, and two of the best things of wild beasts by Snyders and De Vos that I ever saw. I now begin to be impatient for their arrival, which I expect every day. The banker, Mr. Danoot was very ill when we were in Brussels, supposed to be dying; if that should happen his pictures will be sold.

If your Grace should choose to send any commission for the altar piece of Rubens, or for the Van Dyck, the sale begins the twelfth of September; you will please to let me know time enough before the sale for the commission to arrive in Brussels.

September 10th 1785.

Though I have not been so punctual in answering your Grace's letter as I ought, yet I took care that nothing should prevent me writing to my correspondent in Flanders to desire that he would go as far as four hundred guineas for the Van Dyck, and three hundred

for the Rubens. I could not in conscience give him a higher commission. I must beg leave to mention to your Grace the person I have employed in this business; his name is De Gray, a very excellent painter in *chiar oscuro*, in imitation of *basso relievos*. He paints likewise portraits in oil and in crayons extremely well. He was very civil and attentive to me when I was in Antwerp, and was the means of my purchasing some very fine pictures. He then told me he intended going to Ireland, having been invited by Mr Cunningham; and I promised to recommend him likewise to your Grace's protection; which I can with a very safe conscience, not only as a very ingenious artist, but a young man of very pleasing manners. I have no doubt but he is very happy in this opportunity of doing anything to oblige your Grace, and will be very zealous in the performance.

I don't know how to account for the pictures at Antwerp not appearing so striking to me this last journey as they did the first. I was very disappointed in very many other pictures, beside those on sale. It ought at least to teach me this lesson – not to be very impatient when anyone differs with me about the degree of excellence of any pictures, since I find I differ so much from myself at different times.

I have enclosed the title and that part of the catalogue which has the Rubens and the Van Dyck, which I apprehend is all your Grace wished to see.

(Hist. MSS Commission, 14th Report Appendix Part I: Rutland)

In the following year the Duke secured partly through Reynolds and partly through James Byres, an English art dealer in Rome, Poussin's *Seven Sacraments* from the Boncapaduli family for £2,000. They were sent to Reynolds' house in Leicester Fields on 7 September and some weeks later he wrote to the Duke:

October 4 1786.
Everything related to the pictures has hitherto turned out most prosperously. They have past through the operation of lining and cleaning, all of which has been performed in my own house under my own eye. I was strongly recommended to a Neapolitan, as having an extraordinary secret for cleaning pictures, which, though I declined listening to at first, I was at length persuaded to send for the man, and tried him by putting into his hands a couple of what I thought the most difficult pictures of any to clean in my house. The success was so complete that I thought I might trust him with the

Sacraments, taking care to be always present when he was at work. He possesses a liquid which he applies with a soft sponge only, and without any violence or friction takes off all the dirt and varnish without touching, or in the least affecting the colours. With all my experience in picture cleaning, he really amazed me. The pictures are now just as they came from the easel. I may now safely congratulate your Grace on being relieved from all anxiety. We are safely landed; all danger is over. . . .

As to their originality, it is quite out of all question. They are not only original, but in his very best manner, which cannot be said of the set in the Duke of Orleans' collection. The latter are really painted in a very feeble manner, and though they are undoubted originals, have somewhat the appearance of copies.

Wellbore Ellis Agar told me they were offered to him some years ago for £1,500, but he declined the purchase by the advice of Hamilton, the painter, on account, as he said, of their being in bad condition.

It is extraordinary that a man so conversant in pictures should not distinguish between mere dirtyness and what is defaced or damaged. Mr Agar dined with me a few days since with a party of connoisseurs, but the admiration of the company, and particularly of the good preservation of those pictures so mortified him at having missed them, that he was for the whole day very much what the vulgar call *down in the mouth*, for he made very little use of it either for eating or talking.

Lord Spencer tells me that he stood next, and was to have had them, if your Grace had declined the purchase. One of the articles· between Byres and the Marquis [Boncapaduli] was that he should bring strangers as usual to see the copies, and which he says he is obliged to do, and I suppose swear they are originals; and it is very probable those copies will be sold again, and other copies put in their place. This trick has been played, to my knowledge, with pictures of Salvador Rosa by some of his descendants who are now living in Rome, who pretend that the pictures have been in the family ever since their ancestor's death.

4.33 Some sales

Picture prices rose steadily throughout the century as wealth increased and was more widely disseminated.

The constant high price given for pictures; the other day at Mr Fur-

nese's auction, a very small Gaspar [Gaspard Poussin] sold for 76
guineas; and a Carlo Maratti, which too I am persuaded was a
Guiseppe Chiari, Lord Egremont bought at the rate of 260 pounds.
Mr Spencer gave no less than 2,200 pounds for the Andrea Sacchi
and the Guido from the same collection. The latter is of very du-
bious originality. My father, I think, preferred the Andrea Sacchi to
his own Guido and once offered 700 pounds for it, but Furnese said
'Damn him, it is for him, he shall pay 1,000'. There is a pewterer at
Cleeve who some time ago gave 1000 pounds for four very small
Dutch pictures.

(Thomas Gray, *Letters to Wharton*, 1758)

Prices at Sir Luke Schaub's Sale:

Guido's *Boy and Lamb*	£153.10.0.
Claud Lorrain	£105. 0.0.
Rembrandt's *Boy's Head*	£52. 0.0.
Rubens *Landscape*	£76. 0.0.
Vandyke *Laughing Boy*	£126. 0.0.
Correggio *Sigismunda*	£200. 0.0.
Raphael	£703. 0.0.
View of Antwerp (background city by Brill; Flemish foreground Rubens; River L'Escaut; bridge and buildings Gillis; small figures Velvet Bruegel).	£551. 5.0.

(Mrs Delany to B. Granville 1758, *Letters of Mrs Delany* –
London 1861.)

By the late 1780s and onwards however the rise in prices was pre-
cipitous largely because French and other exiles were selling their
collections in London, which established that primacy in the art
selling world which it has subsequently retained.

In March 1795 Skinner and Dale sold at their Great Rooms in
Spring Garden the collection of M. de Calonne, a famous French
collector. Of the 359 pictures sold, the most interesting included:

Claude *Landscape with St George and the Dragon*	£170
Vernet *Ancient Baths near Naples*	£165
Rembrandt *Young Man*	£105
Murillo *Madonna and Child*	£205
Canaletto *The Grand Canal, Venice*	£165
Van Dyck *Portrait of a Lady*	£170
Ostade *Dancers in a cabaret*	£350
Gainsborough *Girl with pigs*	£185

Claude *The Enchanted Castle*		£520
Poussin *Bacchanalian Dance*		£870
Joshua Reynolds *Mrs Siddons*		£320

In December 1798, the Orleans Collection sale started in the Bryan Rooms in Pall Mall, and at the Lyceum in the Strand, and continued for six months. It was the most important sale to have been held in England since that of Charles I's paintings. The Orleans Collection, originally housed in the Palais Royal, was one of the most important in Europe. Amongst the paintings sold were:

Sebastiano del Piombo	*The Resurrection of Lazarus*	350 guineas
Annibale Carracci	*The Descent from the Cross*	4,000 guineas
Titian	*Diana and Calisto*	2,500 guineas
Poussin	*Moses striking the rock*	1,000 guineas
Poussin	*The Seven Sacraments*	4,900 guineas (for 7)
Van Dyck	*The Family of Charles I*	1,000 guineas
Perugino	*Madonna and Child*	5 guineas
Guido Reni	*Ecce Homo*	50 guineas
Titian	*Charles V on horseback*	150 guineas
Tintoretto	*The nursing of Hercules*	50 guineas
Veronese	*The judgement of Solomon*	60 guineas
Velazquez	*Lot and his daughters*	500 guineas
Teniers	*The Pipe smokers*	200 guineas

(W. Buchanan, *Memoirs of Painting*. London 1841.)

4.34 Exhibitions of contemporary art

Public exhibitions of living art had been virtually unknown in England until 1760 when the Society for the Encouragement of Arts Manufactures and Commerce offered artists their premises for an exhibition which opened on 21 April. Although a success there were problems with the Society (now the Royal Society of Arts) which made certain stipulations about hanging etc. The next similar exhibition was therefore held in hired rooms in Spring Gardens at Charing Cross. Admission was by catalogue – costing one shilling – which admitted any number of people and this led to crowding and confusion. At the second exhibition there, which opened on 17 May 1762 admission was a shilling a head, and the catalogue was

free. It contained an introduction which spelt out the ideas of the participants, and the philosophy of exhibitions as it appeared to the eighteenth century. The author was Dr Johnson.

The public may justly require to be informed of the nature and extent of every design for which the favour of the public is openly solicited. The artists who were themselves the first promoters of an exhibition in this nation, and who have now contributed to the following Catalogue, think it therefore necessary to explain their purpose, and justify their conduct. An exhibition of the works of art being a spectacle new in this kingdom, has raised varying opinions and conjectures amongst those who are unacquainted with the practice in foreign nations. Those who set their performances to a public view, have been too often considered as the rivals of each other; as men actuated, if not by avarice, at least by vanity, and contending for superiority of fame, though not for a pecuniary prize. It cannot be denied or doubted, that all who offer themselves to criticism are desirous of praise; this desire is not only innocent, but virtuous, while it is undebased by artifice, and unpolluted by envy; and of envy or artifice those men can never be accused, who are already enjoying all the honours and profits of their profession, are content to stand candidates for public notice, with genius yet unexperienced, and diligence yet unrewarded; who, without any hope of increasing their own reputation or interest, expose their names and their work, only that they may furnish an opportunity of appearance to the young, the diffident and the neglected. The purpose of this exhibition is not to enrich the artist, but to advance the art; the eminent are not flattered by preference, nor the obscure insulted with contempt; whoever hopes to deserve public favour, is here invited to display his merit. Of the price put upon this exhibition some account may be demanded. Whoever sets his work to be shown naturally desires a multitude of spectators; but his desire defeats its own end, when spectators assemble in such numbers as to obstruct one another.

Though we are far from wishing to diminish the pleasures, or deprecate the sentiments of any class of the community, we know, however, what everyone knows, that all cannot be judges or purchasers of works of art. Yet we have found already by experience that all are desirous to see an exhibition. While the terms of admission were low, our room was thronged with such multitudes as made access dangerous, and frightened away those whose approbation was most desired.

Yet because it is seldom believed that money is got, but for the love of money, we shall tell the use we intend to make of our expected profits. Many artists of great ability are unable to sell their works for their due price; to remove this inconvenience an annual exhibition will be appointed, to which every man may send his works, and send them, if he will without his name.[1] These works will be reviewed by the committee that conduct the exhibition; a price will be secretly set on every piece, and registered by the secretary; if the piece exposed is sold for more, the whole price shall be the artist's; but if the purchasers value it less than the committee, the artist shall be paid the deficiency from the profits of the exhibition.

> The Spring Garden exhibitions attracted a great deal of publicity, and gave a great impetus to the nascent profession of the art critic. Much of the writing was of a facetious or controversial type, with the name of certain artists being puffed, and the latent hostility between various factions exploited. Typical is the following piece which appeared in the *St James's Chronicle* in June 1761. The writer is described as an old Etonian, a graduate and a lover of pictures and books, who having come up to London meets an old schoolfellow.

The first man I met in town was Lord Brillus, an old schoolfellow, who, I had heard, had just returned from his travels. He accosted me with an affected ease in his manner, a shamble in his attitude, and a something of a half foreign accent. 'My dear friend' he cried, 'joy attend you – welcome to town. What new horses have you bred this year?' 'None' said I, 'I have no fancy for the modern pleasures of the turf.' He embraced me, 'A man of taste by all that's agreeable! Come with me, and help me despise the wretched English daub at Spring Gardens.' I replied that I would attend him, but would despise nothing merely because it was English or was to be seen at Spring Gardens. 'Come along' he said 'you shall despise them. I am a member of the Society for the Encouragement of the Arts.' 'I am glad' said I, 'that there is such a Society and that you are a member. I have heard of your exhibitions and long to see them. But why do you despise the artists you pretend to encourage?'

'Lord' he said 'why you know nothing. There is a wretched fellow now, one Hogarth...' 'Hold' I said 'I know that Hogarth is the best painter of life and manners in the universe, and I know that

1. This interesting scheme was only put into operation once, when the works not sold at the exhibition were put up to auction at Langford's Room in Covent Garden.

I gave £12 or £14 for his prints, and would not take five hundred for them.' 'Lord' said he again, 'Hogarth, an absolute Bartholomew[2] droll, who paints country elections,[3] and pretends to laugh at the connoisseurs.'

We went up to the gallery, and I soon caught sight of the tailpiece in the catalogue which I bought at the door. However I followed his Lordship upstairs. 'Heavens' said I, 'what's yonder, the unhappy Sigismonda with Guiscard's heart?[4] Would Dryden could but come back to life again to see his thoughts so expressed and coloured. Who did it, my Lord?' 'Hogarth' said he, 'but it is quite out of his walk.' 'Hogarth' said I, 'I could not have expected it even from him. And pray, who is that nobleman – a portrait I cannot call it, for he breathes?' 'Reynolds' Duke of Beaufort,' says he, 'but did you ever see a Vandyck?' 'Never any that beats this, my Lord, and I don't live far from Wilton neither.' I turned about – 'A noble landscape that; bless me, what colouring, what composition, what taste!' 'D'ye mean Wilson's Niobe?' says my Lord. 'What colouring indeed! None of the colouring of Claude's glowing backgrounds.'

I had no longer patience. My Lord said 'Pray look at the tailpiece in the catalogue, and see what you can make of it. It is your friend Hogarth's conceit, can you guess what he means by it?' It struck me at once. 'Pray, my Lord, do not ask me.' But he pressed the question, 'The author' I said 'of the Election and Sigismonda can never draw anything with a meaning, and I swear I think this is very like.' 'Like who?' 'Just like your Lordship upon my honour.' Here we parted, and here I shall conclude by requesting you, Sir, to print this letter from an admirer, but Thank God, no encourager of the Polite Arts.

4.35 The need for public galleries

In 1766 Thomas Martyn (1735–1825), Professor of Botany at Cambridge, published *The English Connoisseur; containing an account of whatever is curious in painting, sculpture etc. in the palaces and seats of the nobility and principal gentry of England both in town and country*. This two-volume work, largely a compilation (cf F. Simpson, 'The English Connoisseur and its Sources', *Burlington Magazine* vol, xliii,

2. The fair at St Bartholomew's was famous for its clowns and mountebanks.
3. *The Election; Chairing the Member* (Sir John Soane Museum); a parody of baroque painting.
4. Hogarth's most ambitious attempt to produce a 'history' painting.

1950), is pedestrian in style but the author made some interesting comments in his preface.

The only way by which we can ever hope to arrive at any skill in distinguishing the style of the different masters in painting is the study of their works; any assistance therefore in this point cannot but be grateful to the rising Connoisseur. It is well known at how few of those houses into which, by the indulgence of their illustrious owners the curious are admitted, any catalogues of the paintings and other curiosities which adorn them can be obtained; and without such catalogues it must be confessed little use can be made by the yet uninformed observer of these valuable collections, besides that general one of pleasing the eye and the imagination by viewing a variety of delightful objects.

The editor cannot help concluding with a wish that the nobility and gentry would condescend to make their cabinets and collections accessible to the public as is consistent with their safety. The polite arts are rising in Britain, and call for the fostering hand of the rich and powerful; one certain way of advancing them is to give all possible opportunities to those who make them their study to contemplate the works of the best masters, that they may not form a bad taste and a poor manner upon such productions as chance throws in their way. It ought to be acknowledged with gratitude that many of the collections of the great are ever open to the inspection of the curious, who have been permitted in the most liberal manner to take copies of their paintings, and to make drawings from them; but at the same time, it must be lamented that some cabinets are not accessible without difficulty and interest. It should be mentioned to the honour of the French nation, that their collections are come at, even by foreigners, with great facility, in particular the royal pictures are not locked up in private appartments from the eyes of the people, but are the pictures of the public.

> One of the people most forward in his arrangements for visitors was Horace Walpole, who wrote a guide book, *A Description of Strawberry Hill* (1784) and prepared a printed leaflet for prospective visitors.

Mr Walpole is very ready to oblige any curious persons with the sight of his house and collection; but as it is situated so near to London and in so populous a neighbourhood, and as he refuses a ticket to nobody that sends for one, it is but reasonable that such persons as send should comply with the rules he has been obliged to lay down for showing it.

Any person, sending a day or two before, may have a ticket for four persons for a day certain. No ticket will serve but on the day for which it is given. If more than four persons come with a ticket, the house-keeper has positive orders to admit none of them. Every ticket will admit the company only between the hours of twelve and three before dinner, and only one company will be admitted on the same day. The house will never be shown after dinner, nor at all but from the first of May to the first of October. As Mr Walpole has given offence by sometimes enlarging the number of four and refusing that latitude to others, he flatters himself that for the future nobody will take it ill that he strictly confines the number; as who-ever desires him to break his rule does in effect expect him to dis-oblige others, which is what nobody has a right to desire of him. Persons desiring a ticket may apply either to Strawberry Hill or to Mr Walpole's in Berkeley Square, London. If any person does not make use of a ticket, Mr Walpole hopes he shall have notice; other-wise he is prevented from obliging others on that day, and thence is put to great inconvenience. They who have tickets are desired not to bring children.

4.36 Access to the British Museum

One of the most spectacular happenings in the cultural history of eighteenth-century Britain was the purchase of the collection of Sir Hans Sloane and the placing of this in the British Museum at Mon-tagu House, Bloomsbury, established by Act of Parliament, and first opened to the public in 1759, as a storehouse of knowledge for the benefit of 'the learned and the curious'. How different its nature and functions were from those of the twentieth-century museum is suggested by the Regulations published in 1760.

The Museum will be kept open every day (except *Saturday, Sunday, Christmas Day, and one week after Easter Day, and Whitsunday, Good Friday, and every public fast and thanksgiving day*) from nine in the morning to three in the afternoon; but on *Mondays* and *Fridays* in May, June, July and August, only from four to eight in the after-noon.

Persons desirous to see the Museum must, in writing, give in their names, conditions, and places of abode, and also the day and hour they desire to be admitted, to the porter, before nine in the morning, or before four and eight in the evening, on some preced-ing day, which he will enter in a register, to be laid every night be-

fore the principal librarian, or, in his absence, before the under-librarian officiating for him; and, if he shall judge them proper, he will direct the porter to deliver tickets to them, on their applying a second time for tickets.

No more than ten tickets will be delivered out for each hour of admittance, which tickets being shown to the porter, he will direct the spectators to a room appointed for their reception, till their hour of seeing the Museum become, at which time they are to deliver their tickets to the proper officers of the first department. Five of the spectators will be attended by the under-librarian, and the other five by the assitant in each department.

The tickets are for the admission of the company at nine, ten, eleven, or twelve in the morning; and four or five in the afternoon of those days in which the Museum is open at that time.

If application be made by more than can be accommodated on the day and hour they had named, the persons last applying will have tickets for any other day or hour within seven days.

If not more than five produce tickets for any particular hour, they will be desired to join in one company.

Persons prevented from making use of their tickets are desired to send them back to the porter, in time, that others may not be excluded.

That the spectators may view the Museum in regular order, they will first be admitted to see the manuscripts and medals; then the natural and artificial productions, and afterwards the printed books.

One hour only will be allowed to the several companies, so that the whole may be inspected in three hours. Notice of the expiration of the hour will given by the ringing of a bell. Each company must be kept together in that room in which the officer who attends them shall then be.

4.37 A new aera of virtu

The hopes, partly justified by history, entertained at the time for the beneficial effects of the Museum were eloquently expressed in 1757 by Horace Walpole, who was one of the Trustees, in his *Advertisement to a Catalogue and Description of Charles the First's Collection.*

The Establishment of the British Museum seems a charter for in-

corporating the arts, a new aera of virtu. It is to be hoped that collections, wont to struggle through auctions into obscurity, will there find a center! Who that should destine his collection to the British Museum, would not purchase curiosities with redoubled spirit and pleasure, whenever he reflected that he was collecting for his country, and would have his name recorded as a benefactor to its arts and improvements? And when so fair a foundation is laid, if pictures and statues flow in to books and medals and curiosities of every kind, may we not flatter ourselves, that a British academy of arts will arise; at least that we shall not want great masters of our own, when models are prepared, and our artists can study Greece and Rome, Praxiteles and Raphael, without stirring from their own metropolis?

4.38 Projects for an academy

The rising social status of the aritst, the examples of France and Italy, the necessity for promoting patronage and establishing some form of art eduction, all conspired to foster the idea of an Academy more official and more highly organized than the rather informal one which had been meeting for some time in St Martin's Lane, and which was rather in the nature of a sketch club. In 1755 a group of the most important artists, including Reynolds, Roubiliac, Hoare, Lambert and others published *The Plan of an Academy for the Better Cultivation, Improvement and Encouragement of Painting, Sculpture, Architecture and the Arts of Design in General; the Abstract of a Royal Charter as proposed for Establishing the same; and a short introduction*. In this introduction some points were made which underlined the admixture of artistic idealism, chauvinism and more commercial considerations which influenced the writers.

The more attention we bestow upon the arts, and the quicker relish we acquire for them, the more enlarged the province of pleasure becomes; and what is equally worthy of consideration, the pleasure of individuals thus derived and obtained become so many inexhaustible sources of profit to the public. It is for the profit of the public that every individual should be employed, and that every vein of industry and ingenuity should be opened; the circulation then is both strong and equal, and every member of the commonwealth helps to communicate health and vigour to the whole. It is a disgrace to a commonwealth to have any want, having within itself the proper materials for supplying it, as also to pay at a foreign

market for any productions which a very little effort might create equally excellent in its own.

The prodigious sums England has laid out at foreign markets for paintings is but a trifle compared to the most prodigious sums expended by English travellers for the bare sight of such things as they despaired of ever seeing at home. But the loss in point of money is not so much in point of character; for we voluntarily yield the palm to every state that has produced a painter, and by the language generally used on this subject, one would think England the only country in the world incapable of producing one; as if the genius of a painter were one kind of essence, and the poet a genius of another; as if the air and soil that gave birth to Shakespeare and a Bacon, a Milton and a Newton could be deficient in any species of excellence whatsoever.

Whereas the whole secret lies in this. When princes for their grandeur, or priests for their profit, have recourse to painting, the encouragement given to the professors gave spirit to the art, and then everyone thought it worth their while so to distinguish himself by encouraging it in the hope of sharing in the reward. If then the national character ought to be consistent, the present wild and neglected state of the arts, and of painting in particular, is worthy of both attention and concern. To bring about this desirable end, it has been thought expedient to solicit the establishment of a Royal Academy, under the direction of a select number of artists chosen by ballot out of the whole body. A charter for such a Royal Academy has been prepared, by which the said committee of artists are to be empowered to receive contributions towards a fund for defraying the charge of the same. A plan has also been digested for directing the whole, which, it is hoped will not be liable to any material objections, and all that is further wanting to carry it into execution is the benevolence of the public. As then the undertaking is of a public nature, as the expense to the public will be inconsiderable in comparison to the advantages to be expected from it, – as one distinguished set of noblemen and gentlemen long ago set apart a sum of money to be applied to a similar purpose, when opportunity offered [The Dilettanti Society] as pecuniary rewards have been offered by another society of noblemen and gentlemen [The Royal Society of Arts] to encourage young beginners; and as no foundation, however narrow its views and purposes, has yet wanted patrons and benefactors, it would be criminal even to suppose that this would be suffered to perish in its birth for want of assistance only.

4.39 An English Academy at Rome?

There was even an attempt made to found an English Academy at
Rome, in imitation of the French one already existing there.

Rome, May 12.

The English Nobleman and Gentlemen now at this place on their
on their Travells, having taken into consideration the Dis-
advantages young students of their nation in Painting and Sculpture
lie under here for want of the Foundation of an *Academy* with Pen-
sions for encouragement of those whose circumstances will not per-
mit them to prosecute their studies for a sufficient time at their own
expense, have begun a generous Subscription towards the founda-
tion of an Academy, and have appointed *Mr John Parker* History
Painter to be the Receiver and Director thereof. The Generous
Promoters of this Foundation are the Lords Bruce, Charlemont,
Tilney and Killmurry; Sir Thomas Kennedy Bart; Messrs. Ward,
Iremonger, Lethullière, Bagot, Scroop, Lypeat, Murphy, and as all
nations in Europe, especially the French have Academies and great
Encouragements, 'tis hoped all Lovers of the Arts will promote this
generous design.

(*Daily Advertiser*, 8 June 1752)

4.40 Opposition to the idea of academies

Although he died before the establishment of the Royal Academy,
Hogarth was cynical about the viability of the idea of such an in-
stitution, and with his usual pungent pessimism expressed his
opinion about English attitudes to art (Ireland's *Hogarth Illustrated*,
London 1851 supplementary volume, pp. 76–9).

Portrait-painting ever has, and ever will, succeed better in this
country than any other. The demand will be as constant as new
faces arise; and with this we must be contented, for it will vain to
attempt to force what can never be accomplished, at least by such
institutions as royal academies, on the system now in agitation. If
hereafter, the times alter, the arts, like water, will find their own
level. Among other causes that militate against either painting or
sculpture succeeding in this nation, we must place our religion,
which inculcating unadorned simplicity, doth not require, nay
absolutely forbids, images for worship, or pictures to excite enthu-
siasm. Paintings are considered as pieces of furniture, and Europe is

already overstocked with the works of other ages. These with copies countless as the sands on the sea-shore, are bartered to and fro, and are quite sufficient for the demands of the curious, who naturally prefer scarce, expensive, and far-fetched productions, to those which they might have on low terms at home. Who can be expected to give forty guineas for a modern landscape, though in ever so superior a style, when he can purchase one which, for little more than double the sum, shall be sanctioned by a sounding name, and warranted original by a solemn-faced connoisseur? This considered, can it excite wonder that the arts have not taken such deep root in this soil as in places where people cultivate them from a kind of religious necessity and where proficients have so much profit in the pursuit? Whether it is to our honour, or our disgrace, but the fact is indisputable, that the public encourage trade and mechanics rather than painting and sculpture.

4.41 The foundation of the Royal Academy

The instrument which the founding fathers of the Royal Academy presented to King George III on 10 December 1768 for his signature, was remarkably precise, detailed and exhaustive. It has remained the basis of the Royal Academy ever since, and its impact on British art was significant. Those who drew it up were conscious of English attitudes – the emphasis was on the near-commercial aspect of 'design' – and though they represented the ideals of their own time, they were imaginative and far-seeing, especially about the concept and techniques of art education.

Whereas sundry persons resident in this metropolis, eminent professors of painting sculpture and architecture, have most humbly represented by memorial unto the King that they are desirous of establishing a Society for promoting the Arts of Design, and earnestly soliciting His Majesty's patronage and assistance in carrying this their plan into execution; and whereas its great utility hath been fully and clearly demonstrated, his Majesty, therefore, desirous of encouraging every useful undertaking, doth hereby institute and establish the said Society under the name and title of the Royal Academy of Arts in London, graciously declaring himself the patron, protector and supporter thereof, and commanding that it be established under the forms and regulations hereinafter mentioned, which have been most humbly laid before his Majesty, and received his royal approbation and consent.

I. The said Society shall consist of forty members only, who shall be called Academicians of the Royal Academy; they shall all of them be artists by profession at the time of their admission; that is to say painters, sculptors or architects, men of fair moral character, of high reputation in their several professions; at least twenty five years of age; resident in Great Britain, and not members of any society of artists established in London.

II. It is his Majesty's pleasure that the following forty persons be the original members of the said Society, viz; Joshua Reynolds, Benjamin West, Thomas Sandby, Francis Cotes, John Baker, Mason Chamberlin, John Gwynn, Thomas Gainsborough, J. Baptist Cipriani, Jeremiah Meyer, Francis Milner Newton, Paul Sandby, Francesco Bartolozzi, Charles Catton, Nathaniel Hone, William Tyler, Nathaniel Dance, Richard Wilson, G. Michael Moser, Samuel Wale, Peter Toms, Angelica Kauffman, Richard Yeo, Mary Moser, William Chambers, Joseph Wilton, George Barret, Edward Penny, Agostino Carlini, Francis Hayman, Dominic Serres, John Richards, Francesco Zuccarelli, George Dance, Willam Hoare, Johan Zoffany.

III. After the first institution, all vacancies of Academicians shall be filled by election from amongst the exhibitors in the Royal Academy; the names of the candidates for admission shall be put in the Academy three months before the day of election, of which day timely notice shall be given in writing to all the Academicians; each candidate shall, on the day of election, have at least thirty suffrages in his favour to be duly elected; and he shall not receive his letter of admission till he hath deposited in the Academy, to remain there, a picture, bas-relief, or other specimen of his abilities approved by the then sitting Council of the Academy.

IV. For the government of the Society there shall be annually elected a President, and eight other persons, who shall form a Council, which shall have the entire direction and management of all the business of the Society; and all the officers and servants thereof shall be subservient to the said Council, which shall have power to reform all abuses, to censure such as are deficient in their duty, and (with the consent of the general body, and the King's permission, first obtained for that purpose) to suspend, or entirely remove from their employments such as shall be found guilty of any great offences. The Council shall meet as often as the business of the Society shall require it; every member shall be punctual to

the hour of appointment, under the penalty of a fine, at the option of the Council; and at each meeting the attending members shall receive forty five shillings, to be divided equally amongst them, in which division however, the secretary shall not be comprehended.

V. The seats in the Council shall go by succession to all the members of the Society, excepting the secretary, who shall always belong thereto. Four of the Council shall be voted out each year, and these shall not re-occupy their seats in the Council till all the rest have served; neither the President nor secretary shall have any vote either in the Council or General Assembly, excepting the suffrages be equal, in which case the President shall have the casting vote.

VI. There shall be a Secretary of the Royal Academy, elected by ballot from amongst the Academicians, and approved of by the King; his business shall be to keep the minutes of the Council, to write letters and send summonses etc; he shall attend at the exhibition, assist in disposing the performances, make out the catalogues etc; he shall also, when the Keeper of the Academy is indisposed, take upon himself the care of the Academy, and the inspection of the Schools of Design, for which he shall be properly qualified. His salary shall be sixty pounds a year, and he shall continue in office during his Majesty's pleasure.

VII. There shall be a Keeper of the Royal Academy, elected by ballot from among the Academicians; he shall be an able painter of history, sculptor, or other artist properly qualified. His business shall be to keep the Academy, with the models, casts, books and other moveables belonging thereto; to attend regularly the Schools of Design during the sittings of students, to preserve order among them, and to give them such advice and instruction as they shall require; he shall have the immediate direction of all the servants of the Academy; shall regulate all things relating to the schools, and with the assitance of the visitors provide the living models etc. He shall attend at exhibition, assist in disposing the performances, and be constantly at hand to preserve order and decorum. His salary shall be one hundred pounds a year; he shall have a convenient apartment allotted to him in the Royal Academy, where he shall constantly reside, and he shall continue in office during the King's pleasure.

VIII. There shall be a Treasurer of the Royal Academy, who, as the King is graciously pleased to pay all deficiencies, shall be appointed by his Majesty from amongst the Academicians, that he

may have a person on whom he places full confidence in an office where his interest is concerned; and his Majesty doth hereby nominate William Chambers, Esquire, architect of his works to be treasurer of th Royal Academy of Arts; which office he shall hold, together with the emoluments thereof from the date of these presents, and during his Majesty's pleasure. His business shall be to receive the rents and profits of the Academy, to pay its expenses, to superintend repair of the buildings and alterations, to examine all bills and conclude all bargains; he shall once in every quarter lay a fair state of his accounts before the Council, and when they have passed examination and been approved there, he shall lay them before the Keeper of his Majesty's Privy Purse, to be by him finally audited, and the deficiencies paid; his salary shall be £60 a year.

IX. That the Schools Design may be under the direction of the ablest artists, there shall be elected annually from amongst the Academicians nine persons who shall be called visitors; they shall be painters of history, able sculptors, or other persons properly qualified, their business shall be to attend the schools by rotation, each a month, to set the figures, to examine the performance of students, to advise and instruct them, to endeavour to form their taste, and turn their attention to that branch of the arts for which they seem to have the aptest disposition. These officers shall be approved of by the King; they shall be paid out of the Treasury ten shillings and six pence for each time of attending, which shall be at least two hours, and shall be subject to a fine of ten shillings and six pence whenever they neglect to attend, unless they appoint a proxy from amongst the visitors for the time being, in which case he shall be entitled to the award. At every election four of the old visitors shall be declared non-eligible.

X. There shall be a Professor of Anatomy, who shall read annually six public lectures in the schools, adapted to the arts of design; his salary shall be thirty pounds a year, and he shall continue in office during the King's pleasure.

XI. There shall be a Professor of Architecture, who shall read annually six public lectures, calculated to form the taste of the students, to instruct them in the laws and principles of composition, to point out to them the beauties or faults of celebrated productions, to fit them for an unprejudiced study of books, and for a critical examination of structures; his salary shall be thirty pounds a year and he shall continue in office during the King's pleasure.

XII. There shall be a Professor of Painting, who shall read annually six lectures, to instruct the students in the principles of composition, to form their taste of design and colouring, to strengthen their judgement, to point out to them the beauties and imperfections of celebrated works of Art, and the particular excellencies or defects of great masters; and finally to lead them into the readiest and most efficacious paths of study; his salary shall be thirty pounds a year.

XIII. There shall be a Professor of Perspective and Geometry, who shall read six public lectures annually in the schools, in which all the useful propositions of Geometry, together with the principles of Lineal and Aerial Perspective, and also the projection of shadows, reflections and refractions shall be clearly and fully illustrated; he shall particularly confine himself to the quickest, easiest and most exact methods of operation. He shall continue in office during the King's pleasure, and his salary shall be thirty pounds a year.

XIV. The lectures of all the Professors shall be laid before the council for its approbation in writing before they can be read in the public schools. All these Professors shall be elected by ballot, the last three from amongst the Academicians.

XV. There shall be a Porter of the Royal Academy, whose salary shall be twenty five pounds a year; he shall have a room in the Royal Academy, and receive his orders from the Keeper or Secretary.

XVI. There shall be a Sweeper of the Royal Academy, whose salary shall be ten pounds a year.

XVII. There shall be an Annual Exhibition of Paintings, Sculpture and Designs, which shall be open to all Artists of distinguished merit; it shall continue for the public one month, and be under the regulations expressed in the bye-laws of the Society hereafter to be made. Of the profits arising therefrom, two hundred pounds shall be given to indigent artists, or their families, and the remainder shall be employed in the support of the Institution. All Academicians, until they have achieved the age of sixty be obliged to exhibit at least one performance under a penalty of five pounds, to be paid into the Treasury of the Academy, but after that age, they shall be exempt from all duty.

XVIII. There shall be a Winter Academy of Living Models, men and women of different character, under the regulations expressed in the bye-laws of the Society, hereafter to be made, free to all students who shall be qualified to receive advantages from such studies.

XIX. There shall be a Summer Academy of Living Models to paint after, also of Laymen with draperies, both ancient and modern, Plaster Figures, Bas-reliefs, models and designs of Fruits, Flower, Ornaments & c. free to all artists qualified to receive advantage from such studies, and under the regulations in the bye-laws of the Society hereafter to be made.

XX. There shall be a Library of Books of Architecture, Sculpture, Painting and all the Sciences relating thereto; also prints of bas-reliefs, vases, trophies, ornaments, dresses, ancient and modern customs and ceremonies, instruments of war and arts, utensils of sacrifice, and all other things useful to students in the Arts, which library shall be open one day a week to all students properly qualified. One of the members of the Council shall attend in the room during the whole time it is open, to keep order and to see that no damage is done to the books; and he shall be paid 10s. 6d. for his attendance. No books shall, under any pretence, be suffered to be taken out of the Library, but every Academician shall have free ingress at all seasonable times of the day to consult the books, and to make designs or sketches from them.

XXI. There shall be annually one General Meeting of the whole body, or more if requisite to elect the Council and Visitors; to confirm new laws and regulations; to hear complaints and redress grievances, if there be any; and to do any business relative to the society.

XXII. The Council shall frame new laws and regulations, but they shall have no force till ratified by the consent of the General Assembly, and by the approbation of the King.

XXIII. Though it may not be for the benefit of the Institution absolutely to forbid pluralities, yet they are, as much as possible, to be avoided, that his Majesty's gracious intention may be complied with, by dividing as nearly as possible the emoluments of the Institution amongst all its Members.

XXIV. If any member of the Society shall, by any means become obnoxious, it may be put to the ballot in the General Assembly, whether he shall be expelled, and if there is found a majority for the expulsion, he shall be expelled, provided his Majesty's permission be first obtained for that purpose.

XXV. No Student shall be admitted to the Schools till he has satisfied the Keeper of the Academy, the Visitor, and Council for the time being, of his abilities; which being done, he shall receive his Letter of Admission, signed by the Secretary of the Academy, certifying that he is admitted a student in the Royal Schools.

XXVI. If any student be guilty of improper behaviour in the Schools, or doth not quietly submit to the Rules and Orders established for their regulation, it shall be in the power of the Council, upon complaint first being made by the Keeper of the Academy, to expel, reprimand or rusticate him for a certain time, but, if he be once expelled, he shall never be re-admitted in the Royal Schools.

XXVII. All modes of elections shall be regulated by the bye-laws of the Society hereafter to be made for that purpose.
I approve of this plan; let it be put into execution. GEORGE R. St James's December 10th 1768
> (William Sandby; *The History of the Royal Academy of Arts.* Landa, 1862, vol. 381, p. 49–55)

4.42 A new Augustan Age?

The first exhibition of the Royal Academy opened to the public on Wednesday 26 April 1769. On the evening of that day what was described as 'an elegant entertainment' was given at the St Alban's Tavern, presided over by Sir Joshua. The event was celebrated by a number of effusions of a literary nature, one of the most remarkable being that composed by that well-known republican Benjamin Franklin.

When Discord late her baneful influence shed,
O'er the fair realms of Science and Art,
Neglected genius bent his drooping head,
And pierced with anguish every tuneful heart;
Apollo swept his broken lyre,
Wept to behold the mournful choir
Of his loved Muses, now an exiled train
And in their seats to see Alecto reign.

When lo! Britannia to the throne
Of Goodness makes her sorrows known;
For never there did grief complain,
Or injured merit plead in vain
The Monarch heard her just request,
He saw, he felt and he redressed;
Quick with a master hand, he tunes the strings
And harmony from discord springs.

Thus good, by heaven's command, from evil flows;
From chaos thus of old creation rose;
When order with confusion joined,
And jarring elements combined,
To grace with mutual strength the great Design,
And speak the Architect divine.

Whilst Eastern tyrants in their trophied car.
Wave the red banner of destructive war,
In George's breast a noble flame
Excites to cherish native worth,
To call the latent seeds of genius forth,
To his discordant factions cease,
And cultivate the gentler arts of peace,
And lo from this auspicious day,
The sun of science beams a purer ray.

Behold a brighter train of years,
A new Augustan Age appears,
The time, nor distant far, shall come,
When England's tasteful youth no more,
Small wander to Italia's classic shore;
No more to foreign climes shall roam,
In search of models better found at home.
With rapture the prophetic Muse
Her country's opening glory views,
Already sees with wondering eyes,
Our Titians and our Guidos rise;
Sees new Palladios grace the historic page,
And British Raphaels charm a future age.

Meantime ye sons of Art, your offerings bring
To grace your patron and your King,
Bid Sculpture grave his honoured name,
In marble lasting as his fame;

Bid painting's magic pencil trace
The features of his darling race,
And as its flows through all the royal line,
Glow with superior warmth and energy divine
If towering Architecture still
Can boast her old creative skill,
Bid some majestic structure rise to view,
Worthy him and worthy you,
Where Art may join with Nature and with sense,
Splendour with grace, with taste magnificence,
Where strength may be with elegance combined,
The perfect image of its master's mind.

4.43 The functions of an Academy

Perhaps the most revealing indication of how some members of the Royal Academy saw its functions can best be illuminated by the letter which Sir William Chambers sent to the General Meeting of that body, assembled on 2 July 1791, to discuss a proposal put forward by Reynolds and West that it should contribute a hundred guineas to the proposed monument to Dr Johnson to be erected in St Paul's Cathedral.

Gentlemen, some very particular business prevents my Attendance this evening at the General Meeting. If nothing more were to be agitated than is mentioned in the summons, my absence, with that of half the Academicians, would be immaterial; there would still be a sufficient number to confer an empty title, but there is reason to apprehend that a proposal is to come forward, totally foreign to the business and views of the Academy; a proposal which, if it is agreed to, must open the doors to all sorts of innovation, must weaken the Academy in its revenues, and disable it from pursuing with proper Spirit and full effect, the true objects of our Institution.

Our business is to establish schools for the Education of young Artists; Premiums for their encouragement; Pensions, to enable them to pursue their studies; an Exhibition wherein they may set their talents to public view; and honorary titles of distinction to be confer'd on such as are deemed to deserve them. The Royal Academy has it still farther in view, to maintain itself; to reward its Members for services done; to assist the Sick or distress'd artist; to extend its beneficence to the relief of his family; to help the Widows and Children of such as leave them unprovided for. All these, I apprehend, are sufficient objects for any Society to carry in view,

without going astray to hunt for more. We find it very difficult to fulfil even these; our Donations do not by any means equal the necessities of our distressed suitors, and our Travelling Pensions are too few for so respectable an Establishment as Ours. If therefore we judge it expedient to tap the fund of the Academy, let it flow into these, its proper channels; and let it not be split in useless driblets, on things absolutely foreign to the intent and Purpose of our Establishment.

The Proposal I allude to, is that made in the last meeting of the Council, which is, I apprehend the true cause of your being Summoned to meet this Evening. It was a proposal made by the President, to contribute, largely out of the Fund of the Royal Academy, towards the Monument of Dr Johnson, about to be erected in St Paul's. To me it seemed, I freely confess, that one might with equal propriety have proposed the erection of a Triumphal Arch to Lord Heathfield, or a Mausoleum to the inventor of Fire Engines, or a statue to any other person whose pursuits, and whose excellence lay totally wide of ours. If Monuments were to be our objects, how could we without Shame and Contrition, vote one to Dr Johnson, whilst Cipriani. Moser, Gainsborough, Cotes, Wilson, and so many other of our departed Brother. Academicians are left unnoticed and forgotten in the dust. Let us therefore save our Credit, and spare our Repentence, by Voting no Monument at all.

(Royal Academy, Minutes of the General Assembly, 2 July 1791)

4.44 Mary Moser gossips about the Royal Academy, 1770

Mary Moser, the flower painter, and one of the foundation members of the Royal Academy, was very much smitten by the charms of Fuseli (who put her name forward as President in 1805), then living in Rome. In one of her many letters to him she gave some account of the goings on at the Royal Academy.

If you have not forgotten at Rome those friends whom you remembered at Florence, write to me from that nursery of arts and rareeshow of the world, which flourishes in ruins; tell me of pictures, palaces, lakes, woods and rivers; say if Old Tiber droops with age, or whether his waters flow as clear, his rushes grow as green, and his swans look as white as those of Father Thames; or write me your own thoughts and reflections, which will be more acceptable

than anything Greece or Rome have done these two thousand years.

I suppose there has been a million letters sent to Italy with an account of our Exhibitions, so it will only be telling you what you know already, to say that Reynolds was like himself in pictures which you have seen; Gainsborough beyond himself in a portrait of a gentleman in a Vandyke habit,[1] and Zoffany superior to everybody, in a portrait of Garrick in the character of Abel Drugger, with two other characters, Subtle and Face. Sir Joshua agreed to give a hundred guineas for the picture; Lord Carlisle half an hour after offered Reynolds twenty to part with it, which the Knight generously refused, resigned his intended purchase to the Lord, and the emolument to his brother artist. (He is a gentleman!). Angelica [Kauffmann] made a very great addition to the show and Mr Hamilton's [Gavin Hamilton] picture of Briseis parting from Achilles was very much admired; the Briseisin taste *à la antique*, elegant and simple. Cotes, Dance, Wilson & C as usual.

Mr West had no large picture finished. You will doubtless imagine that I derived my epistolary genius from my nurse; but when you are tired of my gossiping, you may burn the letter, so I shall go on. Some of the literati of the Royal Academy were very much disappointed as they could not obtain diploma, but the Secretary,[2] who is above trifles, has since made a very flattering compliment to the Academy in the preface to *The Travel*; the Professor of History[3] is comforted by the success of his *Deserted Village*, which is a very pretty poem, and his lately put himself under the conduct of Mrs Horneck and her fair daughters, and is gone to France, and Dr Johnson sips his tea, and cares not for the vanity of the world.

Sir Joshua, a few days ago, entertained the Council and Visitors with callipash and callipee,[4] except poor Cotes (Francis), who last week fell a victim to the corroding powers of soaplees, which he hoped would have cured him of the stone; many a tear will fall on his grave, as he is not more lamented as an artist than a friend to the distressed.

Mary Moser, who remains sincerely your friend, and believes you

1. Presumably the so-called *Blue Boy*, which was first exhibited at the exhibition of 1770.
2. Francis Milner Newton
3. Oliver Goldsmith was appointed the first Professor of History to the Royal Academy.
4. The more delicately edible portions of the turtle.

will exclaim or mutter to yourself 'why did she send this d. . . d nonsense to me?'

4.45 The emergence of the art critic

The growth of public exhibitions did much to stimulate the growth of art criticism and papers such as The *Morning Post*, the *Morning Herald*, the *Public Advertiser* and the *St James's Chronicle* regularly reviewed such exhibitions, and gave publicity to happenings in the world of art. Often too they became involved in artistic rivalries and feuds. Typical of such involvement was the extent to which Sir Henry Bate-Dudley, the editor first of the *Morning Post* and then of the *Morning Herald* took the side of Gainsborough in the sometimes latent, sometimes overt feud which he carried on with Sir Joshua Reynolds. These are his notes on the two artists in his first review of the Royal Academy annual exhibition, which appeared in the *Morning Post* on 25 April 1777.

Royal Academy
Thomas Gainsborough RA
As the pencil of this gentleman has evidently entitled him to the distinction, we have impartially placed him at the head of the artists whose works we are about to review.

131. *His Royal Highness the Duke of Cumberland*
132. *Her Highness the Duchess of Cumberland*
 Both excellent portraits and striking likenesses, but portrayed, in compliment to their Royal Highnesses, no doubt, in rather more state than is consistent with the free and easy designs of the artist.
133. *Portrait of a Lady*
 A beautiful whole length of Mrs Graham, sister to the Duchess of Athol, the drawing of which is correct and masterly, the colouring soft, and the drapery flowing and easy.
134. *Ditto of a Nobleman*
135. *Ditto of Mr Abel*
 Mr Abel's portrait is the finest modern portrait we remember to have seen. The composition thro' every part is finely studied, and the whole is given in a style of colouring that bespeaks the great Master.
136. *A Large Landscape*
 A rural scene from nature, which discovers Mr Gains-

borough's superior taste and execution in the landscape way; it is confessedly a masterpiece of its kind, but viewed to every possible disadvantage from the situation in which the directors have thought proper to place it.

Sir Joshua Reynolds, President of the Society.
It is with reluctance we observe that Sir Joshua Reynolds' present productions are by no means equal in merit to those which he had previously exhibited on a similar occasion. The critics have long found fault with this style of colouring, asserting that its brilliancy soon flies off – he seems determined, however, to obviate that objection in future by giving all his portraits the *lasting* copper complexion of a *Gentoo* family.

283. *Portrait of a Lady*
A whole length of Lady Bamfylde in which there is an harmonious softness of colouring, but the drawing of the right arm is very incorrect; and the little fall of water is one of Sir Joshua's *daubs* without its usual effect.

284. *Ditto*
A whole length of the Countess of Derby; remarkable only for the right hand and arm apparently contracted by the palsy.

285. *Ditto*
The best portrait of the three, being a whole length of Lady F. Marsham, but there is a strange defect in the eyes, and the background rises too precipitately if judged by the rules of perspective.

286. *Portrait of a Nobleman with his Brothers and a Young Lady*
By far the most perfect of this artist's pieces in point of drawing, colouring and composition, but the sky is a miserable daub indeed. Sir Joshua exhibits nine other portraits, but as they are inferior to the above we thought it unnecessary to take notice of them.

4.46 Poetic puffs

One of the most common ways for an artist to boost his reputation was to get a writer friend to compose verses for insertion in the periodic press, which nearly always had a section devoted to poems – usually of unbelievable dreariness. Typical in content to these many effusions, though slightly superior in form, was Cowper's poem, penned after Romney had painted his portrait – and probably in payment for it.

Romney – expert infallibly to trade,
On chart of canvas, not the form alone,
And semblance, but, however faintly shown,
The mind's impression too on every face
With strokes that time ought never to erase –
Thou has so pencill'd mine that, tho' I own
The subject worthless, I have never known
The artist shining with superior grace.
But this I mark – that symptoms none of woe
In thy incomparable work appear
Well – I am satisfied it should be so,
Since, on maturer thought, the cause is clear;
For in my looks what sorrow could'st thou see,
While I was Hayley's guest, and sat to thee.

Sometimes whole criticisms were written in verse. The 1766 ex-
hibition of the Incorporated Society of Artists at Spring Gardens,
was greeted by *The Exhibition or a Candid Display of the Genius and
Merits of the several Masters whose Works are now offered to the Public at
Spring Gardens*, in which after a general introduction the anony-
mous author thus apostrophizes Benjamin West, George Stubbs,
Thomas Hudson (the teacher of Reynolds and Wright of Derby),
Gainsborough and Reynolds.

Sly Malice pluck'd my sleeve and did assure
That most above were Modern, Mean and Poor
But *West* and *Genius* met me at the door;
Virgilian West, who hides his happy Art,
And steals, through Nature's inlets to the Heart,
Pathetic, Simple, Pure, through every part.
Though long expected, wish'd for Stranger, Hail!
In Britain's bosom make thy loved Abode,
And open daily to her raptured Eye
The mystic wonders of thy Raphael's school.

The wide creation waits upon his call,
He paints each species and excels in all
Whilst wondering Nature asks with jealous tone,
Which Stubbs' labours are, and which her own.
Hudson, his art may well Display to Sight,
Who gave Mankind a Reynolds and a Wright.
There Gainsborough shines, much honoured name,
There veteran Reynolds worthy of his Fame.

Not all these puffs however were laudatory. In the *Public Advertiser* in 1777 a poetic duel appeared about Reynolds. The attack appeared first.

When R s with incessant Puff
Bedaubs himself with nauseous stuff,
I think the Man is Mad.
Self-adulation should confine
Her breath to him who paints a sign,
Because his works are bad.
But that this Lord of *gaudy tints*
Should trust his fame to DAILY PRINTS
I own I can't forgive . . .
'Hold there' a surly Critic cried,
'The tints and papers coincide,
Alike they're FUGITIVE.'

A few days later came the riposte.

And doest thou think, though scribbling elf,
Or is it downright lying,
That worthy Reynolds puffs himself
Both sense and shame defying?

He scorns to act so vile a part,
Thy part we well divine,
How ill, poor Bard, thou read'st *his* heart,
How legible is thine!

His fame throughout the world shall fly,
Thine is a passing vapour,
His works with Time alone shall die,
Thine with a daily paper.

4.47 A critical view of art education 1747

The amenities and educational standards of the St Martin's Lane Academy were not very high according to an anonymous contributor to the *London Tradesman* in April 1747.

The present state of the art of Painting in Britain does not afford sufficient education to a painter. We have but one Academy meanly supported by the subscriptions of the students in all this great Metropolis. There they have but two figures, a man and a woman, and consequently there can be but little experience gathered. The sub-

scribers to this lame Academy pay two guineas a season, which goes to the expense of the rooms and the lights. The subscribers in their turn set the figure, that is place the man and the woman in such attitudes in the middle of the room as suit their fancy. He who sets the figure chooses what seat he likes, and all the rest take their places according as they stand in the list and then proceed to drawing, every man according to his prospect of the figure.

4.48 A private art school

A number of private art schools, charging fees, started to appear. One of the most famous of these was run by William Shipley, the driving force behind the foundation of the Society for the Encouragement of Arts, Manufacture and Commerce, which was attended by several students such as Cosway and Nollekens, who later achieved success and fame. The following advertisement appeared in the *Public Advertiser* of 25 June 1757.

Drawing in all its branches taught by William Shipley, Registrar to the Society for the Encouragement of Arts, Manufacture and Commerce, and other Masters at the above Society's offices.

As it will be Mr Shipley's endeavour to introduce Boys and Girls of Genius to Masters and Mistresses in such manufactures as require Fancy and Ornament, and for which the knowledge of Drawing is absolutely necessary; Masters or Mistresses who want Boys or Girls well qualified for such manufactures may frequently meet with them at this School; and parents who have Children of good natural abilities for the Art of Drawing may here meet with opportunities of having them well instructed and recommended to proper Masters or Mistresses by applying to Mr Shipley at Mr Bayley's, the corner of Castle Court, opposite to the New Exchange Buildings in The Strand.

A genteel apartment is provided for the reception of Young Ladies of Fashion, who are attended every day from eleven till one.

4.49 A Dublin art school

In 1746 the Dublin Society decided to establish a School of Art to succeed that which for some years had been run by one Robert West, to which the Society had been sending twelve pupils on a fee-paying basis. In *Faulkner's Dublin Journal* for 3 November 1750 the following advertisement appeared.

We have the pleasure of informing the Public that there has lately
been opened an Academy for Drawing and Design erected in
Shaw's Court in Dame Street at the expense of the Dublin Society,
which is furnished with several fine Models in Plaster imported
from Paris. In which Academy the Pupils have already made very
considerable Progress, both in drawing from the Round, and also
from the Life, Design which we hope must soon shew itself in the
Forms and Elegance of our Manufacturers. The Academy was
yesterday visited by several members of the Society, who expressed
great satisfaction on seeing the several drawing performances of the
pupils, which hang up in the room.

> John O'Keefe, whose *Recollections* were published in 1826, refers to
> his own experiences there in the 1760s (vol. i, p. 2).

We were early familiarized to the antique in sculpture, and in paint-
ing, to the style and manner of the great Italian and French masters.
We also studied anatomy; and indeed the students there turned their
minds to most of the sciences.

We had upon the large table in the Academy, a figure three feet
high, called the anatomy figure; the skin was off to show the mus-
cles; on each muscle was a little piece of paper with a figure of
reference to a description of it, and its uses. We also had a living
figure to stand or sit; he was consequently a fine person; his pay
was four shillings an hour. Mr West himself always *posed* the
figure, as the phrase is, and the students took their views round the
table where he was fixed. To make sure that his attitude was the
same each time we took our study, Mr West with a chalk marked
upon the table the exact spot where his foot, or his elbow, or his
hand came. We had a round iron stove nearly in the centre of the
school, but the fire was not seen; an iron tube conveyed the smoke
through the wall. on the flat top of this stove we used to lay our
pencils of black and white chalk to harden them. The room was
very lofty; it had only three windows; they were high up in the
wall, and so contrived as to make the light descend; the centre win-
dow was arched and near to the top of the ceiling. At each end of
this room was a row of presses with glass doors, in which were sta-
tues kept from the real antique, each upon a pedestal about two feet
high, and drawn out into the room as they wanted to be studied
from – but the busts were placed when required upon the table.
The stools we sat on were square portable boxes, very strong and
solid, with a hole in the form of an S on each side to put in the
hand, and move them. Each student had a mahogany drawing-

board of his own; this was a square three feet by four [*sic*!]; at one end was a St Andrew's cross fastened with hinges, which answered for a foot, and on the other side of the board, a ledge to lay our port-crayons upon. When we rose from our seats, we laid this board flat upon the ground, with the drawing we were then doing upon it.

We had a clever civil little fellow for our porter, to run about and buy our oranges and apples and pencils, and crayons and move our busts and statues for us. We had some students who studied statuary alone, and they modelled in clay. . . .

The members of the Dublin Society, composed of the Lord Lieutenant and most of the nobility, and others, frequently visited our academy to see our goings on, and some of the lads were occasionally sent to Rome, to study the Italian masters.

4.50 The Royal Academy Schools

The establishment of the Royal Academy, which held its first formal meeting on 14 December 1768, meant as much for art education as it did for establishing the status of the artist. Its purpose and functions were described in the *Annual Register* for the year.

The principal object of this institution is to be the establishment of well-regulated schools of design, where students in the arts may find that instruction which has so long been wanted, and so long wished for in this country. For this end, therefore, there will be a winter academy of living models of different characters to draw after, and a summer academy of living models to paint after; there will also be laymen (i.e. inanimate figures) with all sorts of draperies, both ancient and modern, and choice casts of all the celebrated antique statues, groups and basso-relievos. Nine of the ablest academicians, elected annually from amongst the forty, are to attend these schools by rotation, to set the figures, to examine the performance of the students, to advise and instruct them, and to turn their attention to that branch of the arts for which they shall seem to have the aptest disposition.

And in order to instruct the students in the principles and laws of composition, to strengthen their judgement, to form their taste of design and colouring, to point out to them the beauties and imperfections of celebrated performances and the particular excellences and defects of great masters, to fit them for an unprejudiced study of books, and to lead them into the readiest and most effica-

cious paths of study, there are appointed a professor of painting, a professor of architecture, one of anatomy, and one of perspective, who are annually to read a certain number of public lectures in the schools, calculated for the purposes above recited.

Furthermore there will be a library of books of architecture, sculpture, painting and all the sciences relating thereto; also of prints, bas-reliefs, vases, trophies, ornaments, ancient and modern dresses, customs and ceremonies, instruments of war and arts, utensils of sacrifice, and all other things useful to students in the arts.

The admission of all these establishments will be free to all students properly qualified to reap advantage from such studies as are there cultivated. The professors and academicians, who instruct in these schools, have each of them proper salaries annexed to their employment, as have also the treasurer, the keeper of the Royal Academy, the secretary and all persons employed in the management of the said institution, and His Majesty hath for the present allotted a large house in Pall Mall for the purpose of the schools etc.

And that the effects of this truly royal institution may be conspicuous to the world, there will be an annual exhibition of paintings, sculptures and designs, open to all artists of distinguished merit, where they may offer their performances to public view, and acquire that degree of fame and encouragement which they shall be deemed to deserve.

But as all men who enter the career of the arts are not equally successful, and as some unhappily never acquire either fame or encouragement, but after many years of painful study, at a time of life when it is too late to think of other pursuits, find themselves destitute of every means of subsistence; and as others are, by various infirmities incident to a man, rendered incapable of exerting their talents, and others are cut off in the bloom of life before it could be possible to provide for their families, His Majesty, whose benevolence and generosity overflow in every action of his life, hath alloted a considerable sum, annually to be distributed to the relief of indigent artists and their distressed families.

4.51 Art School Regulations 1769

The details of the rules governing the Royal Academy Schools give a clear indication of the nature of art teaching at the time.

Rules and Orders, relating to the School of Design

The Visitors shall draw lots for the times of Attendance, according as they shall be Annually regulated by the Council, which Regulations, together with the names of the respective Visitors shall be put up in the Academy.

Each student, who offers himself for Admission into the Royal Schools shall present a Drawing or Model from some Plaister Cast to the Keeper, and if he thinks him properly qualified, he shall be permitted to make a Drawing or Model from some Cast in the Royal Academy, which if approved of by the Keeper and Visitor for the time being, shall be laid before the Council for their confirmation, which obtained he shall receive his Letter of Admission as a Student in the Royal Academy Where he shall continue to draw after the Plaister, till the Keeper and Visitor for the time being, judge him qualified to draw after the Living Models, when they shall have power to admit him.

The Students shall implicitly observe the Regulations deliver'd to the Keeper by the Council, for preserving Order and Decorum in the Royal Schools.

Any Student that shall deface or damage the Plaister Casts, Models, Books or any other Moveable belonging to the Royal Academy shall be expelled.

No Student shall presume to introduce any Person to see the Royal Academy or any Part thereof, without leave first obtained from the Keeper or Visitor for the time being.

The Winter Academy of Living Models shall begin at Michaelmas and end on the ninth day of April following Inclusive.

The Summer Academy of Living Models shall begin on the twenty sixth Day of May and end on the last Day of August.

There shall be three Vacations in the Year.

The First, to commence on Christmas-Eve, and to end on the Epiphani.

The Second to commence on the tenth Day of April, and to end on the twenty sixth Day of May following.

The Third to commence on the first Day of September and to end on the Feast of St Michael.

The Winter Academy shall begin at Six o'clock in the Evening.

The Summer Academy shall begin at Four o'clock in the afternoon, in other respects to be under the same Regulations as the Winter Academy.

Two or more living Models of different Characters shall be provided by the Keeper and Visitors for the time being.

The Model shall be set by the Visitor and continue in the Attitude two Hours (by the Hour-Glass) exclusive of the Times required for resting.

There shall be two different Models, each Week, each Model to sit three Nights.

While the Visitor is setting the Model, the Students shall draw Lots for their Places, of which they shall take Possession so soon as the Visitor hath set the Figure.

During the time the Model is sitting the Students shall remain quiet in their Places.

As soon as any Student, hath done Drawing or Modeling, he shall put out his Candles, and while Drawing or Modeling, he shall be careful to keep them under the Bells.

Rules and Orders for the Plaister Academy

There shall be Weekly, set out in the Great Room, One or more Plaister Figures by the Keeper, for the Students to draw after, and no student shall presume to move and said Figures out of the Places where they have been set by the Keeper, without his leave first obtained for that Purpose.

When any Student hath taken possession of a Place in the Plaister Academy, he shall not be removed out of it, till the Week in which he hath taken it is expired.

The Plaister Academy, shall be open every Day (Sundays and Vacation times excepted) from Nine in the Morning till Three in the afternoon.

5. The arts of manufacture

Design, pottery and porcelain, textiles and wallpaper, prints.

5.1 Drawing good for manufacture

One of the most fruitful aspects of the firmly held English belief that art had a commercial significance was provided by the activities of the Society for the Encouragement of Arts, Manufactures and Commerce, now the Royal Society of Arts, whose creation was recorded in its first minutes 22 March 1754.

Rawthmell's Coffee House, Henrietta Street, Covent Garden. At a Meeting of some Noblemen, Clergy, Gentlemen and Merchants, in order to form a Society for the Encouragement of Arts, Manufactures and Commerce in Great Britain, it was proposed to consider whether a reward should not be given for the finding of cobalt in this kingdom. . . . It was also proposed whether a reward should be given for the cultivation of madder in this kingdom. . . . It was likewise proposed to consider of giving rewards for the encouragement of boys and girls in the art of drawing. And, it being the opinion of all present that the art of drawing is absolutely necessary in many employments, trades and manufactures, and that the encouragement thereof may prove of great utility to the public, it was resolved to bestow premiums on a certain number of boys and girls under the age of sixteen who shall produce the best pieces of drawing, and show themselves most capable when properly examined.

The further consideration of these proposals was referred to the next meeting, and after directing that a book of rates should be bought for the use of the Society, the company adjourned to Friday next, March 29th.

Present: Lord Viscount Folkestone, Lord Romney, Dr Hales, Mr Goodchild, Mr Lawrence, Mr Messiter, Mr Shipley, Mr Crisp, Mr Baker, Mr Brander.

March 29th
The giving rewards for the best drawings by boys and girls was taken into consideration, and an advertisement was ordered to be worded in the following manner:

For the best drawings by boys and girls under the age of 14 years, and proofs of their abilities on the 15th day of January 1755, £15 to be determined that day fortnight.

Likewise for the best drawings by boys and girls between the age of 14 and 17 with like proof of their abilities, on the same day, £15 to be determined that day fortnight.

5.2 The art of design

All proposals for academies or schools of art emphasized their function as the source of good design (and therefore economically laudable). William Sleater put the point succinctly in his *An Essay on perfecting the Fine Arts in Great Britain and in Ireland* (Dublin 1767, p. 39).

Silks, Tapestries, Velvets, Carpets, Carving, Gilding, Gardening, Architecture owe the greatest part of their price to one branch or other of *design*. Nay, it gives value even to toys. We see what sums the French extract from this article. Now, tho' few could excel as liberal Artists, yet they might influence the form and fashion in some of the above works. He that might not rise to History, might yet paint a Landskip. And he that could not be a Claude Lorraine or a Barret might yet paint coaches, or porcelain ware. If the young Engraver could not be a Strange or a Fry, he might grave Arms on Plate, and be excellent in chased Works.

5.3 Furniture from the East

The import of furniture from China had grown to quite large proportions by the end of the seventeenth century, and in 1697 (month not given) the East India Company's Letter Book recorded the ordering of the following items from their Chinese representatives.

No. 1. 60 cabinets, viz. 20 of the black ground, inlayed with mother-of-pearl with figures; 10 black and gold; 10 red and gold; 20 of engraved work, the ground gold, with Landscapes and figures. 20 sets of screens, 12 leaves of a set, 8, 9 and 10 feet high by 20 to 24 inches broad; black and gold, with Landscapes and Figures engraved on a gold ground.

No. 2. 40 tables of the same sorts as the cabinets.

No. 3. 80 folding card tables, without Pillars, laquered as the cabinets.

No. 4. 500 tables; 200 black and gold;
No. 5. Of this size 500 tables, in other respects as No. 4.
Bring no screens with silk sashes, but all to be of entire Japan work
from top to bottom.

5.4 Furnishing a house

Between 1770 and 1778 Sir Edward Knatchbull refurnished his
house at Mersham-le-Hatch near Ashford in Kent, which had been
renovated by Robert Adam. The firm he employed was Chippen-
dale and Haig.

Sir Edward

I received your letter of 11th inst and am much obliged for your
sending to me; The £150 will be of great service to me, which is the
best way to send I know not, if any person at Ashford could give a
draft payable to me or order at sight, it could be the best and
readiest way of sending it. If that cannot be done perhaps your
Banker will pay it if you desire him, you remitting the money by
the first opportunity, I do not think it safe to remit it in Bank
Notes, as the Mails are so often robbed, I should be greatly obliged
to you if you would do it as fast as possible.

October 15th 1770	I remain
St Martin's Lane	With due Respect
20th October 1770	Your Honours
Remitted Chippendale	Most obedient and Most
£150 on this letter	Honourable Servant
	Thomas Chippendale

London, 7th May 1773

Sir Edward

Your Chairs, Glasses, Table, etc. is all ready to be sent away, but
as Lady Knatchbull seemed to want 4 larger Chairs – what we call
Barjairs, they must be made & in the meantime We must send her
Ladyship patterns for the needlework which will be Very large, con-
sequently will take some time in working. We should rather re-
commend 2 large Barjairs as We think it would be of more propri-
ety in one room – as the Chairs can only at present be finished in
Linnen. We should be glad to know what kind of Covers you
would please to have for them Serge is most commonly used but as
the room is hung with India paper, perhaps you might Chuse some
sort of Cotton – Suppose a green Stripe Cotton which as this time

is fashionable. You will please to favour us with Your orders which shall be duly attended to & much oblige.

You will please to	Sir Edward
observe there is no	Yr most obdt Hble Servts
Chairs made. How many	Chippendale Haig & Co.
you would chuse to have sent.	

London 19th May 1773

Sir Edward

We received your favour of the 11th inst. The Chairs and Stools is stuffed in Canvas and loose Covers made out of Green stripe Cotton, which will be a sort of finish at present & be very necessary when covered with needlework the 10 Chairs, 3 Stools, 2 Glasses, Marble table & frame in 3 Close & 4 open Cases were carefully packed up & put on board the Kent, John Sherwood Martin (Jones or Raymen not being up) this Day, which We hope will come safely to hand and be approved of.

We are
Sir Edward
Your most obdt hble Servts
Chippendale, Haig & Co.

Sir

We have this Evening forwarded by the Canterbury Coach two different designs of Glasses and frames. No. 1 fills the pier in width, is 99 inches long by 58 inches wide, but wants a small head Glass to make it out in height, as you will see by the ornament sketched over that piece of Glass, the very lowest price will be £170 each. We have two other Glasses long enough without any head plate, they will come to £180 each and which size we have often sold for 2000 Guineas.

No. 2 is a smaller Glass as you will see by the sketch not filling the Pier either in width or height, the 96 inches by 53, the price £155 each, but the last mentioned Glasses of £180 according to their size are the Cheapest as well as most suitable for your Room. As to frames No. 1 will cost about £28. No. 2 about £36 but either may be slighted and made for less.

You have likewise a design for an Axminster Carpet to Correspond with your Ceiling to go into Bow and at equal distances from the plinth all round the Room, the Expense of it will be according to their best Price about £100. They will have a painting to make of it at large and the Colours to dye on purpose, but if you Chuse to

have it made square, like your other Carpet it will be proportion-ably less in price and if you or Lady Knatchbull chuses any altera-tions in any of the Colours, by describing it properly, it may be done.

Along with them you have a sketch of a very handsome Geran-dole with Glass in the back for your choice and if all or any of the above designs meet with your & My Lady's approbation we shall be happy in being favoured with your orders.

<div style="text-align: right">

We are Sir
Your most obedient and
obliged humble Servt
Chippendale Haig & Co.

</div>

St Martin's Lane
23 June 1778

In the case with the designs we have sent 4 Spring Barrels which we had to repair.

(Kent County Archives, Maidstone)

5.5 The manufacture of porcelain

There have been several compositions used for the imitation of chinaware in the works set on foot in different parts of Europe, and among the rest I have seen at one of those carried on near London eleven mills at work grinding pieces of the Eastern china, in order, by the addition of some fluxing or vitreous substance which might restore the tenacity to work it over again in the place of new mat-ter. The ware commonly produced at this manufactory had the character correspondent to such a mixture, for it was grey, full of flaws and bubbles, and from want of due tenacity in the paste, wrought in a heavy and clumsy manner, especially with regard to those parts that are to support the pieces in drying. A very opposite kind is produced in another manufactory in the neighbourhood of London,[1] for it has great whiteness, and a texture that admits of it being cast in a most delicate manner; but it is formed of a composi-tion so vitrescent as to have almost the texture of glass, and conse-quently to break or crack if boiling water be suddenly poured on it, which makes it unfit but for the making of ornamental pieces. A later manufactory at Worcester has produced, even at very cheap prices, pieces that not only work very light, but which have great

1. At Lambeth.

tenacity and bear hot water without more hazard than the true
china ware.

(Robert Dossie, *The Handmaid to the Arts*, 2nd edn, 1764)

5.6 The merits of Worcester porcelain

Rising standards of living increased the market for porcelain, and
the process was accelerated as tea and coffee took over from beer
and gin as standard drinks. English porcelain manufacturers became
very active not only in the manufacture of new styles and formulae,
but were very conscious of fostering publicity, as this article (poss-
ibly by Robert Dossie, author of *The Handmaid to the Arts*) in the
London Chronicle for 3–5 May 1763 suggests.

A lover of useful arts is desirous of pointing out to the notice of the
Public an object worthy of its attention and patronage. The
Worcester Porcelain is not altogether unknown or unapproved in
this kingdom; it is even in considerable use; but were its merits still
more generally considered and understood it would of course en-
gage the esteem and encouragement of everyone who thinks him-
self interested in those arts that tend to the embellishment of life,
and to the extension of the Trade and Manufactures of this country.
I myself have travelled into foreign parts, and have both seen and
made trials of most of the different kinds of Porcelain that are
manufactured at home and abroad, and am convinced thereby, that
neither the Dresden ware, though honoured by Royal Patronage,
and in itself truly beautiful and elegant; nor that of Chantilly, which
is so highly extolled and favoured in France, nor any other Euro-
pean Porcelain that I have anywhere seen, can compare with the
Worcester in real and useful excellence.

The body of this last far exceeds all the rest in fineness and
whiteness, in which it almost, if not altogether, equals even the
finest porcelain of China itself and is found to be much harder and
more durable than the body of any other Porcelain whatever. The
glazing of it never nips, breaks off, or parts from the body, except
by extreme violence, and then it discovers no browness, such as is
often seen in the ordinary Chinese, and almost always after wear in
the other kinds of Porcelain. It is perfectly clear and transparent,
which is a quality that almost particularly distinguishes it from
the others of European manufacture; and the finer sort, which is
enamelled, so nearly resembles in every particular the finest Orien-
tal pieces, whether of China or Japan, that where it has been made

in imitation of these, as has often been the case to match and make up sets that have been broken, the difference is scarcely discernible even to judges themselves, and sometimes the Worcester has been mistaken for the foreign. I have been told that it is no uncommon thing to find some pieces of it sold in the shops of dealers for real Chinese, which, tho' an imposition in respect of price (as it may be sold at a much cheaper rate in proportion to its goodness, contrary to what is observable in the Dresden, Chantilly, Chelsea, and other new-invented Porcelains of elegance) yet in consideration of its real intrinsic value and good qualities, it is scarcely to be reckoned any imposition at all. The worst imposition is the selling of other far inferior kinds of ware for Worcester, by which both the buyer is deceived to his loss, and the credit of this manufacture injured, being made answerable for faults that are not its own. To avoid discredit, I would recommend to the Proprietors to think of some expedient, if possible, to ascertain their ware to those that are willing to favour it; and perhaps it might not be improper, if, both to ascertain the ware and its credit, some public trials and experiments were to be made of it by some of those laudable Societies instituted for the encouragement of useful Arts and Sciences who might therefore be enabled to publish to the world their opinion of its merit.

But the most valuable part of all, and which principally calls for notice, is the extraordinary strength and cheapness of the common sort of blue and white Worcester Porcelain. And let any person but impartially consider the difference, in these respects, between this and that of an equal degree, though hardly of equal beauty, imported from abroad, and he will find the advantage so considerable in favour of the former, that if he has any degree of candour, he must see and acknowledge his obligations to a manufacture which not only supplies an ornament fitted for the houses and cabinets of the Rich and Curious, but affords an elegant and desirable furniture, calculated by its easy purchase for general and ordinary use. Certainly therefore it is the public concern to extend such favour and support to this undertaking as may in some measure compensate the pains, expense and hazard of those who engaged in it, and at the same time animate them to make some further improvements. It is even a national object, on account of its national utility, for if the prosecution of it be but carried on, and enforced with proper spirit and vigour, it will prove a constant saving to the community of a considerable sum, that is now exported annually in specie for a foreign commodity; it will, as it does already to a surprising degree, afford a maintenance to multitudes of industrious and

laborious artificers, in which the real and internal wealth of a peo-
ple consist, and may in time, perhaps, be improved into a branch of
valuable exportation.

5.7 The potter and the painters

Josiah Wedgwood was one of the most enterprising industrialists of
the eighteenth century, and one of the first to foster a close rela-
tionship with many artists, notably George Stubbs and John Flax-
man. In the 1770s Wedgwood started making ceramic plaques in
Queen's Ware for Stubbs to paint on in enamel. At the time the ex-
periment did not turn out very successfully. Wedgwood's correspon-
dence with his partner Thomas Bentley in London records some of
the highlights of the relationship, and shows Wedgwood as both
entrepreneur and art patron, besides documenting the evolution of
the Wedgwood family portraits (now in the Wedgwood Museum).
The relationship between portrait painter and patron must have
been typical of the time, though probably few sitters showed
Wedgwood's tact and consideration.

17 October 1778
When you see Mr Stubbs pray tell him how hard I have been
labouring to furnish him with the means of adding immortality to
his very excellent pencil. I mean to arrogate to myself the honour of
being his *canvas maker*. But alas this honour is at present denied to
my endeavours, though you may assure him that I will succeed if I
live a while longer undisturbed by the French, as I only want an in-
clind plane that will stand our fire. My first attempt has failed, & I
cannot well proceed in my experiments 'till we lay by work for
Xmas when our kilns will be at liberty for my trials.

30 May 1779
I wrote to you by post this morning, but wish to say a word or two
concerning Mr Stubbs and his tablets.

We shall now be able to make them with certainty & success of
the size of the 3 in this inventory & I hope soon to be able to say as
far as 30 inches – perhaps ultimately up to 36 inches by 24, but that
at present is in the offing, and I would not mention to Mr Stubbs
beyond 30 at present. If Mr Stubbs succeeds, he will be followed by
others, to which he does not seem to have the least objection, but
rather wishes for it; & if the oil painters too should use them, they
may become a considerable object.

At present I think that we should give Mr Stubbs every en-

couragement to proceed and establish the fashion. He wishes you know to do something for us by way of setting off against the tablets. My picture and Mrs Wedgwood's in enamel will do something. Perhaps he may take your governess and you in by the same means. I should have no objection to a family piece, or rather two, perhaps in oils, if he should visit us this summer at Etruria. These things will go much beyond his present trifling debt to us. . . .

The two family pieces I have hinted at above I mean to contain the children only & grouped perhaps in some such manner as this.

Sukey playing upon her harpsichord, with Kitty singing to her, as she often does & Sally & Mary Ann upon the carpet in some employment suitable to their ages. This to be one picture. The pendant to me, Jack standing at a table making fixible air with the glass apparatus etc. & his two brothers accompanying him. Tom jumping up, and clapping his hands in joy & surprise at seeing the stream of bubbles rise up just as Jack has put a little chalk to the acid. Joss with the chemical dictionary before him in a thoughtful mood, which actions will be exactly descriptive of their respective characters.

My first thought was to put these two pictures into Mr Wright's hands [Joseph Wright of Derby], but other ideas took place & remembering the labourers and cart in the exhibition [Stubbs painted three versions of this subject], with paying for tablets etc., I finally decided in favour of Mr Stubbs, and have mentioned a fire piece to Mr Wright in a letter I wrote him last week to tell him I should be glad to see him in a fortnight or 3 weeks. But what shall I do about having Mr S. & Mr W. here at the same time? Will they draw kindly together, think you? Once more farewell.

> Stubbs arrived early in August 1780, without Wright, and on the 7th Wedgwood wrote again to Bentley.

We have been considering and reconsidering some subjects besides tablets for Mr Stubbs to paint in enamel, & are now making some large jarrs for that purpose. The present idea is to cover them over with painting, with ground figures, trees and skies, without any borders or divisions, in short to consider the whole surface as one piece of canvas, and cover it accordingly & under this form we find a simple jarr form the best for our purpose, and they will come cheap enough, which as times are, may be something in their favour. This morning we are going for the second time to the works to see the jarrs turned & to prepare some clay tablets for modelling upon & we shall then dine with the good parson of

Newcastle, so that this day is fully provided for, only we must find time for a lecture upon perspective, which science Mr Stubbs has kindly engaged to teach my boys.

Mr Stubbs it seems has been a drawing master among other things at Heath's Academy, though he followed that profession but a short time. He begun by teaching perspective to his pupils, which he believes to be just as rational a method in drawing, as learning the letters first is [in] acquiring the art of reading & he would have the learner copy nature and not drawings.

13 August 1780

Just before your last came to hand, not many minutes before, I was telling Mr Stubbs that our vases would sell if they were painted with free masterly sketches, in which way they might be got out of hand, but that our stippeling method was tedious beyond all bearing. He was of the same opinion, & will try his hand upon half a dozen jarrs we have made for that purpose, but these are only for himself and his friends & I have not made any other proposals to him – perhaps it will be best to defer it till he has tried his hand upon his jarrs.

We make but little progress with the family piece at present, but Mr S. talks of laying to in good earnest soon. He has fixed upon his subject for modelling *The Lion and the Horse* from his own engraving. He objected to every other subject, so I gave it up, and he is now laying in the horse while I am writing a few letters this good Sunday morning. He does very well so far, and with a little practice he will be as good with his modelling tools, as he is of his pencils.

Our three little lassies & their coach are just put into colours & the characters of the children are hit off very well. I have given him one sitting, and this is all we have done with the picture. The stable is preparing and the horses are to *sit* this week.

> Wedgwood was taking Stubbs out to dinner amongst the local gentry 'hoping that he will be benefited by the addition he will make here to his acquaintance', though he admitted 'his pieces are beyond the limited conceptions of this country; he has been applied to by Sir Thomas Broughton for his price of painting a horse, and by another for a dog'. His own feelings about the portrait of the family were a little mixed.

21 October 1780

Mr Stubbs is now drawing to a conclusion & talks of going to Liverpool in a few days; but I think he is not quite so near a finish as he seems to apprehend. He thinks he has finished six of the chil-

dren, the horses & little carriage. The children are most of them strong, but not very delicate likenesses. Some parts are a little caricatured, or my own eyes & those of many of my friends are much deceived . . . but I will say no more upon this subject at present *and this is only to yourself*, as it would be hardly fair till the picture is turned out off his hands as completely finished & besides he has promised me to compare the originals and copies carefully together & give any last touches which may be found wanting as soon as he has brought my wife, my daughter Susan and myself up with the rest. I think he has not been so happy in hitting off the likenesses of the two former as he has in the others. I have been sitting a great [part] of the day, but cannot report much progress.

Time and patience in large doses are absolutely necessary in these cases & me thinks I would not be a portrait painter upon any condition whatever. We are all heartily tired of the business & I think the painter has more reason than any of us to be so.

28 October 1780
. . . Mr Stubbs thinks he has quite finished our picture, but he is a little mistaken, for I shall get him to make a few alterations still by degrees, for I have plagued him a good deal in the last finishing strokes & he has been very good in bearing with my impertinence.

(Leith Hill Place papers, University of Keele)

5.8 One great curiosity

Amongst the many foreign artists who visited England and worked here, one of the most unusual was Chitqua (probably only a rough approximation to his real name), a Chinese, who features in Zoffany's *The Life School* in the Royal Academy (Queen's Collection) peering over the back of Benjamin West. He attended the first dinner of the Royal Academy, given at the gallery in Pall Mall, where the annual exhibition was being held, on 23 April 1770, and at which he exhibited a bust. Thomas Bentley wrote about him to Josiah Wedgwood in November 1769.

We are every day finding out some ingenious man or curious piece of workmanship, all of which we endeavour to make subservient to the improvement of our taste, or the perfection of our manufacture. I have not time to mention the things which we have seen, but one great curiosity I cannot omit. I mean a Chinese portrait modeller, lately arrived from Canton, one of those artists who makes the Mandarin figures that are brought to England, a pair of which you may remember to have seen in Mr Walley's shop.

215

He intends to say here some years, is in the Chinese dress, makes portraits (small busts in clay which he colours) and produces very striking likenesses with great expedition. I have paid him three visits, and had a good deal of conversation with him, for he speaks some English, and is a good natured, sensible man, very mild in his temper, and gentle in his motions. His dresses are chiefly of satin, and I have seen him in crimson and in black. The Indian figures on the fans are very resemblances of the original. His complexion is very swarthy, the eyelashes almost always in motion. His arms are very slender, like those of a delicate woman, and his fingers very long; all his limbs extremely supple, his long hair is cut off before, and he has a long tail hanging down to the bottom of his back. He has been with the King and Queen, who were much pleased with him, and he is to take the portraits of the Royal Infantry. He has ten guineas a piece for his little portraits, which are very small.

(*Letters of Josiah Wedgwood*, London 1872)

5.9 A China manufactory in Dublin

Nicholas Sprimont's famous Chelsea factory which produced the fine English porcelain of the eighteenth century failed in 1769 – though the factory was taken over by Duesbury of Derby. One of its employees hit on the idea of starting up a china factory in Dublin, and wrote to that famous Irish patron the Earl of Charlemont, in his capacity as President of the Dublin Society.

Sept. 28th 1772. Coppice Row, Cold Bath Fields

Your character being established here for your fine taste in the polite arts and your generous encouragement of the professors of them, emboldens me to take the liberty to address your lordship upon some hints that were given me of the practicability of establishing a porcelain manufactory in Dublin, of which I respectfully crave your lordship's opinion, and with the greater freedom as I am well informed that from your great affability and condescension I may hope at least not to be presuming, but to expect your lordship's candid advice when I inform your lordship of my design. It will perhaps be necessary, as the basis of my pretensions, to let your lordship know that I served an apprenticeship to Mr Sprimont of Chelsea, whom, I believe I need hardly inform your lordship, was the first person who brought English china to the perfection it has now arrived at. Under him I was made master of the various branches of the art, and though painting was my particular depart-

216

ment in his manufactory, yet with attention I have obtained a thorough practical knowledge of the whole process. Upon leaving Mr Sprimont, being unable to carry on the china business in such a manner as I could wish, I turned to the enamel painting branch. This has lately fallen off, which revived a thought I long had of establishing a manufactory of china. In order to do this I have for a trial built some kilns etc., these I rather designed for proofs in the ornament way, of which I have produced a great quantity, such as figures, vases, groups etc. that for fineness and colour are equal to any and superior to abundance that are for sale in the shops.

The approbation these productions have met with from judges encouraged me to hope a great deal from a more extensive plan for making all kinds of useful china, but there are some very particular objections against an attempt of this sort in London. Wood and coal, two capital materials, are here very dear, beside the dearness of provision. These would always allow a country manufactory to undersell a London one. In this difficulty I happened into conversation with a person who informed me nothing of the kind had yet been attempted in Ireland. That for several years the Dublin society had been generous encouragers of all those arts which have a tendency to improve, enrich and embellish their country. That this manufacture, properly encouraged and carried on with propriety bid fair to save money to the kingdom, and be an ornament to it beside – that as I had some credit in London, with an extensive knowledge of the art, some capital of my own, and a great variety of proofs that I am equal to the undertaking, I ought, by all means look out for a patron, and attempt an establishment in Dublin if practicable. Several ingenious artists named your lordship upon this occasion, and amongst the rest Mr Pingo who is my very good friend. He passed these encomiums on your lordship's character that encouraged me to apply to your lordship upon this occasion. How, my lord, I can make it clear very much can be done in Dublin in this way both in the finely ornamental way, and the useful, as well as the coarser; that a sort may be made after the manner of the common India to come cheap, to please, and be of general sale. In the ornamental way I have on hands a vast variety, finished and unfinished which are open to the inspection of any person willing to see how far my abilities may be depended on. As this is wrote chiefly with submission to your lordship's opinion as to the general undertaking, it will be unnecessary to enter into particulars of the plan I should propose for its establishment, in which I shall risque a considerable part of my property, and shall mention to your

lordship that the sum wanted upon this occasion to carry the work into immediate execution (and to produce a quantity quickly for sale) will not be a great one. I shall beside give proofs in Dublin before the society how immediately the work can be set forward by moulding, painting and burning some figures in a very quick process, leaving the whole to your lordship's kind encouragement as you may think well of the undertaking.

5.10 A contract with a craftsman

It was especially in the field of the decorative arts that the apparatus of contracts, indentures, and other binding agreements of medieval origin still operated in their clearest form, though their influence still persisted in the fine arts, where pupils were indentured. Typical of the nature of such contracts is the one drawn up in 1790 between William Duesbury, the Derby porcelain manufacturer, and a Swiss modeller, John James Spengler of Zurich, who had just joined him. It is revealing too of the nature of working conditions at the time.

It is mutually and reciprocally agreed between the said William Duesbury and the said John James Spengler, that the said John James Spengler shall according to the best of his skill and ability employ and apply himself from time to time from the date of this Agreement for the term of three years now next following in and to the making of all such Models, that is to say Figures, Vases, Groups, Ornaments and Vessels as shall from time to time in the judgement of the said John James Spengler and under the direction of the said William Duesbury be thought fit and necessary for the use of the Porcelain Manufactory of the said William Duesbury at Derby aforesaid, or any other Manufactory which the said William Duesbury may think proper to establish during the said term. And that the said John James Spengler shall himself make an original in Porcelain from each of his Models. And it is also agreed that Ten hours in each of the six working days between the first day of March and the thirtieth day of September, and eight hours in each of the six working days between the first day of October and the last day of February shall be considered as one whole day. And that the hours to be employed by the said John James Spengler in the business of the said William Duesbury shall be solely in the choice of and variable from time to time at the pleasure of the said John James Spengler. And it is also agreed that the said John James Spengler shall be at liberty from time to time whenever he shall

think proper during the term of this Agreement to employ and app-
ly himself in and to the said business aforesaid for any extra or great-
er number of hours than those before specified to constitute a day
not exceeding four hours in each day before the first day of March
and the thirtieth day of September, and three extra hours between
the first day of October and the last day of February. And it is
agreed that the said John James Spengler shall from time to time
during the course of this Agreement find and provide for himself a
room for carrying on his business in such place as he shall think fit
in Derby aforesaid except for the making such designs and models
in which it may be necessary for the aforesaid John James Spengler
to consult nature, in which case the said William Duesbury agrees
to provide for the said John James Spengler a fitting and convenient
room in some part of his Manufactory and to provide all things
necessary for the use of the said John James Spengler at the expense
of him the said William Duesbury. And the said William Duesbury,
in consideration of the Skill and abilities of the said John James
Spengler to be faithfully employed to his use, as aforesaid, doth
hereby agree to and with the said John James Spengler that he the
said William Duesbury shall and will weekly and every week on the
Saturday in each week during the continuance of the said term well
and truly pay, or cause to be paid to the said John James Spengler
the sum of Two guineas lawful British money for each ordinary
week's work, and after the same rate and proportion for any extra
time which in such week shall have been employed by the same
John James Spengler to the use of the said William Duesbury as
such extra time shall bear to the entire week's work at that season.
Provided, never-the-less in case it shall happen that in any one week
during the term of this Agreement the whole number of hours em-
ployed by the said John James Spengler to the use of the said Wil-
liam Duesbury shall not amount to sixty hours in the week between
the first day of March and the thirtieth day of September or forty
eight hours between the first day of October and the last day of
February then the said William Duesbury shall at the end of every
such week be at liberty to deduct out of the said weekly sum of
Two Guineas so much as the deficiency shall from time to time
amount to in proportion to the whole number of Hours which are
hereby agreed to constitute the week. And the said William Dues-
bury agrees at all times during the said term to find and provide
sufficient employment for the said John James Spengler in the busi-
ness aforesaid as well during the ordinary as during the extra hours
aforesaid and that no deduction shall be made by the said William

Duesbury out of the said weekly sum of Two Guineas save only for such loss of time as shall happen through the default of the said John James Spengler. And that the four great feast days, that is to say Christmas day, New Year's Day, Easter day and Whitsun day shall not be deducted out of the said weekly sum of Two Guineas though the same shall not be employed in the said business but shall be paid for and considered as ordinary days of the season in which the same respectively fall. And the said John James Spengler also agrees from time to time to keep a true and faithful account in writing of all time employed by him in the said business, which account and also the room wherein the said John James Spengler shall conduct his said business shall at all reasonable hours in the day be open to the inspection of the said William Duesbury. And the said John James Spengler also agrees that he will not at any time during the continuance of this Agreement either directly or indirectly enter into the service of any other Manufacturer of Porcelain or Earthenware than the said William Duesbury, nor make, dispose of or part with any models of his workmanship to be either directly or indirectly applied to the use of any other manufacturer, but shall and will in all things execute and perform this present Agreement according to the true intent and meaning thereof, and with the greatest attention in his power to the interest of the said William Duesbury. And it is also agreed that the said John James Spengler shall not at any time during this present Agreement absent himself from the said business for more than one week at any time without the consent of the said William Duesbury. And the said William Duesbury agress to give the said John James Spengler on New Year's day in every year during the said term the sum of.........
......in consideration whereof the said John James Spengler agrees to deliver to the said William Duesbury a Model of his Workmanship made in his extra time. And it is agreed that the said John James Spengler shall be at Liberty to make portraits and other small works for his own use in his extra time so that the same be not sold or disposed of to any Manufacturer of Porcelain or Earthenware other than the said William Duesbury. And the said John James Spengler expressly agrees that he will not desert or leave the said William Duesbury during the continuance of this agreement, but shall and will carry the same in all respects into effect according to its true intent and meaning. Provided always and if the father of the said John James Spengler shall die before the expiration of this Agreement, the said William Duesbury agrees that the said John James Spengler shall be at liberty to go into Switzerland, and there

to continue as long as the situation of his affairs shall required, and if his affairs should be so circumstanced as to require it then that he shall be at liberty to continue there without returning to perform this Agreement or be liable to any penalty for neglect thereof so that he doth not under pretext of this power return into Great Britain during the said term to be employed in any other Manufactory or to make any Models abroad for the use of any Manufactory in Great Britain. And in case of the death of the said William Duesbury during the term of this Agreement it is agreed that the Executors or Administrators of the said William Duesbury shall provide a place for the said John James Spengler for the remaining part of the term of this Agreement on the same terms and conditions as are comprised in this Agreement, and that till such place is in such manner provided, they shall continue to pay the weekly wages expressed in this Agreement, and they shall also pay the said John James Spengler all reasonable travelling Expenses as before mentioned together with a Recompence for any damages which may happen to his Boxes, Goods and other Things in consequence of his moving thereto. And the said John James Spengler agrees to work in London or any other part of the United Kingdom during the terms of this Agreement if the said William Duesbury shall think proper, on condition that the said William Duesbury shall pay his travelling Expenses, and raise his wages according to the situation of the place he is to work at.

Witness Bn. Vulliamy JEAN JACQUE SPENGLER
 Joseph Lygo
(William Bernrose, *Bone China and Derby Porcelain*, 1898)

5.11 **Rationalizing craft technology**

Josiah Wedgwood thought a great deal not only about the standardization of production and the utilization to the full of fixed assets, but also of extending the market in near-luxury goods beyond 'The Great People'. In a letter of 23 August 1772 to his partner Thomas Bentley he expounded some of his views.

I have had several serious Talks with our Men at the Ornamental works lately about the price of our workmanship, and the necessity of lowering it, especially in Flowerpots, Bow-pots and Tea-pots, and as I find their chief reason against lowering the price is the small quantities made of each, which creates them as much trouble *tuning their fiddle* as *playing the tune*. I have promised them that they shall make dozens and Groces of Flower and Tea Pots, and of the

221

vases and Bowpots too, as often as we dare venture at such quanti-
ties. In consequence of these reasonings and regulations Roberts
pays his Boys who wait upon him, which is lowering the price of
throwing more than a third. The Turning of Flowerpots is lowered
full as much, and I have now got a book for my own use and spe-
culation with the prices of workmanship of every article, I shall
proceed in the same way where I think there is room for it, and the
infallible consequence of *lowering the price of workmanship* will be a
proportional increase of quantity got up, and if you turn to the Col-
umns of calculation and see how large a share *Modeling and Moulds*
and the three next columns bear in the expense of Manufacturing
our goods, and consider that these expenses move on like clock-
work, and are much the same whether the quantity of goods made
be large or small, you will see the vast consequence in most manu-
factures of *making the greatest* quantity possible in a given time. Rent
goes on whether we do much or little in the time. Wages to the
Boys and Odd Men, Warehouse Men and Book-keeper, who are a
kind of Satelites to the Makers (Throwers, Turners etc.), is nearly
the same whether we make 20 doz. of Vases or 10 doz. per week,
and will therefore be a double expense upon the latter number. The
same may be said to most of the incidental expenses, Coal for the
fires (no small expense), which must be increased rather than dimi-
nished when the Men are idle, in order to keep them warm, Model-
ing and Moulds, and the expense of sale would not be much in-
creased if we could sell double the quantity at our Rooms in Town,
which lowering some of the prices may enable us to do.

We have now upwards of 100 Good forms of Vases, for all of
which we have the moulds, handles and ornaments, and we could
make them almost as currently as useful ware, and at one half the
expense we have hitherto done, provided I durst set the Men to
make from about 6 to 12 doz. of a sort.

The first expense will be all sunk if we do not proceed in the
business this Apparatus is adapted for.

The Great People have had these Vases in their Palaces long
enough for them to be seen and admired by the Middling Class of
People, which Class we know are vastly, I had almost said infinite-
ly superior in number to the Great, and though a *great price* was, I
believe, at first necessary to make the Vases esteemed *Ornaments for
Palaces*, that reason no longer exists. Their character is established,
and the Middling People would probably buy quanties of them at a
reduced price.

(*Letters of Josiah Wedgwood*, London 1872.)

5.12 The Portland Vase

The passion for collecting Greek and Roman antiquities combined with the growing industrial skills of eighteenth-century England to produce what was one of the most remarkable artefacts of the eighteenth century – Josiah Wedgwood's copy of the so-called Portland Vase, found in Rome, which was first exhibited in London in June 1790, and later in The Hague, Berlin, Hanover and Frankfurt, where it won fulsome eulogies from all who saw it. The original glass vase (now in the British Museum) had been brought to England by Sir William Hamilton in 1784, and purchased by the Duchess of Portland, who kept it in circumstances of great secrecy. When she died the Duke her son bought it in from the sale of her extensive art collection for £1,029. Wedgwood had originally intended making his copy from prints, but when the Duke acquired it, he sent it to him on indefinite loan. On 24 June 1786 Wedgwood wrote to Sir William Hamilton the following extremely revealing letter, which underlines both his financial acumen and his concern with artistic excellence.

Sir,
You will be pleased, I am sure, to hear what a treasure is just now put into my hands. I mean the exquisite Barberini vase, with which you enriched this island and which, now that we may call it the Portland Vase, I hope will never depart from it. His Grace the Duke of Portland being the purchaser, at the sale of his late Mother's Museum, has generously lent it to me to copy, and permitted me to carry it down with me to this place, where I stand in much need of your advice and directions in several particulars which I beg leave to state to you, for to whom can I apply with so much propriety or hopes of success, as to so able and willing a patron of the arts.

When I first engaged in this work, and had Montfaucon only to copy I proceeded with spirit and sufficient assurance that I should be able to equal or excel, if permitted, that copy of the vase; but now that I can indulge myself with full and repeated examinations of the original work, my crest is much fallen & I could scarcely muster sufficient resolution to proceed, if I had not, but too precipitately perhaps pledged myself to many of my friends to attempt it in the best manner I am able. Being so pleased, I must proceed, but shall stop at certain points till I am favoured with your kind advice and assistance.

It will be necessary however for you to know something of the

powers I am in possession of for this attempt, before you can tell me what advice to give. I have several modellers employed in the several branches of that art, and one of them, who was recommended to me by Sir Wm Chambers and Sir Joshua Reynolds is esteemed the first of his profession in England. I need not add that I shall give myself unwearied attention to the progress of this great work. The material in which I hope to make the copies is much harder than glass, nearly as hard as agate, so that in this respect I have the advantage of my predecessors: & like the agate it will bear to be cut & take a polish, at the seal-engraver's lathe. It has likewise a property peculiar to itself, which fits it perfectly for this imitation, – which is its taking a blue tint from cobalt, to any degree of strength. It is apparent that the artist has availed himself very ably of the dark ground, in producing the perspective and distance required, by cutting the white away, nearer to the ground as the shades were wanted deeper, so that the white is often cut to the thinness of paper, and in some instances quite away, and the ground itself makes a part of the bas-relief; by which means he has given to his work the effect of painting as well as sculpture; and it will be found that a bas-relief with all the figures of one uniform white colour upon a dark ground, will be a faint resemblance of what this artist has had the address to produce by calling in colour to assist his relief. That hollowness of the rocks and depth of shade in other parts, produced by cutting down to the dark ground, & to which it owes no small part of its beauty, would be all wanting, and disgusting flatness appear in its stead. It is here that I am most sensible of my weakness, and that I must of necessity call in the engraver to my assistance in order to produce the highest finished and closest copies we are capable of making. But in this resource difficulties arise, and, I fear, insurmountable ones; for how few Artists have we in this branch whose touches would not carry ruin to those beautiful & high wrought figures? And suppose one or two could be found equal to the task, would such artists be persuaded to quit a lucrative branch of their profession, & devote half a life to a single work, for which there is little probability of their being paid half as much as they earn by their present employment; for I do not think 5000 [pounds?] for the execution of such a vase, supposing our best Artists capable of the work, would be at all equal to the work they are now engaged in; and the taste of the present age, you well know Sir, is not awake, notwithstanding all you have done to rouse it, to works of much time and great expense. Here than I stand greatly in need of your assistance, for unless some new experiment can be

happily thought of, we must submit to the loss of a beauty which we are perhaps capable of producing, if all other circumstances are favourable to bringing it forward.

I suppose it is admitted, that the form of this vase is not so elegant as it might be made if the Artist had not been possessed of some very good reason for contenting himself with the present form, – either perhaps that he would engage the whole, undivided attention of the spectator to his sculpture, the vase itself being the production of another Artist, of an inferior class, the verrier, – or, because the material made use of, under the circumstances necessary for the display of his art, that is, the body being made of one colour, & the surface covered over to a due thickness with another, was not capable of taking a form with those delicate parts on which its beauty as a simple vase made of metal or more manageable materials. Now, though we should suppose the latter to be the case, I suppose you would still advise me to copy the form of the vase, as well as figures. But what I wish to ask you is, whether you would forbid me to apply these figures to any form of vase, or with the addition of any borders or other ornaments.

I dare confess to you, Sir, that I have at times wrought myself up to a certain degree of enthusiasm, in contemplating the beauties of this admirable work; & in these paroxysms as ready to cry out that this single piece is alone a sufficient foundation for a manufactory, and that of no small extent & then I begin to count how many different ways the vase may be copied, to suit the tastes, the wants & the purses of different purchasers.

The working Artist would be content with a true and simple copy, cast in one colour, of durable material with the price accordingly. Others who could afford to proceed a step further, would desire the addition of a blue ground, though painted only; & a third class would wish to have this addition in the composition of which the vase itself is made, & equally permanent, a fourth perhaps would pay for polishing this durable blue ground, & these two last would be my customers for Jasper copies; but whether any would be found with sufficient confidence in the abilities of our Artist to order, or with patience to wait for, one of the highest order finished by the engraver, or whether any Artist would be found hardy enough to engage in it, I have my doubts. However, if you approve of the idea of making copies suited to different purposes, as above-mentioned, I will attempt one or two of the easiest first.

In examining the bas-reliefs on the vase there are a few palpable slips of the artist's attention. Would it be advisable in these cases, to

make any deviation from the original, or to copy as close as we can its defects as well as its beauties?

Most of the figures have their surfaces partly decayed by time. When we mould from these figures, may we venture to restore their original smoothness, with care to preserve the drawing etc., – or let the copies pass deficient as time has left the original.

I next beg your advice respecting the introduction of these figures in other works and forms, in which they might perhaps serve the arts & diffuse the seeds of good taste more extensively than by confining them to the vase only. For instance, many a young artist, who could not purchase any edition of the vase, would be glad to buy impressions of the heads of the figures, or the whole figures in a durable material of one colour, for studies. Others would purchase intaglios of the heads for seals and cameos of two colours & polished grounds for rings, or the whole figure in separate pieces of groups, finished to any degree for cabinet pieces or pictures. In tablets for chimney pieces and many other purposes, I have some reason to believe they will be acceptable, if I succeed tolerably in the copies. I should be glad to know if you see any objection to these proposed extensions and applications.

Several gentlemen have urged me to make my copies of the vase by subscriptions, and have honoured me with their names for that purpose; but I tell them, and with great truth, that I am extremely diffident of my ability to perform the task they impose on me; & that they shall be perfectly at liberty when they see the copies to take or refuse them; & on these terms I accept of subscriptions, chiefly to regulate the time of delivering out the copies in rotation, according to the dates on which they honour me with their names.

(*Letters of Josiah Wedgwood*, Leith Hill Place)

> The poet Erasmus Darwin included an execrable engraving of Wedgwood's copy of the vase in his *The Botanic Garden* (1789), with the following tribute expressed in his typically infelicitous verse.
>
> . . . on WEDGWOOD ray your partial smile
> A new Etruria decks Britannia's isle,
> To call the pearly drops from Pity's eye
> Or stay Despair's disanimating sigh.
> Whether, O Friend of art, the gem you mould
> Rich with new taste, with ancient virtue bold;
> Form the poor fettered slave on bended knee,
> From Britain's sons imploring to be free;

Or with fair Hope the brightening scenes improve
And cheer the dreary wastes at Sydney Cove;
Or bid Mortality rejoice and mourn
O'er the fine forms on Portland's mystic urn.
Here by fallen columns and disjoined arcades,
On mouldering stones beneath deciduous shades,
Sits Humankind in hieroglyphic state
Serious and pondering on their changeful state;
While with inverted torch and swimming eyes
Sinks the fair shade of Mortal Life, and dies.

5.13 The artist as designer

In the 1780s Reynolds was commissioned to design a stained-glass window, representing the Nativity of Christ, for New College, Oxford. It produced the following reactions from that embattled Gothicist Thomas Warton who was Professor of Poetry at Oxford in 1782.

No more the matchless skill I call unkind
That strives to disenchant my cheated mind.
For when again I view the chaste Design;
The just proportion, and the genuine line;
Those native portraitures of Attic art,
That from the lucid surface seem to start;
Those tints that steal no glories from the day,
Nor ask the sun to lend his streaming ray;
The doubtful radiance of contending dyes,
That faintly mingle, yet distinctly rise;
'Twixt light and shade the transitory strife;
The feature blooming with immortal life;
The stole in casual foldings taught to flow,
Not with ambitious ornament to grow;
The tread majestic and the beaming eye
That lifted, speaks its commeroo with the sky;
Heaven's golden emanation, gleaming mild
O'er the mean cradle of the Virgin's child;
Sudden the sombrous imagery is fled,
Which late my visionary rapture fed;
Thy powerful hand has broke the Gothic chain,
And brought my bosom back to truth again,
To truth by no peculiar taste confined,

> Whose universal pattern strikes mankind;
> To truth whose bold and unresisted aim
> Checks frail caprice and fashion's fickle claim;
> To truth, whose charms deception's magic quells
> And bind coy Fancy in a stronger spell.
> Reynolds! 'tis thine, from the broad window's height,
> To add new lustre to religious light;
> Not of its pomp to strip the ancient shrine,
> But bid that pomp with purer radiance shine;
> With arts unknown before to reconcile
> The willing Graces to the Gothic pile.
> (Thomas Warton, *Collected Poems*. London 1791)

Horace Walpole, however, was less than enthusiastic and on 6 October 1785 wrote to his friend H. S. Conway:

I don't wonder you were disappointed with Jarvis's windows [Reynolds' design at New College], I had foretold their miscarriage. The old and the new are as mismatched as an orange and a lemon; nor is there room to retire back and see half of the new; and Sir Joshua's washy Virtues make the Nativity a dark spot from the darkness of the Shepherds, as I knew it would, from most of Jarvis's colours being transparent.

(Horace Walpole, *Letters*. vol. iii, p 112.)

5.14 A printer's programme

In the preface to his two-volume edition of the works of Milton published in Birmingham on 27 January 1757, John Baskerville made a statement about his typographical ideals and ambitions, which casts some light on the motivation which made him one of the greatest craftsmen of the century.

Amongst the several mechanic Arts that have engaged my attention, there is no one which I have pursued with so much steadiness and pleasure, as that of Letter-Founding. Having been an early admirer of the beauty of Letters, I became insensibly desirous of contributing to the perfection of them. I formed to my self Ideals of greater accuracy than had yet appeared, and have endeavoured to produce a Sett of Types according to what I have conceived to be their true proportion.

Mr Caslon is an Artist, to whom the Republic of Learning has great obligations; his ingenuity has left a fairer copy for my emula-

tion, than any other master. In his great variety of Characters I intend not to follow him; Roman and Italic are all I have hitherto attempted; if in these he has left room for improvement, it is probably more owing to that variety which divided his attention, than to any other cause. I honour his merit, and only wish to derive some small share of Reputation, from an Art which proves accidentally to have been the object of our mutual pursuit.

After having spent many years, and not a little of my fortune in my endeavours to advance this art; I must own it gives me great Satisfaction, to find that my Edition of Virgil has been so favourably received. The improvement in the Manufacture of the Paper, the Colour, and Firmness of the Ink were not overlooked; nor did the accuracy of the workmanship in general, pass unregarded. If the judicious found some imperfections in the first attempt, I hope the present work will shew that a proper use has been made of their Criticisms: I am conscious of this at least, that I received them as I ever shall, with that degree of deference which every private man owes to the Opinion of the public.

It is not my desire to print many books; but such only, as are books of Consequence, of intrinsic merit, or established Reputation, and which the public may be pleased to see in an elegant dress, and to purchase at such a price, as will repay the extraordinary care and expence that must necessarily be bestowed upon them. Hence I was desirous of making an experiment upon some one of our best English Authors, among those Milton appeared the most eligible. And I embrace with pleasure the opportunity of acknowledging in this public manner the generosity of Mr Tonson; who with singular politeness complimented me with privilege of printing an entire Edition of that Writer's Poetical Works.

In the execution of this design, if I have followed with exactness the Text of Dr Newton[1], it is all the merit of that kind which I pretend to claim. But if this performance shall appear to persons of judgment and penetration, in the Paper, Letter, Ink and Workmanship to excel; I hope their approbation may contribute to procure for me what would indeed be the extent of my Ambition, a power to print an Octavo Common-Prayer Book, and a FOLIO BIBLE.

Should it be my good fortune to meet with this indulgence, I would use my utmost efforts to perfect an Edition of them with the greatest Elegance and Correctness; a work which I hope might do some honour to the English Press, and contribute to improve the

1. Thomas Newton who edited Milton's works in a book published in 1749.

pleasure, which men of true taste will always have in the perusal of those sacred Volumes.

5.15 Making Gothic wallpaper

Wallpaper became fashionable and widespread by the middle of the century, but there were problems in adopting it to various styles, as Thomas Gray pointed out in a letter to Thomas Warton on 10 September 1761 (*Correspondence*, ed. Paget Toynbee and Leonard Whibley, 1935, vol. ii).

I own I never yet saw any Gothic papers to my fancy. There is one fault that is in the nature of the thing & cannot be avoided. The great beauty of all Gothic designs is the variety of perspectives they occasion. This a Painter may represent on the walls of a room in some measure; but not a Designer of Papers, where, what is represented on one breadth must be exactly repeated on another, both in the light and the shade, and in the dimensions that we cannot help. But they do not even do what they might. They neglect Hollar to copy Mr Halfpenny's architecture,[1] so that all they do is more like a goosepie than a cathedral. You seem to suppose that they do Gothic papers in colours, but I never saw any but were made to look like Stucco, nor indeed do I conceive that they could have any effect or meaning. Lastly I never saw anything of gilding on paper such as you mention, but we shall see.

On 22 October he returned to the theme:

There are absolutely no papers at all that deserve the name of Gothic, or that you would bear the sight of. I am going to advise that anybody that can draw the least in the world is capable of sketching in Indian ink a compartment or two of diaper work, or a nich or tabernacle with its fretwork; take such a Man with you to Durham Cathedral and let him copy one division of any ornament you think will have any effect, from the high altar suppose, or the nine altars, or what you please. If nothing there suits you, choose in Dart's Canterbury or Dugdale's Warwickshire, and send the design hither, they will execute it here and make a new stamp on purpose, provided you will take twenty pieces of it, and it will come to a ½ or a penny a yard the more (according to the work that is in it).

1. William and John Halfpenny's *Chinese and Gothic Architecture properly ornamented*, 1751, and *Rural Architecture in the Gothic Taste*, 1752.

This I really think worth your while. I very much doubt of the effect of colours (any other than the tints of stucco) would have in a gothic design on wallpaper, and here (in London) they have nothing to judge from. Those I spoke of at Ely were green and blue, with the raised work white, if you care to hazard it.

> November 13th — I applaud your determination, for it is mere pedantry in Gothicism to stick to nothing but altars and tombs, and there is no end of it if we are to sit on nothing but Coronation chairs, nor drink out of nothing but chalices and flagons. The idea is sufficiently kept up if we live in an ancient house, but with modern conveniences about us, nobody will expect us to wear ruffs and farthingales.

5.16 Textile design

The influx of Protestant refugees from France in the late seventeenth century had given a great stimulus to the manufature of textiles, and Spitalfields had become the centre of the industry. As a Frenchman, Rouquet (*The Present of the Arts in England*, 1755) naturally allowed an element of disparagement to creep into his account *Of Silk Manufacture*.

The English cannot bear that we should doubt a moment of the superiority of their silk manufacture. We must confess that their wrought silks are excellent; neither can we deny the choice and plenty of their materials, nor the perfection of their colours; but all this essentially relates only to plain, or at the most to striped silks.

But if we come to talk of the designs, and the paintings, if I may be permitted the expression, with which they are ornamented, we cannot allow them the same perfection. Some designers from Lyons, lately settled in the famous manufacture at Spittlefields, furnish them with their best patterns. A certain woman, who has neither skill nor fancy, has been for many years the principal source of coloured designs employed in this manufacture. The English do not seem to be sensible as yet that the whole skill and dexterity of a painter, though versed and proficient in this branch of art, is hardly sufficient for the task of furnishing designs, in which the gold, the silver and the colours are to produce their effect with all that harmony and brilliance which this sort of picture seems to require.

I was one day at the house of an English lady, where I made the same observations as those now mentioned. They met with that reception which they will certainly meet with again, if ever they

should happen to be read in England. This lady's wardrobe was very rich, and contained a vast variety. I proposed to try the difference which I said there was between those silks in regard to designs, and those of other countries; and I assured her that I should know one from the other, as far as my eyes would permit me to distinguish the designs and the distribution of the colours. Immediately several brocaded gowns were spread open, and I guessed at them all. I own that if I had been shown some copies, tho' not very exact, I should have been mistaken; but this did not happen, and I found it a very easy matter to distinguish the English designs by their want of taste and composition, and by the distribution of colours ill-mixed, without any contrast, force or art, though extremely pretty in other respects.

Their brocades afford us a very strong proof of the excellence of the English artist in simple or symmetrical work, and of the mediocrity of his capacity for things of a more compound character that depend on taste and ornament.

The English manufacturer of brocaded silks, is likewise apt to commit another error, the less excusable, as it is not an error of taste, but of commerce and interest. He injudiciously gives too rich a ground to a commodity that is become too dear by the fashion; he is lavish of his materials in silks that are already too clumsy and heavy. A rich silk is not made to outlast the liveliness of the colours that adorn it; it is intended for ornament, not service. This consideration ought to have the greater weight, as a silk that is too heavy never fits well upon a person, but hangs down without gracefulness more like indeed to a piece of furniture than to a gown.

5.17 A clock

There was a wealth of fine craftsmanship always available in the luxury trades. Typical of this was the clock which Mrs Delany wrote about to her friend Mrs Dewes, on 3 February 1758 (*The Autobiography and Correspondence of Mary Granville, Mrs. Delany*, vol. iii, pp. 478–9. London 1861).

I have been with the Duchess of Portland and her daughters at Mr Dutens, the jeweller's, where my eyes have been dazzled with constellations of diamonds, but I was so modest as to prefer one single diamond to all the bouquets, esclavages, earrings and knots; it was so clear, so perfect, so brilliant, and the price *but* four *thousand pounds*! Mr Dutens entertained us with the sight of a clock of his

own composing. The upper part *a clock*, the middle *a cabinet*, and the lower part contains *musical barrels*, the whole form of it very elegant and most ornamental. The organ part is rich with embossed gilding curiously wrought, the ground of it mosaic of mother-of-pearl and ebony; the cabinet part in the same taste, but smaller work, with pillars of mother-of-pearl and festoons of gold; the clock-case is most exquisitely adorned with foliage of gold, mixed with jewels of all colours of great value, and with little vases of gold filled with flowers of the same metal, seeded with different coloured stones and the leaves as thin as paper. The pendulum moves in sight over the dial-plate, and is a crescent set with brilliants; the ground, under the part where the pendulum moves is azura studded with diamond stars; several springs of flowers are so contrived that they shake as the clock plays, and seem to beat time to the music. In the front on top of the clock-case, is a basket of flowers composed of gold and all manner of coloured jewels, as light and delicate as if designed for a fair lady's forehead, and on the pinnacle of the clock is fixed another crescent of a larger size than the pendulum.

5.18 Observations on different kinds of prints

The development of the print industry in eighteenth-century England promoted an interest in the visual arts of entirely new dimensions. It brought art into the homes of the middle and lower-middle classes; it disseminated a knowledge of art and artists; it extended amongst all classes a new awareness of the world in which they lived, and it engendered its own class of collectors and connoisseurs. In 1768 William Gilpin, one of the main protagonists of the picturesque, published his *Essay on Prints*, which was translated into French, German and Dutch, and which by 1802 had reached its fifth edition and become the standard work on print collecting and appreciation. Here he describes the current varieties of prints available, and their respective characteristics.

There are three kinds of prints, engravings, etchings, and mezzotintos. The characteristic of the first is strength; of the second freedom; and of the third, softness. All these, however, may in some degree be found in each.

From the shape of the engraver's tool, each stroke is an angular incision; which form must of course give the line strength and firmness, if it be not very tender. From such a line also, as it is a deliberate one, correctness may be expected; but no great freedom:

for it is a laboured line, ploughed through the metal, and must necessarily, in a degree, want ease.

Unlimited freedom, on the other hand, is the characteristic of etching. The needle, gliding along the surface of the copper, meets no resistance, and easily takes any turn the hand pleases to give it. Etching indeed is mere drawing: and may be practised with the same facility. – But as aqua-fortis bites in an equable manner, it cannot give the lines that strength which they receive from a pointed graver cutting into the copper. Besides, it is difficult to prevent its biting the plate all over alike. The distant parts indeed may easily be covered with wax, and the grand effect of the keeping preserved; but to give each smaller part its proper relief, and to harmonize the whole, requires so many different degrees of strength, such easy transitions from one into another, that aqua-fortis alone is not equal to it. Here, therefore, engraving hath the advantage, which by a stroke, deep or tender, at the artist's pleasure, can vary strength and faintness in any degree.

As engraving, therefore, and etching have their respective advantages, and deficiencies, artists have endeavoured to unite their powers, and to correct the faults of each, by joining the freedom of the one, with the strength of the other. In most of our modern prints, the plate is first etched, and afterwards strengthened, and finished by the graver. And when this is well done, it has a happy effect. That flatness, which is the consequence of an equable strength of shade, is taken off; and the print gains a new effect by the relief given to those parts which hang (in the painter's language) upon the parts behind them. But great art is necessary in this business. We see many a print, which wanted only a few touches, when it appeared in its etched proof, receive afterwards so many, as to become laboured, heavy and disgustful.

It is a rare thing to meet with a print entirely engraved, and free from stiffness. A celebrated master of our own indeed hath found the art of giving freedom to the stroke of a graver; and hath displayed great force of execution upon works by no means worthy of him: as if he were determined to shew the world he could stamp a value upon any thing. – But such artists are rarely found. Mere engravers, in general, are little better than mere mechanics.

In etching, we have a greater variety of excellent prints. The case is, it is so much the same as drawing, that we have the very works themselves of the most celebrated masters; many of whom have left behind them prints in this way; which, however slight and incor-

rect, will always have somthing masterly, and of course beautiful in them.

In the muscling of human figures, of any considerable size, engraving hath undoubtedly the advantage of etching. The soft and delicate transitions, from light to shade, which are there required, cannot be so well expressed by the needle: and, in general, large prints require a strength which etching cannot give, and are therefore fit objects of engraving.

Etching, on the other hand, is more particularly adapted to sketches, and slight designs; which, if executed by an engraver, would entirely lose their freedom; and with it their beauty. Landskip too, in general, is the object of etching. The foliage of trees, ruins, sky and indeed every part of landskip requires the utmost freedom. In finishing an etched landskip with the tool (as it is called) too much care cannot be taken to prevent heaviness. We remarked before the nicety of touching upon an etched plate; but in landskip the business is peculiarly delicate. The foregrounds may require a few strong touches, and the boles of such trees as are placed upon them; and here and there a few harmonizing strokes will add to the effect; but if the engraver venture much farther, he has good luck if he do no mischief. We have an artist indeed, in landskip, who may be safely trusted with a graver; who can finish in the highest manner, and yet still preserve a freedom.

An engraved plate, unless it be cut very slightly, will cast off seven or eight hundred good impressions: and yet this depends, in some degree, upon the hardness of the copper. An etched plate will not give above two hundred; unless it be eaten very deep, and then it may perhaps give three hundred. After that, the plate must be retouched, or the impressions will be faint.

Besides the common method of engraving on copper, we have prints engraved on pewter, and on wood. The pewter plate gives a coarseness and dirtiness to the print, which is disagreeable. But engraving upon wood is capable of great beauty. Of this species of engraving more shall elsewhere be said.

Mezzotinto is very different from either engraving or etching. In these, you make the shades; in mezzotinto, the lights.

Since the time of its invention by Prince Rupert, as is commonly supposed, the art of scraping mezzotintos is greatly more improved than either of its sister-arts. Some of the earliest etchings are perhaps the best; and engraving, since the times of Goltzius and Muller, hath not perhaps made any very great advances. But mez-

zotinto, compared with its original state, is, at this day, almost a new art. If we examine some of the modern pieces of workmanship in this way, the Jewish Rabbi, the portrait of Mrs Lascelles, with a child on her knee, Mr Garrick between Tragedy and Comedy, and several other prints equally good, by our best mezzotinto-scrapers, they almost as much exceed the works of White and Smith; as those masters did Becket and Simons. It must be owned, at the same time, they have better originals to copy. Kneller's portraits are very paultry, compared with those of our modern artists; and are scarce susceptible of any effects of light and shade. As to Prince Rupert's works, I never saw any, which were certainly known to be his; but I make no doubt they were executed in the same black, harsh, disagreeable manner, which appears so strong in the masters who succeeded. The invention however was noble; and the early masters have the credit of it: but the truth is, the ingenious mechanic hath been called in to the painter's aid, and hath invented a manner of laying ground, wholly unknown to the earlier masters: and they who are acquainted with mezzotinto, know the ground to be a very capital consideration.

The characteristic of mezzotinto is softness, which adapts it chiefly to portrait, or history, with a few figures, and these not too small. Nothing, except paint, can express flesh more naturally, or the flowing of hair, or the folds of drapery, or the catching lights of armour. In engraving and etching we mush get over the prejudices of crossed lines, which exist on no natural bodies: but mezzotinto gives us the strongest representation of a surface. If, however, the figures are too crowded, it wants strength to detach the several parts with a proper relief; and if they are very small, it wants precision, which can only be given by an outline; or as in painting, by a different tint. The unevenness of the ground will occasion bad drawing, and awkwardness – in the extremeties especially. Some inferior artists have endeavoured to remedy this by terminating their figures with an engraved, or etched line: but they have tried the experiment with bad success. The strength of the line, and the softness of the ground, accord ill together. I speak not here of that judicious mixture of etching and mezzotinto which was formerly used by White, and which our best mezzotinto-scrapers at present use, to give a strength to particular parts; I speak only of a harsh and injudicious lineal termination.

Mezzotinto excels each of the other species of prints in its capacity of receiving the most beautiful effects of light and shade: as it can the most happily unite them by blending them together. — Of

this Rembrandt seems to have been aware. He had probably seen some of the first mezzotintos; and admiring the effect, endeavoured to produce it in etching by a variety of intersecting scratches.

You cannot well cast off more than a hundred good impressions from a mezzotinto plate. The rubbing of the hand soon wears it smooth. And yet by constantly repairing it, it may be made to give four or five hundred with tolerable strength. The first impressions are not always the best. They are too black and harsh. You will commonly have the best impressions from the fortieth to the six-tieth: the harsh edges will be softened down; and yet there will be spirit and strength enough left.

I should not conclude these observations, without mentioning the manner of working with the dry needle, as it is called; a manner be-tween etching and engraving. It is performed by cutting the copper with a steel point, holden like a pencil; and differs from etching only in the force with which you work. This method is used by all engravers in their skies, and other tender parts; and some of them carry it into still more general use.

5.19 Sporting pictures to order

Thomas Butler, originally a bookseller in Pall Mall, applied new techniques to the production of those sporting pictures which adorn so many country houses, employing a small staff of artists, whose works he signed (there is one in the Royal collection). In about 1750 he issued a prospectus in which he stated that

He and his assistants, one of which takes views and paints Land-skips and figures as well as most, propose to go to several parts of the Kingdom to take Horses and Dogs, Living and Dead Game, Views of Hunts etc., in order to compose sporting pieces for cu-rious furniture in a more elegant and newer taste than has ever been yet. Specimens of the Landskips and other performances can be seen at my house. Any Nobleman's or Gentleman's own fancy will be punctually observed and their commands strictly observed by ap-plying or directing as above. Will be at Newmarket this meeting and continue in the country adjacent until after the second Meeting, and the painting of the beautiful Foreign Horse taken by Captain Rodney, Lord Northumberland's, also the more eminent Stallions will be finished this summer, with many other Curiosities in the Sporting way.

(Quoted from W. T. Whitley, *Artists and their Friends in England 1700–1799*. Medici Society, 1928).

5.20 Hogarth on his prints

The success of Hogarth's prints was instantaneous, and spread over all Europe. He himself wrote illuminatingly about his work:

Characters and Caricaturas

Being perpetually plagued, from the mistakes made among the illiterate, by the similitude in the sound of the words character and caricatura, I ten years ago endeavoured to explain the distinction by the above print; and as I was then publishing Marriage A-la-mode, wherein were characters of high life, I introduced the great number of faces there delineated, (none of which are exaggerated) varied at random, to prevent if possible personal application, when the prints should come out:

We neither this nor that Sir Fopling call,
He's knight o'th'shire, and represents you all

This, however, did not prevent a likeness being found for each head, for a general character will always bear some resemblance to a particular one.

Industry and Idleness

Industry and Idleness, exemplified in the conduct of two fellow-prentices; where the one, by taking good courses, and pursuing those points for which he was put apprentice, becomes a valuable man, and an ornament to his country; whilst the other, giving way to idleness, naturally falls into poverty, and most commonly ends fatally, as is expressed in the last print. As these prints were intended more for use than ornament, they were done in a way that might bring them within the purchase of those whom they might most concern; and, lest any part should be mistaken, a description of each print is engraved thereon. Yet, notwithstanding the inaccuracy of the engraving, what was thought conducive and necesary for the purpose for which they were intended, such as action and expression, &c. are as carefully attended to, as the most delicate strokes of the graver would have given, sometimes more; for often expression, the first quality in pictures, suffers in this point, for fear the beauty of the stroke should be spoiled; while the rude and hasty touch, when the fancy is warm, gives a spirit not to be equalled by high finishing.

These twelve prints were calculated for the instruction of young people, and everything addressed to them is fully described in

words as well as figures; yet to foreigners a translation of the mottoes, the intention of the story, and some little description of each print, may be necessary. To this may be added, a slight account of our customs, as boys being usually bound for seven years, &c. Suppose the whole story was made into a kind of tale, describing in episode the nature of a night-cellar, a marrow-bone concert, a Lord Mayor's show, &c. These prints I have found sell much more rapidly at Christmas than at any other season.

The Gate of Calais

After the March to Finchley, the next print that I engraved, was the Roast Beef of Old England; which took its rise from a visit I paid to France the preceding year. The first time an Englishman goes from Dover to Calais, he must be struck with the different face of things at so little a distance. A farcical pomp of war, pompous parade of religion, and much bustle with very little business. To sum up all, poverty, slavery, and innate insolence, covered with an affectation of politeness, give you even here a true picture of the manners of the whole nation; nor are the priests less opposite to those of Dover, than the two shores. The friars are dirty, sleek, and solemn; the soldiery are lean, ragged, and tawdry; and as to the fishwomen — their faces are absolute leather.

As I was sauntering about, and observing them near the Gate, which it seems was built by the English, when the place was in our possession, I remarked some appearance of the arms of England on the front. By this, and idle curiosity, I was prompted to make a sketch of it, which being observed, I was taken into custody; but not attempting to cancel any of my sketches or memorandums, which were found to be merely those of a painter for his private use, without any relation to fortification, it was not thought necessary to send me back to Paris. I was only closely confined to my own lodgings, till the wind changed for England; where I no sooner arrived, than I set about the picture, made the gate my background, and in one corner introduced my own portrait, which has generally been thought a correct likeness, with the soldier's hand upon my shoulder. By the fat friar, who stops the lean cook, that is sinking under the weight of a vast sirloin of beef, and two of the military bearing off a great kettle of sup maigre, I meant to display to my own countrymen the striking difference between the food, priests, soldiers, &c. of two nations so contiguous, that in a clear day one coast may be seen from the other. The melancholy and

miserable Highlander, browzing on his scanty fare, consisting of a bit of bread and an onion, is intended for one of the many that fled from this country after the rebellion in 1745.

Beer Street and Gin Lane

When these two prints were designed and engraved, the dreadful consequences of gin drinking appeared in every street. In Gin Lane, every circumstance of its horrid effects is brought to view in terrorem. Idleness, poverty, misery, and distress, which drives even to madness and death, are the only objects that are to be seen; and not a house in tolerable condition but the pawnbroker's and Gin-shop.

Beer Street, its companion, was given as a contrast, where that invigorating liquor is recommended, in order to drive the other out of vogue. Here all is joyous and thriving. Industry and jollity go hand in hand. In this happy place, the pawnbroker's is the only house going to ruin; and even the small quantity of porter that he can procure is taken in at the wicket, for fear of further distress.

Four Stages of Cruelty

The leading points in these, as well as the two preceding prints, were made as obvious as possible, in the hope that their tendency might be seen by men of the lowest rank. Neither minute accuracy of design, nor fine engraving, were deemed necessary, as the latter would render them too expensive for the persons to whom they were intended to be useful. And the fact is, that the passions may be more forcibly expressed by a strong bold stroke, than by the most delicate engraving. To expressing them as I felt them, I have paid the utmost attention, and as they were addressed to hard hearts, have rather preferred leaving them hard, and giving the effect, by a quick touch, to rendering them languid and feeble by fine strokes and soft engraving; which require more care and practice than can often be attained, except by a man of a very quiet turn of mind. Mason, who gave two strokes to every particular hair that he engraved, merited great admiration; but at such admiration I never aspired, neither was I capable of obtaining it if I had.

The prints were engraved with the hope of, in some degree, correcting that barbarous treatment of animals, the very sight of which renders the streets of our metropolis so distressing to every feeling mind. If they have had this effect, and checked the progress of

cruelty, I am more proud of having been the author, than I should be of having painted Raphael's Cartoons.

The French, among their other mistakes respecting our tragedies, &c. &c. assert, that such scenes could not be represented except by a barbarous people. Whatever may be our national character, I trust that out national conduct will be an unanswerable refutation

Election Entertainment 1755

These two patriots, who, let what party will prevail, can be no gainers, yet spend their time, which is their fortune, for what they suppose right, and for a glass of gin lose their blood, and sometimes their lives, in support of the cause, are as far as I can see, entitled to an equal portion of fame with many of the emblazoned heroes of ancient Rome; but such is the effect of prejudice, that though the picture of an antique wrestler is admired as a grand character, we necessarily annex an idea of vulgarity to the portrait of a modern boxer. An old blacksmith in his tattered garb is a coarse and low being; strip him naked, tie his leathern apron round his loins, – chisel out his figure in free-stone or marble, precisely as it appears, – he becomes elevated, and may pass for a philosopher, or a Deity.

The Bench

I have ever considered the knowledge of character, either high or low, to be the most sublime part of the art of painting or sculpture; and caricatura as the lowest: indeed as much so as the wild attempts of children, when they first try to draw: – yet so it is, that the two words, from being similar in sound, are often confounded. When I was once at the house of a foreign face-painter, and looking over a legion of his portraits, Monsieur, with a low bow, told me that he infinitely admired my caricatures! I returned his congé, and assured him, that I equally admired his.

I have often thought that much of this confusion might be done away by recurring to the three branches of the drama, and considering the difference between Comedy, Tragedy, and Farce. Dramatic dialogue, which represents nature as it really is, though neither in the most elevated nor yet the most familiar style, may fairly be denominated Comedy: for every incident introduced might have thus happened, every syllable have been thus spoken, and so acted in

common life. Tragedy is made up of more extraordinary events. The language is in a degree inflated, and the action and emphasis heightened. The performer swells his voice, and assumes a consequence in his gait, even his habit is full and ample, to keep it on a par with his deportment. Every feature of his character is so much above common nature, that, were people off the stage to act, speak, and dress in a similar style, they would be thought fit for Bedlam. Yet with all this, if the player does not o'erstep the proper bounds, and, by attempting too much, become swolen, it is not caricatura, but elevated character. I will go further, and admit that with the drama of Shakespeare, and action of Garrick, it may be a nobler species of entertainment than comedy.

As to Farce, where it is exaggerated, and outré, I have no objection to its being called caricatura, for such is the proper title.

The Five Orders of Perriwigs

There is no great difficulty in measuring the length, breadth, or height of any figures, where the parts are made up of plain lines. It requires no more skill to take the dimensions of a pillar or cornice, than to measure a square box, and yet the man who does the latter is neglected, and he who accomplishes the former, is considered as a miracle of genius; but I suppose he receives his honours for the distance he has travelled to do his business.

(W. Hogarth, *Works*, ed. John Ireland, London 1791).

5.21 Colour engraving

Constant efforts were being made throughout the century to improve the quality and range of engravings. George Vertue – himself an engraver – records one such.

1722. Mnsr Le Blon painter came into England. Had been in France and came hither from Holland. He had long had a project to engrave prints and pictures in colour. Did make some essays abroad, but met with no encouragement. Here he came, being a man of forward spirit, a tolerable assurance, and a tongue of his own, he found people who much admired his project, and cryed it up. But he, finding the inclination of our people to stockjobing, made friends and interest, whereby he got a Patent from the King for the sole vending and publishing such pictures. This came in play just about the time of ye Bubbles [The South Sea Bubble] and was

cryed up by the proprietors, as one of the most surprizing and advantageous so that a Stock was raised, and workmen imployed. At the first beginning all the artists in general condemned their proposal and works fell far short of what had been promised, having given out that their prints could not be known from paintings. All false, because in some degree, all their prints were touch't with the pencil. A picture of King George a wretched thing. Since then they have done better. The place they wrought them was in the Duchy House in the Savoy. They have many hands at work. First a master to draw for them and correct the pictures, several workmen in mezzotint, some engravers, printers, colourers, frame-makers etc. Collonel Guise, their great Patron and promoter of these works swears and bullies for them to every body; he, with several others promote and share their profit and loss a Catalogue of their pictures done to be sold. Oct. 1722.

> Rubens head 10 shillings
> Vandyck's head 10 shillings
> Spencer's head 10 shillings
> St Agnes's head after Dominichino [sic] 10 shillings
> St Catherine after Correggion 10 shillings
> Herodia's daughter after Guido 10 shillings
> Jesus & St John after Vandyke 12 shillings
> The Virgin, Jesus & St Anne after Carlo Moratt. 12 shillings
> Christ's Burial after Titian £1.1s. od.
> Jesus tempted in the wilderness after Carlo Moratt. 12 Shillings
> Jesus in Gethsemanie after Ludovico Carracci. 12 shillings
> Diana after Conchi 15 shillings
> Endymion after Conchi. 15 shillings
> Rebecca and Abraham's servant £1.1s.
> The Royal Family £1.1s.
> (*Notebooks*, Walpole Society)

6. Man and nature

Gardens and landscape.

6.1 A scarcity of perfect gardens

Architect, designer, traveller, creator of the architecture as a profession in Britain, cultural administrator, Sir William Chambers used his interest in Chinoiserie to initiate an attack on current gardening tastes, as practised by 'Capability' Brown, which was published in May 1772 as *A Dissertation on Oriental Gardening*. In actual fact it was an affirmation of an alternate English view of the nature of the garden. It aroused an enormous amount of controversy, but in Europe turned out to be one of the most influential books on gardening of the period. Chambers' general reflexions on the subject encapsulate much English feeling on the subject at the time.

Amongst the decorative arts, there is none of which the influence is so extensive as that of Gardening. The production of other arts have their separate classes of admirers, who alone relish or set any great value upon them; to the rest of the world they are indifferent, sometimes disgusting. A building affords no pleasure to the generality of men, but what results from the grandeur of the object, or the value of its materials; nor doth a picture affect them, but by its resemblance to life. A thousand other beauties, of a higher kind, are lost upon them; for in Architecture, in Painting, and indeed in most other arts, men must learn before they can admire: their pleasure keeps pace with their judgment; and it is only by knowing much, that they can be highly delighted.

But Gardening is of a different nature: its dominion is general; its effects upon the human mind certain and invariable; without any previous information, without being taught, all men are delighted with the gay luxuriant scenery of summer, and depressed at the dismal aspect of autumnal prospects; the charms of cultivation are equally sensible to the ignorant and the learned, and they are equally disgusted at the rudeness of neglected nature; lawns, woods, shrubberies, rivers and mountains, affect them both in the same manner; and every combination of these will excite similar sensations in the minds of both.

Nor are the productions of this Art less permanent than general in their effects. Pictures, statues, buildings, soon glut the sight, and grow indifferent to the spectator: but in gardens there is a continual state of fluctuation, that leaves no room for satiety; the progress of vegetation, the vicissitudes of seasons, the changes of the weather, the different directions of the sun, the passage of clouds, the agitation and sounds produced by winds, together with the accidental intervention of living or moving objects, vary the appearances so often, and so considerably, that it is almost impossible to be cloyed, even with the same prospects.

Is it not singular then, that an Art with which a considerable part of our enjoyments is so universally connected, should have no regular professors in our quarter of the world? Upon the continent it is a collateral branch of the architect's employment, who, immersed in the study and avocations of his own profession, finds no leisure for other disquisitions; and, in this island, it is abandoned to kitchen gardeners, well skilled in the culture of sallads, but little acquainted with the principles of Ornamental Gardening. It cannot be expected that men uneducated, and doomed by their condition to waste the vigor of life in hard labour, should ever go far in so refined, so difficult a pursuit.

To this unaccountable want of regular masters may, in a great measure, be ascribed the scarcity of perfect gardens. There are indeed very few in our part of the globe wherein nature has been improved to the best advantage, or art employed with the soundest judgement. The gardens of Italy, France, Germany, Spain, and of all the other countries where the ancient style still prevails, are in general mere cities of verdure; the walks are like streets conducted in straight lines, regularly diverging from different large open spaces, resembling public squares; and the hedges with which they are bordered, are raised, in imitation of walls, adorned with pilasters, niches, windows and doors, or cut in colonages, arcades and porticos; all the detached trees are shaped into obelisks, pyramids and vases; and all the recesses in the thickets bear the names and forms of theatres, ampitheatres, temples, banqueting halls, ball rooms, cabinets and saloons. The streets and squares are well manned with statues of marble or lead, ranged in regular lines, like soldiers at a procession; which, to make them more natural, are sometimes painted in proper colours, and finely gilt. The lakes and rivers are confined by quais of hewn stone, and taught to flow in geometric order; and the cascades glide from the heights by many a succession of marble steps: not a twig is suffered to grow as nature

directs; nor is a form admitted but what is scientific, and determinable by the line or compass.

In England, where this ancient style is held in detestation, and where, in opposition to the rest of Europe, a new manner is universally adopted, in which no appearance of art is tolerated, our gardens differ very little from common fields, so closely is common nature copied in most of them; there is generally so little variety in the objects, such a poverty of imagination in the contrivance, and of art in the arrangement, that these compositions rather appear the offspring of chance than design; and a stranger is often at a loss to know whether he be walking in a meadow, or in a pleasure ground, made and kept at a very considerable expense: he sees nothing to amuse him, nothing to excite his curiosity, nor anything to keep up his attention. At his first entrance, he is treated with the sight of a large green field, scattered over with a few straggling trees, and verged with a confused border of little shrubs and flowers; upon farther inspection, he finds a little serpentine path, twining in regular esses amongst the shrubs of the border, upon which he is to go round, to look on one side at what he has already seen, the large green field; and on the other side at the boundary, which is never more than a few yards from him, and always obtruding upon his sight: from time to time he perceives a little seat or temple stuck up against the wall; he rejoices at the discovery, sits down rests his wearied limbs, and then reels on again, cursing the line of beauty, till spent with fatigure, half roasted by the sun, for there is never any shade, and tired for want of entertainment, he resolves to see no more: vain resolution! there is but one path; he must either drag on to the end, or return back by the tedious way he came.

Such is the favourite plan of all our smaller gardens: and our larger works are only a repetition of the small ones; more green fields, more shrubberies, more serpentine walks, and more seats; like the honest batchelor's feast, which consisted in nothing but a multiplication of his own dinner; three legs of mutton and turnips, three roasted geese, and three buttered apple-pies.

It is I think obvious that neither the artful nor the simple style of Gardening here mentioned, is right: the one being too extravagant a deviaton from nature; the other too scrupulous an adherence to her. One manner is absurd; the other insipid and vulgar: a judicious mixture of both would certainly be more perfect than either.

But how this union can be effected, is difficult to say. The men of art, and the friends of nature, are equally violent in defence of

their favourite system; and, like all other partisans, loth to give up anything, however unreasonable.

Such a coalition is therefore now not to be expected: whoever should be bold enough to attempt it, would probably incur the censure of both sides, without reforming either; and consequently prejudice himself, without doing service to the Art.

But though it might be impertinent as well as useless to start a new system of one's own, it cannot be improper, nor totally unserviceable, to publish that of others; especially of a people whose skill in Gardening has often been the subject of praise; and whose manner has been set up amongst us as the standard of imitation, without ever having been properly defined. It is a common saying, That from the worst things some good may be extracted; and even if what I have to relate should be inferior to what is already known, yet surely some useful hints may be collected from it.

I may therefore, without danger to myself, and it is hoped without offence to others, offer the following account of the Chinese manner of Gardening; which is collected from my own observations in China, from conversations with their Artists, and remarks transmitted to me at different times by travellers. A sketch of what I have now attempted to finish, was published some years ago; and the favourable reception granted to that little performance, induced me to collect materials for this.

Whether the Chinese manner of Gardening be better or worse than those now in use amongst the Europeans, I will not determine: comparison is the surest as well as the easiest test of truth; it is in every man's power to compare and to judge for himself — Should the present publication contain anything useful, my purpose will be fully answered; if not, it may perhaps afford some little entertainment, or serve at worst to kill an idle hour.

I must not enter upon my subject, without apologizing for the liberties here taken with our English Gardens: there are, indeed, several that do not come within the compass of my description; some of which were laid out by their owners, who are as eminently skilled in Gardening, as in many other branches of polite knowledge; the rest owe most of their excellence to nature, and are, upon the whole, very little improved by the interposition of art; which, though it may have heightened some of their beauties, has totally robbed them of many others.

It would be tedious to enumerate all the errors of a false taste: but the havoc it has made in our old plantations, must ever be remembered with indignation: the ax has often, in one day, laid waste

the growth of several ages; and thousands of venerable plants, whole woods of them, have been swept away, to make room for a little grass, and a few American weeds. Our virtuosi have scarcely left an acre of shade, nor three trees growing in a line, from the Land's-end to the Tweed; and if their humour for devastation continues to rage much longer, there will not be a forest-tree left standing in the whole kingdom.

6.2 Three distances

In 1772 William Mason published the first part of his *The English Garden* in which he put forcibly the view that gardeners depended for their rules and their inspiration on the practice of painters, and in so doing expressed some of the basic principles which informed contemporary landscape painting.

Of Nature's various scenes the painter culls
That for his favourite theme where the fair whole
Is broken into ample parts and bold;
Where to the eye three well-mark'd distances
Spread their peculiar colouring. Vivid green,
Warm brown, and black opake the foreground bears
Conspicuous; sober olive coldly marks
The second distance; thence the third declines
In softer blue, or less'ning still, is lost
In faintest purple.

Five years earlier the anonymous author of *The Rise and Progress of the Present Taste in Planting Parks, Pleasure Grounds, Gardens etc. From Henry the Eighth to George III* had underlined the specific influence of certain painters on specific gardens, designed by Capability Brown.

At Blenheim, Croom and Caversham we trace
Salvator's wildness, Claude's enlivening grace,
Cascades and lakes as fine as Risdael drew,
While Nature's varied in each charming view
To paint his works would Poussin's Powers require
Milton's sublimity and Dryden's fire
Born to grace Nature and her work complete;
With all that's beautiful, sublime and great!
For him each Muse enwreathes the Laurel Crown,
And consecrates to Fame immortal Brown.

Writers describing scenery in the travel books which were becoming increasingly popular as the century wore on, took great pains to produce word-pictures which they felt echoed the approach of an appropriate painter. Here is William Hutchinson in his *Excursion to the Lakes* of 1776 writing in the 'style' of Claude about a Cumberland scene.

As the sun advanced he [i.e. the sun] gave various beauties to the scene, the beams streaming through the divisions in the mountains, shewed us their due perspective, and striped the plain with gold – the light falling behind the castle presented all its parts perfectly to us – through the broken windows different objects were discovered; the front ground lay in shadows; on the left the prospect was shut in by a range of craggy mountains, over whose steeps trees and shrubs were scattered; to the right a fertile plain was extended, surmounted by distant hills; over their summits the retiring vapours, as they fled the valley, dragged their watery skirts, and gave a solemn gloom to that part of the scene. Behind the building, the lofty promontory of Wilbore Fell lifted its peaked brow, tinged with azure hue, and terminated the prospect.

6.3 A school of landscape

There can be little doubt that the English concern with gardens in the eighteenth century and its dependence on the great Italian and French masters, did much to stimulate the development of landscape painting here in the late eighteenth and early nineteenth century. Horace Walpole's comments in his *On Modern Gardening* (1785) are especially pertinent.

The fairest scenes that depend on themselves alone weary when often seen. The Doric portico, the Palladian bridge, the Gothic ruin, the Chinese pagoda, that surprise the stranger, soon lose their charms to their surfeited master. The lake that floats in the valley is still more lifeless, and its Lord enjoys his experience but when he shows it to a visitor. But the ornament whose merit soonest fades is the hermitage, or scene adapted to contemplation. It is almost comic to set aside a quarter of one's garden to be melancholy in. Prospect, animated prospect, is the theatre that will always be the most frequented. Prospects were formerly sacrificed to convenience and warmth. Thus Burleigh stands behind a hill, from the top of which it could command Stamford. Our ancestors, who resided the

greatest part of the year at their seats, as others did two years together or more, had an eye to comfort first before expence. Their vast mansions received and harboured all the younger branches, the dowagers and ancient maiden aunts of the families, and other families visited them for a month together. The method of living is now totally changed, and yet the same superb palaces are still created, becoming a pompous solitude to the owner, and a transient entertainment to a few travellers. If any incident abolishes or restrains the modern style of gardening, it will be this circumstance of solitariness. The greater the scene, the more distant it is probably from the capital; in the neighbourhood of which land is too expensive to admit considerable extent of property. Men tire of expence that is obvious to few spectators. Still there is a more imminent danger that threatens the present, as it has ever done, all taste. I mean the pursuit of variety. A modern French writer has in a very affected phrase given a just account of this, I will call it, distemper. He says *l'ennui de beau amène le goût du singulier*. The noble simplicity of the Augustan age was driven out by false taste. The gigantic, the puerile, the quaint, and at last the barbarous and the monkish, had each their successive admirers. Music has been improved, till it is a science of tricks and sleight of hand; the sober greatness of Titian is lost, and painting, since Carlo Maratti has little more relief than Indian paper. Borromini twisted and curled architecture, as if it was subject to change of fashions like a head of hair. If we once lose sight of the propriety of landscape in our gardens, we shall wander into all the fantastic sharawadgis[1] of the Chinese. We have discovered the point of perfection. We have given the true model of gardening to the world; let other countries mimic or corrupt our taste; but let it reign here on its verdant throne, original by its elegant simplicity, and proud of no other art than softening nature's harshness and copying her graceful touch.

The ingenious author of *Observations on Modern Gardening* (Thomas Wheatley, published anonymously in 1770), is, I think, too rigid when he condemns some deceptions because they have been often used. If those deceptions, as a feigned steeple of a distant church, or an unreal bridge to disguise the termination of water were intended only to surprise, they were indeed tricks that would not bear repetition; but being intended to improve the landscape,

1. Sharawadgis. A word coined by Sir William Temple, which he attributed (facetiously) to the Chinese, to indicate the beauty of studied irregularity. It could apply to the Chinese or Gothic tastes.

are no more to be condemned because they are common, than they would be, if employed by a painter in the composition of a picture. Ought one man's garden to be deprived of a happy object, because that object has been employed by another? The more we exact novelty, the sooner our taste will be vitiated. Situations are everywhere so various that there can never be sameness, while the disposition of the ground is studied and followed, and every incident of view turned to advantage.

In the meantime how rich, how gay, how picturesque the face of the country! The demolition of walls laying open each improvement, every journey is made through a succession of pictures; and even where taste is wanting in the spot improved, the general view is embellished by variety. If no relapse to barbarism, formality and seclusion, is made, what landscapes will dignify every quarter of our island, when the daily plantations they are making have attained venerable maturity! A specimen of what our gardens will be may be seen at Petworth, where the portion of the park nearest the house has been allotted to the modern style. It is a garden of oaks two hundred years old. If there is a fault in so august a fragment of improved nature, it is that the size of the trees are out of all proportion to the shrubs and accompanyments. In truth, shrubs should not only be reserved for particular spots and home delights, but are passed their beauty in less than twenty years.

Enough has been done to establish such a school of landscape as cannot be found in the rest of the globe. If we have the seeds of a Claud or a Gaspar amongst us, he must come forth. If wood, water, groves, vallies, glades can inspire or poet, or painter, this is the country, this the age to produce them. The flocks, the herds, that now are admitted into, now graze on the borders of our cultivated plains, are ready before the painter's eye, and group themselves to animate his picture. One misfortune in truth there is that throws a difficulty on the artist. A principal beauty in our gardens is the lawn and smoothness of the turf; in a picture it becomes a dead and uniform spot, incapable of chiar oscuro, and to be broken insipidly by children, dogs and other unmeaning figures.

Since we have been familiarized to the study of landscape, we hear less of what delighted our sportsman-ancestors, *a fine open country*. Wiltshire, Dorsetshire, and such ocean-like extents were formerly preferred to the rich blue prospects of Kent, to the Thames-watered views in Berkshire, and to the magnificent scale of nature in Yorkshire. An open country is but a canvas on which a landscape might be designed.

6.4 Roman statues for English gardens

Thomas Jenkins, the English banker, painter and art dealer in Rome
was constantly deluged with commissions from England to supply
paintings and statues for those anxious to stock their homes and
gardens with prestigious artefacts. On 3 December 1757 he wrote
to Henry Beckingham.

Rome

The 17th of August last I had the honour to address a letter to you
in which I acquainted you of having finished your picture, and in
the month of September I forwarded it to Leghorn, to the care of
Mr How, merchant there, who on the 22nd of October shipped it
on board *The Mary*, Captain Mead, which was to sail for London
with the first convoy, therefore I hope it will not be long before it
arrives, and shall be very happy if, in any degree, it deserves your
approbation.

Mr Wilson informs me that you have never received those draw-
ings delivered by him for me to you, and the which I sent in a case
of the good Earl of Dartmouth's in the month of February 1755. In
the same portfolio that contained your drawings were the following
drawn by me for the said nobleman; Apollo Belvedere, ditto Villa
Medena, Apollo è Daphne, Villa Borghese Hermaphrodite, ditto,
Zingaro, ditto. I hope by this means Lord Dartmouth will, with
ease, be able to find those things that were for you. Mr Wilson like-
wise informs me that you are desirous I should send you some anti-
quities – such as might be proper for your garden. This, or any
other commands of yours, Sir, I shall always most cheerfully obey,
but beg you will be so good as to let me know for what particular
purpose you intend them. I mean what part they are to ornament,
either walks or buildings, and if to be exposed to the weather, or
under cover, that I may, when occasion offers, choose you such
things as are most proper for the purpose. In the meantime, if I
meet with anything worth having, I shall secure it for you. I am
very glad to find the love of antiquities so much increased among
our gentleman in England, as I do not doubt but that in time our
arts, that depend on drawing, will be very much benefited from it,
it being evident that the superior excellence of the professors in
painting and sculpture that have flourished in this country [Italy],
has been principally owing to the advantage of having the antique
to form themselves upon. This is a doctrine, I know, much decried
by a certain set, but until I see any productions superior to those
above mentioned, I believe I shall not alter my opinion.

(Historical MSS Commission Reports, Dartmouth, vol. i.)

6.5 All sorts of figures and statues

The taste for gardens stimulated the demand for garden ornaments and a whole trade grew up to accommodate those who could not afford classical statuary. These works were virtually mass-produced.

William Squire, at the two Gilt Flower Pots over the door of the yard near Hyde Park, makes all sorts and sizes of figures or statues, flower-pots, urns, and vases for ornament on tops of houses, piers of gates, fountains of all shapes and sizes with figures of men and women, beasts, birds, or fishes; he hath just now made a new sort of half figures for gentlemen to fix in or against walls instead of painting; they will endure all weather; they are likewise fit for gardens, not to be distinguished from others unless you go behind them; all of hard metal, and sells them at very reasonable price.

(*Review* No. 114, 1734)

Advertisement to the nobility and gentry of Great Britain and Ireland by Mr Langley who makes with the utmost exactness, beauty, strength, and duration all manner of sculptured or carved ornaments for buildings and gardens, viz. bustos of gentlemen and ladies, living or dead, at five guineas each.... Also all manner of curious vases, urns, pineapples, pedestals for sundials, balustrades ... columns and pilasters according to the Tuscan, Doric, Ionic, Corinthian, or Composite orders of architecture. Likewise all manner of rock-work, grottoes, cascades, obelisks, porticos, and temples of view after the grand manner of the old Romans. Together with great variety of curious bustos and bas-reliefs of all the most eminent emperors, kings, generals, admirals, ministers of state, philosophers, mathematicians, architects, poets, and painters, placed on trusses, pedestals, or terms.... N.B. For the conveniency of gentlemen there is constantly a servant kept with great variety of specimens of the work in Westminster Hall where orders or directions may be left for Mr Langley who will wait on any gentleman when and where he shall please to appoint.

(*Daily Advertiser*, No. 128, 1731)

6.6 A most elegant structure

The theatre, pleasure gardens, and the provision of special pavilions for state occasions and the like provided useful sources of patronage for architects and artists. Typical of the magnificence of the latter

category was 'the most elegant structure' created by Sir William Chambers around an earlier pavilion designed by Robert Adam in Richmond Gardens for the reception of King Christian IV of Denmark on 24 September 1769. An account of it appeared in the *Gentleman's Magazine* a month later.

A most elegant structure was erected, in the centre of which was a large arch about 40 feet high of the Grecian order, decorated with figures and trophies and other embellishments, from which, on each side was a range of statues, supporting festoons of flowers in proper colours; at the termination of each side were lesser arches, through which appeared emblematic pictures, alluding to the arts and sciences, the whole in extent 200 feet. These were all transparencies with such outside illuminations as the design would admit. The great arch led into a very superb enclosed pavilion, in the centre of which was a dome supported by eight columns, wreathed with flowers and ornamented with gold; from the centre the plan extended four ways, with appartments within for a band of music, sideboards, and the whole decorated with paintings.

6.7 Light from the East

Contact with the Orient had been growing since the last decades of the seventeenth century. The engravings by the Italian Jesuit Matteo Ripa of the Imperial Palace at Peking were known to Burlington, and a taste for architectural Chinoiserie reached as far as Thomas Lightoler's *The Gentleman and Farmers' Architect* of 1762. But the main protagonist of the Chinese taste was William Chambers whose *Designs of Chinese Buildings, Furniture, Dresses, Machines and Utensils* of 1757 was based not only on previous writings on the subject, but on two visits to China. His correlation of painting and gardening in this context typifies a widespread attitude.

The gardens which I saw in China were very small; nevertheless from them, and what could be gathered from Lepqua, a celebrated Chinese painter, with whom I had several conversations on the subject of gardening, I think I have acquired sufficient knowledge of their notions on this head.

Nature is their pattern, and their aim is to imitate her in all her beautiful irregularities. Their first consideration is the form of the ground, whether it be flat, sloping, hilly, or mountainous, extensive, or of small compass, of a dry or marshy nature, abounding with rivers and springs, or liable to a scarcity of water; to all which

circumstances they attend with great care, chusing such dispositions as humour the ground, can be executed with the least expence, hide it's defects, and set it's advantages in the most conspicuous light.

As the Chinese are not fond of walking, we seldom meet with avenues or spacious walks, as in our European plantations; the whole ground is laid out in a variety of scenes, and you are led, by winding passages cut in the groves, to the different points of view, each of which is marked by a seat, a building, or some other object.

The perfection of their gardens consists in the number, beauty, and diversity of these scenes. The Chinese gardeners, like the European painters, collect from nature the most pleasing objects, which they endeavour to combine in such a manner, as not only to appear to the best advantage separately, but likewise to unite in forming an elegant and striking whole.

Their artists distinguish three different species of scenes, to which they give the appellations of pleasing, horrid, and enchanted. Their enchanted scenes answer, in a great measure, to what we call romantic, and in these they make use of several artifices to excite suprize. Sometimes they make a rapid stream, or torrent, pass under ground, the turbulent noise of which strikes the ear of the new-comer, who is at a loss to know from whence it proceeds: at other times they dispose the rocks, buildings, and other objects that form the composition, in such a manner as that the wind passing through the different interstices and cavities, made in them for that purpose, causes strange and uncommon sounds. They introduce into these scenes all kinds of extraordinary trees, plants, and flowers, form artificial and complicated echoes, and let loose different sorts of monstrous birds and animals.

In their scenes of horror, they introduce impending rocks, dark caverns and impetuous cataracts rushing down the mountains from all sides; the trees are ill-formed, and seemingly torn to pieces by the violence of tempests; some are thrown down, and intercept the course of the torrents, appearing as if they had been brought down by the fury of the waters; others look as if shattered and blasted by the force of lightening; the buildings are some in ruins, others half-consumed by fire, and some miserable huts dispersed in the mountains serve, at once to indicate the existence and wretchedness of the inhabitants. These scenes are generally succeeded by the pleasing ones. The Chinese artists, knowing how powerfully contrast operates on the mind, constantly practise sudden transitions, and a striking opposition of forms, colours, and shades. Thus they conduct you from limited prospects to extensive views; from objects of hor-

ror to scenes of delight; from lakes and rivers to plains, hills, and woods; to dark and gloomy colours they oppose such as are brilliant, and to complicated forms simple ones; distributing, by a judicious arrangement, the different masses of light and shade, in such a manner as to render the composition at once distinct in it's parts, and striking in the whole.

6.8 Varieties of landscape

The emotionally evocative power of landscape painting was recognized at an early date, and an anonymous author (BM Harleian Misc. v, 1745, pp. 554–5) thus apostrophizes Francis Hayman, the friend of Hogarth, who had commenced his painting career at Drury Lane Theatre.

Hayman by Scenes our Senses can control,
And with creative *Power* charm the soul;
His easy Pencil flows with just Command,
And Nature starts obedient to his Hand;
We hear the tinkling Rill, we view the Trees
Cast dusky Shades, and wave the gentle Breeze;
Here shoots through leafy Bow'rs a sunny Ray,
That gilds the Grove, and emulates the Day;
There Mountain Tops look glad; there Valleys sing;
And through the Landscape blooms eternal Spring;
But what's this Art, should be such art perform,
And join it to the Horrors of a Storm;
Where quick for's lightnings gleam, loud Thunders roar,
And foaming Billows lash the sounding Shoar;
Where driv'n by Eddies with impetuous Shock;
The whirling Vessel bulges on a Rock;
The hopeless Sailor rearing high his Hand,
And Corpse on Corpse come rolling on the Strand;
In Storm and Landscape we might Beauties find,
But wonder how they came together *join'd*

6.9 Artificial views

A View from The Star and Garter at Richmond reproduced in the *British Magazine* for June 1761 was the unlikely pretext for these widely held sentiments about the nature of landscape and the duty of the artist to make it more interesting if occasion demanded.

The assemblage of objects, known by the name of landscape, is so interesting to the eye and agreeable to the imagination, that when nature does not supply sufficient variety to regale the faculty of sight and the power of fancy, the most eminent painters have employed their talents in exhibiting artificial views and prospects, in which the great and sublime, the gay and the agreeable, objects of inanimate nature are variously combined, so as to furnish an infinite fund of entertainment according to the different dispositions of the human mind. At one moment the imagination loves to contemplate the awful scenes of solitary nature, such as stupendous rocks, gloomy forests and louring skies; sometimes to survey the terrible, the tumbling ruin, the oak uptorn, the blackening cloud and gleaming lightning. Those are scenes that strike the soul with a kind of pleasing horror, and fill it with sublime ideas of greatness and immensity. Such were the subjects that employed the pencil of the celebrated Salvator Ros, in contradistinction to the more mildly pleasing scenes which rose from the labours of a Poussin and Claude Lorrain, according to those lines of the poet.

Whate'er Lorrain light touched with soft'ning hue,
Or savage Rosa dashed, or learned Poussin drew.

6.10 Moral purpose in landscape

There was always the feeling that portraits and landscape were inferior to history painting because they had no moral purpose – a deficiency which the artists of the next century were more than adequately to redress. William Hodges (1744–97), who had sailed as draughtsman with Captain Cook in 1772, and painted a number of views of India for Warren Hastings, was deeply preoccupied with this problem, and towards the end of his life exhibited two paintings *The Effects of Peace and War* (now in the Soane Museum) in a room in Old Bond Street, and expressed himself thus in the catalogue.

To the Public:
It is usual for every exhibitor of works of art to state, with different degrees of modesty, the nature of those objects to which he presumes to solicit the public attention and encouragement.

I have the less scruple to avail myself of the custom, as my peculiar plan demands some little explanation, that my design may be fully known, and my labours fairly appreciated.

The branch of painting, towards which my studies have been

principally directed is landscape. These studies were begun under the greatest modern master of that art, Wilson. I must be permitted to value myself upon such an advantage, which I hope very extensive travels through various countries must have improved.

Upon maturely reflecting on the nature of my profession, I have been led to lament a defect, and humbly to endeavour at a remedy. I found in the ancient and many of the modern masters of landscape, the grandest combinations of nature, and the most exact similitude, the happiest composition, and pencilling governed by the hand of Truth. But I confess there seemed very rarely to me any moral purpose in the mind of the artist. The storm has been collected over the peaceful trader, or the brilliant skies of Italy have illumined merely the forms of inanimate nature. We have seen foliage frowning on one side, and the blasted trunk exhibiting its dreary desolation on the other; but the whole has evinced only the ordinary progress of life, and the effects of elemental war.

It could not escape me, that the other branches of the art have achieved a nobler effect – History exhibited the actions of our Heroes and Patriots, and the glory of past ages – and even Portrait, though more confined in its influence strengthened the ties of social existence. To give dignity to landscape painting is my object. Whatever may be the value of my execution, the design to amend the heart while the eye is gratified, will yield me the purest pleasure by its success. I may flatter myself even with an influence that shall never be acknowledged; and the impression of these slight productions may be felt in *juster* habits of Thought, and Conduct consequently *improved*. From slight causes the Author of our minds has ordained that we should derive most important convictions. Perhaps the enthusiasm of the artist carries me too far, but I hope and trust that my progress in this design may be serviceable to my country, and to humanity.

The first fruits of this purpose I now present to the Public; making it, as every good man should do, a matter of conscience, I shall not desist from the prosecution of my object. My pictures will constantly be lessons, sometimes of what results from the impolicy of nations, or sometimes from vices and follies of particular classes of men. These illustrations will be wide and various – from Europe and Asia, wherever the moralist can draw the substance of his animadversion, I shall draw the subject of my pictures. The task is arduous and new, but I resolve to pursue it with vigour and fidelity.

Requesting attention to the descriptive character of the picture now exhibited, I leave my cause with confidence to the judgement and, I should hope, the feelings of the people.

The Effects of Peace

In the first are intended to be shown the blessings enjoyed by the happiest constitution, and supported by vigorous executive judgement.

The Scene represents a sea-port thronged with shipping, expressive of Commerce; the great public buildings denote its riches; a large bay opening to the Ocean, merchant ships going out, others returning, shew the extension of its trade to the most distant quarters of the globe.

From the interior of the country a river empties itself into the bay, across which is a bridge, for the convenience and communication of commerce; the loaded wagons evincing the labours of the manufacturer.

A rich cornfield marks the industry of the peasant, and the high state of industry in the country.

On the foreground of the picture is displayed the happy state of the peasantry.

Shrouded in a wood is a cottage covered with vine and the fig tree, and the family enjoying the breeze in a mild, soft evening. The group of figures exhibits three generations – from venerable age to infancy – with the sympathy of maternal affection, and surrounded by domestic animals, while the father and brothers are at work in the fields.

The two dogs in the front of the picture point out the beneficence of the landlord, by the care his tenant has taken of them in the recess of the hunting season.

The Consequences of War

The same scene as the above picture, under the most melancholy difference – the city on fire – ships burning and sinking in the harbour – the once happy cottagers destroyed or dispersed – the building dismantled, and the last remnant of the wood is the scathed tree. Batteries of cannon now occupy the rich fields of husbandry – soldiers of a distant region now usurp the happy retreat of the peasant and vultures perch where pigeons brooded over their young.

The exhibition was largely a failure mainly because the Duke of York who visited it observed that 'the effects of the pictures might tend to impress the inferior classes of society with sentiments not suitable to the public tranquility: that the effects of war were at all times to be deplored and therefore need not be exemplified in a way which could only serve to increase public clamour without redressing the evil'.

6.11 No social realism

The choice of figures to adorn a landscape was dictated by a number of considerations; not all of them aesthetic.

If we introduce adorned nature (which the picturesque eye always resists, when it can) we are under a necessity, as Sandby was, & other draughtsmen in that line, to introduce such modern figures, as inhabit those walks. But when we open scenes of wild, or even of unadorned nature, we dismiss all these courtly gentry. No ladies with their parasols – no white-robed misses ambling two by two – no children drawn about in their little coaches, have admittance here. They would vulgarize our scenes. Milk-maids also, ploughmen, reapers, and all peasants engaged in their several professions, we disallow. There are modes of landscape, to which they are adapted: but in the scenes we have characterize, they are valued, for what in real life they are despised – loitering idly about, without employment. In wild, & desert scenes, we are best pleased with banditti-soldiers, if not in regimentals, and such figures, as coalesce in idea with the scenes, in which we place them.

(William Gilpin, '*Instructions for Examing Landscape*' London 1787)

6.12 Country sketching

The taste for landscape grew steadily, and attracted an increasing number of amateurs, William Gilpin, one of the main protagonists of the cult of the picturesque, gave the following technical advice to William Mason in a letter dated 25 April 1772.

The first touches need only be extremely slight. It is a great error, I think, to do too much. In the transient view of a country, all that appears needful, or rather, all that can be done is to mark the shapes, & nature of objects; & their relative distances. By the nature of an object, I mean only the rock, or wood, or broken ground, of which

it consists. The shapes & nature of an object are easily marked; the distance is more difficult. As a wash (which marks a distance the best) is incommodious both to carry, & to manage, we are obliged to substitute lines. Few views, at least few good views, consist of more than a foreground, & 2 distances; all which should be carried off with great distinctness, or the spirit of the view will be infallibly lost. I have practised 2 ways to prevent a confusion of distance. The foreground may be marked with a pen; & the 2 distances with black-lead; only the nearer distance may be touched with more strength. Or, the foreground may be marked with red-chalk; the nearer distance with a mixture of red-chalk, & black lead; & the 2d with pure blacklead. In washing your sketch afterwards, the warmth of the red is not injurious to the foreground; & the coldness of the blacklead is the proper hue for distances. A sketch, I think should be retouched, & washed, as soon as possible, after it is taken; while the air of the view remains upon the memory. In re-touching, I have found pale ink to have a good effect in the distance; & in washing, burnt umbre mixed with black on the foreground; & a slight tinge from the black alone in the sky & distance. I think you told me, that Cozens had left off the use of his own black. I wonder at it; for I find two great advantages in it, beyond Indian ink – it is stronger – & with a bit of moist spunge may be erased.

I have sometimes tryed another method of washing a sketch, which has a grand effect: the foreground with some brown tinge, smartly touched here & there in the lights with some warm lively colour – the distances with grey, tinged, in the slightest manner with purple or blue – the sky with the same tinge. But a sketch washed in this manner must be done upon white paper.

(W. L. Benson Papers, Bodleian Library, Oxford)

6.13 Blots and nature

The merits of spontaneity were already becoming apparent; the necessity of inspiration more pressing. Landscape sketching had become a popular, even in some cases an obligatory, hobby. In his *A New Method of Assisting the Invention in drawing original Compositions of Landscape* (1785) Alexander Cozens propounded a simple device.

The blot is not a drawing, but an assemblage of accidental shapes, from which a drawing may be made. It is a hint, or crude resemblance of the whole effect of a picture, except the keeping and colour-

ing; that is to say, it gives an idea of the masses of light and shade, as well as of the forms, contained in a finished composition. If a finished drawing be gradually removed from the eye, its smaller parts will be less and less expressive; and when they are wholly undistinguished, and the largest parts alone remain visible, the drawing will then represent a blot, with the appearance of some degree of keeping. On the contrary, if a blot be placed at such a distance that the harshness of the parts should disappear, it would represent a finished drawing, but with the appearance of uncommon spirit.

To sketch in the common way, is to transfer ideas from the mind to the paper, or canvas, in outlines, in the slightest manner. To blot, is to make varied spots and shapes with ink on paper, producing accidental forms without lines, from which ideas are presented to the mind. This is conformable to nature; for in nature, forms are not distinguished by lines, but by shade and colour. To sketch, is to delineate ideas; blotting suggests them.

In order to illustrate farther the scheme or blotting, the opinion of a celebrated author (the late Dr Brown) may have some weight, who was so obliging as to give it me in writing.

'A blot in drawing,' says this ingenious Gentleman, 'is similar to the historical fact on which a poet builds his drama; in this historical fact there is nothing but light and dark masses, void of anything that can be called ordonance or design; upon this the poet works, producing, by the power of imagination, regular light and shade, variety of corresponding objects, properly grouped and contrasted, with all the characters requisite to form a finished poem, or picture, and not less original than if the historical fact had never existed.' He might have added – and not less natural than if the poem or picture were entirely historical.

The reader hath already seen what a blot is; I shall now speak more particularly of its use and extent, in the practice of our art.

In order to produce the drawing, nothing more is required than to place a piece of paper, made transparent, upon the blot; or if the practitioner chooses to make the sketch upon paper not so transparent, he should procure a frame, made on purpose, with a glass for small drawings, and strained gauze for larger, to stand on a table, as is mentioned hereafter. The blot with the paper is to be put on it. The first operation in composing from the blot, is to make out the sketch, by giving meaning and coherence to the rude shapes, and aerial keeping to the casual light and dark masses of the blot.

I conceive, that this method of blotting may be found to be con-

siderable improvement to the arts of design in general; for the idea or conception of any subject, in any branch of the art, may be first formed into a blot. Even the historical, which is the noblest branch of painting, may be assisted by it; because it is the speediest and the surest means of fixing a rude whole of the most transient and complicated image of any subject in the painter's mind.

There is a singular advantage peculiar to this method; which is, that from the rudeness and uncertainty of the shapes made in blotting, one artificial blot will suggest different ideas to different persons; on which account it has the strongest tendency to enlarge the powers of invention, being more effectual to that purpose than the study of nature herself alone. For instance, suppose any number of persons were to draw some particular view from a real spot; nature is so precise, that they must produce nearly the same ideas in their drawings; but if they were one after the other, to make out a drawing from one and the same blot, the parts of it being extremely vague and indeterminate, they would each of them, according to their different ideas, produce a different picture. One and the same designer likewise may make a different drawing from the same blot; as will appear from the three several landscapes taken from the same blot, which are given in the four last plates or examples.

To the practitioner in landscape it may be farther observed, that in finishing a drawing from a blot, the following circumstance will occur, viz. in compositions where there are a number of grounds or degrees of distance, several of them will be expected in the sketch by little more than tracing the masses that are in that blot, the last ground of all perhaps requiring only an outline: for the greatest precision of forms will be necessary in the first or nearest ground; in the next ground the precision will be less and so on.

There must doubtless be left a power of rejecting any part of the blot which may appear improper, or unnatural, while the sketch is making; for which no previous directions can be given: in this case imagination leads, while the judgment regulates.

However it is still evident, that, notwithstanding the variety which chance may suggest, and this discretionary power of rejecting any part of a blot, a very indifferent drawing may yet be produced from other causes, such as want of capacity, inattention, & c. the effects of which are not to be counteracted by any rules of assistance whatever.

It hath been already observed, that the want of variety and strength of character may be owing either, first;

To a scantiness of original ideas: or, secondly,

To an incapacity of distinguishing and connecting such as are capable of being properly united: or, thirdly,

To a want of facility and quickness in execution.

But to each of these defects, the art of blotting here explained, affords, in some degree, a remedy. For it increases the original stock of picturesque ideas;

It soon enables the practitioner to distinguish those which are capable of being connected, from those which seem not naturally related; and

It necessarily gives a quickness and freedom of hand in expressing the parts of a composition, beyond any other method whatever.

It also is extremely conducive to the acquisition of a theory, which will always conduct the artist in copying nature with taste and propriety.

This theory is, in fact, the art of seeing properly; it directs the artist in the choice of a scene, and to avail himself of all those circumstances and incidents therein which may embellish or consolidate his piece.

But there is a farther, and a very material purpose that may be attained by it, which is, that of taking views from nature. In doing which, as well as composing landscapes by invention, the following principles are necessary, viz. A proper choice of the subject, strength of character, taste, picturesqueness, proportion, keeping, expression of parts or objects, harmony, contrast, light and shade, effect, & c. All these may be acquired by the use of blotting; so that what remains necessary, for drawing landscapes from nature, is only a habit in the draughtsman, of imitating what he sees before him, which any one may learn through practice, assisted by some simple method.

In short, whoever has been used to compose landscapes by blotting, can also draw from nature with practice. But he cannot arrive at a power of composing by invention, by the means of drawing views from nature, without a much greater degree of time and practice.

Biographical index

Adam, Robert (1728–92) An influential and prolific Scottish-born architect, who, using as his prototypes classical buildings of a domestic rather than a public type, produced a style which transformed the architectural and decorative idiom of the British Isles in the second half of the eighteenth century.

Addison, Joseph (1672–1719) Poet, publicist, politician, man of letters who, with his friend Richard Steele, converted the essay into an important literary form in the pages of the *Spectator*. He was deeply interested in the visual arts.

Agostino (di Duccio) (1418–81) A sculptor, who, born in Florence, produced works which looked back to the Neo-attic traditions of Greece rather than to the contemporary traditions of his own city. Examples of his work are to be found in Rimini, Perugia and Modena.

Alken (or Alkin), Sefferin (*fl.* 1744–83) An active sculptor and decorator, who did work at Somerset House, Blenheim, Dublin and elsewhere. His son Samuel carried on the business, which was situated in Broad Street.

Allan, David (1744–96) A Scottish painter, who became known as 'the Scottish Hogarth' He studied in Rome, painted portraits in London, 1777–80, and became director of the Trustees' Academy at Edinburgh.

Allison, Archibald (1757–1839) A clergyman who, after graduating at Balliol College, studied natural history as a pupil of Gilbert White. He became Prebendary of Winchester and then minister of the Episcopal Chapel, Cowgate, Edinburgh. An exponent of the tradition of Scottish philosophical pragmatism, his essay on taste was published in 1790.

Amigoni, Jacopo (1682–1752) Although born in Naples, his artistic career was spent in Venice. From 1730–39 he worked in England, first as a decorative painter, and then as a portraitist. His subsequent travels took him to Madrid.

Angelini, Giuseppe (1735–1811) A successful Roman sculptor, who did a good deal of work for visiting Englishmen, and was active as a

dealer. In the late 1770s he came and settled in England, and assisted Nolekens.

Archer, Thomas (1668–1743) An architect of good family, who secured a sinecure at court, and produced some remarkable buildings – St John's, Smith Square, St. Philip's Birmingham, and the Cascade House at Chatsworth – which, though they owe a debt to continental Baroque, are highly personal in style.

Baker, John (*c.* 1700–1771) A renowned coach and flower painter, who became a foundation member of the Royal Academy.

Bamfylde, Sir Charles Warwick (1753–1823) Did the Grand Tour and spent a year in Rome in 1777. Reynolds painted a full-length portrait of his wife.

Banks, Thomas (1735–1803) Having won a scholarship from the Royal Academy for his sculpture, he spent several years in Rome, where he came under the influence of Winckelmann, and produced several works for visiting Englishmen. He returned to England in 1779 and became the leader, with Flaxman, of the neo-classical style, the elements of which he had absorbed in Rome.

Barocci, Federico (1526–1612) Trained in Urbino, working in Rome, his works covered the transition from Mannerism to Baroque. One of the first artists to make use of pastel, his drawings were highly esteemed in the eighteenth century.

Barret, George (1732–84) An Irish landscape painter, a protégé of Burke, who brought him over to London, where he was a success with his sensitive views of the lakes and other topographical subjects. He became a foundation member of the Royal Academy, and Master-Painter to Chelsea Hospital.

Barry, James (1741–1806) Another Irish protégé of Burke, who paid for his travels in Italy, Barry was remarkable for the virulence of his temper, and the unchecked fantasy of his artistic ambitions. Dedicated to the ideal of history painting, he was elected to the Royal Academy, and then expelled in 1799.

Bartolozzi, Francesco (1727–1815) A Florentine by birth, he rapidly established a reputation as an engraver especially by his exploitation of the stipple technique. He was brought to England by Richard Dalton, the Royal Librarian, to engrave the Guercino drawings in the royal collection, and made his home here until 1802, when he became first director of the Academy in Lisbon.

Baskerville, John (1706–75) Born in Birmingham, where he worked all his life, he was the originator of a tradition of fine printing in

England, and of one of the most elegant and distinguished type-faces of all time.

Bassano (da Ponte), Jacopo (*c.* 1517–92) Son of a village painter of the same name, he settled in Venice c. 1533, and produced works of dramatic elegance which reflected the influence of his contemporaries, Titian, Veronese and Lorenzo Lotto. His work was popular in England, and there are examples of it at Hampton Court, as well as in the National Galleries of London and Edinburgh.

Bate-Dudley, Sir Henry (1745–1824) Journalist and intermitent clergyman, much given to duelling and writing art criticism, he was editor of the *Morning Post* (founded 1772), and a vigorous propagandist of the cause of Gainsborough as opposed to that of Reynolds.

Batoni, Pompeo Girolamo (1708–87) A successful and affluent Roman portrait painter, who dominated the art life of that city for much of the eighteenth century, and was much patronized by travellers on the Grand Tour.

Beauclerk, Lady Diana (1734–1803) Eldest daughter of John Spencer, 2nd Duke of Marlborough, she was one of the most famous amateur artists of Georgian England, being greatly praised by both Reynolds and Horace Walpole – never one to underrate a title.

Becket, Isaac (1653–1719) Engraver, who specialised in mezzotint, which had been popularized by Prince Rupert, and which he was one of the first to exploit. He engraved many of his own drawings.

Beckingham, Charles (1699–1731) A writer and dramatist, much involved in the art world. His two most successful plays *Henry IV of France* and *Scipio Africanus* were produced at Lincoln's Inn.

Bedford, John Russell, 4th Duke of (1710–1771) An unsuccessful politician, but an outstanding member of a dynasty of patrons and collectors.

Bell, Henry (1653–1717) An architect who lived and worked all his life in King's Lynn, where he practised an elegant variation of Wren's style.

Belloni, Giuseppe (*c.* 1702–80) A Roman banker who had transactions with many visiting Englishmen.

Bellucci, Antonio (1654–*c.* 1713) A Venetian landscape painter, whose work contained many hints at the romantic approach, becoming fashionable in the eighteenth century.

Bentley, Thomas (1731–80) A man of many and varied talents, Bentley had been a teacher, and a prominent member of a Nonconformist

sect before he met Josiah Wedgwood in Liverpool, and became his partner. He moved to London and looked after the merchandizing side of the business.

Berkeley, George (1685–1753) One of the outstanding members of the British Platonic school of philosophy, who wrote extensively about aesthetics.

Blondel, Jacques-Francois (1705–74) An active architect and theorizer, who brought out several books, some practical, others theoretical. He became Professor of Architecture at the Académie in 1759, having previously opened his own school of architecture.

Bodley, Sir Thomas (1545–1613) Founder of the famous library in Oxford which bears his name, he was educated in Geneva, where his parents had fled to escape the Marian persecution, and after studying at Oxford, and becoming lecturer in natural philosophy had a brilliant career as a diplomat. The library was opened in 1603.

Borgognone (or Bergognone), Ambrogio (*fl.* 1481–1523) A Milanese painter, who absorbed the style of Leonardo, and made it into an acceptable, easily expressed idiom, which found great favour in the eighteenth century.

Boydell, John (1719–1804) The most important and influential print producer and salesman in eighteenth century England, he studied art at the St. Martin's Lane Academy, and took up print production in the 1750s, with small sets of landscapes, and views of London, Oxford and other towns. He became very successful, and was Sheriff of London in 1785, and Lord Mayor five years later. His most ambitious project was commissioning a large number of artists to produce paintings to illustrate the works of Shakespeare. These were subsequently engraved, and published in 1802, a gallery having being built in Pall Mall for their exhibition. But by this time he had overreached himself financially, and had to dispose of his property by a lottery, dying however before it was drawn.

Boyle, Richard, 4th Earl of Cork, 3rd Earl of Burlington, *see* **Burlington**.

Brandon, Charles, Duke of Suffolk (*c.* 1480–1545) Soldier, diplomat and politician, who played a prominent role in the reign of Henry VIII.

Bristol, Frederick Henry, 4th Earl of, *see* **Hervey**.

Broughton, Thomas (1714–1774) Clergyman and miscellaneous writer, who wrote libretti for Handel, and is credited with being responsible for the first English translation of *Don Quixote*.

Brown, Lancelot (1716–83) Known as 'Capability Brown' from his optimistic habit of telling clients that their grounds had great capabilities, he commenced as a gardener on the estate of Lord Cobham, and by 1764 he had become gardener to the King at Hampton Court. He ruthlessly destroyed the formal gardens of the past, substituting a naturalistic setting of lawns, serpentine lakes and clumps of trees arranged in the spirit of Claude's paintings. The park at Chatsworth and the lake at Blenheim are his better-known works.

Bruce, Kinnard James of (1730–94) Traveller and explorer, he is famous mostly for his journeying in Africa.

Burke, Edmund (1727–97) Politician, philosopher, patron of the arts and a friend to many artists, his *Philosophical Enquiry into the Origin of Our ideas of the Sublime and the Beautiful* went into 17 editions in his own lifetime, and was an important factor in the development of an aesthetic of romanticism.

Burlington, Richard Boyle, 4th Earl of Cork, and 3rd Earl of (1695–1753) One of the most influential figures in the history of architecture, and indeed of taste generally in the first half of the century, Burlington was, more than anyone else, responsible for the creation of the Palladian idiom, and the imposition of rigid standards. He was closely connected with professionals such as William Kent and Colen Campbell, and encouraged a whole group of painters, writers and architects.

Bute, John Stuart, 3rd Earl of, (1713–92) Although he managed to become one of the most unpopular politicians in British history, and is usually credited (or blamed) with having lost the American colonies, Bute was a man of taste and intellectual refinement.

Byres (or Byers), James (1734–1814) Archaeologist, dealer, general entrepreneur, and active in Jacobite circles, he was for long one of the most prominent figures in English society in Rome.

Caesaroli, Domenico (*c.* 1720–80) A successful Roman mosaicist.

Callot, Jacques (1592–1635) A French engraver with a keen sense of the macabre and the fantastic, born in Nancy. Worked in Rome and Florence, then returned to his native city and created a world of imagery which influenced Goya, amongst others.

Calonne, Charles Alexandre de (1734–1802) Finance minister to Louis XV, he was disgraced in 1787, and fled to England, with his very important collection of paintings, which was sold by Christie's in 1795.

Campbell, Colen (*c.* 1660–1729) Emerging from almost total obscurity, he is first heard of working near Glasgow in the first decade of

the century. By the time he died he had become one of the most influential architects in England, influencing Burlington, spreading the gospel of Palladianism, and designing buildings such as Mereworth and the early stages of Houghton. His book *Vitruvius Britannicus* was highly acclaimed.

Canaletto, Giovanni Antonio (1697–1768) Influenced by the Roman topographical artists with whom he came into contact in his twenties, one of his first major projects in Venice was a series of decorative paintings for the Duke of Richmond. His early work was marked by a certain freedom of handling and interesting contrasts of light and shade, but later on the works he produced, especially for English patrons, became rather stiff and mannered. Even at his most mannered his paintings have a sense of light and air which was to influence English water-colourists.

Capitsoldi (or Capezzuoli), Giovanni Battista (c. 1715–74) When working as a sculptor in Florence, he met Joseph Wilton, whom he accompanied back to England in 1755, and for many years worked in collaboration with him, especially on the monument to Wolfe in Westminster Abbey. By 1774 he had returned to Rome, where he gave lessons to Thomas Banks.

Caravaggio, Michel-Angelo Mersi (1573–1610) Tempestuous in his life, working in Rome, Naples, Sicily and Malta, he was one of the most influential artists of his generation, his influence spreading all over Europe. He had a new way of looking at familiar subjects, and combined startling realism with dramatic intensity.

Carlini, Agostino (c. 1720–1790) A native of Genoa, he settled in London as a young man, and had a great success as a sculptor, making a considerable fortune by the sale of plaster reproductions of his works at between six and ten guineas each. One of the Foundation members of the Royal Academy, he became Keeper in 1783.

Carlisle, Charles Howard, 3rd Earl of (1669–1738) Acting Earl Marshal of England, who commissioned Vanbrugh to design Castle Howard in Yorkshire.

Carracci An Italian family of painters, consisting of Agostino (1557–1602), Annibale (1560–1609) and Ludovico (1555–1619). Although each had his own individual style, they were usually referred to collectively. Working mainly in Bologna, they evolved an approach to painting based on a grammar of gesture and a dedicated approach to drawing, which made them the founding members of the main tradition of European academic art.

Carter, Thomas (d. 1767) A sculptor in Shepherds Market, who specialised in chimney pieces, examples of which are to be found at Welbeck Abbey, Milton Hall, near Peterborough, and Blair Castle, Perthshire. His son, also named Thomas, carried on the business.

Caslon, William (1692–1766) Commencing his career engraving patterns on gun-locks, he became one of the most versatile and well-known printers of his day, producing not only the type-face to which his name is still attached, but a wide range of faces in Hebrew, Greek and Oriental alphabets.

Castiglione, Baldassare (1478–1529) Born at Casatico near Mantua, he moved to the Roman court, where he became a favourite of Pope Leo X. His most famous book, *The Courtier*, has had a profound effect on European patterns of behaviour.

Catton, Charles (1728–98) One of a family of thirty-five, he was apprenticed to a coach-painter, and in this field built up such a reputation for himself that he was appointed Coach-Painter to George III, and became a founding member of the Royal Academy, to whose exhibitions he usually sent paintings of animals, and sometimes of landscapes.

Caulfield, James, 4th Viscount Charlemont, 1st Earl of (1728–99) A distinguished politician and patron of the arts, who was Lord-Lieutenant of Ireland. His interests were wide, and he was a Fellow of the Royal Society and of the Society of Antiquaries, as well as a member of the Society of Dilettanti.

Cawthorn, James (1719–61) Son of a Sheffield upholsterer, he became a poet of some repute, and headmaster of Tonbridge School. His collected poems were published in 1771.

Cellini, Benvenuto (1500–71) Florentine goldsmith, metal-worker and sculptor, whose *Autobiography* achieved remarkable popularity, especially after being translated by Goethe.

Chambers, Sir William (1723–96) Born in Sweden of Scottish parents, he used the Royal Academy, with the foundation of which he was deeply involved, to elevate the status and professional standing of architects. A man of diverse talents, who had much to do with the vogue for Chinese gardens, his most important building is Somerset House. He was on close terms with George III.

Chandler, Richard (1738–1810) Educated at Wincheser and Magdalen College Oxford, he rapidly established a reputation for himself as a classical antiquary after taking orders and becoming a fellow of his college. His travels in Asia Minor and Greece for the Dilettanti Society were recorded in *Ionian Antiquities* (1769), *Inscriptiones Antiqua* (1774) and *Travels* (1775). As well as cataloguing the Arundelian marbles at Oxord, he was interested in medieval history, and wrote a biography of Bishop Wayneflete, published in 1812.

Charlemont, 1st Earl of, *see* **Caulfield.**

Chesterfield, Philip Stanhope, 4th Earl of (1694–1773) Courtier, politician, man of letters, friend of Montesquieu, his *Letters to his Son* epitomize the reactions to life of a man of taste and breeding as that species was seen in Georgian England.

Chippendale, Thomas (1718–79) Yorkshire-born cabinet-maker and furniture designer, who set up business in London in 1754 and seventeen years later went into partnership with Thomas Haig. In the same year that he came to London he published his *The Gentleman and Cabinet Maker's Director*, a pattern-book which had a great influence on furniture styles and enhanced his own reputation.

Christie, James (1730–1803). He set up his auction house in King Street in 1766, and soon established an unrivalled reputation for his business acumen, and his ready wit.

Cipriani, Giovanni Battista (1727–85) Born in Florence, and later working in Rome, he came to London at the age of twenty-seven. Painter, designer, sculptor and engraver, his most publicized work was on the Coronation Coach, of which he pointed the panels. A foundation member of the Royal Academy, he designed its Diploma.

Claude (Claude Gellée or Claude Lorraine) (1600–82) Living mostly in Rome, Claude used the surrounding countryside to produce poetic landscapes of great charm and feeling. His works had a very strong influence on many English painters including Wilson and Gainsborough. English collectors were very much addicted to his works, which had a marked impact on the romantic attitude to gardens.

Clovio, Julio (1498–1578) Born in Croatia, and spending his working life in Italy, Clovio translated the medieval tradition of illumination into a Renaissance idiom, producing a whole series of remarkable books, greatly sought after by both art-lovers and bibliophiles.

Cobb, John (*c.* 1720–78) Furniture-maker and upholsterer, Cobb was extremely successful, leaving a fortune of over £20,000. Working in partnership with William Vile, he was patronized by the royal family, and examples of his work are to be found at Buckingham Palace and Windsor, as well as at Strawberry Hill.

Coke, Thomas William (1752–1842) 1st Earl of Leicester. A famous agriculturalist and parliamentarian, he undertook an extensive grand tour, living for some time in Rome, and was an assiduous and discriminating collector of books and works of art; he acquired, among other things, the famous Leonardo manuscript, recently sold by his descendants.

Conway, Henry Seymour (1721–95) Nephew of Sir Robert Walpole, who after a very varied military career, became a Field Marshal two

years before his death. He was a frequent correspondent of Horace Walpole's, and wrote a good deal of rather mediocre verse.

Cooper, Anthony Ashley 3rd Earl of Shaftesbury, *see* **Shaftesbury**.

Copland, Henry (*c.* 1710–*c.* 1770) A pioneer of the Rococo style in English furniture, he published in 1746 *A new Book of Ornaments*, and it has been claimed, without sufficient evidence, that he and his partner Matthias Lock were responsible for many of the plates in Chippendale's *Director*.

Coram, Thomas (1668–1751) Starting his business career as a shipbuilder in Massachussetts, he came back to London in 1720, became a trustee for Georgia, and planned the colonization of Nova Scotia. Deeply philanthropic, he advocated the creation of a Foundling Hospital, and having obtained a charter for it in 1739, opened the building in 1745. He had very many contacts in the world of art and music, and the hospital became one of the centres of the London art scene.

Corelli, Arcangelo (1653–1713) One of the first great exponents of violin playing, and a master of composition, Corelli was very well known in England. He was also a collector of paintings.

Correggio, Antonio Allegri (*c.* 1489–1534) Famous for the theatrical effects of his paintings and for their limpid emotionalism, Correggio had a great influence on many eighteenth-century painters, and his reputation then was probably higher than it is today.

Cosway, Richard (1742–1821) A miniature painter who became a Royal Academician in 1771, and was a close friend of the Prince Regent. His wife Maria was also a miniaturist.

Cotes, Francis (1726–70) Beginning his career as a painter of portraits in pastel, he turned to oil-painting in mid career and became very popular as a society portraitist. He was a foundation member of the Royal Academy.

Cotton, Charles (1630–87) Poet and miscellaneous writer, who was deeply interested in landscape. 'Loyal to his friends, generous to the poor, he loved good company and good liquor, was an excellent angler, a devoted husband, and a man of piety.'

Cowper, William (1731–1800) A poet, who suffered for most of his life from psychotic disturbances, but whose romantic sensibilities greatly appealed to his contemporaries. He was in close contact with personalities in the world of art and literature.

Coxe, William (1747–1828) Historian and tutor. Educated at Eton, and a fellow of King's College, Cambridge, he wrote books about

the house of Austria, the Spanish Bourbons, Marlborough and other sub-
jects. He accompanied Lord Herbert, son of the Earl of Pembroke, and
others on the Grand Tour.

Coypel, Antoine (1661–1722) Son of a painter and father of one,
Antoine Coypel represented the decorative aspect of the Baroque at its
most melodramatic. His work was greatly praised by Roger de Piles,
whose writings were very influential in England.

Cozens, Alexander (1717–86) Born in Russia, the son of a ship-
builder working for Peter the Great, he devoted himself to landscape art,
and in 1763 was appointed Drawing Master at Eton, where he taught and
perfected the method of composing landscapes by 'blot drawing'. He was
himself a painter of sensitivity and distinction.

Dalton, Richard (1715?–1791) A man of great versatility, who be-
gan by studying art at Rome, where he got involved in art-dealing. He
travelled extensively in Greece, Turkey and Egypt, publishing many till
then unrecorded engravings of monuments in those countries, and became
librarian, keeper of pictures and antiquarian to George III. He greatly ex-
tended the Royal collection, and was one of the committee which drew up
the project for the Royal Academy, with which he maintained close
contacts.

Dance George (1695–1768) Architect who built several city
churches in the style of Wren, and designed the Mansion House.

Dance, Nathaniel (1736–1811) Son of the above, he became a
successful portrait painter, and a foundation member of the Royal
Academy. In 1776 he inherited a fortune, gave up his profession, became
an MP and a baronet, and added Holland to his surname.

Dart, John (d. 1730) Historian and archaeologist, who wrote a de-
finitive history of Canterbury Cathedral, as well as much execrable verse,
and the worst book on Chaucer ever written.

Dartmouth, Earl of, *see* **Legge.**

Darwin, Erasmus (1731–1802) A prolific poet, whose rhapsodiz-
ing about the life of plants brought him great fame and popularity in the
latter half of the century. He was by profession a doctor of medicine.

Deare, John (1759–98) Liverpool-born sculptor, who went to
Rome as a student in 1785, and was so successful that he took up perma-
nent residence there, and married into a Roman family. He was deeply
preoccupied with facial expression as a clue to character, and had decapi-
tated heads taken to his studio from which to make casts.

Delane, Solomon (1727–1784) Landscape painter who spent the first part of his career in Rome, returning to England two years before his death.

Delany, Mrs. Mary (1700–1788) A friend of Swift, and an assiduous letter-writer, she was responsible for the invention of the 'flower mosaic' – a self-explanatory form of amateur artistic activity.

Deval (or Devall), John (1701–74) Mason and carver, who did a great deal of work for the royal palaces and at Woburn. He was assisted by his son John (1728–94), who as mason-contractor was responsible for the actual construction of the south front of Somerset House and Coutts bank in the Strand.

Devis, Arthur (1711–87) Born in Preston, Devis soon established a reputation for himself as a painter of small conversation pieces of great charm and delicacy, mostly for merchants and country squires. He restored Thornhill's paintings at Greenwich. His son Arthur William (1763–1822) did a lot of work in India, and became famous for his painting of *The Death of Nelson*.

Domenichino (Zampieri) (1581–1642) The leading figure in Bolognese painting, who typified the transition from classicism to Baroque, his landscape art prepared the way for that of Poussin and Claude. His drawings have always been very popular.

Dou, Gerard (1613–75) A pupil of Rembrandt, he developed a style which was the exact antithesis of his master's precise, detailed and veristic. He was very largely the founder of a style of academic painting which persisted until the aceptance of Impressionism in the twentieth century. Many of the works attributed to him are either fakes or works by his pupils.

Dryden, John (1631–1700) Poet, pamphleteer, dramatist, and one of the most considerable figures in the history of English literature. He was deeply interested in all aspects of aesthetics, in art as well as in literature.

Du Bos, Jean-Baptiste, Abbé (1670–1742) Born at Beauvais, author of the influential *Reflexions critiques sur la poésie et la peinture*, first published in 1714. He was a member of the Académie française.

Du Deffand, Marie, Marquise (1697–1780) A voluminous letter-writer, who maintained a correspondence with many others in addition to Horace Walpole, who had attender her famous salon when first he went to Paris.

Duesbury, William (*c.* 1725–86) A porcelain manufacturer who from 1756 managed the Derby factory, which specialized in 'soft-paste' tableware, originally in imitation of Meissen, but later evolved its own

style in which fine landscape pictures played a large part. He was also involved in the Chelsea and Bow factories.

Dufresnoy, Charles Alphonse (1611–68) A decorative painter who, having spent some time in Venice, returned to Paris in 1656. His *De Arte Graphica* (On Graphic Art) which sets out the doctrines of French classicism, was written in Latin, but translated into French by Roger de Piles, and into English by Dryden. It was later annotated by Reynolds, and had a great influence on academic theory.

Dugdale, Sir William (1605–86) Historian and antiquarian, whose classic *Monasticon Anglicanum* opened up the scholarly study of the English Middle Ages.

Edwards, Edward (1738–1806) A landscape and history painter, who was employed by the Society of Antiquaries and Alderman Boydell to make drawings from the old masters. In 1780 he was appointed Professor of Perspective at the Royal Academy, but is now best known for his rather acidulous *Anecdotes of Painters* published posthumously in 1808 as a supplement to Horace Walpole's *Anecdotes of Painting*.

Evelyn, John (1620–1705) Though famous as a diarist, his interests were extremely wide, and Horace Walpole said of him: 'If Mr. Evelyn had not been an artist himself, as I think I can prove he was, I should yet have found it difficult to deny myself the pleasure of allotting him a place amont the Arts.'

Flaxman, John (1755–1826) Joined the Royal Academy Schools at the age of fourteen, and for a long time worked as a modeller for Wedgwood. In 1787 he went to Rome, staying there for seven years in the course of which he developed a style of sculpture, neo-classical in feeling, which brought him great success. His illustrations were extremely popular, and he was very interested in medieval art.

Flinck, Govert (1615–60) Dutch painter who lived and worked in Amsterdam. He originally studied with Rembrandt, but later developed a more decorative style, which brought him several important commissions.

France, William (*c.* 1710–*c.* 1770) A cabinet-maker who succeeded William Vile as Cabinet-maker to the king. He worked in collaboration with Chippendale, and made furniture for Kenwood after designs by Robert Adam.

Franklin, Benjamin (1706–90) Politician, philosopher, scientist, and one of the creators of the United States. He was deeply involved in the literary and artistic life of London.

Fuseli, Henry (Johann Heinrich Füssli) (1741–1825) Born in Zurich, Fuseli, after studying for the priesthood, took up painting in Ber-

lin, where his works so impressed the British ambassador that he persuaded him to come to London in 1765. On the recommendation of Reynolds he spent eight years in Italy, where he became fascinated by the works of Michelangelo, upon whose style he based his own. Preoccupied with the sublime and the horrific, his work exemplified many of the new trends which were becoming apparent in art. A man of learning, his lectures to the students of the Royal Academy, when he was Professor of painting there, were very influential. He translated Winckelmann's *Painting and Sculpture of the Greeks* (1765); Lavater's *Aphorisms*(1767); edited Pilkington's *Dictionary of Painters* (1788) and had a great influence on William Blake. Among his pupils were Constable, Etty, Haydn and Landseer.

Gainsborough, Thomas (1727–88) Although lacking the scholarship and social graces of Reynolds, Gainsborough was a natural painter, with a deeply instinctive feeling for form and composition. He was one of the foundation members of the Royal Academy, and the real or imagined rivalry between him and Reynolds was one of the dominant themes of late eighteenth-century art gossip in London.

Garrick, David (1717–79) The famous actor was a friend of many artists – including especially Reynolds – and writers. Like others of his profession he was conscious of the publicity value of his portraits.

Geminiani, Francesco (1687–1762) Composer and violin virtuoso, who was born in Lucca and died in Dublin. A pupil of Corelli, he spent most of his working life in England.

Gibbs, James (1682–1754) Born in Scotland, he went to Rome at the age of seventeen to become a priest, but took up architecture instead. He returned to London in 1709, where he became very successful, practising in the style of Wren, though with his own original vision. His most famous buildings are St. Martin-in-the-Fields, and the Radcliffe Camera at Oxford.

Gilpin, William (1724–1804) Although he achieved a reputation as an animal painter, specialising in horses, Gilpin was more famous for his writings. His *Essay on Prints* (1768) obtained an international reputation, largely because of one of its constituent parts, *Remarks upon the Principles of Picturesque Beauty*. In 1792 he enlarged the ideas he had sketched out there in *Three Essays: On Picturesque Beauty; On Picturesque Travel; and on Sketching Landscape,* and further exemplified them in a series of illustrated travel books – *Picturesque Tours* – which greatly publicised ideas about a romantic approach to nature, which were to have a considerable vogue.

Giotto (*c.* 1267–1337) A Florentine painter who immensely expanded the language of visual expression and the representation of the actual world. A revival of interest in his work took place in the eighteenth century, though he was still scorned by the generality.

Goldsmith, Oliver (*c* 1730–74) Born at Pallasmore in Ireland, and achieving wide popularity through his *The Vicar of Wakefield*, he was closely connected with Reynolds and the art world generally. In 1771 he was appointed honorary Profesor of Ancient History to the Royal Academy.

Goltzius, Hendrick (1558–1617) A Dutch artist of German descent, who was an outstanding line-engråver, and introduced a new sense of classicism into the art. His drawings were highly esteemed, and influenced many landscape artists.

Gravelot, Hubert-Francois Bourgignon (1699–1773) A French book illustrator who became a friend of Hogarth, and taught Gainsborough. He was mainly responsible for introducing into England the French rococo style, and was one of the first to illustrate English novels.

Greenville, George (1712–1770) Politician, and associate of Pitt and Bute, who was interested in art and literature. He was a friend of Wilkes.

Grignon, Charles (1717–1810) A line engraver who studied under Gravelot, and was employed by Hogarth and Horace Walpole.

Grose, Francis (1731–1791) Draughtsman and antiquary, who was the author of many historical and typographical works, usually with drawings by himself. He exhibited tinted drawings at the Academy, and from 1755–63 was Richmond Herald. His *Antiquities of England and Wales* (1773–87) and *Antiquities of Scotland* (1789–91) were very popular.

Guercino (Gian Francesco Barbieri) (1591–1666) Called 'Guercino' because of his squint, he succeeded Guido Reni as the leading painter of Bologna. His original lively, naturalistic style was succeeded by a more classical approach. Few important eighteenth-century English collections were without at least one example of his work, and his drawings were very highly esteemed, one of the most important collections having been acquired by George III who commissioned Bartolozzi to engrave them.

Hackaert, Jacob Philipp (1737–1807) A German painter who was an important figure in the Roman art world, and whose biography was written by Goethe. He became court painter to Ferdinand IV of Naples.

Hackaert, Jan (1628–99) Dutch landscape painter, who travelled extensively in Switzerland and Italy, producing works in a strongly classical style.

Hales, Stephen (1677–1761) Physician, psychologist, inventor, statistician, friend of Pope, he was described by Horace Walpole as 'a good, poor, primitive creature'.

Hamilton, Gavin (1723–98) A versatile Scottish painter, artdealer and archaeologist, who obtained the Portland vase from the Barber-

ini Palace in Rome, in which city he spent most of his life. Although his work as a painter was little known in England, it made an important contribution to the concept of history painting and to the neoclassical revival.

Hamilton, Sir William (1730–1803) Famous mainly for having married Emma, and having been cuckolded by Nelson, Hamilton was a scholar and archaeologist of distinction, whose works and collections have greatly enriched English culture. As plenipotentiary of Britain at Naples, his observations of volcanoes and his work on Greek and Etruscan vases, as well as the discoveries at Pompeii recorded in numerous publications, achieved great publicity.

Handel, George Frederick (1685–1759) Through his connection with the Foundling Hospital, for which he wrote a great deal of music, the composer Handel came into contact with a number of painters.

Hayley, William (1745–1820) Poet and man of letters who was a close friend of Romney, whose biography he wrote. It was severely criticized by the painter's son.

Hayman, Francis (1708–76) Beginning his career as a scene painter, and carrying out the decorations for the Vauxhall Pleasure Gardens, he became famous for his conversation pieces. He was President of the Society of Artists from 1760 to 1768, and a foundation member of the Royal Academy.

Herbert, George Augustus, Lord (Later 11th Earl of Pembroke) (1759–1827) A noted connoisseur, whose account of the Grand Tour and the purchases he made are recorded in *Henry, Elizabeth and George*, edited by Lord Herbert, Cape, 1939.

Herbert, Thomas, 8th Earl of Pembroke, *see* **Pembroke**

Hervey, Frederick, 4th Earl of Bristol and Bishop of Derry (1730–1803) One of the most eccentric and extravagant patrons of the arts Britain has ever known. He built three great houses, travelled extensively, giving his title to many European hotels, dabbled wildly in politics, and was something of a scholar. There is a recent biography of him: *The Mitred Earl* by Brian Fothergill, Faber & Faber, 1974.

Highmore, Joseph (1692–1780) In the course of a career which virtually spanned the century, Highmore began as a portrait painter in the tradition of Kneller, went on to convert his style into a version of Rococo elegance, and before he retired in 1762, had done much to establish a tradition of narrative painting through his twelve illustrations to *Pamela*, written by his friend Samuel Richardson.

Hoare, William (*c.* 1707–92) A portrait painter who settled in Bath where he built up a lucrative practice. Many of his best works are in crayon. He was appointed an RA in 1769.

279

Hodges, William (1744–1797) A landscape painter who accompanied Captain Cook's second expedition, painted views in India under the patronage of Warren Hastings, exhibited at the Academy, and published in 1793 *Travels in India*. He combined the demands of classical landscape with those of a topographer.

Hogarth, William (1697–1764) Apprenticed to an engraver of silver plate, he studied painting in his spare time, first at the St. Martin's Lane Academy, and then under Sir James Thornhill, whose daughter he married. The popularity of his prints led to the passing of the Copyright Act of 1735, with which he had a lot to do. He believed that the theories of a practising painter should carry more weight than those of mere theorists, and was a shrewd publicist.

Holbein, Hans (1497–1543) One of the most famous painters of the Northern Renaissance, Holbein the Younger came to England in 1526, and did a number of portraits here, but obtained no commissions for subject paintings, and returned home disappointed to Basle two years later.

Hollar, Wenceslaus (Vaclav Holar) (1607–1677) A native of Prague, who after living in Frankfurt, Cologne and Antwerp, came to England in 1635, and became drawing master to Charles, Prince of Wales. He executed many engravings, including views and maps of London. Captured by the Parliamentarians at Basing, he escaped to Antwerp, but returned here in 1652, and in 1669 visited Tangier.

Home, Henry, Lord Kames, *see* **Kames.**

Home, Robert (*c.* 1770–1836) A painter who exhibited at the Royal Academy and in Dublin. He became chief painter to the King of Oude, and died in Calcutta.

Hone, Nathaniel (1718–84) Irish miniaturist and portrait painter, who became a foundation member of the Royal Academy, where he was constantly stirring up controversy. In 1775 he staged a controversial one-man exhibition in St. Martin's Lane.

Howard, Charles, 3rd Earl of Carlisle, *see* **Carlisle.**

Hudson, Thomas (1701–79) A pupil of Jonathan Richardson and a teacher of Joshua Reynolds, he had considerable success as a portrait painter, using Joseph van Aken (1699–1749) to paint his draperies.

Hume, David (1711–76) Philosopher and historian, born in Edinburgh, his most famous work was the *Philosophical Essays concerning Human Understanding*, and his ideas on aesthetics had a wide influence both here and in Europe.

Humphrey, Ozias (1742–1810) Commencing his career in Bath, he moved to London where he became a successful miniature painter. In

1772 an eye accident forced him to take up oil painting, and he visited Italy with George Romney. He then went to India, and abandoned oil for crayons. He became an ARA in 1779, and an RA in 1791. Many of his papers are in the Royal Academy library.

Hunter, John (1728–1793) Commencing as a cabinet-maker in Glasgow, he became one of the most famous British surgeons of the eighteenth century. A friend of Reynolds, who painted his portrait, he was a great collector of a wide variety of objects and had a close contact with the Royal Academy. His brother William (1718–83) was also a famous anatomist.

Hutcheson, Francis (1694–1746) Author of *An inquiry into the Original of our Ideas of Beauty and Virtue* (1725) he tried to work out a plan for estimating beauty in terms of the ratio between uniformity and variety.

Hutchinson, William (1732–1814) Topographer and writer of travel books, whose *Excursion to the Lakes* fed and stimulated the passion for the picturesque.

Jarvis (or Jervas), Charles (1675–1739) Principal Portrait Painter to George I, and close friend of Alexander Pope, whose portrait he painted, Jarvis had been born in Ireland. Although his name often appears in the second version of the spelling, it is pronounced as in the first.

Jenkins, Thomas (*c.* 1710–*c.* 1780) Originally a painter, Jenkins settled in Rome, where he started a banking business, catering especially for visiting Englishmen. He combined this with a lucrative sideline in art-dealing.

Jervas, *see* **Jarvis**

Johnson, Samuel (1709–84) One of the formidable figures in the history of English literature, Johnson was a close friend of Reynolds, and was deeply involved in the art world of London. He was appointed Honorary Professor of Ancient Literature at the Royal Academy, and had been actively concerned with its inception.

Jones, Inigo (1573–1652) English architect and stage-designer, who at one time was also a painter, though none of his works in this medium exist. He revolutionised English architecture by bringing in a pure Italian Renaissance style as a substitute for the post-medievalism of Jacobean architecture. The banqueting house in Whitehall, the double cube room at Wilton House, the Queen's House at Greenwich and the Queen's Chapel in St. James's are his most famous surviving buildings. He also laid out the Piazza at Covent Garden.

Kames, Henry Home, Lord (1696–1782) Scottish writer on ethics and aesthetics. His *Elements of Criticism* went through six editions in twelve years, and had a great influence.

Kauffmann, Angelica (1740–1807) Born in Switzerland, she spent her youth in Rome, where she came under the influence of the Neo-classicists, including Winckelmann. She arrived in London in 1766, and became a foundation member of the Royal Academy. She was employed by the Adam brothers to provide decorative schemes for their buildings.

Kent, William (1684–1748) An influential figure in the first half of the century, and a close friend of the Earl of Burlington, with whom he lived, Kent was originally apprenticed to a coachmaker, but became a portrait and decorative painter, an architect, a designer, a sculptor and a landscape-designer. As Walpole put it,' He leaped the fence, and saw that all nature was a garden'.

Kenyon, Lloyd 1st Baron Kenyon (1732–1802) Articled to a Nantwich solicitor, and becoming a barrister at the Middle Temple in 1756, he subsequently became Attorney-General in 1782, Master of the Rolls in 1784, and Lord Chief Justice from 1788 till his death.

Knatchbull, Sir Edward (1704–89) The seventh baronet, and member of an old Kentish family, he had an income of £3,000 a year. He commissioned Robert Adam to build a new house for him at Mersham Hatch, near Ashford. The total cost, including the furniture was £20,526.

Kneller, Sir Godfrey (1649–1723) Born in Lübeck, he came to England in 1674, and established himself in portraiture as the heir of Van Dyck and Lely. He created a workshop studio, employing a large number of artists, which could turn out as many as ten portraits a day. His influence was stultifying, and was not diminished till the arrival of Hogarth, and not destroyed till Reynolds created a new type of portraiture.

Lambert, George (1700–65) One of the first English landscape painters to apply classical rules and precedents to his compositions. In 1732 he and Peter Scott produced for the East India Company a series of views of their settlements. In 1763 he was appointed scene painter to Covent Garden Opera House.

Lamerie, Paul de (1688–1751) Born in Holland of French Huguenot descent, he came to England *c.* 1690, and was apprenticed to a goldsmith with the same background. He soon made a great reputation, and in 1716 was appointed Goldsmith to the king. In addition to carrying out commissions, he kept a stock of cheaper goods for direct sale, and so pioneered the retailing of gold and silver ware.

Langley, Batty (1696–1751) An enterprising architect who with his brother established a school of architecture in London. He wrote extensively, concentrating on practical 'do-it-yourself' type of books, but also covering a wide range of subjects from Gothic architecture to the cultivation of gardens.

Latour, Maurice Quintin de, *see* **Tour.**

Le Blanc (or Le Blonc), Jean-Bernard (1707–81) Protégé of Madame de Pompadour, and author of *Lettres d'un Français* (1745). He translated Hume into French and wrote a good deal of art criticism.

Le Blon (Le Blond) Jacques Christophe (1670–1741) Born at Fankfort-am-Maine, and studied at Zurich, Paris and Rome. He can be claimed as the creator of chromolithography, although his production of coloured engravings was economically unsuccessful in England, where he arrived at the turn of the century.

Legge, William 2nd Earl of Dartmouth (1731–1801) Educated at Westminster and Trinity College, Oxford, he had a successful political career as Colonial Secretary, and Lord Privy Seal. Strongly attached to the Methodists, he was an enlightened patron of the arts.

Lely, Sir Peter (1618–80) Born in Germany of Dutch parents, he came to London *c.* 1643, and on the Restoration became Principal Portrait Painter to Charles II. The dominance of his style in portraiture persisted until almost the middle of the eighteenth century.

Lloyd, Robert (1733–1764) Educated at Westminster and Trinity College, Cambridge, a friend of Garrick, Reynolds and most of the literary and artistic figures of the day, he edited the lively *St. James's Magazine*, for a short period, and published plays, poetry and miscellaneous literature of all kinds. He was constantly beset by financial problems.

Lock, Matthias (*c.* 1710–*c.* 1780) Furniture designer who produced a number of books of designs and ornaments, such as *A New Book of Ornaments, Chimneys, Sconces, Tables etc.* of 1752. In 1768 he published the first book of Neoclassical designs.

Loutherbourg, Jacques Philippe de (1740–1812) He had already established a reputation in France before he came to London. He became a set designer for Garrick at Drury Lane, and developed an acute awareness of the appeal of the picturesque. He was especially interested in the landscapes of North Wales and Scotland.

Lumisden, Andrew (1720–1801) An ardent Jacobite, who became secretary to the Old Pretender in Rome, he was the author of a book *The Antiquities of Rome*, and had a good deal to do with the world of art-dealers in that city. He was the friend and confidant of many artists including especially the engraver Robert Strange.

Lybbe Powys Caroline (1756–1808) The wife of Philip Lybbe Powys of Hardwick House, Oxon., she was an indefatigable traveller and diarist. In 1899 Emily Climenson edited a selection of these, *Passages from the Diaries of Lybbe Powys* (Longman).

Mac Swinny (Swiney), Owen (d. 1754) Actor-manager and playwright he became bankrupt in the 1720s and fled to Venice, where he became very active in the world of art-dealing, in collaboration with Consul Smith and others. He was involved in Canaletto's visit to England, having himself returned to London in 1735.

Malone, Edward (1741–1812) One of the most famous of Shakespeare scholars, he was an author and critic, with interests in many fields.

Maratti (Marrata), Carlo (1625–1713) One of the leading painters in Rome in the latter half of the seventeenth century, he had numerous pupils who perpetuated his baroque style into the latter half of the eighteenth century.

Martyn, Thomas (c. 1750–1818) A draughtsman, who specialised in botanical drawings, he published many books on natural history, and established an academy in Great Marlborough Street.

Mason, Rev. William (1724–97) Poet, writer, archaeologist and composer, he was on friendly terms with many of his more famous contemporaries. He was the author, amongst other things, of the *Heroical Epistle to Sir William Chambers Knt.* of 1773, attacking his views on gardens.

Mead, Dr Richard (1673–1754) Friend of Hogarth and many other artists, he was a collector and connoisseur, as well as being a renowned physician. His collection of manuscripts, drawings, paintings, coins, gems and statues was famous throughout Europe.

Meyer, Jeremiah (1739–89) A miniature painter, born in Germany, who came to England at the age of 14, and rapidly established a reputation for himself. A foundation member of the Royal Academy, it was he who proposed the establishment of a pension fund.

Middlesex, Lord Charles Sackville, Earl of (1711–69) Travelled in France and Italy, becoming an MP and Lord of the Treasury. He was a member of the Dilettanti Society, and in 1763 he became 2nd. Duke of Dorset.

Monamy, Peter (1689–1749) Born in Jersey, he came to London as a boy and took up house painting. He then taught himself marine painting, basing his style on that of the Van de Veldes. He was employed on the decoration of Vauxhall Gardens.

Montagu, Edward Wortley (1713–76) Diplomat, politician, traveller, who carried on an extensive correspondence with many of the leading figures of his time

Montesquieu, Baron de, *see* **Secondat.**

Montfaucon, Dom Bernard (1655–1741) Benedictine monk and scholar, who was the head of a group of historians and scholars centred at the abbey of St Germain-dès-Prés in Paris.

Morland, George (1763–1804) Landscape painter and the producer of bucolic genre paintings, which achieved great popularity as prints.

Morrat, Carlo, *see* **Maratti**

Moser, George Michael (1704–83) Goldsmith, enameller, medallist, he was born in Germany, and came to London in the 1720s, where he rapidly became a member of the art establishment, as manager and treasurer of the St. Martin's Lane Academy, and then first Keeper of the Royal Academy. He was drawing master to George III as a child, and engraved his first royal seal.

Moser, Mary (1726–1819) Daughter of the above, she obtained a considerable reputation as a flower-painter, and was a foundation member of the Royal Academy, her name being proposed for the presidency in 1805.

Murillo, Bartolomé Esteban (1617–82) Born in Seville, and working mainly for religious institutions, he produced a great number of religious paintings and studies of beggar boys. His combination of realism and sentimentalism endeared him to English collectors of the eighteenth century.

Murphy, Edward (*c.* 1796–1841) A highly competent Irish painter of still-life and flower paintings in the Dutch style.

Newton, Francis Milner (1720–94) The prototype of the now familiar bureaucrat of culture, Newton was originally secretary of the St Martin's Lane Academy, and on its foundation, with which he had a great deal to do, became secretary of the Royal Academy, holding that post till 1788, and occupying apartments in Somerset House. He was a portrait painter of merit.

Newton, Thomas (1704–52) A successful and career-conscious clergyman, who became Bishop of Bristol.

Nollekens, Joseph (1737–1823) Of Dutch extraction, Nollekens spent the early part of his working career in Rome, where he made countless reproductions of antique statues. Settling down in London he became highly successful as a portrait sculptor, leaving a fortune of £200,000. He was notorious for his parsimony and general eccentricity of behaviour.

O' Keefe, John (1747–1833) Predominantly a landscape artist, he did a lot of work for the stage. His autobiographical writings are of interest.

Oliver, Isaac (*c.* 1540–1617) Miniature painter, who came to England in 1568 and worked under Hilliard, whose style he absorbed. Together they dominated Elizabethan painting.

Opie, John (1761–1807) Son of a carpenter, he began his career as a travelling portrait painter, and in 1780 was taken up by the writer Dr. Wolcot, who introduced him to court. He immediately became fashionable as 'the Cornish wonder', painting portraits of all the celebrities of the time. Elected A.R.A. in 1782, and R.A. in 1788, he became Professor of Painting at the Royal Academy Schools in 1807, and on his death was buried in St. Paul's.

Palladio, Andrea (1508–80) Born in Padua, he was the most influential architect of the latter part of the sixteenth century, building up a body of theory and practice based on an intimate knowledge of classical architecture, adapted to the needs of his own time. His finest works are to be seen around Venice.

Panini, Giovanni Paolo (*c.* 1692–1765) Born in Piacenza, and studying in Bologna, he moved to Rome where he became famous for his town scenes, and above all for his paintings of ruins, which had a great vogue and were very popular in England.

Parker, John (*fl.* 1762–76) A painter who studied in the Duke of Richmond's gallery, and exhibited at the Royal Academy and elsewhere. He lived in Rome for several years.

Parmigianino Francesco Mazzola (1503–40) Italian painter and etcher, who perfected an elegant formula which combined extreme virtuosity with dramatic verve. A fine draughtsman, he seems to have been the first Italian artist to produce original etchings from his own designs.

Pars, William (1743–82) Portrait painter and landscape draughtsman who was sent to Greece by the Society of Dilettanti and died in Rome.

Patch, Thomas (1725–82) Painter and engraver, born in Exeter, who went to Rome in 1747 and spent the rest of his life in Italy, where he acted as a cicerone and art dealer. In 1755 he was expelled from Rome and took up residence in Florence. He is famous for his 'caricature conversation pieces' usually of visiting noblemen.

Peacham, Henry (1576?–1643) A man of many talents, who painted, drew, engraved landscapes and portraits, composed music, and was a student of heraldry and a mathematician, as well as master of the free school at Wymondham. Peacham seemed the very epitome of the Renaissance man, whose characteristics he described in *The Compleat Gentleman* of 1622, a book which became a manual of behaviour for several generations. In 1606 he published *Graphice*, a practical treatise on art, the title of which

in the 1607 edition was significantly changed to *The Gentleman's Exercise*, under which title it went through several editions.

Pellegrini, Giovanni Antonio (1657–1741) A Venetian artist, who was influenced by Sebastiano Ricci, he came to London in 1708, in the train of the Earl of Manchester, who had been British ambassador to the Doge. He did much decorative work at Castle Howard and elsewhere, helping to establish the rococo tradition here.

Pembroke, Thomas Herbert, 8th Earl of (1656–1732) A man of eminent virtue and great learning, famous for his collection of what was unkindly described as 'statues, dirty gods and coins'. He was the patron of Locke who dedicated his masterpiece to him.

Penny, Edward (1714–91) First Professor of Painting at the Royal Academy, and previously Vice-President of the Incorporated Society of Artists. Born in Cheshire, he had studied under Hudson, and painted historical subjects as well as portraits.

Petitot, Jean (1607–91) Born, and working for most of his life, in Geneva, he was a celebrated miniaturist, and painter of portraits on enamel.

Pine, Robert Edge (1730–88) A portrait painter, who specialised in actors and actresses. In 1783 he migrated to America and settled in Philadelphia.

Piombo, Sebastiano del (*c.* 1485–1547) A pupil of Giorgione, he moved from Venice to Rome, where he got a job in the Papal mint, hence his acquired name (*piombo* lead), his real name being Luciani. Apart from his decorative paintings, he was an accomplished portrait painter.

Pope, Alexander (1688–1744) Poet and writer who dominated the literary scene for half a century, and whose writings on taste and allied subjects exerted a great influence on those who would not normally have been interested in such subjects. He was a friend of Jarvis, Richardson and other artists, and an enthusiastic amateur painter himself.

Poussin, Nicolas (1593–1665) Working for most of his life in Rome, Poussin evolved a style which to the eighteenth century seemed the very epitome of history painting, with its strong reliance on design and composition, its emphasis on the classical past and its high sense of restraint.

Pye, John (1782–1874) The favourite engraver of Turner, after whose paintings he produced several plates which succeeded in translating into terms of their own medium the effects of light and atmosphere, which were the essence of the paintings. One of his main preoccupations was the refusal of the Royal Academy to admit engravers to full membership, and this is one of the themes in his admirable *Patronage of British Art* (1845).

Raphael (Raffaelo Sanzio) (1483–1520) One of the dominant figures of the High Renaissance, whose works became the very symbol of 'high art', copied and extolled by generations of professors of painting. He was especially extolled in England because of the famous cartoons for the tapestries for the Sistine Chapel, which had been acquired by Charles I and remained in the royal collection.

Repton, Humphry (1752–1818) One of the most famous landscape-gardeners, who saw himself as combining the traditions of Brown with a new feeling for the picturesque. He wrote extensively, and was very deeply involved in the planning of the Royal Pavilion at Brighton.

Revett, Nicholas (1720–1804) After studying painting in Rome, where he met James Stuart, he went with him to Venice and Greece (1751–53) where he collaborated on their *Antiquities of Athens*, the first volume of which appeared in 1762, after Stuart had bought him out. Between 1764 and 1766 he made the drawings for the Society of Dilettanti's *Antiquities of Ionia*. As an architect his buildings (e.g. the church at Ayot St Lawrence) were virtually replicas of classical prototypes.

Reynolds, Sir Joshua (1723–92) First President of the Royal Academy, he dominated the English art world of the second half of the eighteenth century. His output was prolific, consisting mostly of portraits distinguished by their elegance and fluency of expression. His Discourses, originally delivered at the Royal Academy, are marked by their sensitivity and good sense. They became the standard exposition of the classical, rational doctrine of art.

Richards, John (1735–1810) A landscape painter, with a penchant for depicting baronial halls, he was for several years chief scene painter at Covent Garden. One of the founding members of the Royal Academy, he exhibited there a great deal, and succeeded Francis Newton as its Secretary in 1788. He compiled a catalogue of its collection.

Richardson, Jonathan (1665–1745) A pupil of John Riley, and a close associate of Kneller, with whom he founded the St Martin's Lane Academy, he was an efficient and occasionally inspired portrait painter. He is mainly known however for his writings, the most important of which are *An Essay on the Whole Art of Criticism* (1719) and *An Account of some of the Statues, Bas-Reliefs and Paintings in Italy* (1722) which became an indispensable guide to those going on the Grand Tour, even though the author himself had never visited Italy. He built up a very fine collection of drawings. His son Jonathan (1694–1771) edited his father's works, and was himself a writer about art.

Rigaud, Hyacinthe (1649–1743) The official portrait painter of the court of Louis XIV, whose image he did so much to perpetuate, his works exerted a considerable influence on English portrait painters such

as Reynolds. His less stately works, however, show the influence of Rembrandt.

Riley, John (1646–91) An English portrait painter who devised a style which owed nothing to the dominance of Lely and Kneller. He was at his best in small scale portraits, which show sensitivity and perception.

Romney, George (1734–1802) Son of a builder and cabinet-maker, he began his career as a potrait painter in Kendal, and came to London in 1762. He studied in Paris for some time, and painted a great many historical paintings as well as the portraits for which he is more famous. Reynolds showed him marked hostility.

Rosa, Salvator (1615–73) Painter, poet, actor and musician, who specialized in picturesque landscapes and boldly handled paint, he greatly appealed to a generation which was developing a taste for romanticism.

Roubiliac, Louis François (1705–62) Born in Lyons, he came to England in 1732 and rapidly made a name for himself as a sculptor of portrait busts marked by their informal, lively and highly naturalistic qualities. His tomb sculpture, much of which is in Westminster Abbey, was especially appreciated.

Rouquet, André (1703–59) Born in Geneva, he moved first to Paris, then in 1722 to London where he practised as a portraitist in enamel, and became very friendly with Hogarth, for whose prints he published a French commentary. In 1752 he moved back to Paris, where he had a successful career, becoming a member of the Académie de Peinture. He published his *État des arts en Angleterre* in 1755, and shortly afterwards became insane.

Rubens, Peter Paul (1577–1640) Born at Siegen he embraced in his career virtually every aspect of art, and succeeded in all of them. His close connections with England – he came here in 1629, and was knighted by Charles I, who commissioned several works from him – was one reason for his continuing popularity here. He came to stand for the use of bold, evocative colour in the writings of commentators such as Reynolds.

Rupert, Prince (1619–82) Second son of Elizabeth, Queen of Bohemia, the daughter of James I. Commander of the royal cavalry during the Civil War, he was an active dilettante of music and art. He introduced mezzotint engraving into England, and invented a metal alloy much used for door furniture in the eighteenth century. He was also active in experimenting with different techniques of staining and painting marble.

Russell, John, 4th Duke of Bedford, *see* **Bedford**

Rysbrack, John Michael (1694–1770) Born in Antwerp, he settled in England *c*. 1720, and soon became a successful sculptor, specializing in busts and tomb sculpture. He was patronized by Lord Burlington, and

his greatest work is generally seen as being the equestrian statue of William III in Bristol.

Sackville, Lord Charles, Earl of Middlesex, *see* **Middlesex.**

Sandby, Paul (1725–1809) **and Thomas** (1721–98) The two brothers worked first as military draughtsmen in the Tower of London, and were engaged on a survey of the Highlands which took place after the last Jacobite rebellion. Their works are indistinguishable, and their use of water-colour to produce crisp, lively landscapes was praised by many, including Gainsborough, and had a strong influence on later practitioners in the same medium. Paul published a print attacking Hogarth.

Schaub, Sir Luke (1682?–1757) A successful merchant and banker who built up a collection of paintings which was sold in 1758 for £8,000.

Scott, Samuel (1702?–72) A marine painter, whose early work was in the style of the Van de Veldes, but who was greatly influenced in the 1750s by Canaletto, whose style he copied in views of the Thames. In 1766 he moved to Bath.

Sebastiano, *see* **Piombo**

Secondat, Charles-Louis de, Baron de Montesquieu (1689–1755) Author of *De l'éspirit des lois*, and a forceful and influential writer about political institutions and national characteristics.

Serres, Dominick (1722–93) Born at Aix, and joining the French navy, he was taken prisoner by the crew of an English frigate, and after being released decided to remain in England, where he built up a great reputation as a marine painter, becoming a foundation member of the Royal Academy, and in the year of his death its Librarian.

Sévigné, Madame de (1626–96) Marie de Rabutin Chantal, Marquise de Sévigné, was one of the most renowned letter-writers in the history of French literature. Her correspondence, first published in 1726, achieved immediate recognition in virtue of its freshness and vitality.

Shaftesbury, Anthony Ashley Cooper, 3rd Earl of (1671–1713) Philosopher and aesthetician, who had a varied, and largely unsuccessful political career. He is credited with being the originator of the concept of 'moral sense', and his collected works published under the title of *Characteristicks of Men & c.* contain many stimulating ideas about the nature of art and beauty.

Shebbeare, John (1709–88) Writer, chemist and man of affairs, who was involved in many cultural projects and had a wide range of scientific interests.

Shenstone, William (1714–63) Poet, scholar and miscellaneous writer, whose garden at The Leasaes was considered one of the sights of

the day, though Walpole claimed that the only reason he had made it was for all the world to talk about him.

Shipley, William (1714–1803) Founder of the Royal Society of Arts, and active in many fields connected with the arts, he opened in 1750 a well-known and popular drawing school.

Skelton, Jonathan (1730–59) A landscape painter who went to study in Rome and died there at an early age.

Sloane, Sir Hans (1660–1753) Owner of most of Chelsea, botanist, scholar and an omnivorous collector of all manner of things, the fruits of his activities in this field forming the original basic stock of the British Museum.

Smirke, Robert (1752–1845) Painter and illustrator who exhibited extensively at the Royal Academy and did a number of book illustrations.

Smith, Adam (1723–90) The Scottish author of *Wealth of Nations* who provided eighteenth-century capitalism with its ideology, and also propounded a system of ethics based on the sentiment of sympathy.

Smith, John Raphael (1752–1812) Painter, miniaturist and engraver, who specialized in mezzotints after Reynolds and Gainsborough.

Smith, Joseph (1665–1770) Originally an English merchant living in Venice, and specializing in the sale of meat and fish, by 1744 he had become British consul in that city, and involved in publishing books of an antiquarian nature. This led to his buying books, gems and paintings for himself, and then for British clients. The friend, patron and agent of Canaletto, he was largely responsible for that artist's success in England. His collection was sold to George III.

Smollett, Tobias George (1721–71) Scottish novelist and miscellaneous writer.

Soldi, Andrea (*c.* 1718–65) An Italian artist who worked for a considerable time in England. He was brought here by a group of English merchants resident in Florence and in the *Universal Magazine* for November 1748 he was included in a list of the most important artists in London.

Solimena, Francesco (1657–1747) A Neapolitan artist who worked in Rome, he was the embodiment of the high Baroque style, with dramatic lighting, vigorous composition and rich colouring. He had a great influence on many artists and was the teacher of Allan Ramsay.

Soufflot, Jacques-Germain (1713–80) A French architect who, after travelling extensively in Italy, made a reputation for himself in his native Lyons, as the designer of the Hotel de Dieu and the Exchange, buildings conceived in what was then an original classical style. In 1755 he was

brought to Paris and became involved with plans for redesigning the city. His most important building there was what is now the Panthéon.

Spengler, Adam (1727–90) One of a famous Zürich family of modellers and glass-makers, he worked for some time in England, undertaking work for the Chelsea pottery.

Stanhope, Philip, 4th Earl of Chesterfield, *see* **Chesterfield.**

Stevens, Edward (*c.* 1748–75) An architect who died in Rome, having exhibited works at the Royal Academy between 1771 and 1773.

Strange, Sir Robert (1721–92) One of the people most responsible for raising the status, and improving the quality, of British engraving in the late eighteenth century. After a Jacobite youth, in the course of which he spent some time in Rome and Paris, he settled down in London, and conducted a war with the Royal Academy about the lack of respect which it accorded to engravers. His prints were as popular in Europe as they were in Britain.

Stuart, James (1713–88) Beginning his career as a fan painter, he went to Rome, where he became involved in the art market. In 1748 he went to Greece with Revett to produce their famous work on the antiquities of Athens, the basis of the classic revival here. As an architect his most respected work is the chapel of Greenwich Hospital.

Stuart-Mackenzie, The Hon. James (*c.* 1720–1800) Brother of the Prime Minister, the Earl of Bute and British envoy at the court of Turin from 1758 till 1763, he became Lord Privy Seal for Scotland. He was actively involved in the sale of the collection of Joseph Smith to George III.

Stubbs, George (1724–1806) Animal painter, born in Liverpool, and largely self-taught, he spent ten years in the preparation of *The Anatomy of the Horse*, and another eighteen months working on the plates. In addition to his great technical skills as a painter, he had a fine sense of composition and feeling for form.

Suffolk, Duke of, *see* **Brandon.**

Taylor, Isaac (1730–1807) An engraver who worked extensively for *The Gentleman's Magazine* and other periodicals. He also did a lot of book illustrations, especially for publications such as Chamber's *Cyclopaedia*. He was also a portrait painter, and an active member of the Society of Artists.

Thornhill, Sir James (1675–1734) The only successful English decorative painter of his day, he mastered the concept of the Baroque mural style, as exemplified in his works at Hampton Court, All Souls, Blenheim and St. Paul's. His most considerable work was the Painted Hall at Green-

wich Hospital. Knighted in 1722, and Master of the Painter-Stainers' Company, he started an unsuccessful Academy.

Thornton, Bonnel (1724–68) A miscellaneous writer and a friend of the poet Cowper, he contributed extensively to the journal *The Connoisseur*.

Tintoretto, Jacopo Robusti (1518–94) A Venetian painter whose style contains elements of expressionism in its brushwork, sense of drama and deeply felt religious experience. His handling of light and shade greatly impressed eighteenth century artists.

Titian (Tiziano Vecellio), (*c.* 1487–1576) A pupil of Giovanni Bellini, he came to be regarded as the greatest 'exponent of the Venetian school of painting, with its emphasis on colour and atmosphere. Reynolds said of him that 'whatever he touched, however mean and familiar, by a kind of magick he invested with grandeur and importance'.

Toms, Peter (*c.* 1710–76) The son of an engraver, he was a pupil of Hudson, and became especially expert in painting draperies, a task which he undertook for Reynolds, Gainsborough and Francis Cotes. He charged 20 guineas for doing this for a full-length figure. A foundation member of the Royal Academy, he took to drink and eventually committed suicide.

Tonson, Jacob (1656–1736) Publisher who purchased copyright of *Paradise Lost*, and was closely associated with Dryden, Swift, Addison Pope and others. Involved in the art world, he published Dryden's important *Remarks on Several Parts of Italy* (1705).

Tour, Maurice Quentin de la (1704–88) After a short visit to England in his youth, he returned to Paris at the age of twenty pretending to be an English painter. His skills as a pastellist were formidable, and his success enormous. His portraits have great vivacity, and he exploited the medium to the full.

Towneley, Charles (1737–1805) Of a North Country recusant family, he spent much of his life in Rome and the south of Italy, building up a remarkable collection of classical sculpture.

Tresham, Henry (*c.* 1740–1814) Born in Ireland, he received his training at West's Academy in Dublin. He came to England in 1775, and then spent fourteen years on the continent, mainly in Rome, where he made an important collection of Greek and Etruscan vases for Lord Carlisle, who gave him an annuity of £300. In 1807 he became Professor of Painting at the Royal Academy.

Tyler, William (*c.* 1735–1801) Architect and sculptor, who studied under Roubiliac, and in 1765 became a director of the Society of

Artists. He became a foundation member of the Royal Academy as a sculptor, and took an active part in its affairs.

Udney, John (1721–80) and **Robert** (1729–1802) Two brothers who had close connections with Florence. Robert became a banker in England, but John spent most of his life in that city, where he became British Consul, and was actively involved in the sale and acquisition of works of art. The two brothers had a scheme for creating a collection of paintings to be used by students at the Royal Academy Schools.

Van Dyck, Sir Anthony (1599–1641) In the course of his nine years stay in England, from 1632 until his death, Van Dyck had an immense influence on the development of portraiture here, and we see the English seventeenth century mainly through his eyes. He did more than anyone else to introduce into England the main characteristics of the baroque style, which he had perfected in Italy and Antwerp.

Vanloo, Jean-Baptiste (1684–1745) Born at Aix, he studied at Rome under Benedetto Luiti. After working for some time in Paris, he was persuaded to come to England with a recommendation to Sir Robert Walpole, and here he became a very successful portrait painter, his work being compared with that of Rubens. He returned to Aix in 1742.

Vasari, Giorgio (1511–74) Italian painter, architect and biographer. Although he achieved a great deal in these spheres, he is mostly famous for his *Lives of the most Excellent Painters, Sculptors and Architects*, which was first published in 1550.

Vernon, Joseph (1738–1782) Actor, singer of tenor and soprano parts at Drury Lane and a prolific composer of songs, he published a songbook in 1782.

Vertue, George (1684–1756) An engraver of considerable skill, who from 1723 to 1751 was responsible for the views on the *Oxford Almanack*. He made a massive collection of notes about the history of art in England, which was bought by Horace Walpole, who used it as the basis of his *Anecdotes of Painting in England* (1762–71). Vertue's material has since been published in its original form by the Walpole Society.

Vile, William (*d.* 1767) A cabinet-maker whose work is remarkable for its originality of design and superb craftsmanship. He carried out a great deal of work for the royal family.

Voyez, John (1720–73) Served his time with a silversmith, became a carver in wood for Robert Adam, and was then taken up by Wedgwood, who treated him very well. In 1769 however he was sentenced to three months' imprisonment, and later started producing fake Wedgwood ware. Examples of his work are in the Bristol Museum.

Wale, Samuel (c. 1720–86) Although he produced some decorative works, he was mainly known as an illustrator, and he became the first Professor of Perspective (and later Librarian) at the Royal Academy. He also produced the most famous inn sign of eighteenth-century England at the Shakespeare Inn in Drury Lane, which cost £500.

Walpole, Horace (1717–97) Fourth son of the famous statesman. Connoisseur, dilettante, letter-writer, novelist, art historian, amateur artist and architect, he mirrored the taste and aesthetic ideals of his time perfectly. Fastidious, camp, a snob, and very engaging, he imprinted on English art history an amateur quality of an admirable kind, which persisted until the mid twentieth century. He gave the early phases of the Gothic revival a social cachet which assisted its growth considerably.

Walpole, Sir Robert (1676–1745) The Prime Minister of George I and II, his picture collection at Houghton in Norfolk included 20 Van Dycks, 19 Rubens, 8 Titians, 5 Murillos, 2 Velázquez and a Frans Hals (surprising for the time). The third Earl of Oxford, his descendant, sold them for about £40,000 to Catherine the Great of Russia.

Ware, Isaac (d. 1766) An architect, who studied in Italy, where he was sent by Lord Burlington, having commenced his working career as a chimney boy. He designed many important houses, most of which, like Chesterfield House, have been destroyed, though Wrotham Park, Middlesex largely survives. He was mostly renowned for his edition of Palladio, and his numerous publications for builders and patrons.

Warton, Thomas (1728–1790) A poet, archaeologist, historian and poetic journalist, who was extremely prolific in his output, and on friendly terms with most of the leading figures in the world of art and literature. He became Professor of Poetry and of Ancient History at Oxford, and was poet-laureate from 1785 till his death

Watteau, Jean-Antoine (1684–1721) Born in Valenciennes, he brought into French painting something of the Flemish traditions of art, expressing an idyllic world of pleasure and contentment. Suffering from tuberculosis he came to England to consult Dr. Mead, but, unfortunately for the latter's reputation, died in the following year.

Webb, Daniel (1719–98) A graduate of New College, Oxford, he published *Beauties of Painting* in 1760, and followed it up by *Beauties of Poetry* in 1762.

Wedgwood, Joseph (1730–95) Born at Burslem he transformed by his taste and business acumen, the whole of the Staffordshire pottery industry and brought Neoclassical taste and domestic elegance to thousands of middle-class homes. His best-known productions were in unglazed

black, deep red and jasper ware, the latter a fine white stoneware which could be coloured with metallic oxides.

West, Benjamin (1738–1820) Born in Philadelphia, and self-taught, he began his career in America as a portrait painter, and came to London in 1764, by which time he had started to produce historical pictures. His *Death of Wolfe* (1771) marking a milestone in the genre, in that it was the first to depict contemporary dress in a painting of that kind. A great favourite of George III, who employed him extensively – in preference to Reynolds – he was a foundation member of the Royal Academy, and in 1792 became its second president.

White, George (1684?–1732) One of the first exponents of mezzotint engraving, he was son of Robert White (1645–1703) who was also an engraver. He also did portraits in pencil, crayon and oils.

Wilson, Richard (1714–82) Born in Wales, he commenced his career as a portrait painter, and then spent four years in Italy, where he was deeply influenced by the work of Claude, from which he derived a style which combined classical elements with the picturesque, and showed a remarkable gift of direct observation of nature.

Wilton, Joseph (1722–1803) Son of an ornamental plasterer, he studied sculpture in Flanders, Paris and Italy. He carved the state coach for the coronation of George III, and became well known for his portrait busts and monuments. He was Keeper of the Royal Academy from 1790 till his death.

Winckelmann, Johann Joachim (1717–68) In a sense the father of modern art history, his *Reflections on the Painting and Sculpture of the Greeks* (1755) first drew a clear distinction between the Greek and Roman contributions to the classical heritage, and provided the historical basis for the revival of classicism. He spent most of his life in Rome, and was murdered in a homosexual brawl in Trieste.

Wood, John (1704–54) Architect and town planner, who largely designed Georgian Bath, and was a leading figure in the dissemination of the Palladian style. His son John (1728–81) carried on his father's work.

Woolett, William (1735–85) Draughtsman and line engraver, who made an international reputation for the delicacy and accuracy of his work. His most famous engraving was of West's *Death of Wolfe*, which had a considerable commercial success, and for which he was given the title of 'Historical Engraver to His Majesty'.

Wooton, John (1668–1775) After studying in London under Jan Wyck, he went to Rome, where he was greatly impressed by the work of Claude and Dughet. Returning to London, he specialised in horse painting, but introduced into his works important elements of classical landscape.

Wren, Sir Christopher (1632–1723) Architect and scientist, he was the son of a Dean of Windsor, and held the chair of astronomy at Oxford in his twenties. He began as an amateur architect, but rapidly acquired remarkable skills. After the Great Fire of London he produced a radical plan for rebuilding the City, but he was foiled by vested interests. His design of St Paul's and of some fifty city churches show imaginative skill combined with a rare ability to make it conform to liturgical demands.

Wright, Joseph (1734–97) Known as Wright of Derby, he was born in that town, and apart from a visit to Italy, and a short residence in Bath, spent the rest of his life there. Landscape painter and portraitist, he was renowned for his unusual and dramatic lighting effects, for the romantic quality of his compositions, and for his interest in scenes of a scientific or industrial nature.

Yeo, Richard (*c.* 1705–79) An engraver of medallions, and for some time Chief Engraver to the Mint. He was a foundation member of the Royal Academy.

Young, Arthur (1741–1820) A widely popular author whose accounts of his various travels both in Britain and Europe are a rich source of information about the life and agriculture of the eighteenth century.

Zoffany, Johann (1734–1818) Born in Germany, he studied painting in Austria and Italy, arriving in England *c.* 1758. He started off painting clock faces, and then, with the support of Garrick went on to stage creation of those conversation pieces which are his main claim to fame.

Zuccarelli, Francesco (1702–88) A Venetian landscape artist, who was taken up by Consul Smith, and spent seventeen years in England, where his picturesque landscapes were greatly appreciated by George III. He was a member of the Royal Academy and of the Venetian Accademia.

Zuccaro (Zuchero) Taddeo, (1529–66) and **Federico** (1543–1609) Born in Urbino, the two brothers played an important role in sixteenth century Roman art, producing an eclectic style which was widely copied throughout Europe. Federico spent some in time in England, where he is reputed to have painted the 'Rainbow Portrait' of Queen Elizabeth at Hatfield, and another now in Siena.

Wren, Sir Christopher (1632–1723) Architect and scientist, he was the son of a Dean of Windsor and held the chair of astronomy at Oxford in his twenties. He began as an amateur architect, but rapidly acquired considerable skill. After the Great Fire of London he produced a radical plan for rebuilding the City, but he was foiled by vested interests. His rebuilding of St Paul's and of some fifty city churches show imaginative skill combined with a rare ability to make a tool in textural or liturgical demands.

Wright, Joseph (1734–97) Known as Wright of Derby, he was born in that town and apart from a visit to Italy, and a short residence in Bath, spent the rest of his time there. Landscape painter and portraitist, he was renowned for his unusual and dramatic lighting effects, for the romance of quality of his compositions, and for his interest in scenes of a commercial or industrial nature.

Yeo, Richard (1720?–67) An engraver of medallions, and for some time chief engraver to the Mint. He was a foundation member of the Royal Academy.

Young, Arthur (1741–1820) A widely popular author whose accounts of his various travels both in Britain and Europe are a rich source of information about the life and agriculture of the eighteenth century.

Zoffany, Johann (1733–1810) Born in Germany, he studied painting in Austria and Italy, arriving in England in 1758. He started off painting stock faces, and then, with the support of Garrick, went on to supervise many of those conversation pieces which are his main claim to fame.

Zuccarelli, Francesco (1702–88) A Venetian landscape artist, who was taken up by Consul Smith, and spent seventeen years in England, where his picturesque landscapes were greatly appreciated by George III. He was a member of the Royal Academy, and of the Venetian Academies.

Zuccaro (Zuccheri) Taddeo (1529–66), and **Federico** (1543–1609) Both in Urbino, the two brothers played an important role in sixteenth-century Roman art, producing a mannerist style which was widely copied throughout Europe. Federico spent some time in England, where he is reputed to have painted the famous Portrait of Queen Elizabeth at Hatfield, and another now in Siena.

Index